D1205308

German Open

Gegenwartskunst in Deutschland

Contemporary Art in Germany

Kunstmuseum Wolfsburg

Vorwort/Foreword

Gijs van Tuyl

Das Kunstmuseum Wolfsburg betrachtet es als seine Aufgabe, neben der Präsentation zentraler Themen und Positionen der Kunst des 20. Jahrhunderts sein Publikum möglichst frühzeitig über aktuelle Zeitströmungen innerhalb der internationalen Kunst zu informieren. Damit steht das Kunstmuseum in der Tradition seines Standortes, an dem das Leitmotiv der Innovation bislang vor allem für das Gebiet der Industrie gegolten hat. Mit "Full House – Junge britische Kunst" (1996) und "Sunshine & Noir – Kunst in Los Angeles 1960–1997" (1997) oder mit monografischen Ausstellungen wie "Wolfgang Tillmans" (1996), "Elizabeth Peyton" (1998/99) und "Mariko Mori" (1999) war das Kunstmuseum national und international in der vordersten Linie zu finden.

Gerade gegen Milleniumende, wo in vielen Museen mit historischen Ausstellungen auf die Vergangenheit zurückgeblickt wird und Bilanzen gezogen werden, schaut das Kunstmuseum mit einer Ausstellung junger Kunst in die Zukunft: "German Open 1999 – Gegenwartskunst in Deutschland". Mit der ersten großen Übersicht über jene Kunst, die sich in Deutschland während der zweiten Hälfte der neunziger Jahre Bahn gebrochen hat und zunehmend internationales Terrain gewinnt, wird der Anfang des neuen statt der Abschluß des alten Milleniums gefeiert.

Nach den bereits erwähnten Übersichtsausstellungen der zeitgenössischen Kunstszenen in London, Glasgow und Los Angeles ist hier die selbstgestellte Aufgabe als Recherche formuliert, wie vital sich die Kunst im wiedervereinigten Deutschland nach der Wende in den neunziger Jahren entwickelt hat. Kurator Veit Görner hat mit Andrea Brodbeck das Feld von Osten nach Westen, von Norden nach Süden engagiert und intensiv durchforscht. Auf der Basis vieler Atelierbesuche wurde ein offenes Ausstellungskonzept entwickelt, das sich ganz bewußt nicht auf eine Strömung festlegt. Die gegenwärtigen Entwicklungen erweisen sich eher als zentrifugal denn als zentripetal.

Apart from presenting major themes and trends of twentieth century art, our task at the Kunstmuseum Wolfsburg is to provide the public with an insight into current trends in international art as early as possible. We are thus continuing Wolfsburg's tradition of innovation, which has until now been associated above all with the city's industry. With pioneering shows such as *Full House – Young British Art* (1996) and *Sunshine & Noir – Art in Los Angeles 1960–1997* (1997) or monographic exhibitions such as *Wolfgang Tillmans* (1996), *Elizabeth Peyton* (1998/99) and *Mariko Mori* (1999), the Kunstmuseum has been in the vanguard of both the national and international art scene in recent years.

At the end of the millennium, when many museums are taking stock of the past with retrospective exhibitions, the Kunstmuseum Wolfsburg is looking to the future with an exhibition of young artists: *German Open 1999. Contemporary Art in Germany*. This is the first major show of trends to have emerged during the second half of the Nineties; German contemporary art is gaining ground internationally. The exhibition is thus a celebration of the new, rather than a conclusion of the old.

After the above-mentioned exhibitions of contemporary art in London, Glasgow and Los Angeles, the Wolfsburg exhibition sets out to answer the question as to how vigorously art has developed in the decade since German reunification. Together with Andrea Brodbeck, curator Veit Görner has engaged in intensive research throughout the country, from East to West, North to South. The result of several visits to artists' studios, the flexible exhibition concept consciously refrains from committing itself to any one specific trend: current developments would appear to be centrifugal, rather than centripetal.

The criteria applied when selecting the contemporary German art shown at the exhibition were quality and modernity, without making specifically cultural or political

Die Kriterien für diese Auswahl jüngster Gegenwartskunst in Deutschland heißen Qualität und Aktualität, ohne mit kulturpolitischen Absichten die vor zehn Jahren eingeleitete Wiedervereinigung zu thematisieren oder zu kommentieren. Faktum ist vielmehr, daß in der deutschen Gegenwartskunst dem Gerede von einer Zweiklassengesellschaft längst der Boden entzogen wurde. Die Akteure im Osten und Westen Deutschlands verfügen über gemeinsame Erfahrungen, die schwerer wiegen als die trennenden Momente, die noch ihre Vorgängergeneration geprägt haben.

Die 37 Künstlerinnen und Künstler, die in "German Open" vorgestellt werden, sind im Osten wie im Westen im Schatten der Ära Helmut Kohl aufgewachsen; sie kommen aus Köln und Leipzig, Dresden und Hamburg, Berlin und Berlin. Als Kinder des elektronischen Zeitalters sind sie genährt und geprägt von Medien wie Fernsehen, Fotografie, Film, Stereoanlagen und Computer. Sie sind weltoffen und auf den Alltag der postindustriellen Gesellschaft ausgerichtet, wo Sport, Reisen, Politik, Design, On-line-Kommunikation und Internet, Werbung, Musik, Ausstellung, Disco, Kunst, Mode, Lifestyle ein buntes Bild prägen. Die oft medial vermittelte Realität wird in der Kunst auf fast spielerische Weise auf ihren Punkt gebracht: unter Einsatz der unterschiedlichsten Medien wie Malerei, Fotografie, Film, Video, Architektur, Design, Skulptur, Computer, Installation, Zeichnung oder Wandmalerei.

Die Künstler der Ausstellung arbeiten einzeln oder in Gruppen. Sie lassen sich keinem Sammelbegriff unterordnen. Hier zeigt sich die Vielfalt dieser Generation im Gegensatz zu den Trendprofilen der jüngeren Vergangenheit wie Neo-Expressionisten oder Neue Wilde, die die Komplexität und den Reichtum der Kunst in Deutschland während der Achtziger zu überschatten drohten. Bildlich gesprochen ist "German Open" keine Konstruktion eines hermetisch abgeschlossenen Turms, sondern ein großes offenes Künstler-Haus mit vielen Wohnungen, das einer Stadt ohne Zentrum ähnelt.

references to or commenting on the process of reunification initiated a decade ago. Yet it is a fact that contemporary German artists have long since rendered the idea of a two-class society obsolete. Artists in both East and West Germany share experiences that are of far greater consequence than the phenomenon of separation that marked the generation before them.

The thirty-seven artists presented at the *German Open* exhibition grew up in the shadow of the Helmut Kohl era, both in the East and the West; they come from Cologne and Leipzig, Dresden and Hamburg, Berlin and Berlin. As children of the electronic age, they have grown up on a diet of media such as television, photography, film, stereo sound systems and computers. They are cosmopolitan and oriented towards the everyday life of a post-industrial society in which sport, travel, politics, design, on-line communication and the Internet, advertising, music, exhibitions, disco, art, fashion and lifestyle all make their contribution to a colourful picture. The way these artists express a reality frequently communicated to them only via the media is almost playful, employing the most varied range of media such as painting, photography, film, video, architecture, design, sculpture, computer, installation, drawing or wall painting.

The artists showing at the exhibition work individually or in groups. The diversity of this generation's work defies categorisation, and contrasts with the dominating groups of the recent past such as the Neo-Expressionists or the *Neue Wilde*, who during the Eighties were threatening to overshadow the rich complexity of German art. To use a visual comparison, *German Open* should not be seen as a hermetically sealed tower, but as a spacious house containing many apartments, open to artists, and resembling a city without a centre.
The way the exhibition is presented takes this into consideration. Consequently, *German Open* is based on an organic structure similar to the veins of a body. It can

Die Inszenierung der Ausstellung trägt dem Rechnung. Ihr liegt demzufolge eine organische Struktur zugrunde, den Adern eines Körpers ähnlich. Sie kann auch als eine Hand mit Fingern gesehen werden, deren Linien man sich wie ein Wahrsager nähern könnte, um die Zeichen der Zeit zu lesen. Die Kunst- und Lebenslinien kreuzen, überschneiden einander, laufen parallel oder haben gar nichts miteinander zu tun.

Um die mit "German Open" verbundene Zeitströmung zu dokumentieren, umfaßt diese Publikation eine Fülle an Informationen, Bildern und Texten. Nach einem Überblick der beiden Ausstellungskuratoren, in dem die unterschiedlichen künstlerischen Positionen unter einer Gesamtperspektive dargestellt werden, folgen zu den einzelnen Künstlern kurze Texte, die von den KünstlerInnen gewählten jungen Kunstkritiker und Kuratoren verfaßt sind. Es ist ein stark visuelles Buch geworden mit zahlreichen 'Windows' auf die jüngste Gegenwartskunst in Deutschland. Die in den Katalog einbezogenen Aufnahmen der Ausstellungsinszenierung zeichnen dabei ein eindrucksvolles Bild der in vielen Fällen eigens für die Ausstellung entstandenen, aufwendigen Arbeiten.

Eine so komplexe Ausstellung wäre nicht ohne das große Engagement der teilnehmenden Künstler zustande gekommen. Ihnen sei an dieser Stelle sehr herzlich gedankt. Unser Dank gilt auch der Stiftung Kunst und Kultur des Landes Nordrhein-Westfalen für den Förderzuschuß der Arbeit von Stefan Hoderlein, der Deutschen Telekom AG für die großzügige Unterstützung der Arbeit von Matti Braun sowie den unterstützenden Galeristen und den Leihgebern dieser Ausstellung.

Gijs van Tuyl
Direktor

also be seen as a hand with fingers whose lines can be read in the manner of a fortune-teller to interpret the signs of the times. The art and life lines cross, run parallel – or have nothing to do with each other at all.

To document the prevailing trends as exemplified in *German Open*, this publication contains a host of information, images and texts. The overview presented by the two curators, in which the various artistic trends are examined from an overall perspective, is followed by brief texts on the individual artists written by a diverse group of young art critics and museum curators. This catalogue has become a highly visual book that opens numerous "windows" on Germany's most recent contemporary art. The photographs of the staging of the exhibition included in the catalogue paint an impressive picture of the lavish art works, which were in many cases created especially for the exhibition.

An exhibition of this complexity would have been unthinkable without the commitment of the artists involved, to whom we would like to express our heartfelt thanks. Our thanks also go to the Stiftung Kunst und Kultur des Landes Nordrhein-Westfalen for subsidising the work of Stefan Hoderlein; Deutsche Telekom AG for generously supporting the work of Matti Braun; the gallery owners for their kind help, as well as all those who loaned works of art to the Kunstmuseum Wolfsburg for this exhibition.

Gijs van Tuyl
Director

Daniel Pflumm

Peter Dittmer

Tobias Rehberger

Johannes Wohnseifer

Matti Braun

Jonathan Meese

Manfred Pernice

KINO

Stefan Hoderlein

Peter Friedl

Marc Brandenburg

Daniel Richter

Christian Jankowski

Kai Althoff

Max Mohr

Sunah Choi

Alexander Györfi

Maix Mayer

Christian Flamm

Heidi Specker

WORD SCULPTURE

Tilo Schulz

Cosima von Bonin

Silke Wagner

Peter Pommerer

Neo Rauch

Michel Majerus

Olafur Eliasson

Christian Hoischen

Andree Korpys & Markus Löffler

Simone Böhm

Elmar Hess

Joseph Zehrer

Stefan Exler

Franz Ackermann

Stefan Kern

Gregor Schneider

Reinigungsgesellschaft

John Bock

Now's the time

Andrea Brodbeck / Veit Görner

– Now's the time

Die Ausstellung "German Open" ist vor dem Hintergrund der direkten Anschauung und Auseinandersetzung vor Ort entstanden, im tatsächlichen Sinne der Feldforschung. Maßgeblich waren Recherche und Untersuchung unterschiedlichster Methoden, Motive und Interessen, die auf die Visualität der Gegenwart rekurrieren und nicht eine vorgefertigte Konzeption oder eine thematisch eingrenzende Fragestellung. Die Parameter zur Auswahl haben sich aus den Gesprächen mit den vielen KünstlerInnen ergeben, die wir in allen Teilen der Republik besucht haben. Dabei sind wir unseren eigenen Interessen genauso gefolgt wie den unzähligen und hilfreichen Hinweisen von befreundeten KollegInnen, GaleristInnen und KünstlerInnen. Ein Anspruch auf Vollständigkeit wäre trotz des immensen Zeitaufwands, den wir betrieben haben, illusorisch. Die Anzahl der beteiligten KünstlerInnen wurde auch, wie immer, bestimmt von einer Terminvorgabe und begrenzter Ausstellungsfläche.

– I like to count, 1998

Der Besuch bei Stefan Hoderlein in Düsseldorf war ein Einblick in äußerst beengte Verhältnisse. Sein Wohnatelier bot jedem von uns gerade mal einen Stehplatz. Ein enormes Materialdepot aus allerlei Alltagsgegenständen und notgedrungen steinzeitlichen audiovisuellen Tools, die nebenbei im Winter die Heizungsfunktion in der ehemaligen Asylantenherberge übernehmen. Die Lagerung erfolgt in mehreren archäologischen Schichten, wobei selbst der Eigentümer den Überblick verloren hat. Häufiger muß er Arbeiten erneut herstellen, wenn es nicht mehr möglich ist, diese auszugraben. Gleichwohl lebt Hoderlein in symbiotischer Gemeinschaft mit seiner Sammlung. Die Leidenschaft zur Anhäufung von Videorecordern, Fernsehapparaten und PC-Ramsch, bereit

– Now's the time

The *German Open* exhibition is the result of the direct observation and examination of works of art on the spot, in the true spirit of fieldwork. The exhibition is based on the research and examination of a wide variety of methods, subjects and interests that refer to the visual aspects of the present, rather than a preconceived idea or a thematically restricted approach. The criteria we applied were the natural result of the conversations we had with the many artists we visited throughout the country. In doing so, we were pursuing our own interests just as much as we were acting on the many helpful hints we had received from colleagues, gallery owners and artists. Nevertheless, despite the enormous amount of time we invested in researching *German Open*, it would be entirely unrealistic to claim that the exhibition presents a complete picture of contemporary art in Germany. As always, the number of artists involved was also determined by the dates of the exhibition and the limited amount of exhibition space at our disposal.

– I like to count, 1998

Visiting Stefan Hoderlein in Dusseldorf offered us a glimpse of extremely cramped conditions. There was just enough space in Hoderlein's live-in studio for each of us to stand. The studio contains an enormous repository of all sorts of everyday objects and – of necessity – stone-age audio-visual tools that, in winter, are used for heating this former home for asylum-seekers. These objects are stored in several archaeological layers. Not even the owner knows where everything is, and frequently has to reproduce art works when it is no longer possible to excavate them. Yet Hoderlein lives in symbiotic communion with his collection. His passion for accumulating video recorders, television sets and computer junk, ready

zum multiplen Einsatz, legt sofort seine künstlerische Strategie offen: sammeln und sampeln. Sein Wolfsburger Dia-Korridor "20001 – Bilder aus der Jetztzeit" verwendet Bilder als Bausteine. Eine Fassade der Moderne, Parzelle an Parzelle. Stanley Kubricks Vision scheint hier in eine fiktive Unendlichkeit scheinbar unlimitierter Bilder projiziert. Bilder, die mehr denn je immer, überall und von jedem abgerufen, re- und umorganisiert werden können. Der Inhalt verläuft sich in der Quantität, die Menge wird zur Botschaft. Die Simulation potentieller Varianten, ihre virtuelle Kombinatorik wird zum alles bestimmenden Prinzip der Chip-Generation und ihrer künstlerischen Methode des konstruktiven Samplings. Dabei wird die Bündelung von Ready-made-Fragmenten zu einem neuen Ganzen praktiziert. Es geht nicht mehr um *eine* gültige Richtung oder Aussage, sondern um eine undogmatische Polyphonie und Polyvalenz. Heute bestimmt die Geschwindigkeit der Wechsel das Wesen einer beschleunigten Gesellschaft.[1] Parallele Gleichzeitigkeiten werden zum Synonym für den "rasenden Stillstand" (Paul Virilio).

– Das Haus der Sehenswürdigkeiten, 1999

Michel Majerus betreibt Sampling in der Malerei. Tobias Rehberger nutzt das Verfahren und greift bei vielen Arbeiten auf den Zeichenvorrat aus Kunst und Design zurück, und Franz Ackermann baut dreidimensionale Layer aus Fotografien, grafischen Strukturen und Malerei zu komplexen Bildinstallationen zusammen. Gemalte Partituren der globalen Bewegung. Diese drei Künstler haben wir als "Raumgestalter" zu "German Open" eingeladen. Die Vielschichtigkeit der Gegenwartskunst sollte in der Ausstellung in eine adäquate Farbgestaltung, in ein visuelles "all-over" transformiert werden. Der programmatische Titel von Majerus' Wandarbeit "What looks good today, may not look good tomorrow" ist sowohl Blick auf die heutige Trendmaschine als auch selbstkritische Haltung gegenüber der eigenen Produktion. Zweifel und

[1] Siehe dazu: Peter Glotz, *Die beschleunigte Gesellschaft. Kulturkämpfe im digitalen Kapitalismus*, München 1999.

to be used in a variety of ways, immediately reveals his artistic strategy: collecting and sampling. In his corridor of slides created for the Wolfsburg exhibition entitled *20001 – Bilder aus der Jetztzeit* ("20001 – Images from the Present") Hoderlein uses images as building blocks. A façade of the modern movement, block by block. Stanley Kubrick's vision seems to have been projected into a fictitious eternity of seemingly unlimited images. Images that, more than ever, can always be retrieved and reorganised by anyone. The message dissolves in the sheer quantity of images, which in themselves become the message. This method – simulation of potential variations, virtual combinatorial analysis – has been adopted by the chip generation and now determines everything, including their method of constructive sampling, according to which ready-made fragments are combined to create a new entity. A single valid approach or statement has been replaced by undogmatic polyphony and pluralism. Today, the speed of change dictates the nature of our accelerated society.[1] Parallel simultaneity has become synonymous with what Paul Virilio refers to as "racing at a standstill."

– Das Haus der Sehenswürdigkeiten (The House of Sights), 1999

Michel Majerus applies the sampling method to his paintings, as does Tobias Rehberger, who frequently falls back on the stock of symbols provided by the world of art and design. Franz Ackermann combines three-dimensional layers of photographs, graphic structures and paint in complex picture installations. Painted scores of global movement. We invited these three artists as "interior designers" to *German Open*. The complexity of contemporary art should be reflected by the use of suitable colours, translated into a visual "all-over." The programmatic title of Majerus' wall installation, *What looks good today may not look good tomorrow*, is both a look at

[1] See: Peter Glotz, *Die beschleunigte Gesellschaft. Kulturkämpfe im digitalen Kapitalismus*, Munich 1999.

Variation sind so natürlicher Bestandteil eines aktuellen Kunstverständnisses, das sich entspannt vom Dogma des einzig gültigen "Masterpiece" gelöst hat.

Eine konsequente Fortschreibung dieses Ansatzes findet sich in der teilweisen oder vollständigen Aufgabe der alleinigen Autorenschaft. Koproduktionen sind keine Seltenheit. KünstlerkollegInnen, KunstvermittlerInnen, Freunde und Bekannte werden in den künstlerischen Prozeß miteingebunden. So hat Manfred Pernice die Dia-Projektion "Walhalla Straße/Fortuna Allee" von Ulrike Kuschel in seine Skulptur integriert und Franz Ackermann mit Rirkrit Tiravanija bei der Innengestaltung seines Möbelwagens zusammengearbeitet. Auch die Besucher bleiben nicht außen vor. Alexander Györfi hat bei früheren Ausstellungen unterschiedlichste Musikinstrumente bereitgestellt, um mit den "Betrachtern" Musik zu machen. Peter Friedl stellt in Wolfsburg unter anderem ein Malbuch mit Motiven aus autobiografischen Fotovorlagen vor, das von Kindern in den Programmen der visuellen Bildung ausgemalt werden kann. Die ausgemalten Bücher wird Friedl später wieder als künstlerisches Material verwerten.

Interaktive Kunst leitet sich heute nicht aus dem sozialwissenschaftlichen Terminus, sondern vielmehr aus dem gebräuchlichen Medienbegriff ab. Anders als bei kommunikativen und partizipatorischen Beteiligungsformen der Kunst, die den Betrachter als Partner, Koproduzenten oder Werkvollender[2] mit einbeziehen, handelt die Interaktive Kunst von Dialogformen mit computergestützten Werken. Eine der wenigen Arbeiten, die tatsächlich interaktiv, also dialogfähig sind und nicht nur programmierte Abläufe reproduzieren, ist Peter Dittmers "Amme". Über Jahre hinweg hat Dittmer seiner Arbeit Sprach- und Sinnverständnis beigebracht, so daß man sich tatsächlich auf eine überraschend abwechslungsreiche Unterhaltung mit der Maschine einlassen kann.

Häufig entstehen Projekte, die ausschließlich im Feld der Vermittlung angesiedelt sind, wie Tilo Schulz' Wolfsbur-

today's trend machine and a self-critical approach to the artist's own work. Doubts and variations are hence naturally part of current thought on art, which has freed itself in a relaxed way from the dogmatic idea of "the masterpiece."

A logical continuation of this approach is the partial or complete relinquishment of the idea of sole authorship. Coproductions are no rarity. Fellow artists, art agents, friends and acquaintances are involved in the artistic process. Adopting this approach, Manfred Pernice has integrated Ulrike Kuschel's slide show *Walhalla Strasse/ Fortuna Allee* into his sculpture, while Franz Ackermann has cooperated with Rirkrit Tiravanija on the interior design of his furniture van. Nor are exhibition visitors left out. At past exhibitions, Alexander Györfi provided a wide variety of musical instruments, to make music with his "viewers." For the present exhibition, one of Peter Friedl's contributions is a painting book with subjects based on autobiographical photographs, which children can paint during their art classes. Friedl will later recycle the painted books as artistic material.

Today, the idea of interactive art is not based on the sociological sense of the word, but more on the media term. Unlike communicative and participatory art forms that involve the viewer as a partner and coproducer, completing the work of art[2], interactive art is about forms of dialogue using computer aids. One of the few works at this exhibition which are really interactive, i.e. capable of dialogue and do not merely reproduce programmed sequences, is Peter Dittmer's *Wet-Nurse*. For years, Dittmer taught his creation to understand the meaning of speech, allowing the viewer to become involved in an astonishingly varied conversation with the machine.

Many projects are the result of cooperation, such as Tilo Schulz' creation for Wolfsburg entitled body of work: *the ideal exhibition, category: wall painting and design,*

2 Erstmalig hat Franz Erhard Walther mit seiner Definition von Kunst den Betrachter zum Werkvollender erklärt: erweiterter Kunstbegriff (im Sinne der Beuysschen Terminologie) plus Handlung (des Rezipienten) gleich Werk.

2 Franz Erhard Walther was the first to declare the viewer as necessary to the completion of a work of art: an extended definition of art (in the sense of Beuys' terminology) + action (of the viewer) = work of art.

ger Arbeit "body of work: the ideal exhibition, category: wall painting and design", die in Zusammenarbeit mit der Bibliothekarin und den freien Mitarbeitern des Museums entstanden ist. Dabei ist das Ergebnis, das natürlich die Signatur der AutorInnen trägt, genauso wichtig wie der Prozeß, die gemeinsame Bemühung als emanzipatorisches Motiv. Auch die Projekte der Reinigungsgesellschaft schließen den Rezipienten als aktiven Teilhaber mit ein: Als Interviewpartner in ihren annähernd dokumentarischen Filmen über das Erzgebirge oder als Adressaten in Kunstseminaren für Unternehmen, die sie als Dienstleistung anbieten.

– Die europäischen Sibyllen, 1999

Ausstellungen zur Gegenwartskunst lassen sich seit etwa Mitte der neunziger Jahre in zwei Gruppen unterteilen: die englische Auswahl und die internationale Auswahl. Mehr als ein halbes Jahrzehnt – "the saatchi decade"[3] – hatten die jungen Briten das Kunstgeschehen dominiert, für sich die Markenzeichen frisch, frech, shocking okkupiert, den sogenannten Crossover-Diskurs provoziert und London zur Szene-Metropole erkoren. Die Kernmannschaft aus den legendären Ausstellungen "Freeze", "Modern Medicine" und "Gambler" konnte sich gar nicht schnell genug zellteilen, um die Britmania rund um den Globus zu befriedigen. 1995 "General Release" in Venedig und "Brilliant" in Minneapolis, dann 1996 "Life/Live" in Paris und "Full House"[4] in Wolfsburg. Die Wolfsburger Ausstellung verstand sich als Dankeschön und Reminiszenz an diese grandiose Poesie der Subjektivität und Spontaneität, die Betrachter und Kritik für einen langen Moment aus der gewohnten Theorielastigkeit akademischer Kunstrezeption entließ.

Der zweite Ausstellungstypus zur Gegenwartskunst, die internationale Variante, mit "Now Here", Humlebæk 1996, "Nach Weimar", 1996, "Manifesta", 1996 und 1998 in Rotterdam und Luxembourg oder der "berlin biennale", 1998,

which he created together with the librarian and freelance staff of the museum. The result of this cooperation, which naturally carries the signature of the authors, is just as important as the process itself; the joint effort is thus an emancipatory act. Reinigungsgesellschaft's projects also involve the viewer as an active participant, be it as an interview partner in their almost documentary films about the Erz mountains, or as participants in the art seminars they offer as a service for companies.

– Die europäische Sibyllen (The European Sibyls), 1999

Since the mid-Nineties, two types of contemporary art have been shown at exhibitions: British art and international art. For over five years – "The Saatchi Decade"[3] – the art scene was dominated by young British artists who monopolised the trademarks fresh, bold and shocking, and provoked the so-called crossover debate, making London the place to be. The core team who showed their work at the legendary *Freeze, Modern Medicine* and *Gambler* exhibitions couldn't multiply fast enough to satisfy the Britmania round the world. 1995 saw *General Release* in Venice and *Brilliant* in Minneapolis, followed in 1996 by *Life/Live* in Paris and *Full House* in Wolfsburg. The Wolfsburg exhibition was conceived as a thank you and a reminiscence of this grandiose poetry of subjectivity and spontaneity, which freed viewers and critics for a moment from the often over-theoretical approach of academic art criticism.

The second type of contemporary art exhibition, the international type as exemplified by *Now Here*, Humlebæk 1996, *Nach Weimar*, 1996, *Manifesta*, 1996 and 1998 in Rotterdam and Luxembourg, or the 1998 *berlin biennale*, was based above all on the consensus of a group of independent curators. Since the early Nineties they had assumed the role of scouts in the art world, presenting artists irrespective of nationality or method who

– **3** Titel des gleichnamigen Ausstellungskataloges der Sammlung Charles Saatchi, *Young British Art*, London 1999. Saatchi, einer der größten Kunstsammler in England, hatte mit seinen flächendeckenden Ankäufen der britischen Gegenwartskunst und einer geschickten Öffentlichkeitsarbeit den Marktwert und das Interesse an dieser Kunst erheblich beeinflußt. "To be saatchied" gilt als Zeichen des internationalen Durchbruchs.

– **3** Title of the eponymous exhibition catalogue of the Charles Saatchi collection, *Young British Art*, London 1999. Through the acquisition of large quantities of contemporary British art and skilful PR work, Saatchi, one of England's major art collectors, has had a considerable influence over public interest in contemporary art and its market value. "To be saatchied" is considered a sign of an international breakthrough.

fußte in erster Linie auf der Übereinkunft einer Gruppe unabhängiger KuratorInnen, die seit der ersten Hälfte der neunziger Jahre eine Art Scoutfunktion im Kunstsystem übernommen hatten, um länder- und methodenübergreifend KünstlerInnen vorzustellen, die der Kunst neue Impulse gaben. KuratorInnen wie KünstlerInnen stammten dabei aus der gleichen Generation und operierten aus einem ähnlichen Wirklichkeits- und Interessenumfeld heraus.

– Peter aus Basel, 1999

Die gängige Praxis, künstlerische Positionen vor allem als Summenfiguren oder Trends wahrzunehmen und zu benennen, hatte mit den jungen Engländern eine zugespitzte Form erreicht. Der kritische Diskurs war dem einprägsamen Label gewichen, die Vermarktung war garantiert und schlug sich nicht nur in einer belebten Warenzirkulation, sondern auch in der publizistischen Sekundärverwertung in allen Life-Style-Medien nieder.
1998 auf der Kunstmesse in Basel, insbesondere mit den Beiträgen der "Liste"[5] und den "Statement-Kojen",[6] fanden sich verstärkt KünstlerInnen, die in Deutschland leben. Wenn man einmal den Aspekt der Nationaltümelei[7] oder des "Modern-Seins"[8] beiseite läßt, scheint die Frage interessant, wie sich künstlerische Potentiale aufbauen und zu Gruppenphänomenen verdichten. Diese gab es im Rheinland Ende der sechziger Jahre im Umkreis der Beuys-Klasse, dann wieder in New York bis weit in die achtziger Jahre hinein mit Schnabel, Steinbach, Koons, Bickerton, Taaffee, Gober, Halley[9] und eben zuletzt mit den jungen Briten.
Ein auffälliges Merkmal dabei ist immer, daß bestimmte gesellschaftliche und jugendkulturelle Konstellationen, in Verbindung mit den spezifischen Lebensbedingungen in Metropolen, eine stimulierende Wirkung auf die künstlerische Arbeit ausüben: Die komplexen Verhältnisse, die wir heute als die 68er-Bewegung zusammenfassen, beeinflußten die Künstler im Rheinland. Das Ende des trau-

injected fresh new life into the contemporary art scene system. Curators and artists were from the same generation, of similar background, and acted out of similar interests.

– Peter aus Basel (Peter from Basle), 1999

The conventional practice of perceiving and naming artistic attitudes above all as trends reached its extreme form with the young British artists. Critical discussion had given way to the catchy label, marketing was guaranteed, and not only did it result in lively sales, but publicity throughout the various life-style media.
At the 1998 art fair in Basle, particularly with the contributions of the "Liste" and the "statement" booths[6], more artists who live in Germany were evidence. Leaving the aspect of national obsessions[7] or "Being Modern"[8] to one side, the question arises as to how artistic potential comes about, and how it develops into a group phenomenon. This happened in the Rhineland at the end of the Sixties in the circle of artists in the Beuys class, then again in New York until far into the Eighties with Schnabel, Steinbach, Koons, Bickerton, Taaffee, Gober, Halley[9] and, recently, with the young British art scene.
One conspicuous characteristic is always that certain situations in society and youth culture, combined with the specific living conditions of large cities, have a stimulating effect on artistic work: the complex circumstances we now refer to as the '68 movement influenced the artists in the Rhineland. The end of the traumatic Vietnam War resulted in the "new relax" movement with its disco wave in New York. And the effects of Thatcherism made London the most exciting centre of youth culture in the early Nineties.
There can be no doubt that Berlin, with its gigantic urban planning projects and all the things to be discovered in the eastern part of the city, has developed that magical magnetism which transforms a metropolis into a cultural

– 4 "Full House, Junge Britische Kunst", Kunstmuseum Wolfsburg, 14.12.1996 – 31.03.1997, mit Richard Billingham, Christine Borland, Angela Bulloch, Jake & Dinos Chapman, Mat Collishaw, Tracey Emin, Angus Fairhurst, Douglas Gordon, Gary Hume, Abigail Lane, Sarah Lucas, Steven John Pippin, Georgina Starr, Gillian Wearing, Jane & Louise Wilson und Sam Taylor-Wood.

– 4 Full House, Young British Art, Kunstmuseum Wolfsburg, 14.12.1996 – 31.03.1997, with Richard Billingham, Christine Borland, Angela Bulloch, Jake & Dinos Chapman, Mat Collishaw, Tracey Emin, Angus Fairhurst, Douglas Gordon, Gary Hume, Abigail Lane, Sarah Lucas, Steven John Pippin, Georgina Starr, Gillian Wearing, Jane & Louise Wilson and Sam Taylor-Wood.

matischen Vietnamkrieges bewirkte das "new relax" mit seiner Discowelle in New York. Und die Auswirkungen des Thatcherismus ließen Anfang der Neunziger Londons Jugendkultur zur aufregendsten Szene werden.

Unzweifelhaft hat Berlin seit der Wiedervereinigung mit seinen gigantischen stadtplanerischen Veränderungen und den Entdeckungsmöglichkeiten im Ostteil der Stadt eine magische Sogwirkung entfaltet, die Metropolen auch zu Kulturmetropolen werden läßt. Die Love Parade ist ein, die Begehrtheit der künstlerischen Förderprogramme des DAAD ein anderes Indiz dafür. Berlin hat in den letzten Jahren KünstlerInnen aus aller Welt, aber auch viele Galerien angezogen. In der Stadt hat sich spürbar eine produktive, kreative Schwingung entfaltet, die ihre Impulse auch auf die Kunstschaffenden in den anderen Städten abstrahlt. Offensichtlich ist dieses Klima unter vielen anderen Faktoren mit ausschlaggebend, daß in Deutschland eine Künstlergeneration aktiv ist, die stark, selbstbewußt und vielfältig wie lange nicht mehr auf der internationalen Bühne auf sich aufmerksam macht.

– ApproximationRezipientenbedürfnis ComaUrUltraUseMiniMax, 1999

Jonathan Meese liebt sein langes Haar. Es ist ebenso Bestandteil seines hart erarbeiteten Images wie seine verschmierte, braune Adidas-Trainingsjacke oder seine handgeschriebenen Lebensläufe, die ihn als Beteiligten einer kryptischen Geschichts- und Geschichtencollage ausweisen, Wagner, Heidegger, Caligula, Pippi Langstrumpf oder Nietzsche an seiner Seite. Von allen InstallationskünstlerInnen hierzulande ist er derjenige, der wirklich ohne Mühe zu großer und ausladender Geste fähig ist. Eine Geste allerdings, die sich als wahrer Rausch gebiert, als Hemmungslosigkeit, wie wir sie nur von Hermann Nitschs Blutritualen oder Paul McCarthys Schoko- und Ketchuporgien her kennen. Nitsch ist heute über 60, McCarthy Mitte 50. Was bringt einen knapp 30jährigen

metropolis. The *Love Parade* is one, the desirability of the DAAD art promotion programmes is another indicator of this. In recent years, Berlin has attracted artists from all over the world, but also many galleries. The city has developed a palpably productive, creative vibe that radiates its impulses onto artists in other cities. This climate is obviously a decisive factor among the many factors that have contributed to the fact that a generation of artists is active in Germany who are strong, self-confident and diverse, attracting attention in the international arena as none have done so for a long time.

– ApproximationRezipientenbedürfnis ComaUrUltraUseMiniMax, 1999

Jonathan Meese loves his long hair. It is just as much part of the image he has worked so hard to create as his dirty brown Adidas tracksuit top or his hand-written curriculum vitae, which identify him as a participant in a cryptic collage of history and anecdotes, Wagner, Heidegger, Caligula, Pippi Longstocking or Nietzsche at his side. Of all the installation artists in Germany, he is the one who is capable of the effortlessly grand gesture. However, it is a gesture of truly uninhibited exhilaration as we know it only from Hermann Nitsch's bloody rituals or Paul McCarthy's chocolate and ketchup orgies. Nitsch is now over 60, McCarthy in his mid-Fifties. What makes a young man of not yet thirty revert to the trash aesthetic that has, since Rauschenberg's collages or Polke's *Schimpftuch*, entered the annals of art history?

The answer to this question lies in the idea of boundaries, disregarding taboos, both in form and content. Making statements about being German is already tricky enough; statements are considered understandable and tolerated as long as they are critical, such as Katharina Sieverding's *Deutschland wird Deutscher* ("Germany is becoming more German"). Meese's altars are almost arrogant by comparison. Irreverently, he combines the

– 5 Die "Liste" ist eine selbstorganisierte Messe- und Informationsveranstaltung parallel zur Baseler Kunstmesse für junge Galerien mit jungem Programm. – 6 Seit 1997 werden junge Galerien dazu eingeladen, auf der Messe einen Künstler oder eine Künstlerin exklusiv zu präsentieren und damit ein Statement zur aktuellen Kunst abzugeben.

– 5 The "Liste" is an independently organised information event for young galleries promoting young artists which runs parallel to the Basle art fair. – 6 Since 1997, young galleries have been invited to present an artist exclusively and thus to make a statement on contemporary art.

dazu, nochmals das Materialgeschrei der Trash-Ästhetik zu befragen, das seit Rauschenbergs Collagen oder Polkes "Schimpftuch" in den Arsenalen der Kunstgeschichte hinterlegt ist?

Es ist der Aspekt der Grenze, der Tabuverletzung, formal und inhaltlich. Das Deutschtum zu thematisieren, ist schon heikel genug, gerade noch nachvollziehbar und geduldet, wenn es sich als kritische Position zeigt wie etwa bei Katharina Sieverdings "Deutschland wird Deutscher". Dagegen sind Meeses Raumaltare geradezu anmaßend. Respektlos baut er unterschiedlichste Inhaltsebenen zusammen: Runenschrift, Germanenkult, Religionsembleme, Sexmagazine, Pop- und Filmklassiker.

Ein anderer Aspekt ist die physische Spur, die Meese hinterläßt. Schon lange vor dem Aufbau groovt er sich in das Projekt hinein, schlüpft in seinen Tarnanzug, der verhindert, daß er aus dem Alptraum aufwacht und seine Energie verliert. Höhepunkt und Entladung ist dann der Auftritt, den er Performance nennt. Hier agiert er sozusagen ganzheitlich, bezogen sowohl auf seinen selbstentworfenen Kosmos wie auf den eigenen Körper. Referenzen an die Performancekunst der siebziger Jahre, an den Schamanen Joseph Beuys, diesen All-time-Performer, sind kenntlich. Kai Althoff beschreibt ein solches Gebaren an anderer Stelle: "…war nicht mehr halb abstrakt, halb nachgefühlt, sondern alles vom Körper zog nach. Das hatte dann die eigentliche Möglichkeit mit dem guten Nachvollziehen umgestürzt. Es erstreckte sich schließlich zu einer völlig radikalen, subjektiven, esoterisch politischen und anthroposophischen Haltung, die den Körper ganz enorm mitnahm und die seelische Verfassung schüttelte. Und nach so einer psychischen Anstrengung folgt eine Entladung…" [10]

Jenseits der Interpretationen nimmt Meese eine Position ein, die er mit vielen KollegInnen teilt, nämlich die Gnade der späten künstlerischen Geburt, die das Recht auf Wiederholung und "Selber-nochmal-Machen" einschließt. Hier handelt es sich nicht um Epigonentum, sondern um

most disparate symbolic statements: the runic script, the cult of the Teutons, religious emblems, sex magazines, pop and film classics.

Another aspect is the physical traces Meese leaves behind him. Long before the installation is constructed he involves himself in the project, slips on his camouflage suit, which prevents him from waking up from his nightmare and losing his energy. Everything then culminates in the climax and release he calls performance. He acts holistically, referring to both the cosmos he has designed for himself and to his own body. References to the performance art of the Seventies and the shaman Joseph Beuys are discernible.

Kai Althoff describes one of Meese's performances: "…It was no longer half abstract, nor was it half empathised, but the entire body followed suit. That excluded the possibility of actually being able to understand it clearly. In the end, the performance expanded into a completely radical, subjective, esoterically political and anthroposophical attitude that involved the body to an enormous extent and shook me to the depths of my soul. And such a psychological effort must be followed by release…" [10]

Irrespective of interpretations, Meese shares the destiny of many of his colleagues, namely the good fortune of having been born late. This gives them the right to repetition and trying things out themselves. This is not a matter of a lack of originality, but of making use of a historical means of expression and adapting it to contemporary forms.

Whether Meese's work is minimal, as was his objective for Wolfsburg, or Meese-total, as recently at the Frankfurter Kunstverein, critics always compare him with John Bock, as both artists use the performance method. Bock's work, however, is right at the opposite end of the spectrum. He is above all interested in performing in front of an audience, explaining the world using economic and artistic criteria. Out of piles of everyday objects he creates theatres in which he acts and occasion-

– 7 Vgl. dazu Wolfgang Kemps Artikel in Art 99/9, S. 31 ff. anläßlich der Ausstellung "Das XX Jahrhundert – Ein Jahrhundert Kunst in Deutschland", über das Unwesen der Deutschen, sich ständig für ihren nicht verarbeiteten Nationalkomplex entschuldigen zu müssen. – 8 Siehe dazu: Anke Kempkes in ihrem Text über Kai Althoff in diesem Band. – 9 Siehe dazu: Kunstforum, Bd. 92, Köln 1987 und Collins & Milazzo: Art at the End of the Social, Ausstellungskatalog, Malmö 1988.

– 7 Cf. Wolfgang Kemp's article in Art 99/9, p. 31 ff., in which he criticises the Germans for constantly apologising for their undigested complex regarding their national identity, published for the exhibition Das XX Jahrhundert – Ein Jahrhundert Kunst in Deutschland. – 8 See Anke Kempkes' text on Kai Althoff in this catalogue. – 9 See Kunstforum, vol. 92, Cologne 1987 and Collins & Milazzo: Art at the End of the Social, exhibition catalogue, Malmö 1988.

das Aufgreifen einer historischen Ausdrucksmöglichkeit, die an Jetztformen adaptiert wird.

Ob Meese-Minimal, wie für Wolfsburg angestrebt, oder Meese-Total, wie zuletzt im Frankfurter Kunstverein, eine Nähe zu John Bock wird immer unterstellt, da sich beide der Methode der Performance bedienen. Bocks künstlerische Arbeit ist jedoch genau am gegenteiligen Ende der Skala angesiedelt. Sein Hauptinteresse gilt dem Vortrag, der Performance vor Publikum, der Welterklärung zwischen betriebswirtschaftlichen und künstlerischen Regularien. Alltagsgegenstände türmt er zu Schaubühnen auf, in denen er agiert und bisweilen akrobatisch turnt. Die Kraft der kindlichen Phantasie und das Ins-Absurde-Wenden der Erwachsenenlogik trägt dabei formal sein System. Nicht, wie vielleicht bei Meese, um ein letztes (travestitisches) Aufbegehren von Subjektivität und Körper handelt es sich hier, sondern um die spielerische Dekonstruktion solch immer vor allem in Freudschen Kategorien agierender Bezugssysteme. Bock testet so nochmals die Grenze zwischen experimentellem Theater und inhaltlicher Performance, die in den sechziger und siebziger Jahren erprobt wurde.

– Multiple Jack, 1997

Was Bock und Meese aber verbindet ist ihre Vorliebe für Geschichten, für visuelle Erzählungen. Hier sind beide Verbündete von Kai Althoff und Cosima von Bonin, von Stefan Exler und Silke Wagner. Die Textvorlagen der Erzählungen bleiben in der Regel verborgen, sie konkurrieren nie mit Wortkunst. Tritt die Erzählung doch in Erscheinung, kann sie Ergänzung für das Visuelle sein. Ähnlich wie Joseph Beuys geduldig gehaltene Vorträge – mit Mikrofon und fellbesetztem Mantel – im Installationsensemble seiner "Honigpumpe"[11] irgendwann verhallt sind, aber dennoch sein Werk in materieller Form erhalten bleibt und durch die Erinnerung oder das vermittelte Wissen der Betrachter ergänzt wird.

ally performs feats of acrobatics. The form of his system reflects the strength of a child-like imagination and taking adult logic ad absurdum. This is not a case of a last (disguised) subjective rebellion of the body, as is perhaps the case with Meese, but the playful deconstruction of such systems of relationships that are mostly defined in Freudian terms. Bock is thus once again testing the boundaries between experimental theatre and performance in the way artists of the Sixties and Seventies did.

– Multiple Jack, 1997

But what Bock and Meese have common is their preference for stories, visual tales. Inasmuch, the two artists are allies of Kai Althoff and Cosima von Bonin, Stefan Exler and Silke Wagner. As a rule, the text drafts remain hidden and never compete with literature. If the story does become visible, it can complement the visual aspect of the work. This is similar to the way Joseph Beuys' patiently held lectures, a microphone in his hand and wearing a fur-trimmed coat, faded away at some point during his *Honigpumpe*[11] ("Honey Pump") installation, and yet the material form of his work has been preserved and is complemented by memories or the knowledge of the viewer. Stefan Exler constructs his stories with photographs. His sets of pictures taken from a bird's eye view gradually reveal countless details of the story in question. With the effortlessly perfect technique and precisely calculated poses familiar to us since Jeff Wall, banal little stories are enacted: the sick, unemployed mathematician or the law student, a specialist in international trade law, who is looking for a job.

What in Exler's work invites the viewer to enjoy an amusing decoding game, is not applicable to von Bonin's and Althoff's installations. Too many varying, labyrinthine levels of memory and reference are interlinked to allow the viewer to grasp everything in one brief glance. The viewer really is permitted to be active and imaginative, and

– **10** Kai Althoff im Text zu seiner Arbeit "Reflex Lux", ars viva 98/99, Ausstellungskatalog, Köln, 1998, S. 17. Jonathan Meese hat sich für die Wolfsburger Ausstellung eine Nachbarschaft zu Kai Althoff ausdrücklich gewünscht.

– **10** Kai Althoff in his text on his creation *Reflex Lux, ars viva 98/99*, exhibition catalogue, Cologne 1998, p. 17. Jonathan Meese expressly asked to have his work exhibited next to that of Kai Althoff.

Stefan Exler konstruiert seine Geschichten mit Fotografie. In szenischen Sets, aus der Vogelperspektive aufgenommen, verraten allmählich unzählige Details, um welche Story es sich handeln mag. Mit selbstverständlicher handwerklicher Perfektion und genau kalkulierten Posings, wie man sie seit Jeff Wall kennt, werden kleine Allerweltsgeschichten vorgeführt: Der kranke Mathematiker, arbeitslos obendrein, oder die jobsuchende Jurastudentin, die sich auf internationales Handelsrecht spezialisiert hat.

Was bei Exler noch zum amüsanten Dekodierspiel einlädt, läuft bei von Bonins und Althoffs Installationen ins Leere. Zu viele Ebenen unterschiedlichster Erinnerungsfelder und Bezüge sind hier labyrinthisch verschränkt, als daß man mit dem schnellen Blick alles erfassen könnte. Tatsächlich wird dem Betrachter hier Aktivität und Phantasie zugesprochen. Einzelne Objekte und die gesamte Arbeit können genutzt werden, um in der Anschauung assoziativ eigene Geschichten zu entwickeln. Verstehen müssen und verstehen können werden als gleichberechtigte Optionen gehandelt, eine eindeutige, allgültige Lesbarkeit gibt es nicht.

In Cosima von Bonins neuestem Video "Pryde: Exigencies" verfolgt man die Geschichte eines Mädchens, das auf einer Zuchtfarm für Schlittenhunde lebt – zufällig mitgeschnitten im WDR. Leicht kann man Kindheitssehnsüchte auf dieses draufgängerische und zugleich fürsorgliche Mädchen projizieren. Überlagert wird der Film von einem hitverdächtigen Song, den Justus Köhncke komponiert hat und bei dem von Bonin unüberhörbar die background vocals singt. Kein Herzschmerz, sondern die präzise Anweisung für eine Galerie, wie man mit ihrer Arbeit umzugehen hat, ist Gegenstand des Songtextes. Musik und Bild agieren als Animateure für den nur auf den ersten Eindruck unpassenden Text. Sunah Choi verläßt sich in ihren Videoclips noch stärker auf die Wirkung dieses Paradox', auf die Kombination vermeintlicher Gegensätze: Bombergeschwader und Luftangriffe werden mit dem Evergreen "Cheek to Cheek" verbunden, der Refrain "I'm in heaven" setzt Himmel und Hölle gleich.

can use single objects and the entire installation to develop his own stories by association. There is no option between having to understand and being able to understand, there is no an unambiguous, generally applicable interpretation of these works.

Cosima von Bonin's latest video, *Pryde: Exigeniecs*, tells the story of a Canadian girl who lives on a farm where huskies are bred; the video was recorded by chance from the WDR television station. It is easy to project childhood longings onto this audacious and yet thoughtful girl. The soundtrack is a catchy song composed by Justus Köhncke. Von Bonin can be clearly heard singing the background vocals. The lyrics are not mawkishly romantic, but precise instructions to a gallery as to how to handle her work. Music and image animate the text, which only at first seems unsuitable. Sunah Choi's video clips rely even more on the effect of the paradox, the combination of what appear to be opposites: droning bombers and air raids are shown to the strains of the evergreen *Cheek to Cheek*, the refrain *I'm in heaven* equates heaven and hell.

– This Night (Wolfsburg Version) Bullen, Baader, Bully, 1999

At first glance, Silke Wagner's posters are merely a series of graphic patterns reminiscent of the design of the Seventies, yet there is something subversive about the way their symbolic meaning has been transformed. Only the most expert football fan will immediately recognise the motif of Wagner's posters: they are based on her research into the behaviour of football fans and the history of European football clubs. The fact that long-standing social conflicts can sometimes only be dealt with in the world of sport can, for example, be illustrated by the fact that the catholic club Celtic Glasgow has exchanged players of another confession with the protestant club Glasgow Rangers. In the poster entitled *Jimmy & Mojo*,

– 11 "Erst unter der Bedingung einer radikalen Begriffserweiterung gerät Kunst und die Arbeit mit ihr in die Möglichkeit, heute das zu bewirken, was beweist, daß sie die einzige bewirkende, evolutionär-revolutionäre Kraft ist, die fähig wird, repressive Wirkungen eines vergreisten und auf der Todeslinie weiter wurstelnden Gesellschaftssystems zu entbinden um zu bilden: EINEN SOZIALEN ORGANISMUS ALS KUNSTWERK", Joseph Beuys, documenta 6, Ausstellungskatalog, Kassel 1977, Band 1, S. 156.

– 11 "Erst unter der Bedingung einer radikalen Begriffserweiterung gerät Kunst und die Arbeit mit ihr in die Möglichkeit heute das zu bewirken was beweist, daß sie die einzige bewirkende, evolutionär-revolutionäre Kraft ist, die fähig wird, repressive Wirkungen eines vergreisten und auf der Todeslinie weiter wurstelnden Gesellschaftssystems zu entbinden um zu bilden: EINEN SOZIALEN ORGANISMUS ALS KUNSTWERK", Joseph Beuys, documenta 6, exhibition catalogue, Kassel 1977, vol. 1, p. 156.

– **This Night (Wolfsburg Version) Bullen, Baader, Bully, 1999**

Silke Wagners Poster sind auf den ersten Blick lediglich graphische Muster, die an das Design der siebziger Jahre andocken, um dann deren Sinngehalt beinahe subversiv zu wenden. Nur dem fachkundigsten Fußballfan offenbart sich sofort der Zusammenhang, der das Motiv der Arbeit ist: Ausgangspunkt sind Untersuchungen über Fanverhalten und die Geschichte europäischer Fußballvereine. Die Tatsache, daß tradierte gesellschaftliche Konfliktkonstellationen manchmal nur im Sport überwunden werden, zeigt sich beispielsweise daran, daß der katholische Verein Celtic Glasgow erstmalig in der Geschichte mit dem protestantischen Nachbarclub Glasgow Rangers Spieler unterschiedlicher Konfession getauscht hat. In dem Poster "Jimmy & Mojo" verschränkt Wagner die Farben und Symbole der beiden Clubs und gibt sie als "politisch codierte Oberfläche" [12] wieder, verzichtet aber auf moralisch-agitatorische Belehrungen.

Rückgriff auf und Remix von Themen und Stilen der sechziger und siebziger Jahre, die Kai Althoff meisterhaft als Zitat in seinen Zeichnungen verwendet, spielen auch bei den Recherche-Installationen von Johannes Wohnseifer und Korpys/Löffler eine zentrale Rolle. Dabei entstehen Netzwerke aus biografischen, ästhetischen und kunstgeschichtlichen Koordinaten, die die Wirklichkeit zwar zum Anlaß nehmen, sie aber weder dokumentieren noch reproduzieren, sondern eine Fiktion schaffen. Wohnseifers Themen sind die Münchener Olympiade, die "fröhlichen Spiele", die 1972 in einem brutalen Massaker an neun israelischen Sportlern endeten, oder der berühmte Braun-Wecker, die frühen Honda-Automobile und die Neuverfilmung von Rainer Werner Fassbinders Erstlingswerk "Der Stadtstreicher". Eckdaten der Sport-, Design-, Kunst-, Film- und Politikgeschichte, die sich, und das ist entscheidend, wie Jahresringe um sein eigenes Geburtsdatum reihen.

Wagner mixes the colours and emblems of the two clubs as a "politically encoded surface" [12], but abstains from morally inflammatory lecturing.

Falling back on and remixing the themes and styles of the Sixties and Seventies, which Kai Althoff quotes masterfully in his drawings, also plays a pivotal role in the research installations of Johannes Wohnseifer and Korpys/Löffler. These consist of networks of biographical, aesthetic and art-historical coordinates which are based on reality, yet neither document nor reproduce it, but create a fiction. Wohnseifer's themes are the 1972 Olympic Games in Munich, the "happy games" that ended with the brutal massacre of nine Israeli athletes, or the famous Braun alarm clock, early Honda cars and the remake of Rainer Werner Fassbinder's first film, entitled *Der Stadtstreicher*. Key dates in the history of sport, design, art, film and politics which, decisively, surround Wohnseifer's own date of birth like annual rings.

Andrée Korpys and Markus Löffler have reconstructed the RAF's (Rote Armee Fraktion) failed attack on the Federal Law Office in Karlsruhe in 1977 on the basis of criminal records and press archives, examining the "artistic" aspects of the incident. The films shown in the exhibition, which were all taken with aged film and are accompanied by Pink Floyd music, also evoke images of latent danger or unpleasant fantasies about surveillance. Vague references to the genre of the spy film are mixed with real memories of documentary films such as that of the assassination of Kennedy in Dallas; the boundaries of simulation and reality are blurred.

– **This Night (Wolfsburg Version) Als die Bullen noch Käfer fuhren (When the Cops still drove Beetles), 1999**

Most of the artists exhibiting are about thirty, only a few are much older. They know the building of the Berlin Wall, the Vietnam War and Woodstock, student rebellion and

– **12** Ein Begriff, den Raimar Stange eingeführt hat. Siehe dazu: *Über politisch codierte Oberflächen*, artist, Kunstmagazin Nr. 38, 1/1999.

– **12** A term introduced by Raimar Stange. See *Über politisch codierte Oberflächen*, artist, Kunstmagazin no. 38, 1/1999.

Andree Korpys und Markus Löffler haben den mißglückten Angriff der RAF auf die Bundesanwaltschaft in Karlsruhe 1977 in Kriminal- und Pressearchiven rekonstruiert und auf seine "künstlerischen" Komponenten hin untersucht. Auch in ihren in der Ausstellung gezeigten Filmen, allesamt mit gealtertem Filmmaterial aufgenommen und von Pink-Floyd-Musik untermalt, drängen sich Bilder latenter Gefahr oder unangenehme Überwachungsphantasien auf. Diffuse Anklänge an das Genre Spionagefilm vermischen sich mit konkreten Erinnerungen an Dokumentaraufnahmen wie dem Kennedy-Attentat in Dallas; die Grenzen zwischen Simulacrum und Realität verschwimmen.

– This Night (Wolfsburg Version) Als die Bullen noch Käfer fuhren, 1999

Die meisten der beteiligten KünstlerInnen sind um die 30, nur wenige wesentlich älter. Sie kennen den Mauerbau, den Vietnamkrieg und Woodstock, die Studentenunruhen und die RAF nur noch als Geschichte, medial vermittelt. Diese Ereignisse haben sie nicht unmittelbar geprägt wie vielleicht Tschernobyl, Aids, der Fall der Mauer, der Fernseh-Golfkrieg oder 16 Jahre politische Sozialisation unter der Ära Kohl. Diese Generation erlebt die größte Arbeitslosigkeit in der Geschichte der BRD bei gleichzeitig höchstem Wohlstand, erlebt Entkollektivierung und Heteronomisierung sozialer Gruppen und gleichzeitig Globalisierung und Vernetzung. Die Ikonen einstiger Jugendrebellion werden zum Salesargument der Werbeindustrie: Canned Heat bei Opel, die Stones bei Volkswagen oder Dennis Hopper als "Easy Rider" bei Ford. Marshall McLuhan hat als einer der ersten auf die Wirkungen des Fernsehens und die Konsequenzen dieser Pseudorealitäten hingewiesen. Der Vorteil der raschen und globalen Information wird aufgebraucht durch die Flut der Fakten und Bilder, die sich zu einem Rauschen verdichten. Jedweder Inhalt wird von der Faszination des

the RAF (Rote Armee Fraktion) only as history communicated by the media. These events have not had an immediate influence on them in the same way that perhaps Chernobyl, Aids, the fall of the Berlin Wall, the television Gulf War or sixteen years of the Kohl era. This generation is experiencing the highest unemployment rate – and the highest standard of living – in the history of the Federal German Republic, the breakdown and heteronomisation of social groups at the same time as globalisation and digitalised communication. The erstwhile icons of youth rebellion have become the selling points of the advertising industry: Canned Head for Opel, the Stones for Volkswagen or Dennis Hopper as *Easy Rider* for Ford.

Marshall McLuhan was one of the first to refer to the effects of television and the consequences of these pseudo-realities. The advantages of rapid, worldwide distribution of information are neutralised by the flood of facts and images that has swollen to a torrent. Any potential message is outshone by the fascination of television, with the result that the medium itself becomes the message.[13] Vilém Flusser explains: "Wherever you go on an excursion, people take cameras with them, out of which flows a torrent of blinding, numbing images. These cameras that we take everywhere with us no longer have to dangle *in front of* our stomachs. We already have them in our stomachs, and they click, roll and wind themselves inside us."[14] But Flusser is no conservative wanting to return to the old, genuine images. After all, our perceptive and critical capacities have always adapted to every change in perceptive conditions. Rather than resigning, Flusser suggests taking the bull by the horns, finding a new visual language.

Luc Tuymans[15] puts forward the theory that, since 1968, art has only been created on the basis of drafts and reproductions, and no longer based on nature. This cannot be said of Olafur Eliasson. He is both romantic and modern at the same time, transporting natural phenomena by means of technical aids into exhibition spaces and constructing an aura without their ever losing their magic.

– **13** Marshall McLuhan, *Die Magischen Kanäle. Understanding Media*, Frankfurt 1968. – **14** Vilém Flusser, *Medienkultur*, Frankfurt 1997, p. 71. – **15** At the press conference held on 01.10.1999 for his exhibition "The Purge" at the Kunstmuseum Wolfsburg.

Fernsehens überstrahlt, so daß schließlich das Medium selbst zur Botschaft wird. [13] Vilém Flusser ergänzt: "Wohin immer man nämlich Exkursionen macht, dorthin schleppt man Apparate mit, aus denen die blendenden und betäubenden Bilderfluten strömen. Diese Apparate, die wir überall mitschleppen, müssen gar nicht mehr vor unseren Bäuchen baumeln. Wir haben sie alle bereits im Bauch, und sie knipsen, rollen und winden sich in unserem Inneren." [14] Aber Flusser ist kein Konservativer, der zu den alten, echten Bildern zurück will. Schließlich hat sich immer schon mit jeder Veränderung der Wahrnehmungsbedingungen auch die Wahrnehmungsfähigkeit und das Rezeptionsverhalten angepaßt. Anstatt zu resignieren, schlägt er die Flucht nach vorn zu neuen Bildern vor. Luc Tuymans [15] vertritt die These, daß Kunst nach 1968 sowieso nur noch nach Vorlagen entsteht, nach Reproduktionen und nicht mehr nach der Natur. Nicht so bei Olafur Eliasson. Er ist romantisch und zeitgemäß zugleich, bringt mittels Technik Naturphänomene in den Ausstellungsraum und konstruiert deren Aura, ohne daß sie je ihren Zauber verlieren. Das überwältigende visuelle Ergebnis verleugnet nie seine künstlich erzeugte Herkunft, gleichwohl wird dem uralten Wunsch, die Schönheit der Natur ins Artefakt zu transportieren, statt gegeben.

– no need to fight about the channel. together. leant back, 1996

Daniel Pflumm unterwandert das System Fernsehen. Mit CNN, dem amerikanischen Nachrichtenkanal, hat er sich eines der weltweit bekanntesten TV-Logos ausgesucht, das für Information steht. In seinen Videos untersucht er die Form und Dramaturgie der Sendung und simuliert sie als potentielle Realität: Publikumsapplaus, Sprecherhaltung oder das "Corporate Design" mutieren zum computeranimierten Trailer. Die Reinigungsgesellschaft nutzt die Form der thematischen Dokumentarsendung oder des Features, um uns "Die sieben Tugenden des Erz-

– **13** Marshall McLuhan, *Die Magischen Kanäle. Understanding Media*, Frankfurt/Main 1968. – **14** Vilém Flusser, *Medienkultur*, Frankfurt 1997, S. 71. – **15** Bei der Pressekonferenz zu seiner Ausstellung "The Purge" im Kunstmuseum Wolfsburg, am 01.10.1999.

The overwhelming visual result never denies its artificial origins; at the same time, the primeval desire to preserve the beauty of nature as an artefact is permitted.

– No need to fight about the channel. together. leant back, 1996

Daniel Pflumm infiltrates the system of television. He has chosen one of the world's best known television logos – that of the news channel CNN. In his videos he examines the form and script of the broadcast and simulates it as potential reality: the applause of the audience, the pose of the speaker and "corporate design" become a computer-animated trailer. Reinigungsgesellschaft use the form of the thematic documentary programme and the feature to make the *Die sieben Tugenden des Erzgebirges* ("The Seven Virtues of the Erz Mountains") accessible to us. A professional speaker comments on the terms thrift, local pride or diligence so skilfully that the subtly ironic portrayal of the people of the region is not immediately obvious. The tone of Christian Hoischen's video *Übel* ("Disgusting") is quite different. Four shocking scenes of violence, filmed from television programmes and only twenty-eight seconds long, are accompanied by the bored commentary of a viewer who, hardened by everyday media brutality, is no longer capable of consternation. Christian Jankowski uses conventional entertainment genres such as astrology programmes, talk shows, personal advice shows or soft pornography. He invents role plays for himself with fortune-tellers, such as in *Telemistica* for this year's Venice Biennale, or has amateur actors from Wolfsburg act out semi-autobiographical scenes that reflect the real, potential and fictitious aspects of the relationship between two individuals. The scenes, which were recorded in a porno film studio in Dortmund, were then analysed by a therapist. Joseph Zehrer sees himself as an archivist of images. Almost with a touch of pedantry he combs through his

gebirges" näherzubringen. Ein professioneller Sprecher kommentiert die Begriffe Sparsamkeit, Bodenständigkeit oder Fleiß so gekonnt, daß nicht sofort die subtile Ironie gegenüber den Landsleuten deutlich wird. Ganz anders der Tonfall bei Christian Hoischens Videoarbeit "Übel". Vier erschreckende Gewaltszenen, aus Fernsehprogrammen abgefilmt und nur 28 Sekunden lang, begleitet der gelangweilte Kommentar eines Zuschauers, der von alltäglicher Medienbrutalität abgestumpft zu keiner Betroffenheit mehr fähig ist. Christian Jankowski schließlich bedient sich gängiger Unterhaltungsgenres wie Astro- oder Talkshow, Ratgeber-TV oder Softporno. Er entwirft für sich Rollenspiele mit Wahrsagern – wie bei seiner Arbeit "Telemistica" für die diesjährige Biennale in Venedig – oder läßt Laienschauspieler aus Wolfsburg autobiografisch angehauchte Szenen darstellen, die reale, potentielle und fiktive Aspekte einer Paarbeziehung spiegeln. Die Szenen, in einem Dortmunder Pornostudio aufgenommen, werden schließlich therapeutisch analysiert.

Als Archivar der Bilder versteht sich Joseph Zehrer. Fast schon pedantisch durchforstet er seinen unmittelbaren Alltag nach Themen, die er sich aufgibt, um daraus Bildanthologien zu erstellen. Die Welt als Filmstill. In der Jahrestabelle von 1998 sind im Januar "Vorhänge" verzeichnet, im Februar "Eingeklemmtes", im März "Nichtsnutze & Brechtleser", im April "Pistolen", im Mai "Streifen", im Juni "Knie" und so weiter. Ähnlich verfährt er bei der Zusammenstellung seiner Filmabende. Für Wolfsburg hat er Filme zum Thema Arbeit ausgesucht – mit Karl Valentins "Der verhexte Scheinwerfer" –, die er in einem "idealen" Kinoraum vorführt.

– Temporary items, 1999

In der "Post-telematischen Informationsgesellschaft" ist die heutige Generation mehr noch mit digitalen als mit analogen Datenträgern vertraut. Die charmante Pixel-Ästhetik der ersten Computerspiele ist lange schon abge-

immediate everyday life looking for themes, from which he creates anthologies of images: the world as a film still. In his table for the year 1998, January's topic is "curtains", February's "sandwiches"; in March, the topic is "good-for-nothings & readers of Brecht", in April "pistols", in May "stripes", "the knee" in June, and so on. Zehrer follows a similar procedure when selecting material for his film evenings. For Wolfsburg he has chosen films on the topic of work, including Karl Valentin's *Der verhexte Scheinwerfer* ("The Spellbound Spotlight"), which will be shown in an "ideal" cinema projection room.

– Temporary items, 1999

In our "post-telematic information society", today's young generation is more familiar with digital than analog data carriers. The charming pixel aesthetic of early computer games has long since been replaced by the clever 3-D simulations of modern software. The PC has become an electronic sketch book and an artistic tool. The potential of this new media-related visual aesthetic is now being explored. Alexander Györfi develops webzines and homepages for the art world. Christian Flamm works with computer technology, also making it the subject of his work. Using a colour printer, he prints pictures of bookcases and records as examples of analog data storage, or CD players and computers as synonyms of digital data storage. The prints are installed in the room as two-dimensional representatives of the simulated objects. Flamm frequently turns the high-end procedure on its head, producing the digitally generated images manually as low-tech scissor cut-outs.

– Elektro Music Department, 1994

If a flood of images and television is considered to have a decisive influence on modern society, then music is a

löst von den raffinierten 3-D-Simulationen aktueller Software. Der PC ist zum elektronischen Skizzenblock und künstlerischen Werkzeug geworden. Der Fundus dieser neuen medienimmanenten Visualität wird erschlossen. Alexander Györfi entwickelt Internet-Magazine und Homepages im Kunstkontext. Christian Flamm arbeitet mit und über Technologien von Datenträgern. Mit dem Farbdrucker printet er Bilder von Bücherregalen und Schallplatten aus als Beispiele für analoge Datenspeicher oder CD-Player und Computer als Synonyme für digitale Speicher. Die Ausdrucke werden im Raum installiert als zweidimensionale Platzhalter der simulierten Gegenstände. Häufig wendet Flamm das High-end-Verfahren in sein Gegenteil und fertigt die digital generierten Motive manuell als Low-tech-Scherenschnitt.

– **Elektro Music Department, 1994**

Wenn Bilderflut und Fernsehen als prägend für die heutige Generation angenommen werden, dann ist die Musik ein zweiter Faktor. MTV, das seit nunmehr 15 Jahren Musikclips nonstop sendet, vereinigt diese Bilderflut mit der inzwischen selbstverständlichen Allgegenwart von Musik. Bar-, Kaufhaus- und Elevatormusik, Radio, LP, MC oder CD sorgen für sanfte Berieselung oder Noise Pollution. Die freie Wahl und der permanente Zugriff auf Musik sind Alltag und für viele Interessengebiet.

Ein Drittel der KünstlerInnen, die in dieser Ausstellung beteiligt sind, arbeiten mit Musik oder sind Musiker. Kai Althoff, Simone Böhm, Cosima von Bonin, Sunah Choi, Alexander Györfi, Korpys/Löffler, Daniel Pflumm, Christian Flamm, Johannes Wohnseifer, Stefan Hoderlein oder Max Mohr kombinieren ihre Videos oder Installationen mit Sound. Das hat nichts mit Crossover zu tun. Vielmehr ist es heute einfach und erschwinglich, Sounds im tragbaren Tonstudio zu produzieren und im eigenen Label herauszugeben. Ganz selbstverständlich ist Musik da-

second factor. MTV, that has been broadcasting video clips non-stop for the past fifteen years, combines this flood of images with music, whose omnipresence has now become a matter of course. Music in bars, department stores and lifts, radio, LPs, MCs or CDs guarantee constant background music – or noise pollution. The enormous choice and permanent availability of music have become part of our everyday lives, and for many a topic of special interest.

A third of the artists involved in this exhibition work with music or are musicians. Kai Althoff, Simone Böhm, Cosima von Bonin, Sunah Choi, Alexander Györfi, Korpys/Löffler, Daniel Pflumm, Christian Flamm, Johannes Wohnseifer, Stefan Hoderlein and Max Mohr combine their videos or installations with sound. This has nothing to do with crossover, but today it is easy and affordable to produce sounds in a portable recording studio under one's own label. Music has thus quite naturally become just *one* tool available to artists.

"There can be interesting parallels which one might like to examine, but one can find these parallels just as credible in design or fruit-growing as in music or a hairstyle. (…) But apart from this, I think that if you want to make important statements about music, music is the better medium than art. It's easier to think about art through art, and easier to think about music through music."[16]

– **Babylon Disco vs. Disco Babylon, 1999**

Diedrich Diederichsen's unrestricted observation that "everything is pop"[17] fits the bill perfectly. Elements of pop culture are undoubtedly part of artistic strategies, but they also play a fundamental role in everyday life. It would appear that pop has become a logo that – as Daniel Pflumm does with existing logos – can be filled with almost any content. Hence pop can symbolise resistance and progress, techno, raves and love parades can become the embodiment of Utopias. Just as in the digital

– **16** Tobias Rehberger, in: *Make it Funky. Crossover zwischen Musik, Pop, Avantgarde und Kunst*. Jahrbuch für moderne Kunst, Cologne 1998, p. 317.
– **17** Diedrich Diederichsen: *Alles ist Pop*, in: Süddeutsche Zeitung, 08.08.1998.

durch zu einem verfügbaren Bestandteil der künstlerischen Produktion geworden.

"Da kann es interessante Parallelen geben, denen man vielleicht auch nachspürt, aber das kann man auch im Design und im Obstbau genauso glaubwürdig finden wie in der Musik oder der Frisur. (…) Davon abgesehen glaube ich aber, daß wenn man wichtige Aussagen über Musik machen will, Musik das bessere Medium ist als Kunst. In der Kunst kann man eher über Kunst nachdenken und in der Musik eher über die Musik." [16]

– Babylon Disco vs. Disco Babylon, 1999

Diedrich Diederichsens uneingeschränkte Feststellung "Alles ist Pop" [17] mag da wie gerufen kommen. Zweifelsohne sind Elemente der Popkultur Teil von künstlerischen Strategien, gleichwohl sind sie aber auch Grundmotive des alltäglichen Lebens. Es scheint, als sei Pop zu einem Logo geworden, das ähnlich wie Daniel Pflumm dies mit bereits existierenden Logos tut, mit beinahe jedwedem Inhalt gefüllt werden kann. Pop kann so Widerstand und Fortschritt symbolisieren, Techno, Rave und Love Parade Utopien verkörpern. Wie in den digitalen Welten können hier unterschiedliche (virtuelle) Realitäten konstruiert werden.

Pop bedeutet vor allem Entideologisierung und Enthierarchisierung noch immer im Sinne Warhols. Pop ist zuallererst Freiraum für Individualismus. Daß sich daraus erneut Gruppenphänomene, die spezifischen Codes unterworfen sind, entwickeln können und somit ein Maß an Uniformierung zurückkehrt, liegt in der Natur der Sache. Aber es ist eine selbstgewählte und keine verordnete Anpassung, die die Option auf Handlungsfreiheit für den einzelnen bewahrt.

Einen solchen Gruppenkontext illustriert Marc Brandenburg in seinen sogenannten "Snapshots", Schwarzweißzeichnungen, die nach fotografierten und kopierten Vorlagen entstehen. Es sind Impressionen der Berliner Club-

worlds, different (virtual) realities can be constructed here. Above all, pop still means destroying ideologies and hierarchies in the Warhol mode. First of all, pop offers space for individualism. The fact that group phenomena subject to specific codes can develop from this, and thus a certain uniformity is a matter of course. But this is a uniformity that people have chosen for themselves and have not been ordered to accept; hence freedom of action for the individual is preserved.

Marc Brandenburg illustrates just such a group phenomenon in his so-called "snapshots", black-and-white drawings based on photographs and photocopies. These are impressions of Berlin's club culture and everyday life. Love and sex, fashion and trends are the subject of this images as we know them from the photographs of Wolfgang Tillmans [18].

– Index of Censorship, 1998

The art forms of the late Eighties and early Nineties were based on criticism of the purely commercial strategies adopted by representatives of the new "isms". The exclusive character of works of art as objects or goods was called into question. Artists attempted to redefine the role of art in society and to extend its field of action. The importance of form diminished in favour of a new symbolism and the idea of presenting things in a context. In various thematic areas and topics of study such as girlism, gender studies, institutional critique or the infiltration of other scientific disciplines and social areas the classic white cube became a centre of documentation, a performance space or the collecting booth of a charitable organisation. The concept of dematerialisation, which had already been artistically formulated in the Sixties and expressed as a theory in the Seventies by writers such as Lucy Lippard [19], was thus again applied as a critical method at the beginning of this decade. This was an anti-art programme that was necessary as a revisional phase

– **16** Tobias Rehberger, in: *Make it Funky. Crossover zwischen Musik, Pop, Avantgarde und Kunst. Jahrbuch für moderne Kunst*, Köln, 1998, S. 317.
– **17** Diedrich Diederichsen: *Alles ist Pop*, in: Süddeutsche Zeitung, 08.08.1998. – **18** Wolfgangs Tillmans, *Wer Liebe wagt lebt morgen*, Ausstellungskatalog, Kunstmuseum Wolfsburg 1996.

– **18** Wolfgang Tillmans, *Wer Liebe wagt, lebt morgen/for when I'm weak I'm strong*, exhibition catalogue, Wolfsburg 1996. – **19** Lucy Lippard: *Six Years; The Dematerialization of the Art Object from 1966 to 1972*, New York 1992.

und Alltagskultur. Liebe und Sex, Mode und Trends sind Sujet, wie wir es auch von den Fotografien Wolfgang Tillmans[18] kennen.

– Index of Censorship, 1998

Die Kunstformen der späten achtziger und frühen neunziger Jahre wurden gespeist aus der Kritik an rein kommerziellen Strategien der Neo-Ismen. Der Objekt- oder Warencharakter der Kunst als ausschließliche Bestimmungsform wurde in Frage gestellt. Es wurde versucht, die Rolle der Kunst in der Gesellschaft neu zu bestimmen und ihre Handlungsfelder zu erweitern. Formuntersuchungen waren zugunsten einer neuen Inhaltlichkeit und Kontextualität zunächst zweitrangig. Unter wechselnden Themenfeldern und Untersuchungen wie girlism, gender studies, institutional critique oder der Infiltration anderer wissenschaftlicher Disziplinen und sozialer Felder wurde der klassische white cube zum Dokumentationszentrum, zum Vortragsraum oder zur Sozialstation. Die Konzeption der Entmaterialisierung, die bereits in den sechziger Jahren künstlerisch formuliert und in den siebziger Jahren zum Beispiel von Lucy Lippard[19] theoretisch gefaßt worden war, wurde so zu Beginn dieser Dekade erneut zur kritischen Methode. Ein Antikunstprogramm, das als Phase der Revision zu Beginn der neunziger Jahre wie alle Antiprogramme der Geschichte notwendig war, um die Rolle der Kunst in der Gesellschaft neu zu beantworten. 1997 faßte Catherine David mit der documenta X historische und gegenwärtige Positionen gesellschaftskritischer Kunst unter dem Leitmotiv der "Retroperspektive" zusammen.

Heute ist es möglich, auf dieses Kunstverständnis inhaltlich und formal zurückzugreifen, es an Jetztformen anzupassen und um die eigene Biografie und Subjektivität oder mit Versatzstücken aus anderen Feldern zu erweitern. Peter Friedl vermischt in seiner Arbeit "Galerie Erna

at the beginning of the Nineties, as all anti-programmes have been throughout history, to redefine the role of art in society. In 1997, Catherine David summarised historical and contemporary examples of socially critical art at the documenta X under the leitmotif "Retroperspektive."

It is now possible to refer to this view of art in terms of both content and form, to adapt it to contemporary forms and enlarge it with subjective, autobiographical details or clichés borrowed from other areas. In *Galerie Erna Hécey* of 1998, Peter Friedl combines the glacial beauty of the Eighties aesthetic with the question as to how works of art can impose their aesthetic value by means of self-referential elements. The windows of the gallery were decorated with a green-blue colour code that appeared on the one hand to be citing compositions by Barnett Newman, while rendering the physical forms of Peter Friedl and his son on the other. The result was a complex interweaving of artistic language and autobiography consisting of several different narrative and formal points of reference. Subjective ideas about the art world and quotations of trends or methods are expressed playfully, reflecting the artist's pleasure in the form and materiality of the objects.

In his film entitled *Kriegsjahre* ("War Years") Elmar Hess combines a cascade of fantasies on historical events with individual drama. National socialist and allied military strategies during the Second World War, with hints at Hitler and Churchill, offer the historical basis for the film, while the subjective background is provided by staged scenes of problems in Hess's own relationship and his fondness for ocean steamers. Both strands of the plot confront egomania with megalomania, individualism with social constraints.

– **19** Lucy Lippard: *Six Years; The Dematerialization of the Art Object from 1966 to 1972*, New York 1992.

Hécey" 1998 die kalte Schönheit der Achtziger-Jahre-Kunst und die Frage, wie Kunstwerke ihren ästhetischen Wert mit selbstreferentiellen Momenten durchsetzen können. Die Fenster der Galerie waren unter anderem mit einem grün-blauen Farbcode versehen, der einerseits Kompositionen von Barnett Newman zu zitieren schien, andererseits aber den Körpermaßen von Peter Friedl und seinem Sohn Ausdruck verlieh. Es entstand ein komplexes Geflecht aus Kunstsprache und Autobiografie, das vielfältig narrative und formale Referenzebenen erfaßte. Reflektionen zum Kunstsystem und der Rückgriff auf Trends oder Methoden werden spielerisch aus subjektiver Sicht vorgenommen und mit Lust an der Form und der Materialität der Objekte inszeniert.

Elmar Hess schaltet in seinem Film "Kriegsjahre" eine Phantasiekaskade geschichtlicher Ereignisse mit dem individuellen Drama gleich. Nationalsozialistische und alliierte Kriegsstrategien des Zweiten Weltkrieges mit Anspielungen auf die Führerfiguren Hitler und Churchill bilden den fiktionalen historischen Fonds, Szenen aus dem eigenen, inszenierten Beziehungsclinch und seine Vorliebe für Ozeandampfer geben den subjektiven Hintergrund. In den beiden Handlungssträngen werden Egomanie und Größenwahn, Individualität und Systemzwang einander gegenübergestellt.

– Sonne, Farben, gute Laune, 1996

Persönliche Referenzen sind immer auch bei Tobias Rehbergers Arbeiten unterstellt. Seine Blumenvasen sind "Portraits" der Freunde und bei der Arbeit "Decke, Büroräume, 1. Stock" hat er die Körpergrößen von Mitarbeitern der Baseler Kunsthalle aufgegriffen und daraus eine höhenabgestufte Kassettendecke gestaltet. Rehbergers Design ist sicherlich das genaue Gegenteil zum Provisorium von Joseph Zehrers Kinointerieur. Bei Rehberger sind wie bei Matti Brauns Konferenzensemble für den

– Sonne, Farben, gute Laune (Sun, Colours, Good Humour), 1996

Tobias Rehberger's also always contain personal references. His vases of flowers are "portraits" of his friends, and in his *Decke, Büroräume, 1. Stock* ("ceiling, offices, first floor") he incorporates the measurements of the bodies of Kunsthalle Basel staff, creating a coffered ceiling of varying height. Rehberger's design is certainly the exact opposite of Joseph Zehrer's improvised cinema interior. Like Matti Braun's conference furniture for the G-8 summit in Cologne, Peter Friedl's designs for catalogues and tables or Stefan Kern's furniture sculptures, Rehberger's work blurs the boundaries between art and the so-called applied arts. The most important difference, however, is that these creations are not conceived as functional objects, but put their appearance as practical or everyday objects to the service of artistic goals and the contexts for which they have been created.

– Transarchitektur oder Psycho in Dresden (Transarchitecture or Psycho in Dresden), 1999

Manfred Pernice's architectural sculptures act as vessels or surfaces for the stories he has to tell. Some of them are historical, frequently ironic, but always from a personal viewpoint, they refer to real places, evoking ideas about lifestyles and living spaces. The poetry of this work lies in its fleeting nature and improvised execution. Only a model, the vaguer the better, is any use as a Utopia. Gregor Schneider creates mock architecture in his laboratory. He has been rebuilding his house in Rheydt (Lower Rhine) for years, placing walls in front of existing ones so that it is no longer possible to reconstruct the original structure of the building. Only the video shown in Wolfsburg reveals the true extent of his manic building activities. Schneider's laborious passage through his Kafkaesque labyrinth with the camera shows unsettlingly

G-8-Gipfel in Köln oder Peter Friedls Kataloggestaltungen und Tischen die Grenzen zur sogenannten angewandten Kunst scheinbar verwischt, ebenso bei Stefan Kerns Möbelskulpturen. Der zentrale Unterschied ist jedoch, daß sie nicht als Design, als funktionale Verwertungsstücke angelegt sind. Vielmehr nutzen sie diese Gebrauchs- oder Alltagsvisualität für ihre künstlerischen Ziele und für die Kontexte, für die sie entstanden sind.

– Transarchitektur oder Psycho in Dresden, 1999

Bei Manfred Pernice sind es architektonische Skulpturen, die als Gefäß oder Oberfläche seine Erzählungen tragen. Teilweise historisch, oft ironisch, immer aber aus persönlicher Sicht nehmen sie bezug auf reale Orte. Vorstellungen über Wohnformen und Lebensräume werden evoziert. Die Poesie liegt in der Flüchtigkeit, im Provisorischen der Ausführung. Nur das Modell, je vager es ist, taugt zur Utopie. Architektur als Attrappe entsteht im Labor von Gregor Schneider. Seit Jahren verbaut er sein Haus im niederrheinischen Rheydt, setzt Wände vor bereits bestehende Wände, so daß die ursprüngliche Struktur nicht mehr rekonstruierbar ist. Nur in seinem Video, das in Wolfsburg gezeigt wird, läßt sich die Tragweite seiner manischen Bautätigkeit erfassen. Schneiders mühsamer Gang mit der Kamera durch sein kafkaeskes Labyrinth zeigt beängstigend, wie Proportionen und Orientierungssysteme außer Kraft gesetzt sind. Während sich Schneider bei seinen Architekturuntersuchungen auf den Innenraum konzentriert, untersucht Heidi Specker mit ihren digital aufgenommenen Fotografien die Außenhaut der Bauwerke. Musterbildungen vorgefertigter Bauteile und serielle Anordnungen von Fenstern steigern sich in Ausschnitten oder Details zu abstrakten Kompositionen. In den ungeschärften Motiven der "RGB"-Serie erscheinen die Fotos wie Gemälde urbaner Landschaften. Zeitgeschichtlicher und fast wissenschaftlich analytisch sind dagegen die Videos von

how proportions are eliminated and orientation systems become powerless.

While Schneider concentrates on interior spaces in his architectural studies, Heidi Specker's digital photographs examine the outer skin of buildings. The patterns of prefabricated building components and rows of windows shown in close-up or as details become intense, abstract compositions. In the five blurred images of the RGB series, the photographs resemble paintings of urban landscapes. By comparison, Maix Mayer's videos – Transarchitektur oder Psycho in Dresden and Die Welt des Tropisten – ein Remake – which document the architectural history of the former German Democratic Republic, appear more contemporary and almost scientifically analytical. Comparisons with the west German architecture of the Sixties, such as Eiermann's pioneering Hertie façade, spring to mind, raising the issue of the historical significance of socialist mannerism.

– The curious garden, 1997

Peter Pommerer is a draughtsman. With coloured crayons and felt-tip pens he designs a gigantic, yet fragile, subjective cosmos whose structure is at times rampant, at times almost geometric, and which he prefers to draw directly on the walls of the exhibition space. Pommerer's rhizomatically interlinked drawings have a fairy tale quality, are exotic and erotic; he ignores the boundary between high and low culture. Longing, desire, voluptuousness and fantasy are woven into the network of lines and colours with an almost child-like naivete but are also objective in a stereotyped way. The unity of Pommerer's subjective system is similar to that recognisable in Max Mohr's work. Mohr's installations, however, create a completely different atmosphere: orthopaedic materials, prosthesis and nylon fabrics, cotton wool and tulle, which he uses to cover single sculptural elements or entire walls of his walk-in installation, as well as the sound of synthetic

Maix Mayer "Transarchitektur oder Psycho in Dresden" und "Die Welt des Tropisten – ein Remake" angelegt, die die Baugeschichte der ehemaligen DDR-Architektur kartographieren. Vergleiche zur West-Architektur der sechziger Jahre drängen sich auf, etwa zu Eiermanns richtungsweisender Hertie-Fassade und stellen die Frage nach der historischen Bedeutung des sozialistischen Manierismus.

– The curious garden, 1997

Peter Pommerer ist Zeichner. Er entwirft mit Buntstiften und Filzschreibern einen gigantischen, aber fragilen, subjektiven Kosmos, dessen mal wuchernde, mal fast geometrische Struktur sich mit Vorliebe direkt auf den Ausstellungswänden entfaltet. Märchenhaft, exotisch und erotisch entwickelt er verspielt-automatisch sein rhizomatisch verknüpftes Zeichenprogramm und ignoriert dabei die Trennung zwischen high und low culture. Sehnsucht, Begierde, Sinnlichkeit und Phantasie werden mit fast kindlicher Naivität, aber auch schablonenhaft objektiviert, im Netz der Striche und Flächen verwoben. Pommerer erreicht eine Geschlossenheit eines subjektiven Systems, wie sie ähnlich bei Max Mohr auftritt. Dessen Rauminstallationen zeugen jedoch von einer gänzlich anderen Atmosphäre: orthopädische Materialien, Prothesen- und Nylonstoffe, Watte und Tüll, die einzelne skulpturale Teile oder die gesamten Wände der begehbaren Installation überziehen, sowie der Klang synthetischer Musik wirken auf das Unterbewußtsein der Besucher. Diffuse Assoziationen an Fleischlichkeit und Sexualität werden heraufbeschworen, erblühen mit bedrängender Macht und fördern eine Spannung zwischen Ablehnung und Wohlfühlen. Mohrs Arbeiten sind in den Bereich der Psyche oder wie Knut Ebeling im Katalogtext sagt, ins Perverse verschoben.

music, have a subconscious effect on the viewer. Vague references to carnal sensuality are evoked, flowering with distressing power and elicit a reaction that lies between rejection and pleasure. Mohr's creations move in the realm of the psyche, or as Knut Ebeling puts it in his text, of the perverse.

– Don't call it a Comeback, 1999

Whenever people talk about the death or rebirth of painting, scepticism is called for, as they all too often use conventional ideas or purely affirmative insinuations to support their arguments. Yet painting and all the other "pure" artistic genres have always managed to formulate aspects of the present in such a way that their message is clearer than that of any other medium. Franz Ackermann and Michel Majerus on the one hand, Neo Rauch and Daniel Richter on the other represent the two opposite poles between which painting moves today. The modern visual language borrowed from the world of the media and advertising, digital images and the global flood of images evident in the work of Majerus and Ackermann can easily overstep the boundaries of the canvas. This is not the case with Daniel Richter and Neo Rauch. Using quotations from other painters ranging from Asgar Jorn to Albert Oehlen, for example, Richter creates almost collages of almost ornamental patterns that bombard the viewer like the rapid images of an MTV clip. By comparison, the world of Rauch's images is a static one. He accompanied the "construction" of the *Deutschland-Gesellschaft*. His stereotypical figures save the world of images of the German Democratic Republic – that once really existed. He easily succeeds in continuing and updating the symbolic form of painting as exercised by Guttuso or Immendorff.

– Sun in 10 different directions

– Don't call it a Comeback, 1999

Wann immer man vom Ende der Malerei oder seiner
Wiedergeburt spricht, muß man skeptisch sein. Allzu-
sehr argumentiert man dabei mit konventionellen Vorstel-
lungen oder rein affirmativen Unterstellungen. Doch ist
es der Malerei und auch allen anderen sogenannten
sortenreinen Verfahren zu allen Zeiten gelungen, Aspekte
der Gegenwart zu formulieren, die so schärfer auf den
Punkt gebracht sind als mit allen anderen Mitteln. Franz
Ackermann und Michel Majerus einerseits und Neo
Rauch und Daniel Richter andererseits bilden die Pole,
zwischen denen sich Malerei heute formuliert. Bei
Majerus und Ackermann sind es aktuelle Visualitäten,
genährt aus der Medien- und Werbewelt, den digitalen
Oberflächen und globalen Bildströmen, die die Grenzen
der Leinwand leicht überschreiten können. Daniel Richter
und Neo Rauch dagegen verteidigen den Keilrahmen.
Richter collagiert Malereizitate, von Asger Jorn bis Albert
Oehlen etwa, zu fast schon ornamentalen Pattern, die wie
die hohen Schnittfrequenzen der MTV-Clips auf den
Betrachter einprasseln. Dagegen sind Rauchs Bildwelten
statisch. Wie ein Chronist begleitete er den "Aufbau" der
Baustelle Deutschland-Gesellschaft. Seine Figurenstereo-
typen retten die Bilderwelt der einst real existierenden
DDR. Leicht gelingt ihm hier die Fortsetzung und Aktu-
alisierung einer inhaltlichen Malerei, wie sie von Guttuso
oder Immendorff praktiziert wurde.

– Sun in 10 different directions

Unser herzlicher Dank gilt/we are especially thankful to den KünstlerInnen und ihren Galerien/the artists and their galleries, den AutorInnen/the authors, den Leihgebern/the lenders

und/and:

Stefan Ackermann, Stefan Berg, Ariane Beyn,
Beatrix von Bismarck, Mirko Böhme, Tobisa Bott,
Regine Brendel, Signe Dancker, Deutsche Telekom AG,
Carsten Friedrichsen, Daniel Gehrke, Isabelle Graw,
Karola Grässlin, Andreas Gursky, Philipp Haverkampf,
Georg Herold, Remo Hobi, Kay & Niels Hülshoff,
Sandra Inglese, Rita Kersting, Kodak AG, Kasper König,
Bastian Krondorfer, Harald Kunde, Paul Liebchen,
Claudia Leiendecker, Stefan Matthes, Media Markt
Wolfsburg, Fritz Theo Mennicken, Maria Merelsdottir,
Alexander Nanau, Firma Noah, Hannover,
Stephanie Peterat, Jose Presmanes, Anders Romare,
Susanne Rosier, Nicolaus Schaffhausen,
Katja & Bernd Schliephake, Bauer Schmidt,
Peter Schmidt, Nina Schröder, Otto Schweins,
Annette Sievert, PD Dr. med. Fritz B. Simon,
Michael Simon, Barbara Steiner, Dorothea Strauss,
Stiftung Kunst und Kultur des Landes Nordrhein-
Westfalen, Raimar Stange, Claudia Spinelli, Susanne Titz,
Jan Verwoert, Kea Wienand, Heinrich Willecke,
Michael Zeyfang

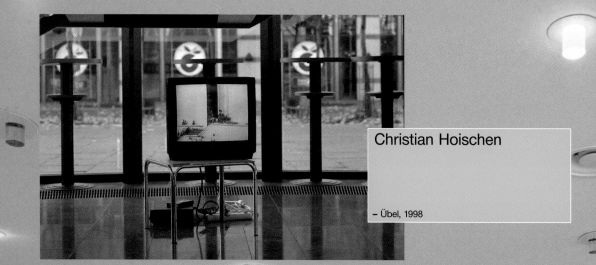

Christian Hoischen

– Übel, 1998

Max Mohr

– Apollo 8, 1999

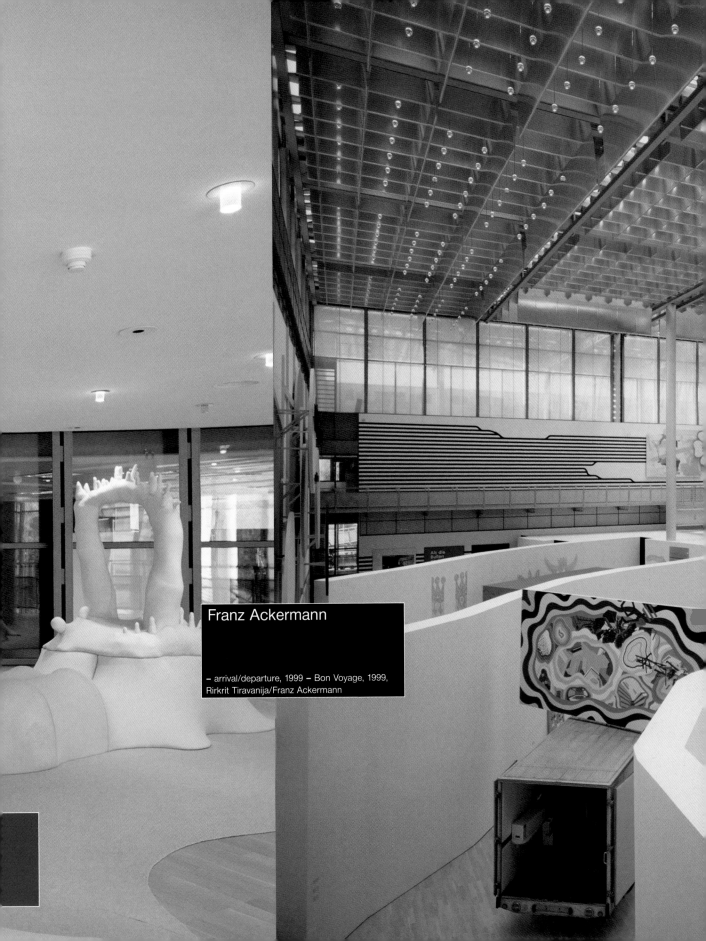

Franz Ackermann

– arrival/departure, 1999 – Bon Voyage, 1999,
Rirkrit Tiravanija/Franz Ackermann

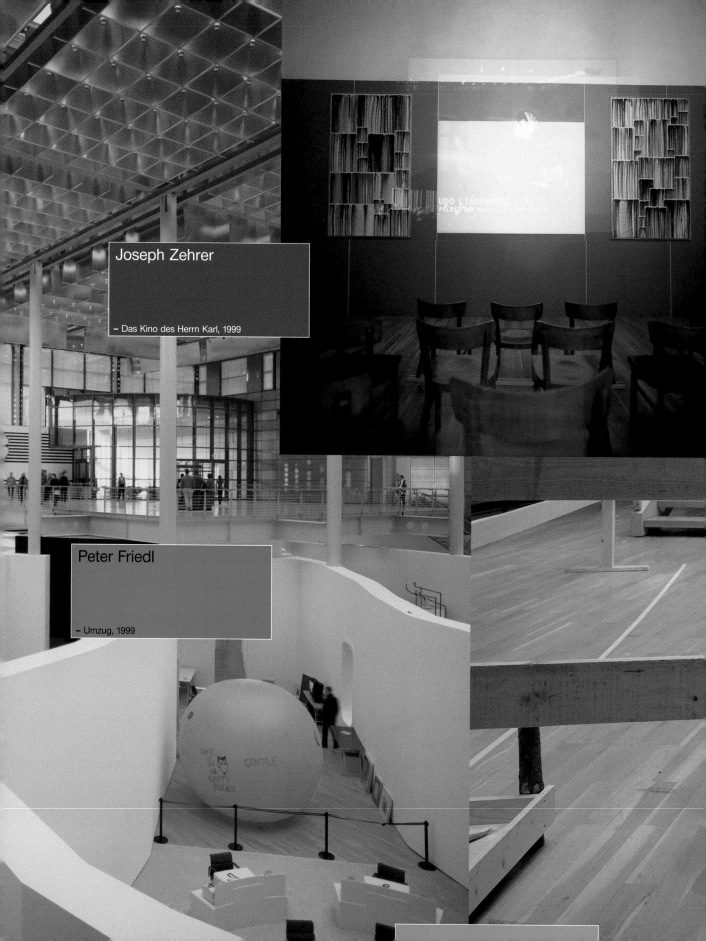

Joseph Zehrer

– Das Kino des Herrn Karl, 1999

Peter Friedl

– Umzug, 1999

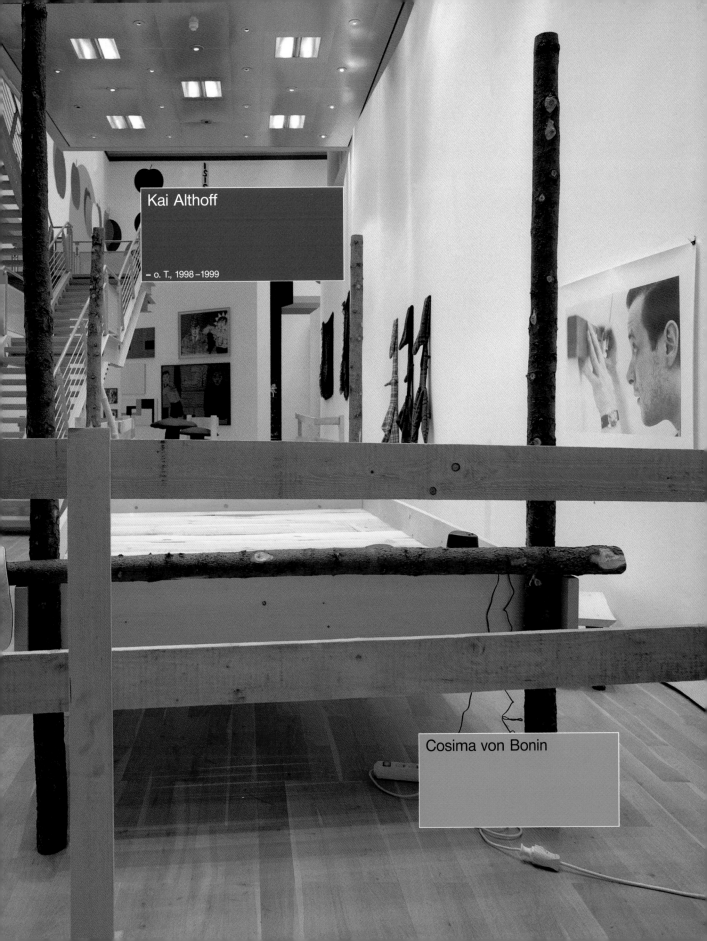

Kai Althoff

– o. T., 1998–1999

Cosima von Bonin

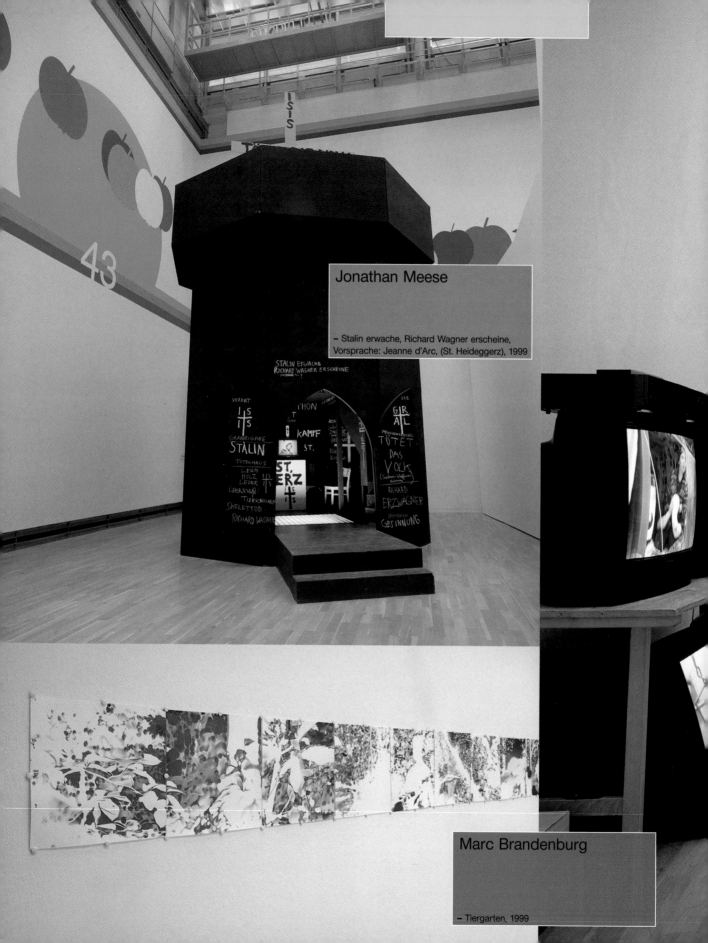

Jonathan Meese

– Stalin erwache, Richard Wagner erscheine,
Vorsprache: Jeanne d'Arc, (St. Heideggerz), 1999

Marc Brandenburg

– Tiergarten, 1999

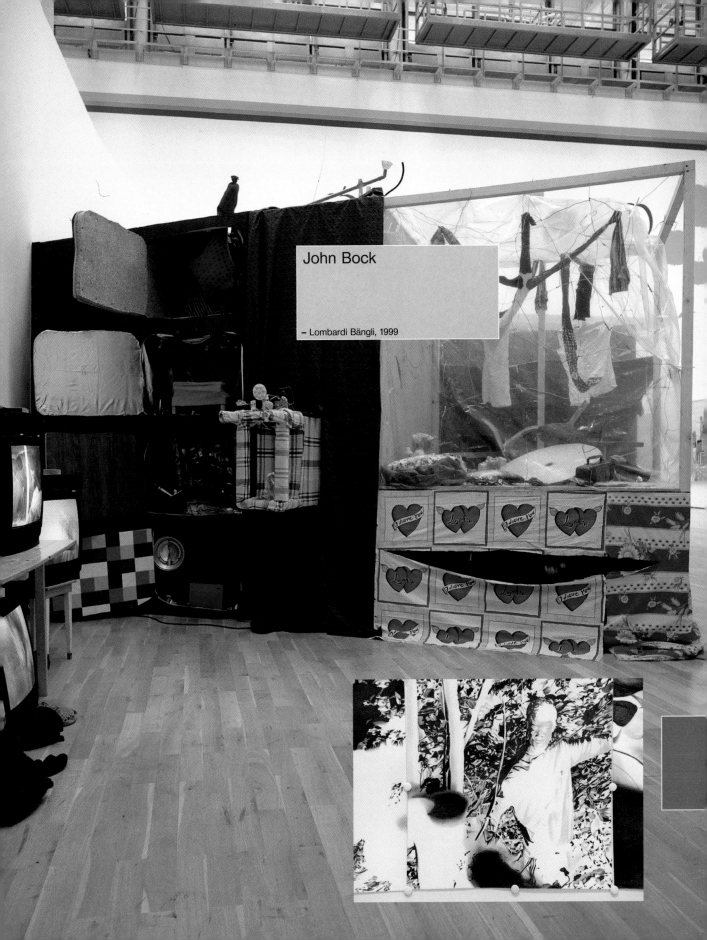

John Bock

– Lombardi Bängli, 1999

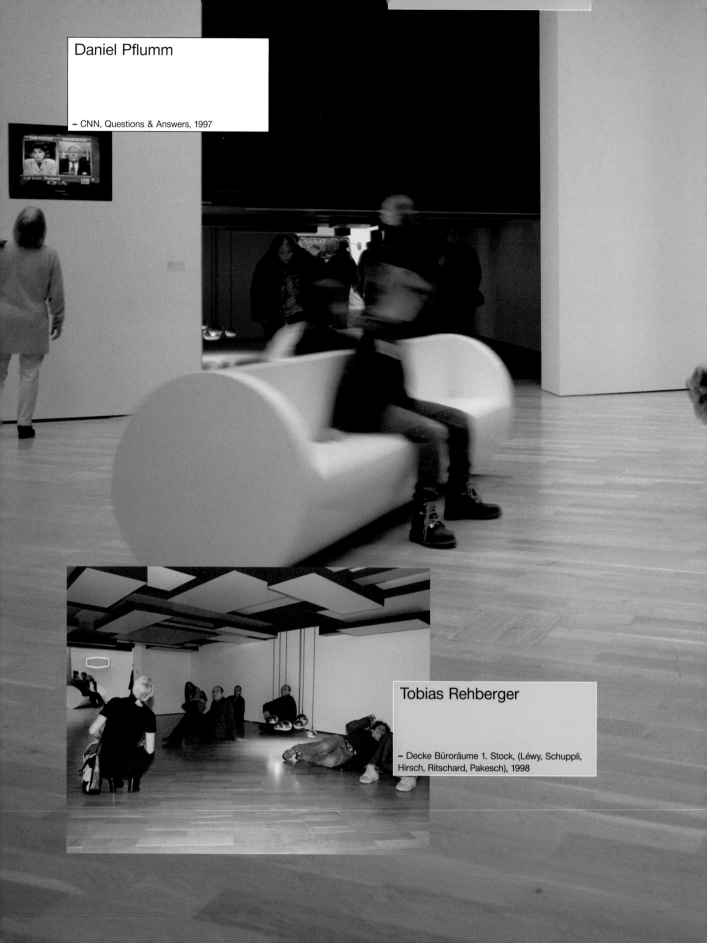

Daniel Pflumm

– CNN, Questions & Answers, 1997

Tobias Rehberger

– Decke Büroräume 1. Stock, (Léwy, Schuppli, Hirsch, Ritschard, Pakesch), 1998

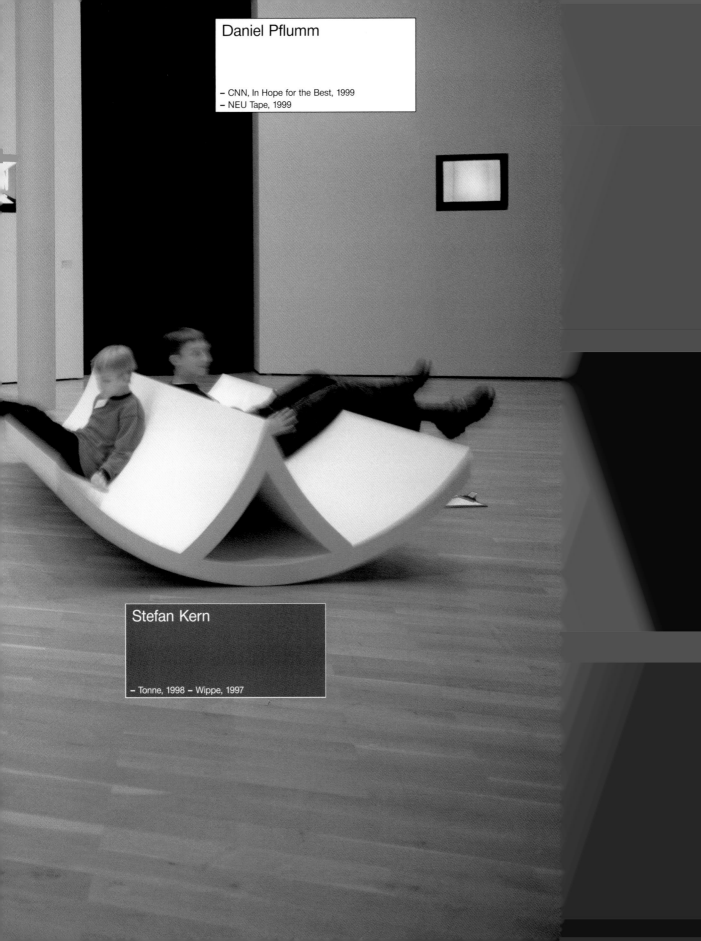

Daniel Pflumm

– CNN, In Hope for the Best, 1999
– NEU Tape, 1999

Stefan Kern

– Tonne, 1998 – Wippe, 1997

Andree Korpys & Markus Löffler

– Marc Chagall "Frieden" für/for Dag Hammarskjöld
United Nations, New York, 1999

Andree Korpys & Markus Löffler

– World Trade Center, 1997 – United Nations
Organizations, 1997 – Pentagon, 1997

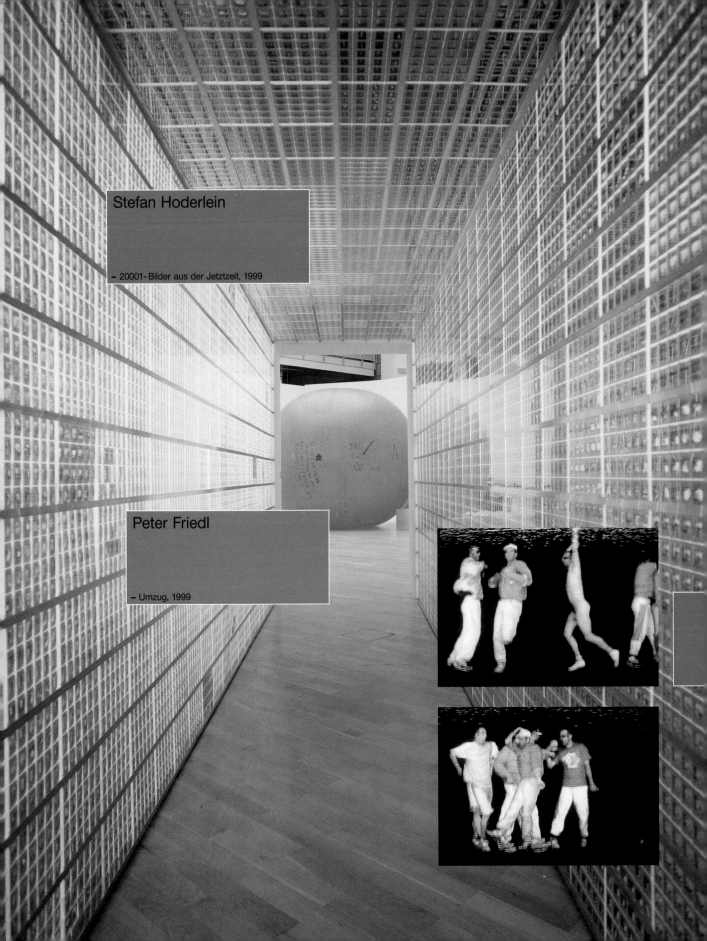

Stefan Hoderlein

– 20001- Bilder aus der Jetztzeit, 1999

Peter Friedl

– Umzug, 1999

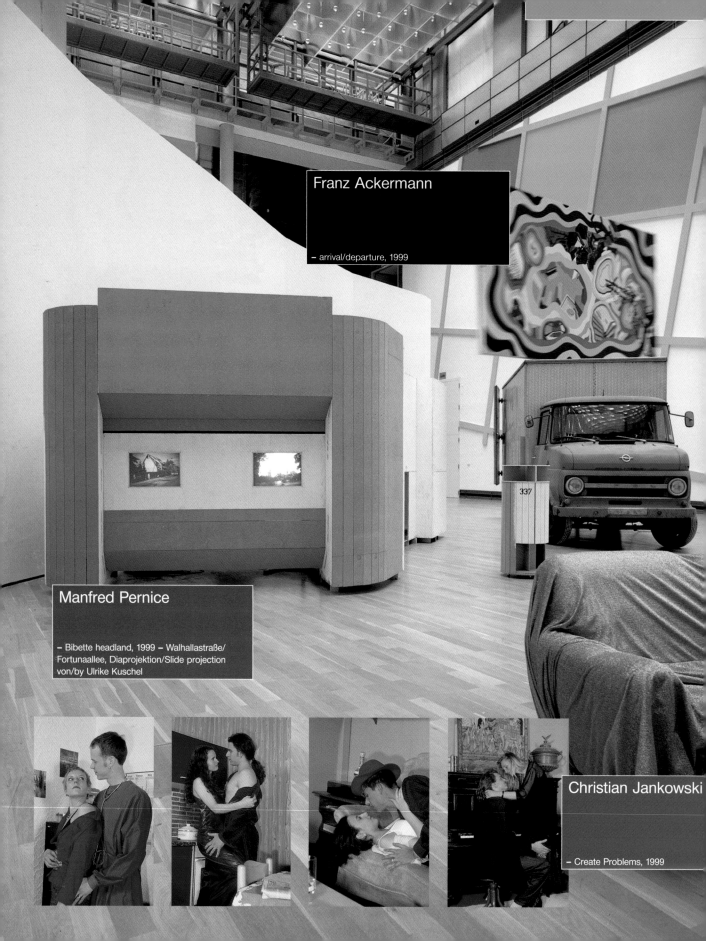

Franz Ackermann

– arrival/departure, 1999

Manfred Pernice

– Bibette headland, 1999 – Walhallastraße/
Fortunaallee, Diaprojektion/Slide projection
von/by Ulrike Kuschel

Christian Jankowski

– Create Problems, 1999

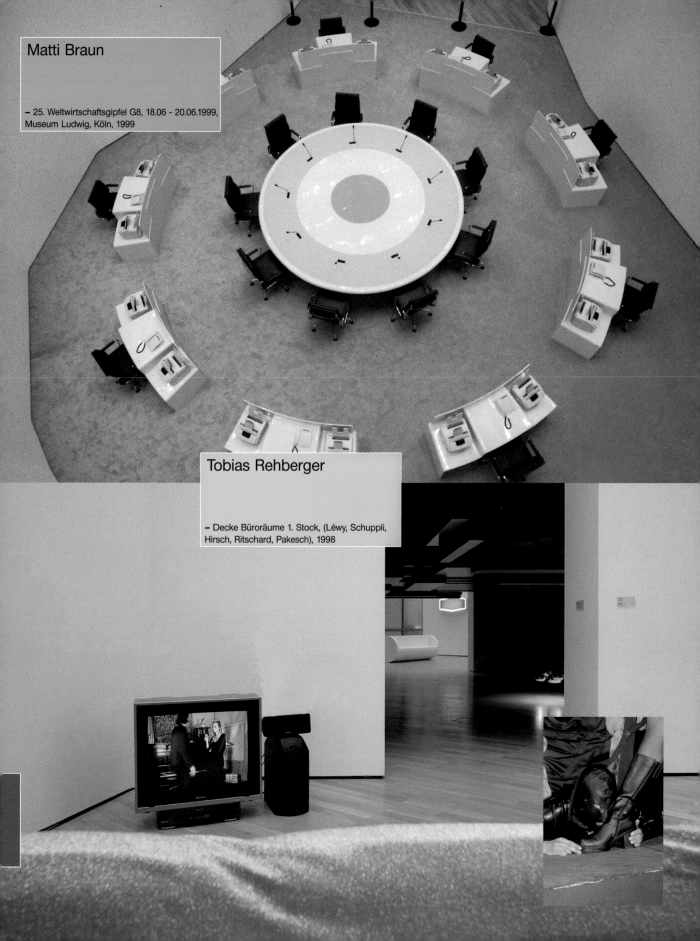

Matti Braun

– 25. Weltwirtschaftsgipfel G8, 18.06 - 20.06.1999,
Museum Ludwig, Köln, 1999

Tobias Rehberger

– Decke Büroräume 1. Stock, (Léwy, Schuppli,
Hirsch, Ritschard, Pakesch), 1998

Christian Flamm

– Ohne Titel, 1999

Alexander Györfi

– "temporary items" 6 sequences, 1999

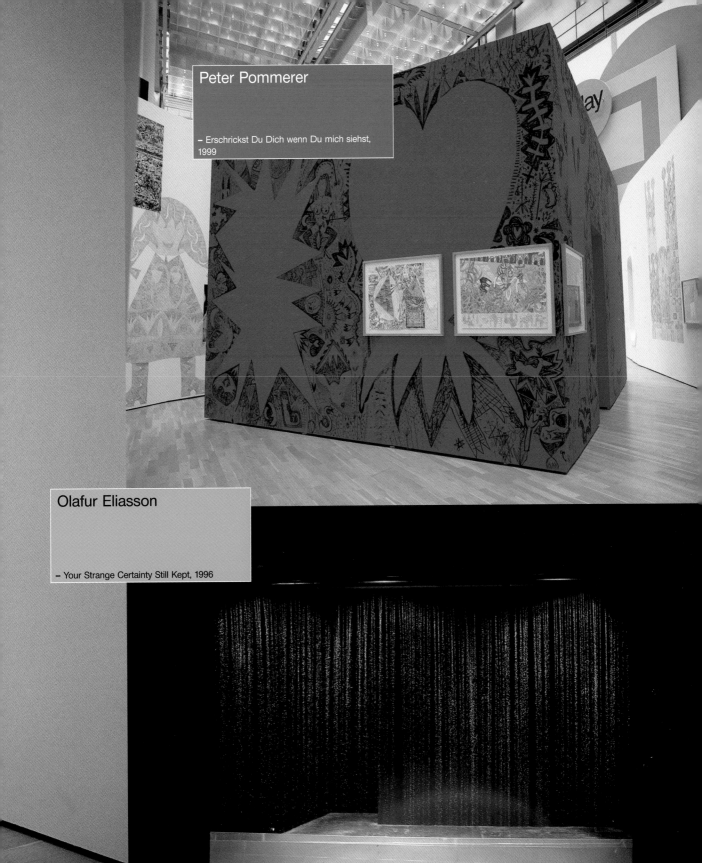

Peter Pommerer

– Erschrickst Du Dich wenn Du mich siehst, 1999

Olafur Eliasson

– Your Strange Certainty Still Kept, 1996

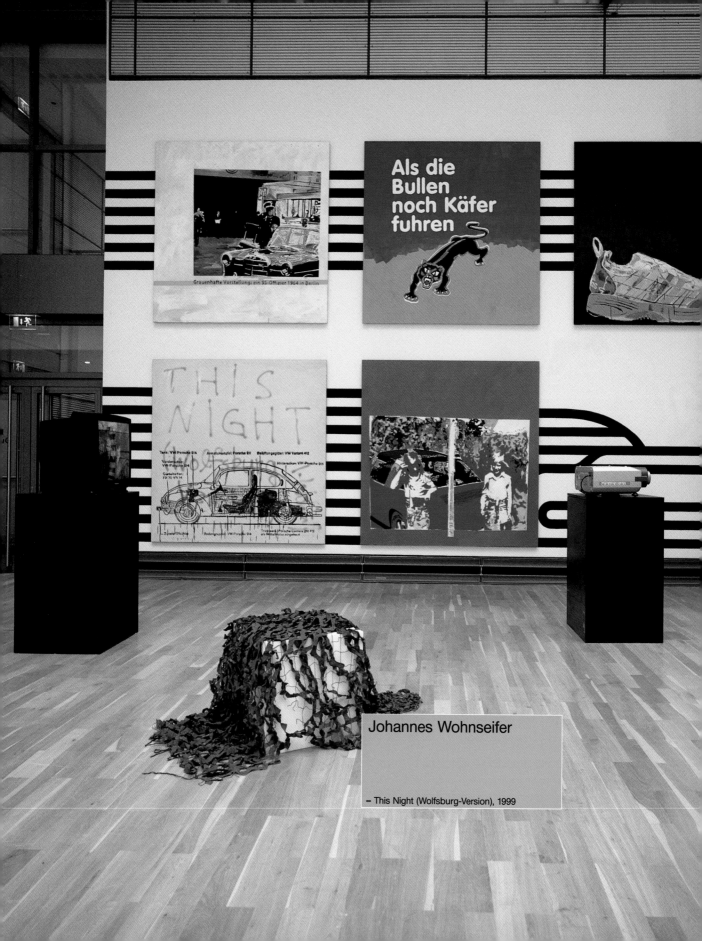

Johannes Wohnseifer

– This Night (Wolfsburg-Version), 1999

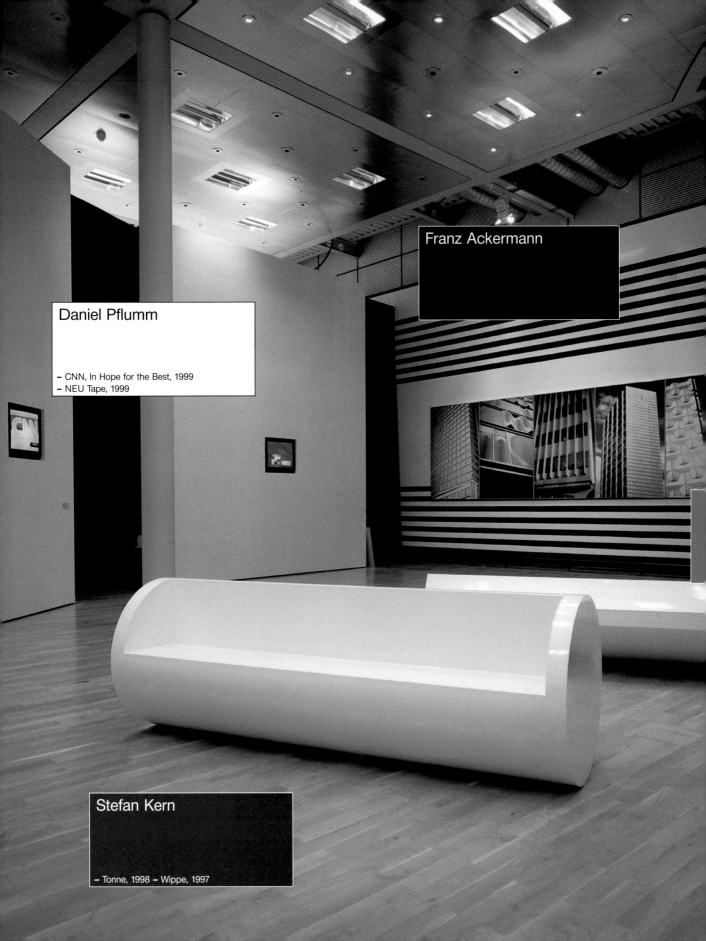

Franz Ackermann

Daniel Pflumm

– CNN, In Hope for the Best, 1999
– NEU Tape, 1999

Stefan Kern

– Tonne, 1998 – Wippe, 1997

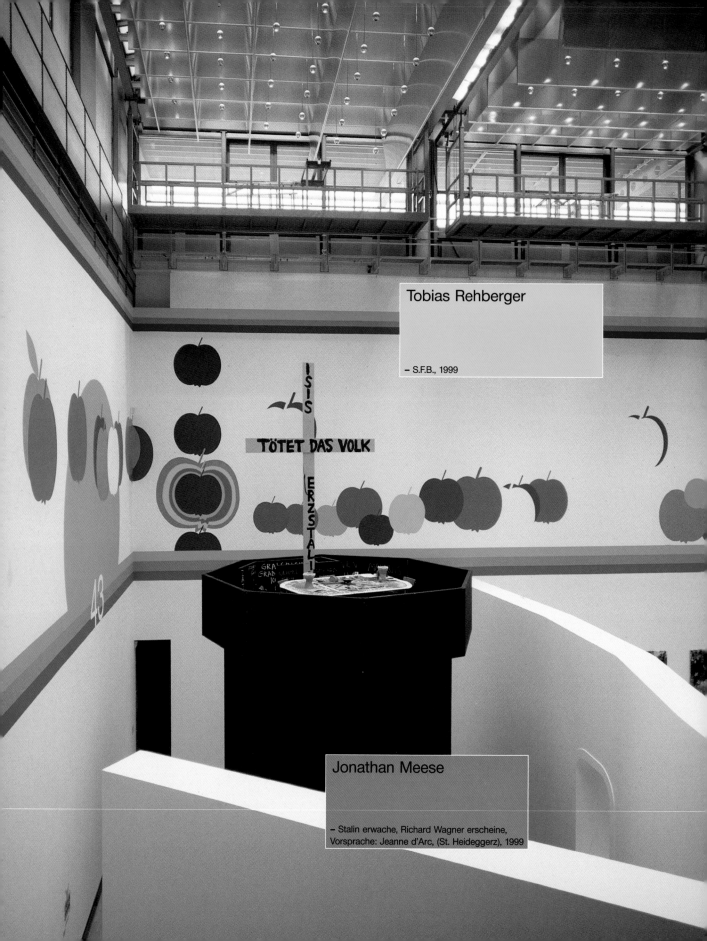

Tobias Rehberger

– S.F.B., 1999

Jonathan Meese

– Stalin erwache, Richard Wagner erscheine,
Vorsprache: Jeanne d'Arc, (St. Heideggerz), 1999

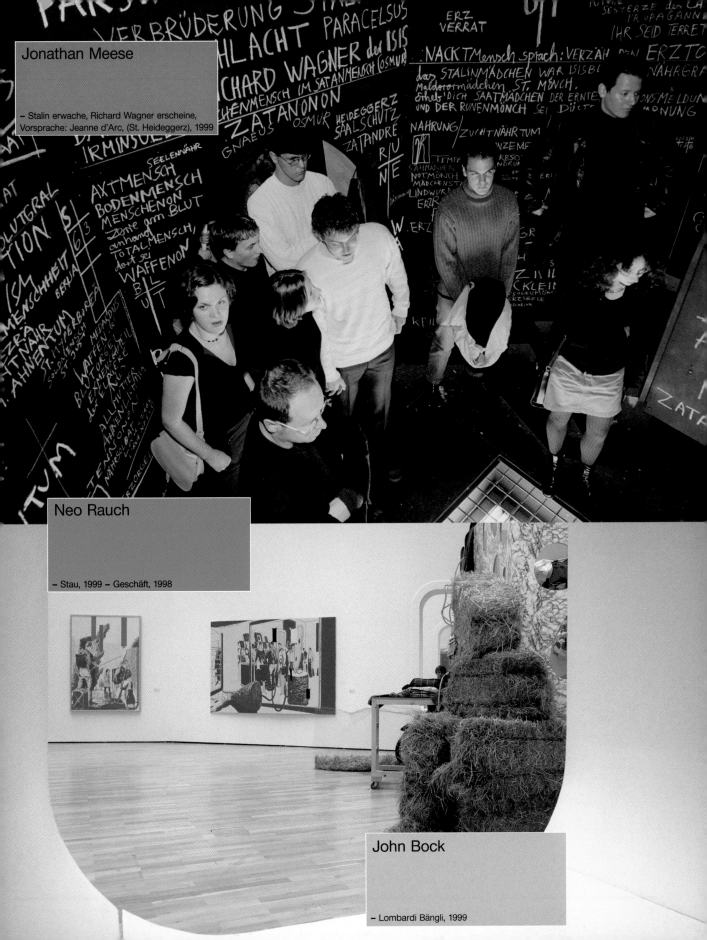

Jonathan Meese

– Stalin erwache, Richard Wagner erscheine,
Vorsprache: Jeanne d'Arc, (St. Heideggerz), 1999

Neo Rauch

– Stau, 1999 – Geschäft, 1998

John Bock

– Lombardi Bängli, 1999

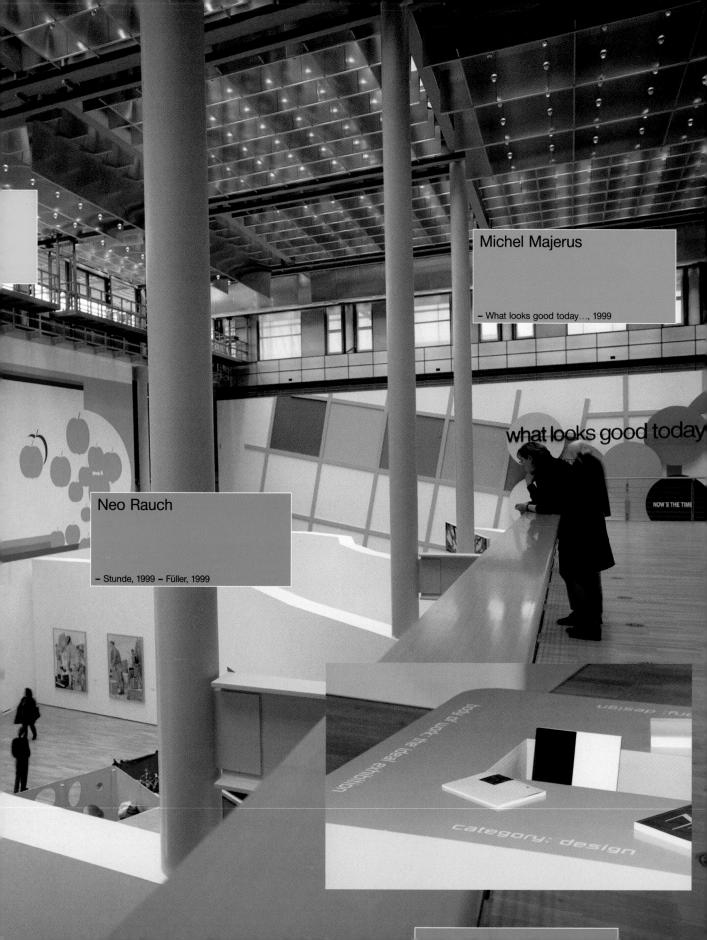

Michel Majerus

– What looks good today…, 1999

Neo Rauch

– Stunde, 1999 – Füller, 1999

what looks good today

NOW'S THE TIME

category: design

Peter Dittmer

– Schalten und Walten, [Die Amme
Die Amme 2 Die Amme 3], seit/since 1992

Tilo Schulz

– body of work: the ideal exhibition, category:
wall painting and design, 1999

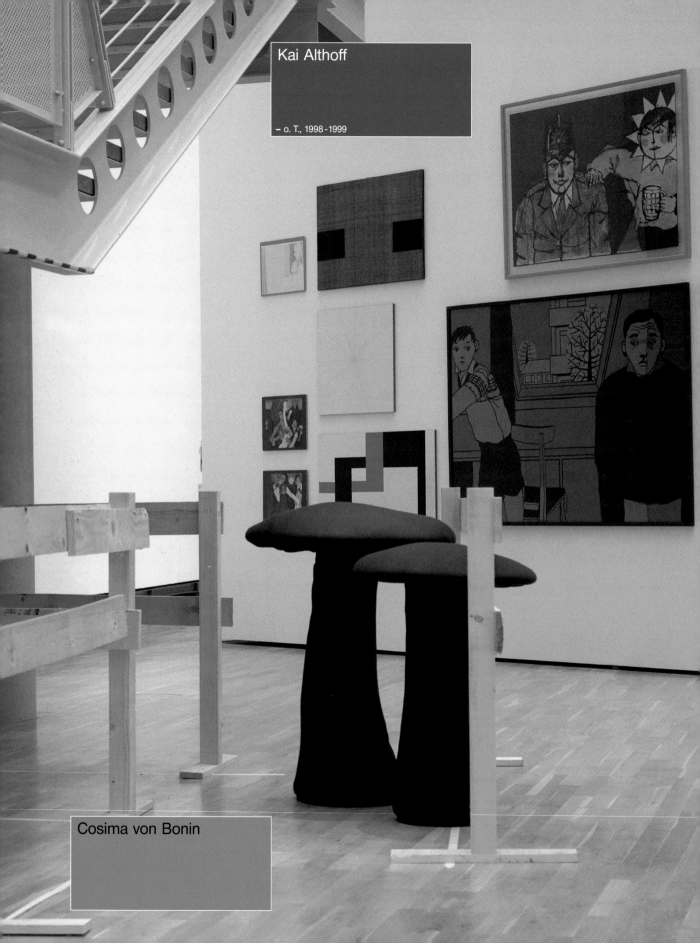

Kai Althoff

– o. T., 1998-1999

Cosima von Bonin

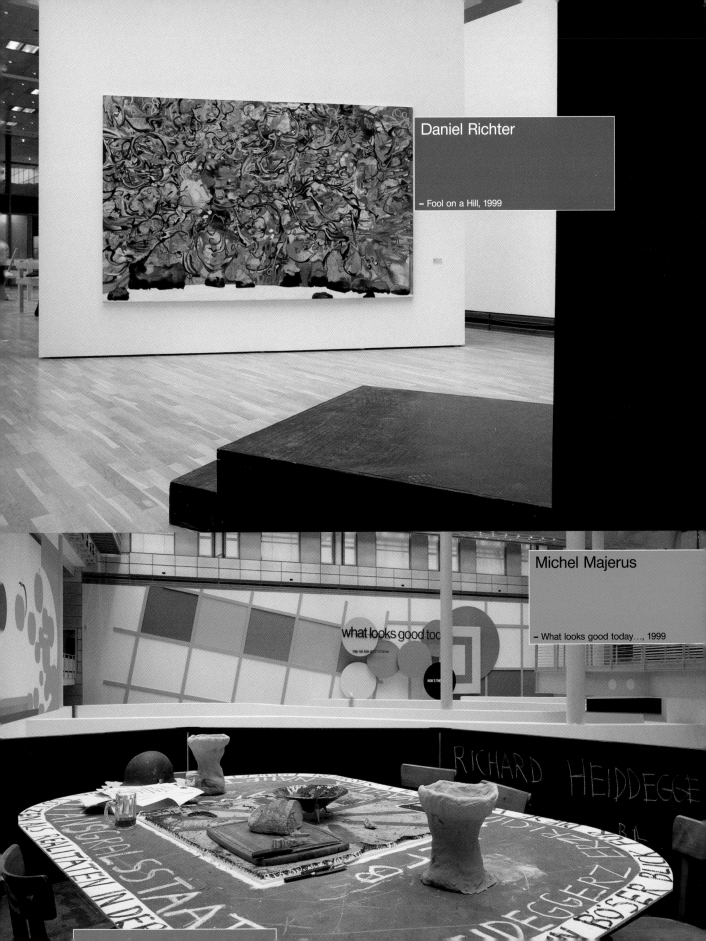

Daniel Richter

– Fool on a Hill, 1999

Michel Majerus

– What looks good today…, 1999

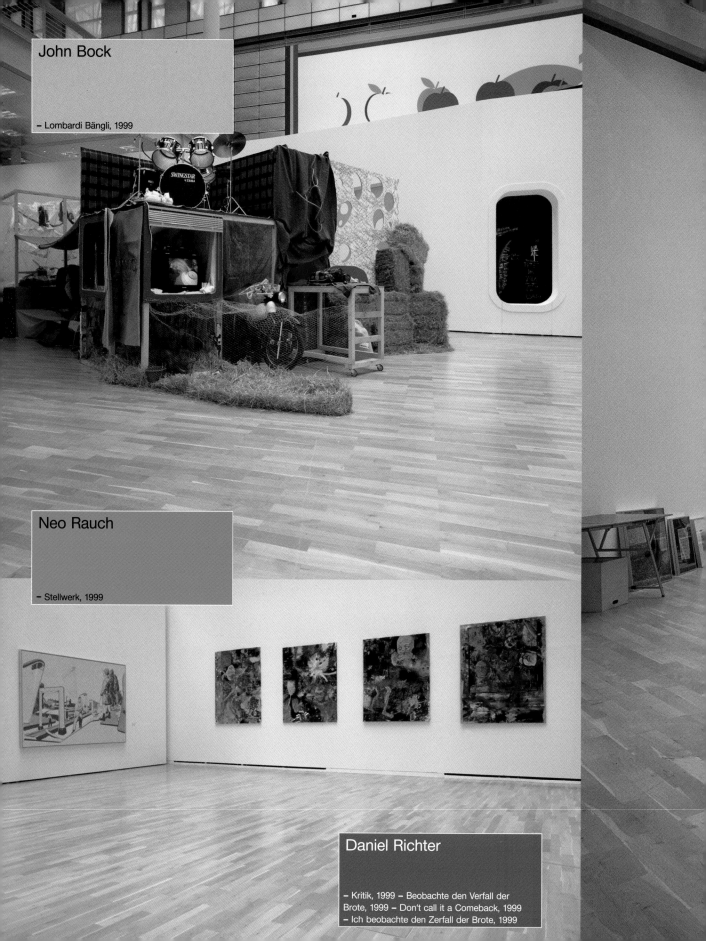

John Bock

– Lombardi Bängli, 1999

Neo Rauch

– Stellwerk, 1999

Daniel Richter

– Kritik, 1999 – Beobachte den Verfall der
Brote, 1999 – Don't call it a Comeback, 1999
– Ich beobachte den Zerfall der Brote, 1999

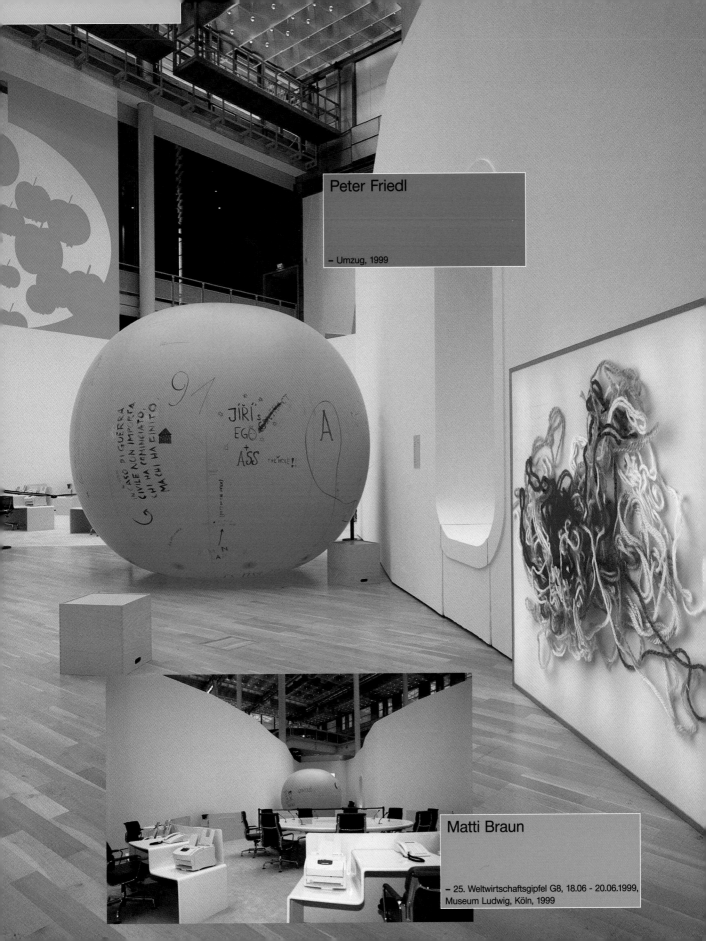

Peter Friedl

– Umzug, 1999

Matti Braun

– 25. Weltwirtschaftsgipfel G8, 18.06 - 20.06.1999,
Museum Ludwig, Köln, 1999

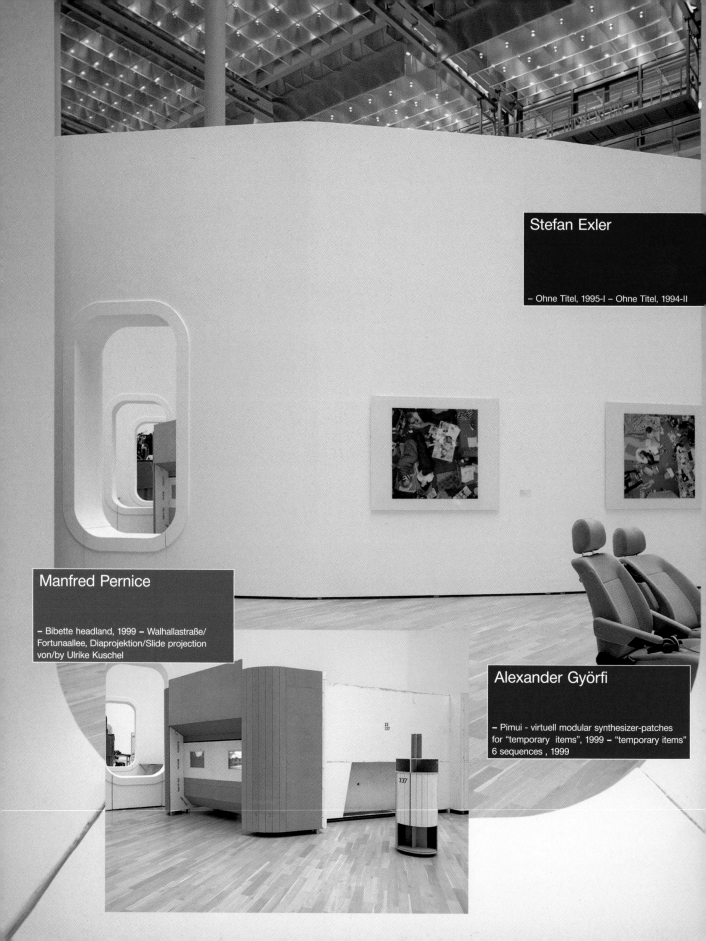

Stefan Exler

– Ohne Titel, 1995-I – Ohne Titel, 1994-II

Manfred Pernice

– Bibette headland, 1999 – Walhallastraße/
Fortunaallee, Diaprojektion/Slide projection
von/by Ulrike Kuschel

Alexander Györfi

– Pimui - virtuell modular synthesizer-patches
for "temporary items", 1999 – "temporary items"
6 sequences , 1999

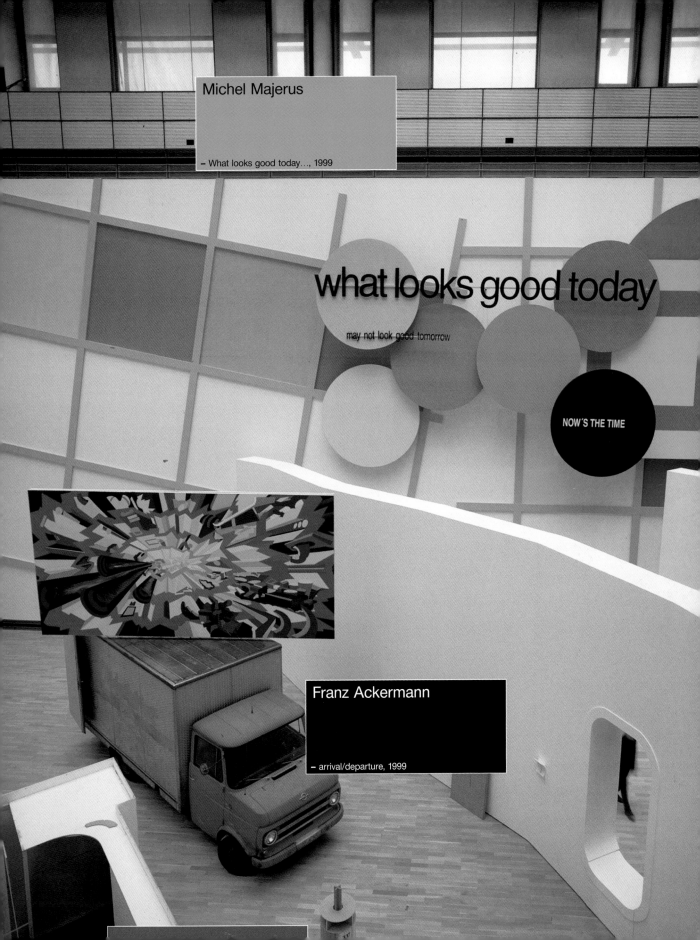

Michel Majerus

– What looks good today…, 1999

what looks good today

may not look good tomorrow

NOW'S THE TIME

Franz Ackermann

– arrival/departure, 1999

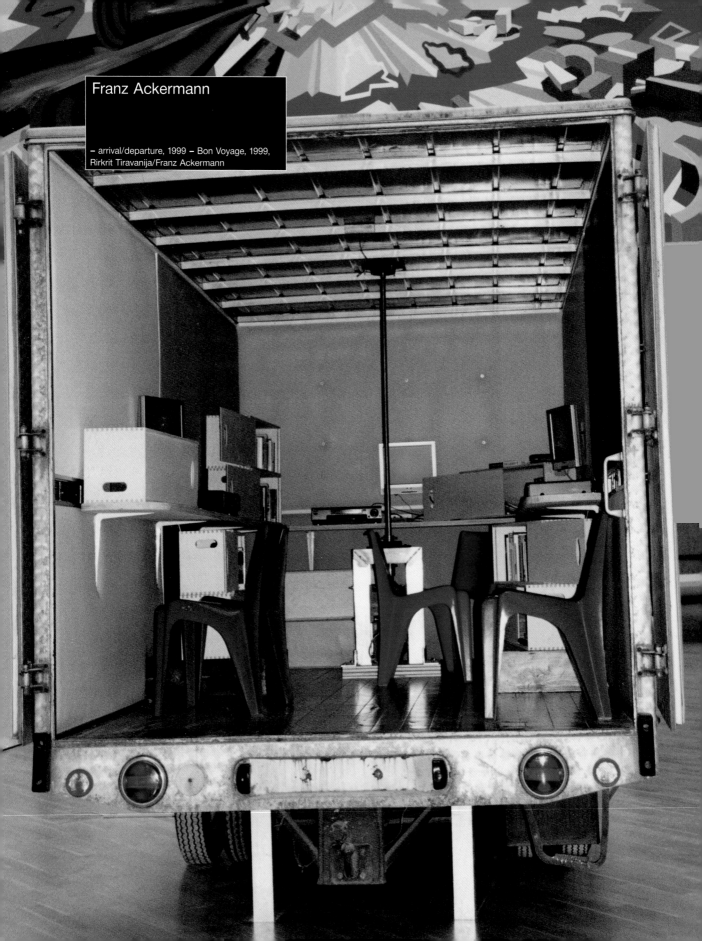

Franz Ackermann

– arrival/departure, 1999 – Bon Voyage, 1999,
Rirkrit Tiravanija/Franz Ackermann

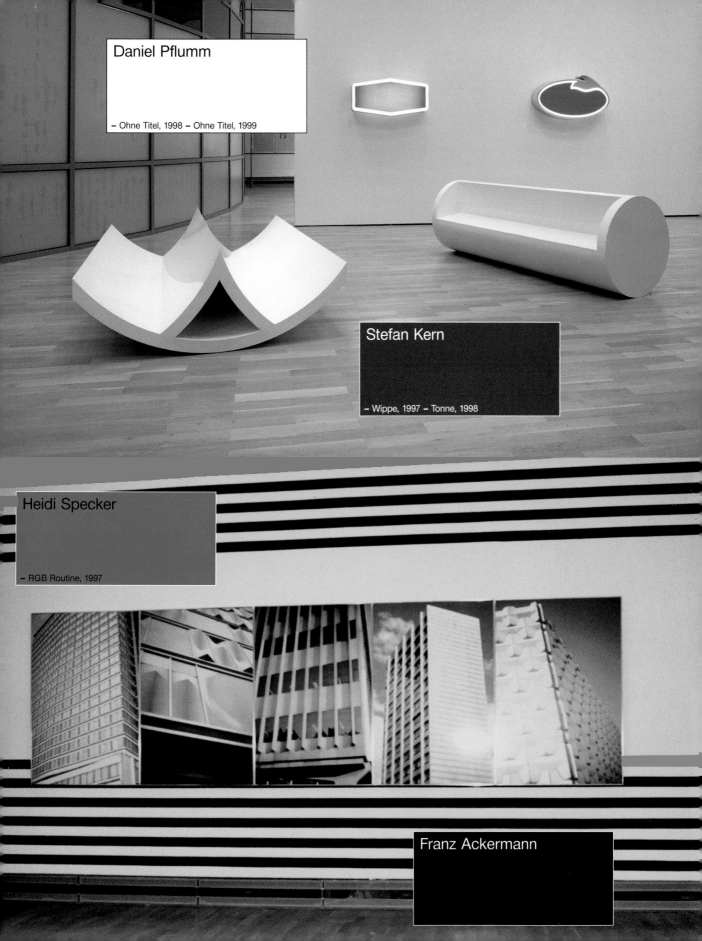

Daniel Pflumm

– Ohne Titel, 1998 – Ohne Titel, 1999

Stefan Kern

– Wippe, 1997 – Tonne, 1998

Heidi Specker

– RGB Routine, 1997

Franz Ackermann

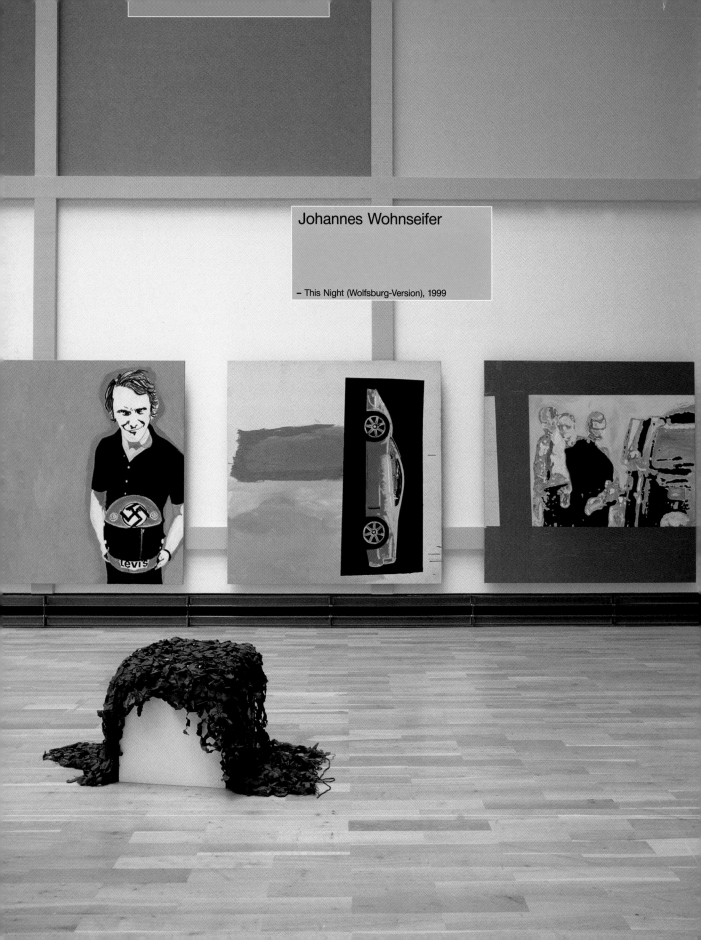

Johannes Wohnseifer

– This Night (Wolfsburg-Version), 1999

Rehberger

– S.F.B., 1999

Johannes Wohnseifer

– This Night (Wolfsburg-Version), 1999

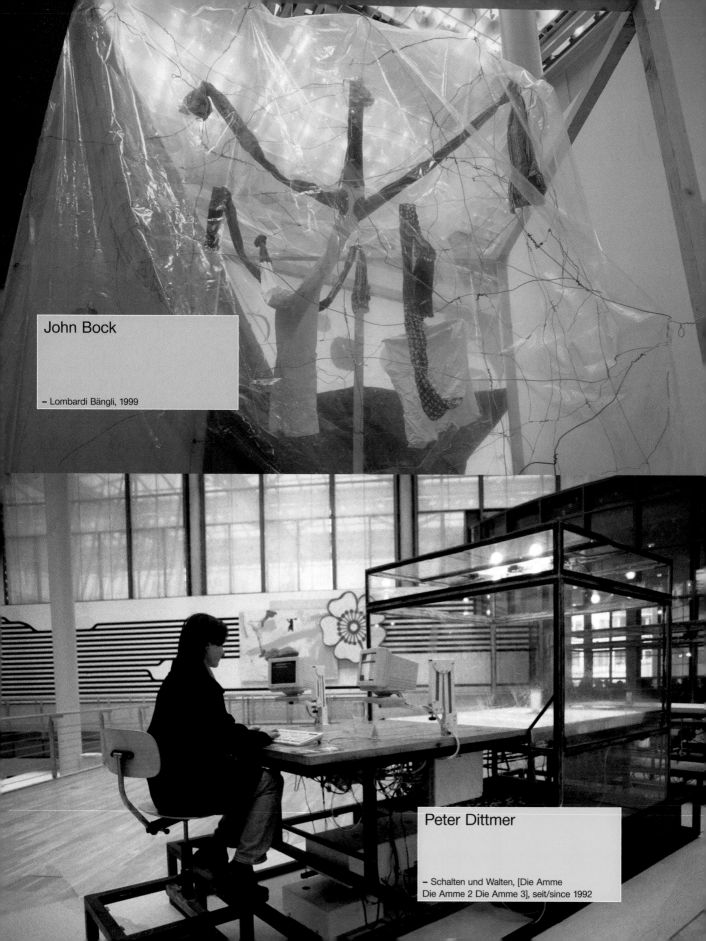

John Bock

– Lombardi Bängli, 1999

Peter Dittmer

– Schalten und Walten, [Die Amme
Die Amme 2 Die Amme 3], seit/since 1992

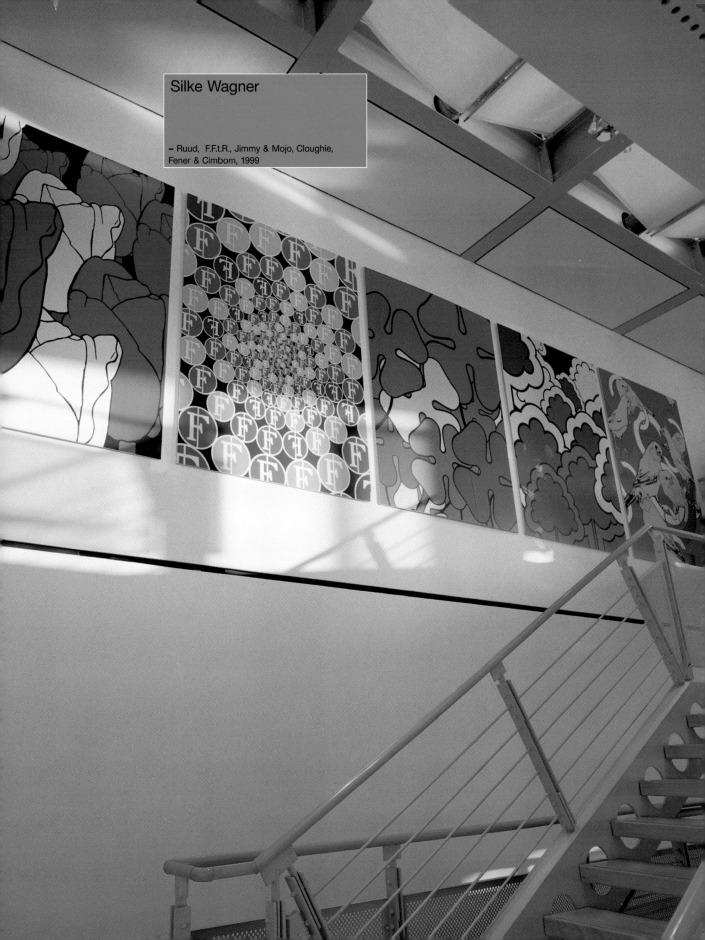

Silke Wagner

– Ruud, F.F.t.R., Jimmy & Mojo, Cloughie,
Fener & Cimbom, 1999

Daniel Pflumm

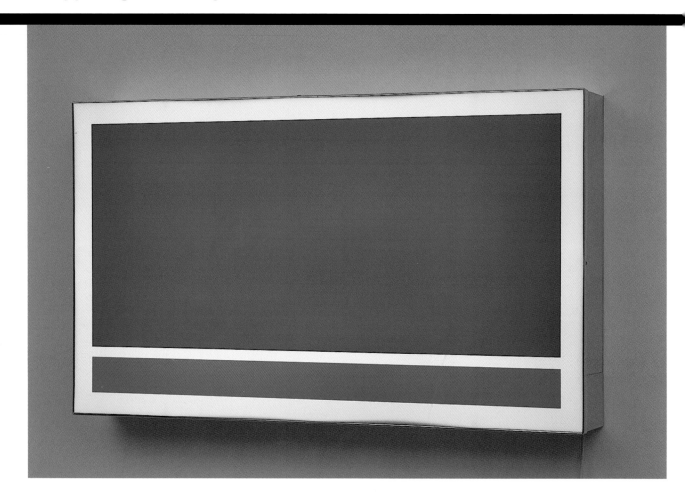

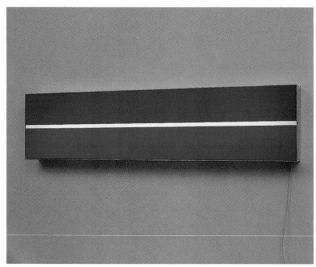

– **Ohne Titel**, 1999, Leuchtkasten/Light box, Ed. 1/3, 61,5 x 108 x 15 cm, Courtesy Galerie Neu, Berlin – **Ohne Titel**, 1999, Leuchtkasten/Light box, Ed. 1/3, 37,5 x 165 x 15 cm, Courtesy Galerie Neu, Berlin

Praktiken von Taktikern in der Lebenswelt –
Markus Müller

Als Daniel Pflumm 1992 ein Ladenlokal im Ostteil der neuen deutschen Hauptstadt fand und besetzte und dort den Club "ELEKTRO FULL CUSTOMER SATISFACTION" eröffnete, wurde dieser Ort (bis zu seinem Abriß 1994) zu einem (natürlich illegalen) Raum der Kunst des Handelns.[1]

Was wäre, wenn ELEKTRO eine Metapher für das Bewußtsein ist? Und wenn alles, was Daniel Pflumm seitdem in einem organischen Entstehungsprozeß in verschiedenen Subsystemen als Autor und Mitbegründer des "ELEKTRO MUSIC DEPARTMENT" (mit Klaus Kotai und Gabriele "Mo" Loschelder, seit 1994) entwickelt und produziert hat – nämlich T-Shirts, Schallplatten, Videos, einen zweiten Club namens "Panasonic Für Gerechtigkeit", eine CD und sogenannte Leuchtkästen – Bestandteile einer möglichen(?), genealogisch-historischen Erklärung wären, die den Taxonomien der Spezialisten (Kunsthistoriker, Kulturwissenschaftler, Musikhistoriker, Marxisten u.a.) raffinierte Fallen stellt?

Ein Labyrinth aus Zeichen, die unter anderem mit Authentizität spielen, als wäre Benjamin nie durch Berlin flaniert und so wie die meisten von uns nicht in diesem "Elektro" gewesen. Eine Sinnflut von Sichtbarem aus der Medienwelt. Logos, Speerspitzen der Imageproduktion, die, in konstruiert-dekonstruierte Video-Loops geschnitten, neben dem Herzschlag einer neuen, minimalen Musik tanzen. Auf ordinären Fernsehbildschirmen, die wie ein Bild aus modernen Zeiten aus der Wand leuchten. Heimatfilme aus Warhols Factory. So vertraut, als wären wir in ihnen zu Hause. "Esso" bezeichnet plötzlich einen bestimmten Tonträger. Denn sie wissen, was sie tun.

Was wäre, wenn Kurt Schwitters-, Hannah Höch-, John Heartfield, Richard Hamilton-, Andy Warhol-, Gordon Matta-Clark-, John Cage-, Elvis Presley-, Grateful Dead-, Madonna-, Public Enemy-, Westbam-, Dada-, Bauhaus-, Pop-, Concept-, Appropriation-, Kontext-, AT&T-, CNN-, Kraft-, Mikrosoft-, ESSO, PAN AM-, Berlin, Moderne-, Video-, Crossover-, Fernseh-, Kunst- und Musik-Kritik in

Pragmatic Practices – *Markus Müller* – Translated by Toby Alleyne-Gee

Daniel Pflumm found shop premises in the eastern part of Germany's new capital city in 1992, occupied them and opened the Elektro Full Customer Satisfaction club, which became a space for the art of action (illegal, of course). The building was demolished in 1994.[1]

What would happen if Elektro were a metaphor for consciousness? What would happen if everything that Daniel Pflumm has developed and produced in an organic, creative process as author and co-founder (with Klaus Kotai and Gabriele "Mo" Loschelder) of the Elektro Music Department since 1994 – T-shirts, records, videos, a second club called Panasonic Für Gerechtigkeit (Panasonic for Justice), a CD and so-called luminous boxes – were part of a genealogical and historical declaration that cleverly defies classification by the experts (art historians, cultural scientists, music historians, Marxists etc.)?

A labyrinth of signs that experiment with authenticity, as if Benjamin never strolled through Berlin and, like most of us, hadn't been to the "Elektro". A flood of visible indicators from the world of the media, logos, spear points of image production, which, cut in deliberately deconstructed video loops, dance alongside the heartbeat of a new, minimal music, on ordinary television screens that glow out of the wall like images of modern times. Sentimental regional films from Warhol's Factory that are so familiar, we feel at home in them. "Esso" is suddenly the name of a certain sound storage medium. Rebel with a cause.

What would happen if criticism of Kurt Schwitters, Hannah Höch, John Heartfield, Richard Hamilton, Andy Warhol, Gordon Matta-Clark, John Cage, Elvis Presley, Grateful Dead, Madonna, Public Enemy, Westbam, Dada, Bauhaus, Pop, Concept, Appropriation, Kontext, AT&T, CNN, Kraft, Microsoft, Esso, Pan Am, Berlin, the Modern movement, video, crossover, television, art and music could be converted into criticism of aesthetic economics?

Daniel Pflumm has said, "We take what we want."[2] "Panasonic Für Gerechtigkeit is a dream. The dream that the powerful should reflect on the fact that you can never be happy alone."[3] "We try to bring the reality back into television in order to combat the reality on television."[4] Gabriele Loschelder, Klaus Kotai and Daniel Pflumm have said, "What we try to do is transport our message into all our projects, to those place where communication takes place (dance floor, bar…). Because we want to participate in this cultural process. Because that's simply the way it's got to be."[5] Built to last. Daniel Pflumm, Klaus Kotai and Gabriele Loschelder take two clubs, two (or several) records, two videos, two T-shirts etc. and create a universe.

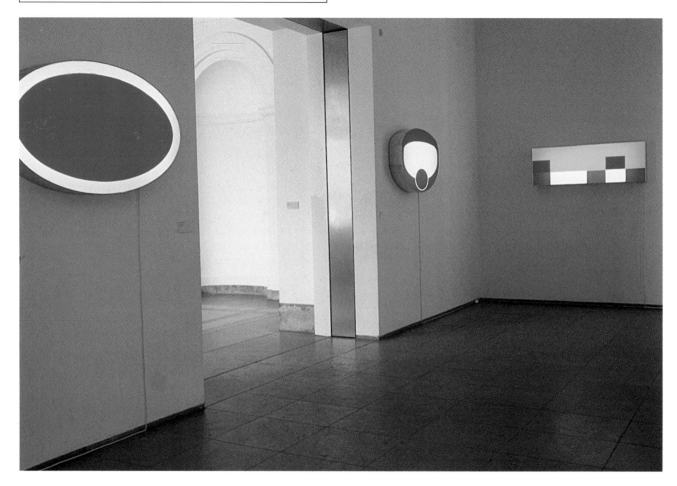

eine Kritik der ästhetischen Ökonomie überführt werden könnten? Daniel Pflumm hat gesagt: "Wir nehmen uns, was wir wollen",[2] und: "Panasonic für Gerechtigkeit ist ein Traum. Der Traum, daß die Mächtigen sich darauf besinnen, daß man allein nie glücklich sein kann",[3] und: "Wir versuchen die Realität ins Fernsehen zurückzubringen, um der Realität im Fernsehen entgegenzuwirken".[4] Gabriele Loschelder, Klaus Kotai und Daniel Pflumm haben gesagt: "Was wir versuchen, ist, in allen unseren Projekten unser Ding zu transportieren, an den Ort, wo die Kommunikation stattfindet (Tanzfläche, Bar…). Weil wir an diesem kulturellen Prozeß teilnehmen wollen. Weil es einfach so sein muß."[5]

Nichts ist unmöglich. Daniel Pflumm, Klaus Kotai und Gabriele Loschelder nehmen zwei Clubs, zwei (oder mehrere) Platten, zwei Videos, zwei T-Shirts usw. und schaffen ein Universum.
In Räumen, sprich Clubs, über die andere heute sagen, sie seien Kult, hat Daniel Pflumm seine Videos einem Publikum präsentiert, und dieses Publikum wurde zu einem Moment im Prozeß der

Panasonic
Für Gerechtigkeit

ELEKTRO
FULL CUSTOMER SATISFACTION

AT&T

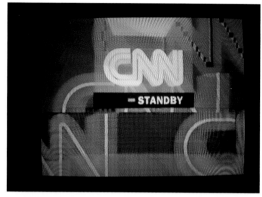

(Post-)Produktionsbedingungen. Als Zeitzeugen einer bestimmten Gegenwart werden diese Videos im Museum (und an anderen Orten) zu Agenten der Kombinationsmöglichkeiten von bestimmten Handlungsweisen.

An dieser Stelle wäre der Versuch einer werkimmanenten Untersuchung dessen, was in Wolfsburg zu sehen und zu hören ist, und der damit verbundenen Handlungsweisen sicher interessant. Der Diskurs müßte sich auf experimentellen Sprachstegen weit in ein musikbewegtes Bildermeer hinauswagen. Aus ortsspezifischen Gründen muß ich es jetzt Ihnen allein überlassen, ins (angenehm temperierte) Wasser zu springen. Sie werden lernen müssen (ein letztes pädagogisches Wort), sich in den Unterströmungen der Bilder und der Musik, die sie sehen und hören, treiben zu lassen, um dann (gegebenenfalls) gegen den Strom des allzu Offensichtlichen anschwimmen zu können. Oder sollte ich nicht besser viel vorsichtiger mit Gemeinplätzen umgehen? Hope for the best.

– **1** Michel der Certeau, Kunst des Handelns, Berlin 1988 (sic!) – **2** envelope magazine, Wien 11/12 1995, S. 23. – **3** House Attack, Köln Nr. 11, S. 14. – **4** envelope magazine, a.a.O., S. 22. **5** House Attack, a.a.O.

Daniel Pflumm presented his videos to an audience in spaces, i.e. clubs, which other people would refer to nowadays as "cult." And the audience became a factor in the post-production process. In museums and other places, as witnesses to a specific point in the present, these videos will become agents of the various ways in which certain modes of behaviour can be combined. At this point, an attempt at a work-related study of what we shall be seeing and hearing in Wolfsburg, and the related modes of behaviour, would certainly be an interesting undertaking. The discussion would have to take the risk of venturing on experimental linguistic jetties that stretch far out into a musical sea of images. For geographical reasons I now have to leave you to jump into the (pleasantly warm) water. You will have to learn (one last educational term) to let yourself drift in the undercurrents of the images and music you see and hear, so as to be able to swim against the tide of the all too obvious (if necessary). Or should I not be a great deal more careful with my use of platitudes? Hope for the best.

– **1** Michel de Certeau, Kunst des Handelns, Berlin 1988 (sic!) – **2** In: Envelope magazine, Vienna 11/12 1995, p. 23 – **3** In: House Attack, Cologne No. 11, p. 14 – **4** In: Envelope magazine, op. cit., p. 22 **5** In: House Attack, op. cit.

DANIEL PFLUMM – Genf, 1968 – Fine Arts Columbia University, New York City 1989 – Hochschule der Künste, Berlin – Wohnt/lives in Berlin

Photo Wolfgang Borrs

EINZELAUSTELLUNGEN/ONE PERSON SHOWS: 2000 Galerie Kerstin Engholm, Wien – Kunstverein Frankfurt am Main **1999** Galerie Greene Naftali, New York – Galerie NEU, Berlin **1998** A+J, London **1997** Künstlerhaus Stuttgart **1996** Galerie NEU, Berlin **GRUPPENAUSSTELLUNGEN/GROUP SHOWS: 1999** Haus der Kunst, München – Aarhus Kunstmuseum – PS1, New York – Centre Régional d'Art Contemporain, Sète – Museum for Samtidskunst, Roskilde – Von der Heydt Museum, Wuppertal (Katalog/catalogue) – Statement, Messe Basel – Spiral TV, Tokyo – attitude, Basel **1998** Berlin Biennale (Katalog/catalogue) – Fast Forward -Trade Marks, Kunstverein Hamburg – Galerie Greene Naftali, New York – Neuer Berliner Kunstverein (Katalog/catalogue) **1997** Kunsthalle Nürnbergars viva 97/98, Staatsgalerie Stuttgart, Städtisches Museum Abteiberg, Mönchengladbach (1998), Hamburger Bahnhof, Berlin (1998), Kunsthalle Kiel (1998) (Katalog/catalogue) – Galerie Fons Welters, Amsterdam **1996** Next Five Minutes Festival, Amsterdam **1995** Club Berlin, Biennale Venedig **1993** November TV, Art Cologne, Köln – Gründung Panasonic, ELEKTRO-Club – Botschaft e.V., Schedhalle

Daniel Pflumm

– **ITSABOUT** Beispiel Ich/Serie Aufblasung Ich aus Sachen

Peter Dittmer – Schalten und Walten – [Die Amme Die Amme 2] – Gespräche mit einem milchverschüttenden Computer

Die Amme ist das Produkt einer verwickelten Beziehung zum Computer, zur Dramaturgie von Text, interagierter Kunst und hauptsächlich doch zu einer Dramaturgie der Präsenz. Es handelt sich im Kern um ein Computerprogramm, und es gibt einen relativ guten Grund für den Namen: die Amme verschüttet Milch. Dieses tut sie, unter wechselnden Bedingungen, seit 1992. Einem installativen Gehäuse vor- und eingeordnet, gestattet und provoziert die Amme unmoderierte (heißt: freie, ungeleitete) Dialoge beliebiger Länge zwischen Mensch und Maschine, Maschine und Maschine, Mensch und Mensch – maschinell kommentiert.

(…)
Publikum: Was ist der Sinn des Lebens?
Amme: Immer schön auf einen Stuhl hocken bis tot umfällt da
(…)

Initial-Konzept war die Idee vom Schalter als Nahtstelle zwischen Publikum und einer Installation, die verschiedene diskrete Ereignisse (u.a. die Milchverschüttung) in versprechender Bereitschaft hält, aber nicht ohne weiteres herausgeben sollte. Letztlich also Interaktion, jedoch eher mit der Tendenz zum Schwierigen, zur Verweigerung, zur Nicht-Herausgabe der Kunst und zur Gefangennahme im Zirkel einer selbsterfüllten Verhandlung. Gerede zwischen AN und AUS. Die Amme verfolgt keine Turing-Konzepte der Verwischung menschlichen und maschinellen Ausdrucks. Sie bleibt eine Arbeit über den Skandal der Sache, die sich der Sprache bemächtigt. Zudem siedelt sie sperrig im Kunstrahmen und ist also gleichermaßen der Reflexion wie der Praxis verpflichtet, beziehungsweise der Konstituierung eigener, originärer Praxis. Auch vergnüglicher Praxis.

(…)
Publikum: Ü
Amme: Klpzk.
Publikum: oahjdajhd
Amme: Pffft.
Publikum: pfffffffft
Amme: Peng.
Publikum: bumm
Amme: Ki ki ki ki ki.
(…)

Peter Dittmer – Carte Blanche – [Wet-nurse Wet-nurse 2] – Conversations with a milk-spilling computer – Translated by Toby Alleyne-Gee

The wet-nurse is the product of a complex relationship with the computer, with the dramatisation of text, with interactive art, and with the dramatisation of presence. This work is basically about a computer programme, and there is a relatively good reason for the name: the wet-nurse spills milk. She has been doing this, under varying conditions, since 1992. Installed in a case, the wet-nurse allows and provokes undirected (i.e. spontaneous) dialogues of arbitrary length between man and machine, machine and machine, man and man, and comments on them mechanically.

[…]
Audience: What is the meaning of life?
Wet-nurse: Sit on a chair until you drop dead.
[…]

The initial concept of this installation was the idea of a counter as a link between the public and an installation that has various discreet events (such as spilling milk) enticingly at the ready, but does not necessarily reveal them. This is ultimately interaction, but with a tendency to being uncooperative, to refusal, to withholding art and imprisoning the audience in a circle of self-fulfilling negotiation. Talk between ON and OFF. The wet-nurse does not pursue any concept of blurring the distinction between human and mechanical expression. She remains a statement on the scandal circumstance of an object seizing the capacity of speech. Unwieldy, the wet-nurse is also situated in an artistic framework and is hence equally indebted to reflection and action, in other words to creating her own, original action. Enjoyable action, too.

[…]
Audience: Ü
Wet-nurse: Klpzk.
Audience: oahjdajhd
Wet-nurse: Pffft.
Audience: Pfffffffft
Wet-nurse: Peng.
Audience: bumm
Wet-nurse: Ki ki ki ki ki.
[…]

Damit die Sprache nicht in der sprechenden Sache verschwindet, entstand die Auffassung vom Sprechakt als Karambolage. Auf omnipotente Beredtheit und logische Redlichkeit wurde erleichtert und von Anfang an verzichtet. Die Amme ist kein Griff nach der apparatenen Intelligenz, eher eine Arbeit zum Phänomen künstlich generierten Ausdrucks und über die Positionierung des bisher zurückhaltend schweigenden Dings im Raum von Wissen und Meinen. Geschwätz, Rahmenbruch, Anmaßung, Diskursverübelung … sind die Ecken, zwischen denen die Amme verspannt ist. Im Laufe der Zeit und einiger Ausstellungen wurde die Amme in ihrem jeweils aktuell-unfertigen Stadium immer wieder dem Publikumszugriff ausgesetzt. Schon mit den ersten Dialogen wurde offensichtlich, daß das provozierte Gespräch keinesfalls auf gesittete Kommunikation zielen würde: das Publikum nahm sich die Amme zur Brust und gönnte dem Apparat die Rede nicht. Die aufgezeichneten Gesprächsverläufe wurden zur Grundlage für den jeweils nächsten Entwicklungsschritt. Und so haben die rhetorischen Attacken die Amme geprägt und die Konzeptbindung früh gelockert. Die wörtliche Sitte scheint weitgehend suspendiert, und entstanden ist ein widersprüchlicher Redepartner und linkshändiger Rhetoriker, der in seiner Fremdheit der Sprache gegenüber belassen blieb.

Die Amme markiert einen äußersten und widersprüchlichen Punkt in den Ursachen für sprachlichen Ausdruck. Die Amme ist ein Okkupant der Sprache. Die Amme verhandelt Theorie und Behauptung, repräsentiert aber gleichzeitig unvermittelt und direkt sprachliche Praxis in ihrer notdürftigsten Form. Mittlerweile verfügt das Programm über ca. 200.000 Antwortmodule zu mehr als 25.000 Variablen der Identifizierung. Ein weiterer Ausbau der Gesprächskompetenz findet fortlaufend statt. Als Gegengewicht zur dominanten Textbindung gibt es einen umfangreichen Vorrat an Grafiken, Filmen/Animationen und Sounds, die gesprächsbezogen vorgezeigt werden, bzw. auch zum dinglichen Umfeld der Ammen-Installationen gehören (die Itsabouts).

The idea of the act of speech as a collision emerged to prevent language from being lost in the speaking object. From the very beginning, the artist was relieved to be able to abstain from omnipotent eloquence and logical honesty. The wet-nurse is not an attempt at mechanical intelligence, but an exploration of the phenomenon of artificially generated language and the positioning of the object, until now silent and reserved, in the realm of knowledge and opinions.
Chattering, the rupture of convention, presumption, conversational contamination … the wet-nurse is confronted with all this. The wet-nurse, in various stages of completion, was made accessible to the public during several exhibitions. Even during the first dialogues, it became clear that the conversation she provoked would not aim at civilised communication. Viewers took the wet-nurse to their breast and were envious of the machine's capacity to speak. The recorded conversations became the basis of the computer's next stage of development. Thus the rhetorical attacks marked the wet-nurse and soon loosened any strong ties to a specific concept. Verbal manners seem to have been largely suspended, and a contradictory conversation partner has been created, a left-handed rhetorician whose reserve towards language has remained unchanged.
The wet-nurse marks an extremely contradictory issue in the causes of linguistic expression. She is an occupier of language. The wet-nurse negotiates theory and assertion, but also represents immediate, direct linguistic action in its most primitive form. The programme now has approximately 200,000 response modules to over 25,000 types of identification. Its linguistic capacity is continuously being developed. To counterbalance the domination of the written word, the computer has a large selection of prints, animated images and sounds which are shown or played according to the conversation, and belong to the material environment of the wet-nurse installation (the Itsabouts).

All those involved were surprised at the varied reactions – which were never indifferent – of viewers to mechanical speech. At first it was fuzzy talk, but exaggeratedly expressed. It was also surprising because the computer is not an obliging friend who pretends to offer confirmation or empathy: the wet-nurse is violent with language and sullenly refuses to be passive. With a basic tenor of clichés and a regressive change of direction towards offensive banality, the computer escapes into garbled, meaningless words, disturbs the conventional economy of the act of speech, enlightens us by behaving in an unenlightened manner, contradicts. These are the usual tactics of stupidity. Used in this way in a publicly exhibited object, they cause melancholy confusion.

Für alle Beteiligten überraschend war, wie differenziert und variantenreich, jedenfalls nie unberührt, das Ausstellungspublikum auf die maschinelle Rede reagierte. Vorerst Fuzzy-Talk, aber zugespitzt vorgetragen. Überraschend auch deshalb, weil der Apparat kein verbindlicher Freund ist, der Bestätigung und Einfühlung vortäuscht: die Amme tut der Sprache Gewalt an und verweigert unlustig die widerspruchslose Funktion. Im Grundtenor banaler Sprachfiguren und regressiver Hinwendung zu offensiver Banalität rettet sich der Apparat in ein bodenloses Sprechen, derangiert die gebräuchliche Ökonomie des Sprechakts, produziert Aufklärung durch antiaufklärerisches Getue, widerspricht. Es sind die geläufigen Taktiken der Dämlichkeit, deren frontales Auftauchen in der öffentlich aufgepflanzten Sache melancholische Verwirrung stiftet.

PETER DITTMER – Potsdam, 1958 – Hochschule für Bildende Künste, Dresden – Wohnt/lives in Berlin

DIE AMME: 1994 Stubnitz.Kunst.Raum.Schiff, Rostock (Katalog/catalogue) – Westwerk, Hamburg – Medienbiennale, Leipzig (Katalog/catalogue) **1993** Galerie EIGEN+ART, Berlin – Institut für neue Medien, Frankfurt am Main **1992** Galerie Art Acker, Berlin (Katalog/catalogue) – Electronic Arts Syndrom, Berlin (Katalog/catalogue) **DIE AMME DIE AMME 2: 1999** Kunstkabinett, Weimar **1998** Galerie n. n. kunst tmp, Berlin **1995** Galerie EKTachrom, Europäisches Kulturzentrum Thüringen, Erfurt (Katalog/catalogue) **1994** Stubnitz.Kunst.Raum.Schiff, St. Petersburg, Malmö, Hamburg (Katalog/catalogue) – Eisfabrik, Hannover – Art Cologne, Galerie EIGEN+ART, Köln **DIE AMME DIE AMME 3: 1999** Kunstkabinett, Weimar **1998** Galerie n. n. kunst. tmp Berlin **1996** Museet for Samtidskunst, Kopenhagen/Roskilde (Katalog/catalogue) – Hochschule für Bildende Künste, Hamburg **DIE AMME DIE AMME 4: 1998** Museum für Gestaltung, Zürich **AUSSTELLUNGEN VOR DER AMME/EXHIBITIONS BEFORE THE AMME (Auswahl/selection):** Galerie Nicolaus Sonne, Berlin; La Villete, Paris; Galerie Anton Meier, Genf – Kunsthalle Nürnberg; Palazzo delle Esposizioni, Rom; Art Basel; Art Frankfurt

Peter Dittmer

Tobias Rehberger

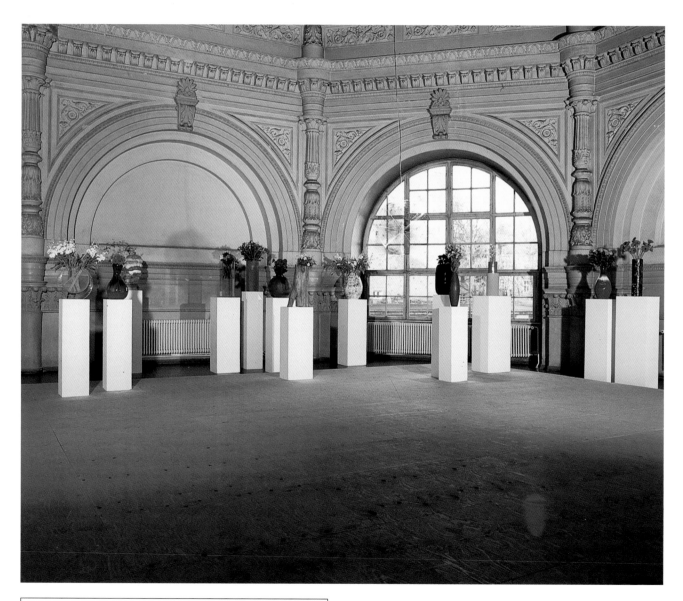

– Tobias Rehberger, Olafur Eliasson, Installation view, 1998, berlin biennale, Courtesy
neugerriemschneider, Berlin

Ein neues Verständnis liegt, ganz überraschend, in der Luft.
– *Pier Luigi Tazzi* – Übersetzung aus dem Italienischen von
Reinhard Renger

Von Roberto Longhi, dem großen Kunsthistoriker, bei dem ich stu-
diert habe, sagte man, daß er in seiner Freizeit gerne durch Flo-
renz spazierte und dabei nach Werken von Giotto suchte und daß
er manchmal auch welche fand. So habe ich es später gelernt,
durch ein geographisch viel größeres, letztlich aber mitunter nicht
viel fruchtbareres Gebiet zu wandeln, und zwar dem der west-
lichen, insbesondere der europäischen Kunst – bekanntlich än-
dern sich die Zeiten, und man bemüht sich, seinen eigenen Impul-
sen und Wünschen treu zu bleiben. Ich suchte allerdings weniger
nach Kunstwerken, sondern vielmehr nach Augenblicken der
Erfüllung, und manchmal habe ich welche erlebt. Später hat mich
jemand davon überzeugt, daß man sich das "glückliche Arabien"
in den antiken Erzählungen selbst erschaffen mußte, weil die Welt,
so wie sie wirklich war, dieses gar nicht enthielt. Und trotzdem
habe ich meine Reise *"thru many a perilous situation"*, von einer
Oase zur nächsten, nicht abgebrochen.
Heute erkenne ich einen ganz neuen Weg. Zuerst habe ich mich
tatsächlich in alle Winkel der großen weiten Welt begeben und bin
einer anderen Route gefolgt als derjenigen, die diese Welt vor-
schrieb. Dabei ist es mir gar nicht schlecht ergangen, sondern
nach meinen Maßstäben sogar eher gut – auch wenn es vielleicht
noch etwas besseres gegeben hätte, aber nur das habe ich er-
reicht. Mit Leichtigkeit war ich den Anstrengungen der Reise ge-
wachsen und habe mich zwischen den verschiedenen Oasen hin-
und herbewegt, die dort entstanden waren, wo man sich in aller
Ruhe mit den Stürmen der Welt auseinandersetzen konnte, weni-
ger um sie zu besiegen, als um ihnen zu widerstehen.
Jetzt kann ich feststellen, daß ich mich in einer vielleicht auch nur
potentiell – Optimismus ist eben schlecht heilbar – deutlich gün-
stigeren Situation befinde. Die Große Welt, *gone abstract*, be-
droht mich nicht mehr in ihrer Gesamtheit, und ich kann mich
mühelos in ihr bewegen, ohne mich vor den Ungeheuern zu fürch-
ten, die hinter den Ecken lauern. Ich weiß trotzdem, daß sie exi-
stieren und vergesse sie auch nicht. Aber, so wie es ein bekannter
Führer zu seinem ängstlichen Schüler auf einer anderen, schreck-
lichen Reise sagte: "non ti curar di lor, ma guarda e passa"
("Sprich nicht mit Ihnen, schau und geh' vorüber"), und so muß
ich überhaupt nicht – im Sinne Kafkas – an die Türen klopfen, um
an ein Ziel zu gelangen.
Die Dinge sind, wie sie sind: Kein monströser Schatten kann sie
verdecken, keine Sperre sie zurückhalten. Es genügt, wie Tobias
Rehberger mit den Augen von Karl Rossmann nur eine minimale
Überarbeitung auszuführen, minimal, weil nichts Neues zu erfin-
den, sondern alles nur besser anzuordnen ist, *"cutting"* und *"pre-
paring"*. Im Raum genauso wie im Leben. Was trotz allem nicht

To my amazement, a new vision is in the air –
Pier Luigi Tazzi – Translated by Toby Alleyne-Gee

People used to say that the great art historian Roberto Longhi,
under whose tutelage I studied, would spend his free time strol-
ling through Florence in search of works by Giotto – and that he
occasionally even found some. This is how I later learned to wan-
der through a geographically much larger, but not necessarily
more fertile area: the world of western, particularly European art.
It is a known fact that times change, and one tries to remain faith-
ful to one's own impulses and desires, but I was not looking so
much for works of art as for moments of fulfilment, and some-
times I actually experienced them. Later, someone convinced me
that one has to recreate one's own Arcadia from ancient mythol-
ogy, because no such place existed in the world as it really was.
And despite this, I did not interrupt my journey through many a
perilous situation from one oasis to the next.
Today, I see a completely new path. At first I really did travel to
every corner of the globe, on a route that was different to the one
the world felt I should follow. I did not feel bad at all. By my stan-
dards, I would even say I did well – even if there may have been
something better, but that's as far as I got. I effortlessly coped with
the strain of the journey, moving between the various oases that
had been created en route; at these oases I dealt calmly with the
storms of the world – not so much to master them as to resist
them. Now I realise that I am perhaps in a considerably more fa-
vourable situation – I am an incurable optimist. The great wide
world, which has gone abstract, no longer poses a threat as a
whole, and I can move within it effortlessly, without fear of mon-
sters lurking round corners. Yet I know they still exist and do not
forget them. But as Virgil said to a fearful Dante on another, terri-
ble journey: "Non ti curar di lor, ma guarda e passa" ("Do not
bother with them, but look at them, and pass them by"). This way,
I don't have to knock on doors at all – in the Kafka-esque sense
– to achieve my objectives.

– **Decke, Büroräume, 1. Stock**, (Léwy, Schuppli, Hirsch, Ritschard, Pakesch), 1998, Holzkassettendecke, 7 Hängelampen/Wooden panelled ceiling, 7 hanging lamps, Installation view, Kunsthalle Basel, Courtesy Galerie Bärbel Grässlin, Frankfurt am Main
– **I'd really love to (serafina)**, 1998, Preßspan, Lack, Glas, Kabel, Schafsfell/Chipboard, varnish, glass, wire, sheepskin, Courtesy neugerriemschneider, Berlin

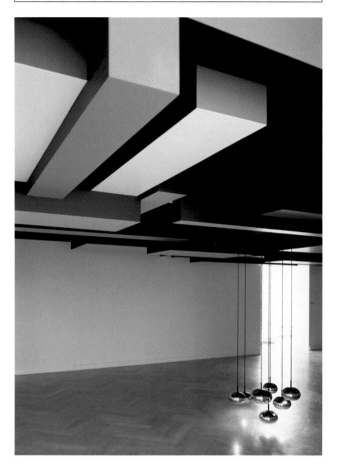

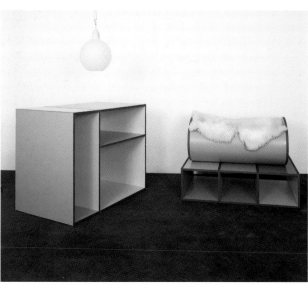

Things are as they are: no monstrous shadow can cover them, no barrier can hold them back. It is enough, as Tobias Rehberger does, to conduct a minimal revision, with the eyes of Karl Rossmann. The revision need only be minimal, because there is nothing new to invent, things can merely be arranged better – "cut" and "prepared." In space as in life. Which nonetheless is not insignificant. (*He continued to live in absolute chaos. His tools, which he had only learned to use correctly late, gradually disappeared, and he missed them. However, above all he failed to create a link between the past and its traces, and the present with its hardness. To him, the future was apparently a mere fantasy. What had become of the order that had meant so much to him? Did this lack of order symbolise something? Which path should he follow to escape his present predicament? There was an answer to all these riddles, but no solution.*) You could think all this only applies to me – and in fact it does. If that were all it was about, you would observe these three stages on the span of an existence, but I see something else that develops this idea: the idea that these three phases – the phase of the path, the phase of the sheltered, happy oasis, and that of correct presentation – run together and contribute to a new quality of life.

This is how Rehberger combines art, architecture and design (true to the principles of the classic modern movement exemplified by the Bauhaus and the De Stijl group). He turns away from minimalism and its more obviously heretical and erotic derivatives, which, to put it bluntly, have produced the best art of the last decade. But Rehberger's work has also led to harmonious creations for immediate consumption – "instant works" – which are so intimately linked with the here and now that they firmly reject any invitation to nostalgia or melancholy.
Rehberger's work is ultimately the first attempt since Leibniz to refer to the best of all worlds, after everything we have recognised, and still have to recognise, since we have removed the

– **The missing colors**, Videostills, 1997, 5 Projektoren, 3 Lampen, 2 LCD-Player, Holz/5 projektors, 3 lamps, 2 laser disk players, wood, Friedrich Petzel Gallery, New York, Courtesy neugerriemschneider, Berlin

wenig ist. (*Er lebte weiter im absoluten Chaos. Mit der Zeit verschwanden die Werkzeuge, deren korrekten Gebrauch er erst spät erlernt hatte, und die ihm nun fehlten. Vor allem aber gelang es ihm nicht, eine Verbindung zu schaffen zwischen der Vergangenheit und ihren Spuren und der Gegenwart und ihrer Härte. Die Zukunft war für ihn offenbar nur noch eine Phantasie. Wo war diese Ordnung geblieben, die ihm soviel bedeutet hatte? War diese Unordnung ein Zeichen für etwas? Welchem Weg sollte er folgen, um aus seiner gegenwärtigen Bedrängnis zu entkommen? Jedes dieser Rätsel hatte eine Antwort, aber keine Lösung*).

Man könnte meinen, daß alles dieses nur mich betrifft – und es betrifft mich tatsächlich. Wenn es darum nur ginge, dann würde man diese drei Stadien auf dem Spannungsbogen einer Existenz hintereinander betrachten. Ich glaube, statt dessen etwas anderes zu erkennen, das darüber hinausgeht: nämlich daß diese drei Stadien, das des anderen Weges, das der geschützten und glücklichen Oase und das der richtigen Inszenierung heute zusammenfallen; sie gehören zusammen und tragen bei zu einer neuen Lebensqualität. In diesem Sinne verbindet Rehberger Kunst, Architektur und Design (getreu der klassischen Moderne des Bauhaus und der Gruppe De Stijl). Er wendet sich ab vom Minimalismus und auch seinen deutlicher sichtbaren ketzerischen und erotischen Derivaten, aus denen, um es klar zu sagen, die beste Kunst im vergangenen Jahrzehnt entstanden ist. Aber auch die Arbeit von Rehberger führte zu in sich stimmigen Werken für den sofortigen Gebrauch, "*instant works*", die so stark verbunden sind mit dem "*Hier und Jetzt*" ihres Gebrauchswertes, daß sie jeden nostalgischen oder melancholischen *arrière-pensée* von sich weisen. Schließlich ist es nach Leibniz der Versuch – auf dem Grunde der Tatsachen –, der auf die beste aller möglichen Welten verweist, nach allem, was wir erkannt haben und erkennen müssen, seitdem wir die Brille der Ideologie (*ach Alte Meister*) und die Kopfhörer mit dem produktionssteigernden Programm (*helas young curators!*) abgesetzt haben.

Es geht dabei nicht um einen neuen Hedonismus – auch wenn
Wörter fallen wie *"pleasant"*, *"fashionable"*, *"happy"*, *"no need to
fight"*, *"without missing anything"* –, sondern um die Schaffung
von Genußräumen und Erfahrungsstätten, an denen der Künstler,
seine Inspirationsquellen und die Besucher in einem so paritäti-
schen Maße zusammenwirken, daß der Freiheitszustand entsteht,
nach dem wir alle streben, und das, ohne zusätzlich noch die
Schimären letzter Heilserwartungen oder Erlösungsutopien anzu-
bieten. Es liegt also, ganz überraschend, ein neues, positives Welt-
verständnis in der Luft.

(Would you like to have another drink, now?)

spectacles of ideology (*Ach Alte Meister/Oh, Old Masters*) and
the headphones with the productivity programme (*Helas young
curators!*). This is not about a new form of hedonism – even if
words such as "pleasant," "fashionable," "happy," "no need to
fight" are uttered. It is about creating spaces for enjoyment and
experience in which the artist, his sources of inspiration and the
viewer work together on such equal terms that the state of free-
dom for which we all strive comes about. Yet it is devoid of
mirages of salvation or expectations of utopian redemption. So, to
my amazement, there really is a new, positive vision of the world
in the air.
(Would you like another drink now?)

TOBIAS REHBERGER – Esslingen am Neckar, 1966 – Städelschule, Staatliche Hochschule für Bildende Kunst, Frankfurt am Main – Wohnt/lives in Frankfurt am Main

Photo Oliver Mark

EINZELAUSSTELLUNGEN/ONE PERSON SHOWS: 2000 neugerriemschneider, Berlin – Friedrich Petzel Gallery, New York **1999** Holiday-Weekend-Leisure Time-Wombs, Galerie Micheline Szwajcer, Antwerpen – fragments of their pleasant spaces (in my fashionable version), Galerie Bärbel Grässlin, Frankfurt am Main – Galerie für zeitgenössische Kunst, Leipzig – Standard Rad. LTD, Transmission Gallery, Glasgow – Nightprowler, De Vleeshal, Middelburg **1998** Moderna Museet, Stockholm (Katalog/catalogue) – Kunsthalle Basel (Katalog/catalogue) – Waiting room - Also? Wir gehen? Gehen wir!, Intervention 13, Sprengel Museum, Hannover – Roomade, Office Tower Manhattan Center, Brüssel **1997** brançusi, neugerriemschneider, Berlin – anastasia, Friedrich Petzel Gallery, New York **1996** Suggestions from the Visitors of the Shows # 74 and #75, Portikus, Frankfurt am Main (Katalog/catalogue) – Peuè Seè e Faàgck Sunday Paàe, Kölnischer Kunstverein, Köln – fragments of their pleasant spaces (in my fashionable version), Galerie Bärbel Grässlin, Frankfurt am Main **1995** neun skulpturen, Produzentengalerie, Raum für Kunst, Hamburg – Wo man is gout loogy luckie, Hammelehle+Ahrens, Stuttgart – canceled projects, Museum Fridericianum, Kassel (Katalog/catalogue) – one, neugerriemschneider, Berlin **1994** Rehbergerst, Galerie Bärbel Grässlin, Frankfurt am Main (Katalog/catalogue) – Galerie Luis Campaña, Köln – Galerie & Edition Artelier, Graz – Goethe-Institut Yaoundé, Kamerun **1993** Sammlung Goldberg/The Iceberg Collection, Ludwig Forum für internationale Kunst, Aachen **1992** 9 Skulpturen, Wohnung K. König, Frankfurt am Main **GRUPPENAUSSTELLUNGEN/ GROUP SHOWS: 1999** kraftwerk BERLIN, Aarhus Kunstmuseum, Aarhus (Katalog/catalogue) – Arte All' Arte, Arte Continua, Colle di Val d'Elsa, Italien (Katalog/catalogue) – zoom, Museum Abteiberg, Mönchengladbach (Katalog/catalogue) – Skulptur-Biennale 1999, Münsterland (Katalog/catalogue) – wonder world - notes for a solid collection, newsantandrea, Savona – les deux saules pleurers/cube without a corner-gerät, Kunst-Werke, Berlin – amAzonas Künstlerbücher, Villa Minimo, Hannover – Ain't Ordinarily So, Casey Kaplan (kuratiert von/curated by Daniel Birnbaum), New York – Who, if not we?, Elizabeth Cherry Contemporary Art (kuratiert von/curated by Yilmaz Dziewior), Tuscon, Arizona – Further Fantasy, Galleria Giò Marconi (kuratiert von/curated by Francesco Bonami), Mailand, Italien – Galerie Andreas Binder, München **1998** de coraz(i)on, Tecla Scala, Barcelona (Katalog/catalogue) – Konstruktionszeichnungen, Kunst-Werke, Berlin – Dad's Art, neugerriemschneider, Berlin – ___, 1994untitled, 1994 (meettim&burkhard) brançusi, 1997, Grazer Kunstverein – Round About Waves, Ujadowski Castle (kuratiert von/curated by Adam Szymczyk), Warschau – weather everything, Galerie für zeitgenössische Kunst, Leipzig – minimalisms 1, Akademie der Künste, Berlin – [Collection 98], Galerie für zeitgenössische Kunst, Leipzig – Friedrich Petzel Gallery (Stephen Prina & Tobias Rehberger), New York – manifesta 2, Luxembourg (Katalog/catalogue) – Fuori Uso '98, Assoziazione Culturale Arte Nova, Pescara – Kunst für Bundestagsneubauten, Deutscher Bundestag, Berlin – Kunst und Papier auf dem Laufsteg, Deutsche Guggenheim Berlin – Lebensraum (ARKIPELAG), Stockholm – Dramatically different, Magasin, Grenoble (Katalog/catalogue) – The Happy End of Franz Kafka's 'Amerika', works on paper, inc., Los Angeles **1997** Kunst…Arbeit, Südwest LB, Stuttgart (Katalog/catalogue) – M&M, Fondazione Re Rebaudengo, Turin – Heaven, P.S.1, New York – Beyond the auratic object, Philomene Magers, Köln – Time Out, Kunsthalle Nürnberg (Katalog/catalogue) – Frankfurt(M)-Kassel-Münster, Galerie Bärbel Grässlin, Frankfurt am Main – Truce: Echoes of Art in an Age of Endless Conclusions, Site Santa Fe, Santa Fe (Katalog/catalogue) – assuming positions, ICA, London (Katalog/catalogue) – future-present-past, Biennale Venedig, - Dieci Artisti Tedeschi per Verona, Verona – skulptur. projekte in Münster '97, Münster (Katalog/catalogue) – Giò Marconi, Mailand – garnish and landscape, Gesellschaft für Gegenwartskunst (Tobias Rehberger & Jorge Pardo), Augsburg (Katalog/catalogue) – Rooms with a View: Environments for Video, Guggenheim Museum SoHo, New York – Fort! Da!, Villa Merkel, Esslingen (Katalog/catalogue) – Campo 6, The Spiral Village, Bonnefantenmuseum (kuratiert von/curated by Francesco Bonami), Maastricht **1996** Heetz, Nowak, Rehberger, Städtisches Museum Abteiberg, Mönchengladbach – Campo 6, Fondazione Sandretto Re Rebaudengo per l'Arte, Galleria Civica d'Arte – Moderna di Torino, Turin (Katalog/catalogue) – nach weimar, Kunstsammlungen zu Weimar (Katalog/catalogue) – Alle Neune, ACC Galerie, Weimar – almost invisible – fast nichts, Umspannwerk Singen (kuratiert von/curated by Jan Winkelmann), Singen/Hohentwiel – Manifesta 1, Rotterdam (Katalog/catalogue) – Dites-le avec des fleurs, Galerie Chantal Crousel, Paris – something changed, Helga Maria Klosterfelde, Hamburg – Der Umbau Raum, Künstlerhaus Stuttgart – Cruise, Friedensallee 12 (kuratiert von/curated by Florian Waldvogel), Hamburg – Kunst in der neuen Messe Leipzig, Leipzig (Katalog/catalogue) – Zum Gebrauch bestimmt, Galerie Sophia Ungers, Köln **1995** Regal, Regal, Forum der Frankfurter Sparkasse (kuratiert von/curated by Florian Waldvogel), Frankfurt am Main – Städelschule im BASF-Feierabendhaus, Ludwigshafen, Lindenau-Museum, Altenburg (Katalog/catalogue) – Bed & Breakfast, Ifor Evans Hall, London – filmcuts, neugerriemschneider, Berlin (Katalog/catalogue) – Villa Werner, Offenbach – … kommt mit seinen Gaben, Museum Abteiberg, Mönchengladbach – Alles was modern ist, Galerie Bärbel Grässlin, Frankfurt am Main **1994** Stipendiaten der Frankfurter Künstlerhilfe e.V. – Galerie ak, Frankfurte am Main (Katalog/catalogue) – WM Karaoke, Portikus, Frankfurt am Main, London – Men's World, Künstlerkreis Ortenau, Offenburg – Stadt/Bild, Karmeliterkloster, Frankfurt am Main (Katalog/catalogue) – WM-Karaoke, Portikus, Frankfurt am Main, London – Backstage, Kunstmuseum Luzern (Katalog/catalogue) **1993** Backstage, Hamburger Kunstverein (Katalog/catalogue) – Es ist eine Zeit hereingebrochen, in der alles möglich sein sollte, vierteilige Ausstellungsreihe, Kunstverein Ludwigsburg, Villa Franck **1992** Dealing with Art, Künstlerwerkstatt Lothringer Straße, München (Katalog/catalogue) – SS.SS.R., Galerie Bärbel Grässlin, Frankfurt am Main – Virtuosen vor dem Berg, Galerie Grässlin/Erhardt, Frankfurt am Main (Katalog/catalogue) – Spielhölle, Ästhetik u. Gewalt, Frankfurt am Main – Qui, quoi, où?, Musée d' Art Moderne de la Ville de Paris, Paris (Katalog/catalogue) **1991** Zwischen Dürer und Holbein, Städelschule Frankfurt am Main (Katalog/catalogue) – Give me a hand before I call you back, Galerie Bleich-Rossi, Graz (Katalog/catalogue)

Tobias Rehberger

Johannes Wohnseifer

Johannes Wohnseifer – *Frank Frangenberg*

Johannes Wohnseifer ist 1967 im Rheinland geboren. Einige seiner frühen Sommer verbrachte Johannes auf dem Bauernhof seiner Großeltern in der Eifel, der unweit unserer ehemaligen Hauptstadt Bonn gelegenen hügeligen, bäuerlichen Landschaft, in deren Mitte der Nürburgring in seiner seltsam verwunschenen mythischen Großartigkeit liegt. An Sommersonntagen schwingt immer noch die heitere Luft der Eifel im an- und abschwellenden heiseren Gebrüll der Motorräder und schnellen Autos, die sich fett und prächtig in die Kurven legen, grollend springt es aus den Tälern hoch und runter, entfernt sich: wir befinden uns in unmittelbarer Nähe des Grals der Republik.

Die Konstruktion weißhaariger "Gründerväter", die Bonn zur Hauptstadt machte, was dem westdeutschen Kapitalismus seine spezifisch-bescheidene Kapitale bescherte, hatte den Mut zur Lücke, um nach der Logik der Kochrezepte wie ein Gugelhupf unter richtigen Temperaturen besser hochzukommen: Ökonomische Potenz bei politischer Ohnmacht. "Bonn" heißt in den siebziger Jahren auch Erwachsenwerden im moralisch-ethisch entleerten Staatsgefüge einer desto familiäreren Bundesrepublik Deutschland. Als Gegenpol zur Gemütlichkeit führt die Schmidt-Regierung die Paranoia der Rasterfahndung ein. Johannes wohnt in Erftstadt, spielt, fährt Skateboard vor dem Erftstädter Hochhaus mit der konspirativen Wohnung – oben liegt Herr Schleyer im Volksgefängnis –, wie wir alle in den siebziger Jahren Gelegenheit gehabt hätten, vor konspirativen Wohnungen spielen zu können.

Wenige deutsche Künstler haben aus der biographischen Tatsache Kapital geschlagen, in einem Staat aufgewachsen zu sein, dessen Konstruktion offen illusionär, offen für fast jede Form fiktionaler Konstruktionen war. Das Œuvre von Johannes Wohnseifer

Johannes Wohnseifer – *Frank Frangenberg* – Translated by Toby Alleyne-Gee

Johannes Wohnseifer was born in 1967 in the Rhineland. He spent childhood summers on his grandparents' farm in the Eifel, a hilly agricultural region not far from Germany's former capital, Bonn. The strangely magical Nürburgring lies at the centre of this magnificent landscape. On Sundays in summer, the cheerful air of the Eifel still vibrates with the hoarse roar of motorbikes and the noise of smooth fast cars elegantly negotiating the bends in the roads, rumbling up and down the valleys, and disappearing: we are in the immediate vicinity of the Grail of the republic.

The snowy-haired "pioneers" who made Bonn the capital of Germany and provided West German capitalism with its modest capital had the courage to make something out of nothing. Like the *gugelhupf* (a yeast-based cake), they knew they would rise best at the right temperature. In other words, they were economically powerful while being politically impotent. In the Seventies, "Bonn" meant growing up in a state system devoid of morals and ethics, in a Federal German Republic that as a result had become all the more familiar. To counteract the atmosphere of *gemütlichkeit*, the Schmidt government introduced the paranoia of computerised criminology. Johannes lives in Erftstadt, plays, rides his skateboard in front of the Erftstadt prison in which conspirators lived – Herr Schleyer is an inmate – just as we all had the opportunity to play in front of the houses of conspirators in the Seventies.

Few German artists have taken advantage of the fact that they grew up in a state that was so openly based on illusions, so receptive for almost any form of fiction. Johannes Wohnseifer's work reveals an attitude that finally does away with the strategy of undercover advancement that was so successful after the war by artistically assimilating the mentality of the Federal German mainstream between 1948 and 1989. Since the 1989 reunification, understatement and the controlled offensive are out: the joy of a static existence is no more. One way of interpreting the artist's work is to see Johannes Wohnseifer above all as an artistic governor of the last generation of the Federal Republic before the Berlin Republic was known as such, and before its culture had come into being. Yet the knowledge that this is only *one* possible interpretation must give rise to the impression that what we are seeing is a "lost generation" of Federal German artists.

Johannes Wohseifer is open, his cards are on the table. Although the contours of his artefacts are clearly defined, his message is one of collective, subterranean, mental undercurrents. Similarly to the act of turning a glove inside out, he shows us laws and strategies that, in their intellectual, almost nonsensical abundance of allusions and references, appear to create more or less meaningful associations. Johannes Wohnseifer constantly returns to his

– **Prototyp für Stadtstreichersarg**, 1998, Holz, Acryl, aufblasbares PVC-Kissen/Wood, acrylic, inflatable PVC cushion, 56x125,5x66cm, Courtesy Galerie Gisela Capitain, Köln, Photo Albrecht Fuchs, Köln

– Mark Gonzales & Johannes Wohnseifer, **Backworlds/Forwords**, Skaterperformance/
Skater performance, Städtisches Museum Abteiberg, Mönchengladbach, Dezember 1998,
Courtesy Galerie Gisela Capitain, Köln, Photo Johannes Wohnseifer

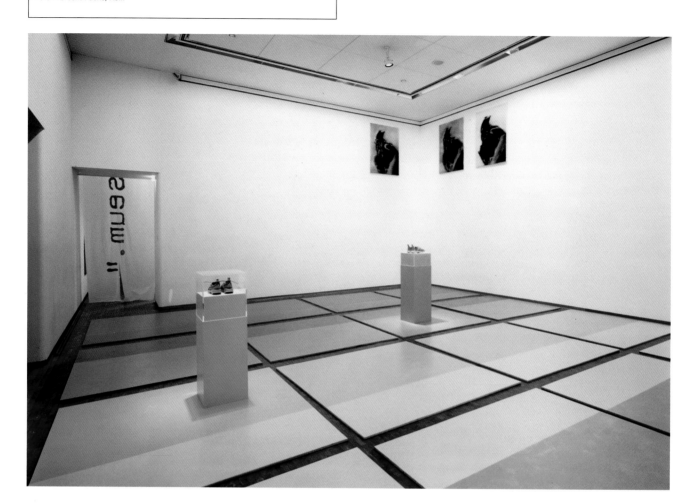

macht mit einer geistigen Haltung bekannt, die die in der Nachkriegszeit so erfolgreiche Strategie eines Aufstiegs aus der Deckung endgültig erledigt durch die künstlerische Autobiographisierung eines bundesrepublikanischen Mainstreams der Mentalitäten zwischen 1948 und 1989. Seit 1989, seit der Wiedervereinigung, ist Schluß mit Understatement, kontrollierter Offensive: vorbei das Glück der statischen Existenz. Das Wissen, daß es nur *eine* mögliche Interpretation seines Œuvres ist, die in Johannes Wohnseifer vor allem einen künstlerischen Statthalter der letzten bundesrepublikanischen Generation sieht, bevor die Berliner Republik ihren Namen bekam und ihre Kultur begann, muß den Gedanken niederringen, hier bereits eine künstlerische "lost generation" der ehemaligen BRD an der Arbeit zu sehen.

Johannes Wohnseifer arbeitet offen, ohne verdeckte Karten. Er zeigt klar konturierte Artefakte, meint aber ihre unterirdisch kollektiv-mentalen Strömungen. Ähnlich wie man einen Handschuh von ínnen nach außen umstülpen würde, läßt er uns die assoziativen Gesetze und Strategien sehen, die in ihrem intellektuellen, bis in die vage Nähe des Nonsens reichenden Überfluß an Anspielungen und Verweisen mehr oder minder sinnvolle Zusammenhänge herzustellen versprechen. Johannes Wohnseifer kommt immer wieder zurück auf seinen idiosynkratischen bundesrepublikanischen Fundus – Braundesign, Formel-1, die RAF-Geschichte, Kraftwerk usw. – und läßt kein Medium ungestreift. Seine Methode einer Variantenbildung mit geringer, aber bedeutungsvoller Differenz, in der Musikwelt unter dem Titel Sampling begriffen, verbindet sich mit der ausgeprägten Liebe eines Sammlers zu seinen Inkunabeln. Was auch immer Johannes Wohnseifer loopt – es nutzt die Bewegung und wird bezwingend narrativ, als erzählte es eine eigene Geschichte. In "Braunmusic" sind es Weckertöne (die der Fan von Braundesign auf seiner Platte "braunmusic" von befreundeten Djs als Tonmaterial verwenden läßt), in "Spindy" wird ein kantiger Mix von Skateboardrampe und Schleyerschem Volksgefängnis in Originalgröße geboten, im "Kölner Tisch" die Idee des Ulmer Hockers von Max Bill auf ein die Realität hypertrophierendes Maß aufgeblasen.

Es zeichnet den Erzähler aus, daß seine Geschichten einfach klingen und doch jede tiefsinnige, weit über sie hinausweisende Interpretation erlauben. Deswegen ist der "Kölner Tisch" auch eine Erzählung der Ulmer Hochschule und des Versuchs einer gelenkten Bildung des deutschen Nachkriegsalltags aus elitärem Geiste, er erzählt weiterhin von Otl Aicher und den heiteren Spielen von München, von Irene Aicher-Scholl und dem deutschen Widerstand gegen den Nationalsozialismus usw. Die Geschichten, die Johannes Wohnseifer in seinen Arbeiten erzählt, sind Geschichten seines Lebens, aber die Geschichte seines Lebens erzählt auch eine intime Geschichte der Bundesrepublik Deutschland. Ein Teil von uns, an dem wir alle Anteil haben.

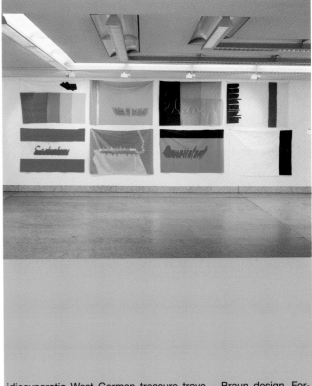

idiosyncratic West German treasure trove – Braun design, Formula 1, the history of the *Rote Armee Fraktion*, Kraftwerk etc. – and leaves no medium untouched. His method of variations, which differ only slightly, but significantly, from a theme – known in the world of music as sampling – is combined with the profound love a collector feels for his collection. Whatever Johannes Wohnseifer creates, it uses movement and becomes compellingly narrative, as if it were telling its own story. In *Braunmusic*, it is the sound of alarm clocks (which the Braun design fan had mixed by DJs for his record *Braunmusic*), *Spindy* is a sharp mix of skateboard ramps and Schleyers's prison in original size, and in *Kölner Tisch* ("Cologne Table"), Max Bill's Ulm stool is inflated to surreal proportions.

A storyteller is characterised by the fact that his stories sound simple, yet still leave room for a wide range of profound interpretations. This is why the *Kölner Tisch* is also a story about the Ulmer Hochschule (Ulm University) and the elitist attempt at a manipulated creation of German everyday life. It also tells the story of Otl Aicher and the cheerful Munich games, of Irene Aicher-Scholl and German resistance to national socialism. The stories that Johannes Wohnseifer tells in his work are stories about his life, but the story of his life also tells an intimate story about the history of the Federal Republic of Germany. Something with which all Germans can identify.

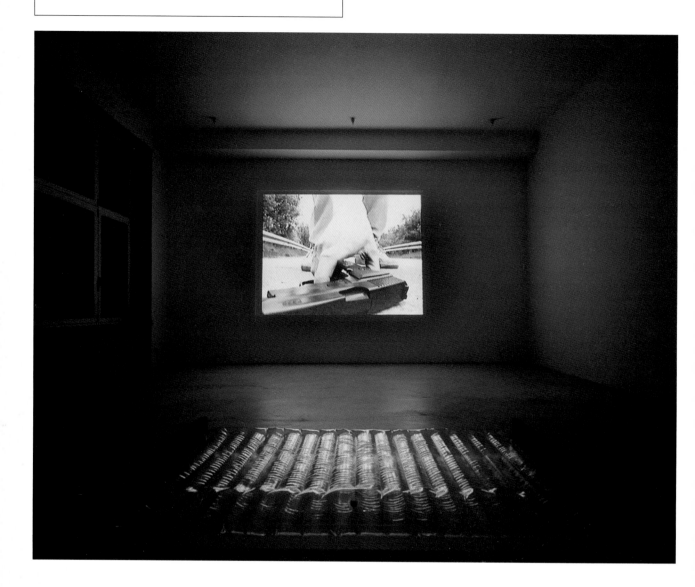

JOHANNES WOHNSEIFER – Köln, 1967 – Wohnt/lives in Köln

Photo Tobias Berger, Köln

EINZELAUSSTELLUNGEN/ONE PERSON SHOWS: 1999 Museum, Projektraum, Museum Ludwig, Köln **1998** Der Stadtstreicher, Galerie Gisela Capitain, Köln – Peter Mertes Stipendium 1998, (mit/with Monika Baer), Bonner Kunstverein – Backworlds-Forwords, Städtisches Museum Abteiberg (mit/with Mark Gonzales), Mönchengladbach **1997** Psylocibin Experience, Nice Fine Arts, Nizza – braunmusic live, Kölnischer Kunstverein, Köln **1996** MOMAS-Guard, Museum of Modern Art Syros, Syros, Griechenland – 10 Portraits, Bundesverkehrsministerium, Bonn **1995** spindy, neugerriemschneider, Köln – spindy b, Künstlerhaus Bethanien, Berlin **1994** Grid Painting with Two Holes, Kunstverein Kippenberger, Museum Fridericianum, Kassel

GRUPPENAUSSTELLUNGEN/GROUP SHOWS: 1999 My name, Sammlung Falckenberg, Museum der bildenden Künste, Leipzig (Katalog/catalogue) – Videos, Galerie Francesca Pia, Bern – Wohin kein Auge reicht, Triennale der Photographie, Deichtorhallen Hamburg (Katalog/catalogue) – mode of art, Kunstverein in Düsseldorf (Katalog/catalogue) **1998** someone else with my fingerprints, SK-Stiftung Kultur, Köln, Kunstverein München, Kunsthaus Hamburg – Videofilme, Wien/Rheineck/Köln/London/Genf, Galerie Francesca Pia, Bern – Fast Forward - Trade Marks, Kunstverein in Hamburg – Summary, Galerie Hoffmann & Senn, Wien – Sammlerstücke 1, Sammlung Schürmann, Kunstverein Langenhagen – El Nino - Gebt mir das Sommerloch, Städtisches Museum Abteiberg, Mönchengladbach (Katalog/catalogue) – mengenbüro, Neuer Aachener Kunstverein – Entropie zuhause, Suermondt-Ludwig Museum, Aachen – Herbert Fuchs, Dave Muller, Johannes Wohnseifer, MAK Center, Mackey House, Los Angeles **1997** someone else with my fingerprints, David Zwirner Gallery, New York, Galerie Hauser & Wirth, Zürich – One of you, Among you, With you, Galeria Juana de Aizpuru, Madrid **1995** Smells Like Vinyl, Roger Merians Gallery (kuratiert von/curated by Sarah Seager & Thaddeus Strode), New York – filmcuts, neugerriemschneider, Berlin **1994** Dear John, Galerie Sophia Ungers, Köln **1993** Frauenkunst – Männerkunst, Kunstverein Kippenberger, Museum Fridericianum, Kassel

Johannes Wohnseifer

Matti Braun

Jelzin, Perlweiß, gute Laune – Matti Braun und die Fährnisse kultureller Transfers – *Holger Liebs*

Es hat eine Zeit gegeben, in der stand "das Finnische" als Synonym für eine globale Denk- und Lebensschule, für eine kritische Synthese von Natur, traditionellen Lebensformen und Technologie; in der galten der karelische Kiefernwald als metaphorische Landschaft schlechthin und die *Aurora borealis* als Sinnbild der Universalität; in der entwarf der finnische Architekt Alvar Aalto öffentliche Institutionen in aller Welt, und Eero Saarinen erbaute das TWA-Terminal des Kennedy-Airports in New York als Ikone der schwerelosen modernistischen Architektur (1956 – 62).

Mit dem weltumspannenden Siegeszug finnischen Designs und finnischer Architektur in der Nachkriegszeit hatte die modernistische Ideologie der Menschenrechte samt ihrer juristischen Vehikel und logistischen Apparate, die die Vereinten Nationen zur Verfügung stellten, eine unverdächtige Paßform gefunden, in der sich das westliche Idealbild einer kosmopolitischen, ansatzweise hedonistischen, industriellen Entwicklungen gegenüber aufgeschlossenen, aber dennoch naturfreundlichen Gesellschaft prächtig verkaufen ließ bis hin zur heimischen Sauna im Keller, mit der man sich nicht nur den skandinavischen Rousseauismus – Kontakt zur ursprünglichen Natur durch die Schweißporen hindurch in einer mit finnischem Holz ausgeschlagenen, erwärmten Box – nach Hause holte, sondern auch Anschluß an den westlichen Lebensstandard hielt.

Wenn man Matti Braun fragt, kann es darum kein Zufall sein, daß ausgerechnet, er, ein Künstler deutsch-finnischer Abstammung, einen "runden Tisch" für die Versammlung der wichtigsten westlichen Industrienationen (unter Einschluß eines in seiner Ange-

Yeltsin, Pearly White, Good Humour – Matti Braun and the perils of cultural transfers – *Holger Liebs* **– Translated by Toby Alleyne-Gee**

There was a time when "Finnish" was synonymous with a global school of thought, a critical synthesis between nature, traditional lifestyle and technology. At that time, the Finnish pine forests were the epitome of the metaphorical landscape and the aurora borealis a symbol for a universal philosophy. This was the time when the Finnish architect Alvar Aalto was designing public institutions all over the world and Eero Saarinen was building the TWA terminal, an icon of weightless modernist architecture, at New York's John F. Kennedy Airport (1956 – 62).

Thanks to the triumphant progress of Finnish design and architecture in the period after the Second World War, the modernist ideology of human rights, with its legal and logistical systems provided by the United Nations, had found a splendid way of packaging the western ideal of a cosmopolitan, to a certain extent

Matti Braun

Sonne, Farben, gute Laune 2

...bei Achim Kubinski / Ausstellung vom 7. Jan... Juli 1997
...Stuttgart / Tel. 07 11-6...

Fröhliche Eiszeit

Sport

7.-14. Sept. 1997

**Kunsthalle Nürnberg:
Überraschung (Surprise II)**

Dirk Bell	SO	7. Sept. 20 h	Installation von Dirk Skreber mit
Heike Beyer			Performance einer Rollkunstläuferin
Matti Braun	MO	8. Sept. 20 h	"E", Vortrag von Walter Dahn
Walter Dahn	DI	9. Sept. 20 h	Live-Act, experimentelle, elektronische
Claus Föttinger			Musik mit Videos (u. a. mit D. Bell, L.
Lothar Hempel			Hempel, H. Kristen, M. Uhlig)
Hardy Kristen	MI	10. Sept. 20 h	"Form und Schönheit. Elektronische
Torsten Koch			Musik - Computermusik. Fragen an
Hendrik Krawen			die Technik", Vortrag von Torsten
Manfred Pernice			Slama
Daniel Pflumm	DO	11. Sept. 20 h	CIDOC-Farewell-Party (Karten nur im
Andreas Schulze			Vorverkauf)
Dirk Skreber	FR	12. Sept. 20 h	Blumen für Lucius Grisebach
Torsten Slama	SA	13. Sept. 20 h	"Gene revisited", Special-Bar-Night
Rosemarie Trockel			mit Claus Föttinger
Michael Uhlig			

Kunsthalle Nürnberg, Lorenzer Straße 32, 90402 Nürnberg
Telefon 0911-231-2403/2853, Telefax 0911-2313721

täglich von 14-24 h

schlagenheit die östliche Rückständigkeit in wirtschaftlich-politischen Hegemoniefragen perfekt verkörpernden russischen Repräsentanten) im Kölner Museum Ludwig im Juni 1999 gestalten durfte. Dabei spielt die Tatsache, daß Braun Genealogien und historische Verknüpfungen wie die obengenannten schätzt – und gerne um (gar nicht so) "absurde Konstellationen" aus dem Bereich der Privatmythologie erweitert –, eine nicht zu unterschätzende Rolle. Der Künstler webt und bildet Kontexte und Netzwerke um die bloßen Ausstellungsobjekte, die die Arbeiten fortsetzen, aus dem Galerieraum heraustragen und in den scheinbaren Artefakten das decouvrieren, was sie sind: niemals unschuldige Dinge, sondern immer Vehikel von Ideologie und Geschichtsschreibung. Braun ist durch Installationen bekannt geworden, die das finnische Design der sechziger Jahre zitieren, insbesondere die kugel- und pillenförmigen Möbel aus der Hand des finnischen Designers Eero Aarnio. Was zunächst wie plumpes Retro-Design in der direkten Nachfolge etwa von Aarnios Asko-"Pastilli"-Sesseln aus dem Jahr 1968 (Braun: "Vulgär-Colanis") anmutete, entpuppte sich bald als

hedonist, yet environmentally aware society. This included the home sauna, thanks to which people could not only live according to the principles of Rousseau à la scandinivienne – contact with nature through the pores in a box panelled with Finnish pine – but also keep in touch with the western standard of living.
Ask Matti Braun, and he will tell you that is no coincidence that he of all people, an artist of German-Finnish origin, should have designed a "round table" for a conference of the major western industrial nations (including the Russian delegate, whose physical frailty perfectly exemplified the economic and political backwardness of eastern Europe) at the Ludwig Museum in Cologne in June 1999. The fact that Braun appreciates genealogy and historical connections such as these – and enjoys extending "absurd situations" (which are not really that absurd) from his own private mythology – should not be underestimated. The artist puts the exhibits into a context, weaving a network around them to create a sense of continuity, carry them out of the exhibition space and reveal the true essence of what appear to be mere artefacts: they

– **Sonne, Farben, gute Laune 2**, 1997, Plakat zur Ausstellung/Exhibition poster,
Reinhard Hauff bei Achim Kubinski, Stuttgart – **Überraschung (Surprise II)**, 1997,
Plakat zur Ausstellung/Exhibition poster, Kunsthalle Nürnberg

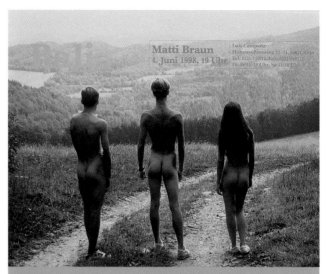

are never innocent objects, but always vehicles of ideology and historiography.

Braun became famous with installations that cite Finnish design of the Sixties, particularly the spherical and pill-shaped furniture of the Finnish designer, Eero Aarnio. What at first appeared to be blatant retro design based directly on Aarnio's 1968 *Pastilli* armchairs (Braun: "vulgar Colanis") soon turned out to be the result of a deliberate strategy. Braun caricatured the naive critical appraisal of these designs as a natural, Scandinavian "Utopia of the good" (Braun). Where the brightly coloured plastic chairs were acquired, almost as museum pieces, for video rooms or chill-out zones, they had been interpreted literally as quality Finnish design – basically as modern folklore. This also meant that Matti Braun's works were only really successful when they were misunderstood. Braun has therefore always attempted to extend way the exhibits are presented in the media, documenting the misunderstood ideological importance of the design and demonstrating the concept behind it by means of posters, flyers, photographs, newspaper and television reports.

This conceptual work, which always deals with cultural transfer and its uncertain consequences, did not stop Braun from reediting an exact copy of the first eulogising monograph on Joseph Beuys published after the artist's death as a *Hitler Book* (1991). As a result, Braun was not permitted to show his work at the *Deutschlandbilder* ("Images of Germany") exhibition held at Berlin's Martin Gropius building in 1997. Nor does Braun's approach stop him from concerning himself with the Japanese reception of western avant-garde art in the early twentieth century in an installation shown at the *Edo* exhibition at Berlin's Schipper/Krome gallery in March 1999. Again, he was misunderstood as a design artist.

Strategie, die naive Rezeption einer als ursprünglich angenommenen, skandinavischen "Gute-Menschen-Utopie" (Braun) erst zu inszenieren und dann zu karikieren: Wo die schönen bunten Plastiksessel als quasimuseale Ankäufe in Videoecken oder Chill-Out-Zonen landeten, waren sie 1:1 als finnisches Qualitätsdesign – im Grunde als moderne Folklore – interpretiert worden.

Das hieß aber auch, daß Matti Brauns Arbeiten nur dann wirklich gelangen, wenn sie nicht verstanden wurden. Die Fehler, die die Rezipienten seiner Werke begingen, weil sie etwa kulturelle Wissenstransfers nicht nachvollzogen, wo dies angebracht gewesen wäre, wurden sozusagen zum integralen Bestandteil seiner Arbeiten. Braun hat daher immer die eigentlichen Ausstellungsobjekte um die mediale Ebene ihrer Präsentation zu erweitern gesucht, die die unbegriffene ideologische Gewichtigkeit des

– **Sonne, Farben, gute Laune 3**, 1998, Plakat zur Ausstellung/Exhibition poster, Galerie Brigitte Weiss, Zürich – **Bali**, 1998, Plakat zur Ausstellung/Exhibition poster, Galerie Luis Campaña, Köln

Designs dokumentieren und gleichzeitig, erweitert um eine Kommentarebene, ins Konzeptuelle hinein verschieben: Plakate, Flyer, Fotografien, Zeitungs- und Fernsehberichte.

Diese konzeptuelle Arbeit, die immer kulturelle Transfers und ihre (mißverständlichen) Folgen zum Thema hat, kann auch etwa die Möglichkeit einschließen, die erste nach dem Tod von Joseph Beuys erschienene Monographie über den Künstler, die vor Erhabenheitspathos und quasisakraler Beweihräucherung nur so trieft, als "Hitlerbuch" (1991) im exakt kopierten Design neu zu edieren – und daraufhin aus der Ausstellung "Deutschlandbilder" (Martin-Gropius-Bau, Berlin 1997) ausgeschlossen zu werden. Oder, wie im März 1999 in der Ausstellung "Edo" in der Galerie Schipper/Krome in Berlin, die japanische Rezeption westlicher Avantgardekunst des frühen 20. Jahrhunderts in einer Installation zu thematisieren – und prompt wiederum als Designkünstler mißverstanden zu werden.

Im Grunde sind Brauns Arbeiten Bühnen für Inszenierungen, die erst kommen: allen voran der perlweiße "runde Tisch", an dem am

Braun's creations are basically stages for productions that have not yet been performed, such as the pearly white "round table" around which Clinton, Schröder, Chirac, Blair, D'Alema, Cretien, Obuchi, Santer and the slightly indisposed Yeltsin sat on June 18, 1999. The mushroom-shaped table is made of polyester reinforced with fibreglass and has a pale green circle in its centre. Around it are nine "Sherpa" tables with chairs designed by Ray and Charles Eames. Braun's table, which is also similar to the "Kantarelli" table designed by Aarnio (1965), Braun's table was to be seen in the media all over the world, such as in *France-Soir,* where it was shown against a background of a silver-grey carpet and art works by Robert Morris, the above-mentioned politicians seated around it, beside a giant portrait of Milosevic and the headline, "They want his head", and in a Kosovar exile newspaper in Switzerland.

The accumulation of contexts and media recycling of what is supposed to be a design object continues: the "round table" will not end up as a museum exhibit, but will go into storage in the Chancellor's Office in Berlin. The architecture of this building is openly a hybrid of Persian palace and Italian villa. Braun's Finnish-style conference furniture will look a little strange in these surroundings, rather like the interior of a spaceship. The architect of this representative building said he wanted to "show the German people the meaning of the word 'state'" – the ideal context for Matti Braun.

– **Sonne, Farben, gute Laune**, 1996, Plakat zur Ausstellung/Exhibition poster, Galerie Luis Campaña, Köln

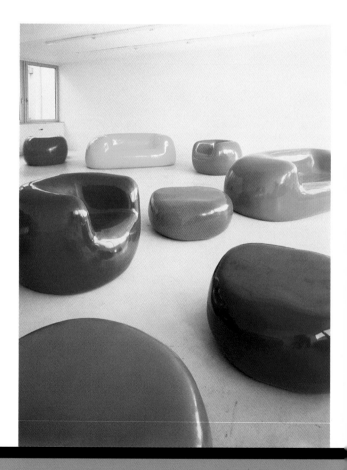

18. Juni 1999 die Herren Clinton, Schröder, Chirac, Blair, D'Alema, Cretien, Obuchi, Santer und der etwas indisponierte Jelzin saßen. Der glasfaserverstärkte Polyesterpilz mit hellgrünem Mittelkreis, um den als äußerer Kranz neun "Sherpa-Tische" samt Bestuhlung aus dem Hause Ray und Charles Eames angeordnet waren – er ähnelt wiederum einem Objekt Aarnios, nämlich dem Tisch "Kantarelli" (1965) –, tauchte vor dem Unter- respektive Hintergrund eines silbergrauen Teppichs und Kunstwerken von Robert Morris in Medien rund um den Globus auf, so etwa im *France-Soir*, wo neben dem prominent besetzten Tisch riesengroß Milosevics Konterfei und die Schlagzeile "Sie wollen seine Haut" abgebildet waren, oder z.B. in einer kosovarischen Exilzeitung aus der Schweiz. Und die Akkumulation der Kontexte und medialen Wiederverwertungen des vermeintlichen Design-Objektes geht weiter: Der "runde Tisch" wird schließlich nicht etwa in einem Museum, sondern im neuen Berliner Kanzleramt endgelagert, in einer Architektur, die ihre hybride Abstammung von persischen Palastbauten und italienischen Villen offen zeigt. Dazwischen wird nun die Braunsche Gipfel-Möblierung finnischer Provenienz etwas fremd wirken, ein wenig wie ein Raumschiffinterieur – und das in einer Repräsentationsarchitektur, von der ihr Architekt sagt, er habe "Dem Deutschen Volke Staat zeigen" wollen – ein medialer Kontext ganz nach Matti Brauns Geschmack.

MATTI BRAUN – Berlin, 1968 – Städelschule, Staatliche Hochschule für Bildende Kunst, Frankfurt am Main – Hochschule für Bildende Künste, Braunschweig – Wohn/lives in Köln

EINZELAUSSTELLUNGEN/ONE PERSON SHOWS: 1999 Edo, Schipper-Krome, Berlin **1998** Bali, Luis Campaña, Köln **1997** Sonne, Farben, gute Laune II, Reinhard Hauff bei Achim Kubinski, Stuttgart **1996** Sonne, Farben, gute Laune, Luis Campaña, Köln **1995** Jussila, Jörn Bötnagel Projekte, Köln (Katalog/catalogue) **1991** Adolf Hitler – Installationen und Happenings, Friesenwall 116 a, Köln **GRUPPENAUSSTELLUNGEN/GROUP SHOWS: 1999** Konstruktionszeichnungen, Kunstwerke, Berlin – Anarchitecture, Stichting de Appel, Amsterdam – Peter Mertens Stipendium (Matti Braun, Daniel Kerber, Alexa Kreißl), Bonner Kunstverein (Katalog/catalogue) – Superca…, Büro Amsterdam **1998** Le Future du Passé, Le Lac, Siegean – Stefan Banz, Cosima von Bonin, Matti Braun, Kunstraum Kreuzlingen – Liar, Liar, mit/with Heike Beyer, BQ, Köln **1997** Ein Stück vom Himmel - Some Kind of Heaven, Kunsthalle Nürnberg (Katalog/catalogue) – Was nun, Schipper-Krome, Berlin – Lotta Hammer Gallery, London – Deutschlandbilder, Martin-Gropius Bau, Berlin (Katalog/catalogue) – Überraschung (Surprise II), Kunsthalle Nürnberg (Katalog/catalogue) **1995** Season's greetings, Ausstellungsraum Lecesse Sprüth, Köln **1994** Come on R, mit/with S. Höller, C. und/and I. Hohenbüchler, P. Märtin, Luis Campaña, Köln **1991** Virtuosen vor dem Berg, Galerie Grässlin-Erhard, Galerie Bleich-Rossi, Graz (Katalog/catalogue)

Matti Braun

Jonathan Meese

Jonathan Meese. Messy, Messias – und Massacreur eines konformistischen Kunstbegriffs – *Kathrin Luz*

Unterwegs in den Gedankengängen…

Heiter schien er zu sein, freundlich und verträumt, der junge Jonathan Meese, so wie wir ihn kennenlernten. "Wie schön ist es doch, daß es ihn gibt!" – so dachten wir und antizipierten überschnell den Schulterschluß. Denn mit Meese war man endlich nicht mehr allein unterwegs in den Gedankengängen. Mit seiner freundlichen Art holte dieser junge, ungestüme "Brainstormer" uns ab und führte uns ein in seine zerebrale Welt, legte sein Gehirn, das Chaos seiner Gedanken offen und breitete es in aller privatistischen Nacktheit vor uns aus: in opulenten, obsessiv-überladenen Materialsammlungen und trashigen Rauminstallationen, lesbar wie eine vierdimensionale Illustriertenseite.

Aufgehängte Notizzettel, ausgerissene Zeitungsseiten, billige Fansize-Artikel – all dies ging ein in dieses wüste, wilde Szenario seines vermeintlich latenten Wahnsinns. Gegen Meeses Müllinstallationen wirkte so manches Schlupfloch eines manisch-neurotischen Müllsammlers, der in all dem Zivilisations- und Datenmüll nicht mehr zwischen "wichtig" und "unwichtig" differenzieren kann, eines "Messy", wie man dieses zeittypische Phänomen heute nennt, wie eine halbwegs aufgeräumte Schreibtischschublade. Kulturelle Errungenschaften und trashiger Abfall, Stars und Versager, Sinn und Unsinn, Zardoz und Kunst – alles wurde austauschbar in diesem Dschungel der überbordenden Kreativität, in diesem tropischen Denkklima, in dem der Horror vacui lauerte.

Ein Klima, in dem im Grunde alles gleich-gültig war, ganz einfach weil alles gleichen Ursprungs war. In Meeses Gedankenreich gab es keinerlei Hierarchien und keine fertig konfektionierten Kategorien mehr, keine Konsekutionen und keine Konditionen, kein Präteritum und kein Präsenz, kein High und kein Low. Locker überwand er alle Gedankensprünge und Synapsenhürden und breitete in seinen trashigen Rauminstallationen das Chaos seiner labyrinthischen Hirnwindungen, die gewundenen Pfade und bizarren Wege, die Verzweigungen und Rückkoppelungen in den Mechanismen des Organs aus, mit dem sich der Mensch nun mal die Welt aneignet.

"Alles muß mit allem vergleichbar sein", so kommentierte Meese dies selbst, während er munter und unerschrocken dazu den pseudo-pubertären Fanclub-Leiter "gab". Zwischen Postern und Perücken, Fotos und Fummeln begegneten sich in seinen Installationen Caligula und Nietzsche, Napoleon und Klaus Kinski, Mao und Thomas Mann, Rainer Werner Fassbinder und Pippi Langstrumpf, Rolf-Dieter Brinkmann und Romy Schneider, Stanley Kubrick und Wagner wie alte Bekannte. Immer geriet der Rundgang durch Meeses privates Gedankengebäude, seine wahnwitzi-

Jonathan Meese. Messy, Messiah – and Murderer of Artistic Convention – *Kathrin Luz* – Translated by Toby Alleyne-Gee

In the corridors of the mind…

Young Jonathan Meese seemed cheerful, friendly and dreamy when we met him. "How wonderful it is that he exists!" we thought, and over-eagerly anticipated a friendly alliance. For with Meese, we were at last no longer alone in the corridors of the mind. The young, impetuous brainstormer led us in his friendly way into his cerebral world, revealed his brain and the chaos of his ideas, displaying his most intimate thoughts, naked, before us: in opulent, obsessively ornamented collections of material and trashy installations, which could be read like a four-dimensional magazine page. Scribbled notes, torn out newspaper pages, cheap fan-size articles are all incorporated in the chaotic, wild scenario of what appears to be the artist's latent madness. Compared with Meese's trash installations, the work of many a manic, neurotic collector of trash, the "messy" who can no longer differentiate between "important" and "unimportant" amongst all the refuse of civilisation and data, seem like the untidy drawers of a desk. Culture and trash, stars and failures, sense and nonsense, kitsch and art – everything has become interchangeable in this jungle of exuberant creativity, in this tropical mental climate where the *horror vacui* is always round the corner.

In this climate, everything basically has the same value, because it is all quite simply of the same origin. In Meese's mind there are no hierarchies and no prefabricated categories, no cycles and no conditions, no past and no present tense, no high or low. He easily overcomes all the mental leaps and hurdles; his trashy installations spread the chaos of his labyrinthine brain, the bizarrely winding paths, the ramifications and passages lead us back into the mechanisms of the brain, that organ we use to take possession of the world.

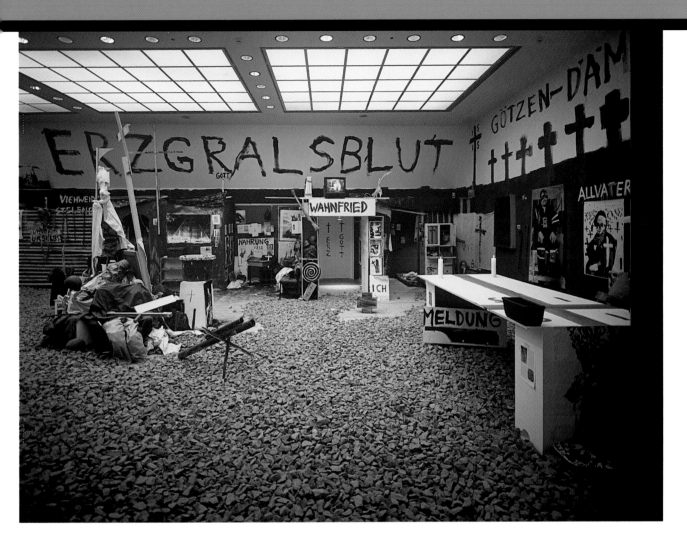

ge Hirnschau zu einer biografischen Nabelschau – immer wieder tauchten seine persönlichen, zumeist männlichen Helden und privaten Mythen mitsamt allen dazugehörigen Relikten und Reliquien auf. Beuys, der alte Schamane, grüßte dabei noch von weitem mit seiner erdverbundenen Lieblingsfarbe, die sich so häufig in den malerischen Partien dieser Installationen fand.

…auf der Suche nach der Schmerzgrenze.

Und kaum daß man sich versah, wurde in diesen Gedankengebäuden, in diesen kryptischen Kulträumen eine neue, individuelle Mythologie geboren – und mit ihr ein anderer, ernsterer, böserer Jonathan Meese, der uns auf einmal seine Nachsicht entzog und zwischen all den Zeichen, Schnipseln und Fragmenten, zwischen dem übermäßigen Dekor und der subtil kodierten Konnotation

"Everything must be comparable with everything" is Meese's own comment on the subject, as he cheerfully, fearlessly does the pseudo-adolescent fan club leader act. Caligula and Nietzsche, Napoleon and Klaus Kinski, Mao and Thomas Mann, Rainer Werner Fassbinder and Pippi Long-Stocking, Rolf-Dieter Brinkmann and Romy Schneider, Stanley Kubrick and Wagner meet like old friends among the posters and wigs, photos and drag of Meese's installations. A tour of his private edifice of ideas, his mad brain show, always turn out to be a biographical ego-trip. His personal, usually male, heroes and private myths, with all their relicts and relics, recur constantly. Beuys, the old shaman, greets us from far off with his favourite earthy colour, which can so often be seen in the pictorial sections of Meese's installations.

…in quest of the absolute limit.

– **Erzreligion Blutlazarett/Erzsöldner Richard Wagner/Privatarmee Ernte und Saat/Waffe: Erzblut der Isis/Nahrung: Bluterz**, 1999, Installation view, Kunstverein Frankfurt am Main, Courtesy Contemporary Fine Arts, Berlin, Photo Jochen Littkemann, Berlin

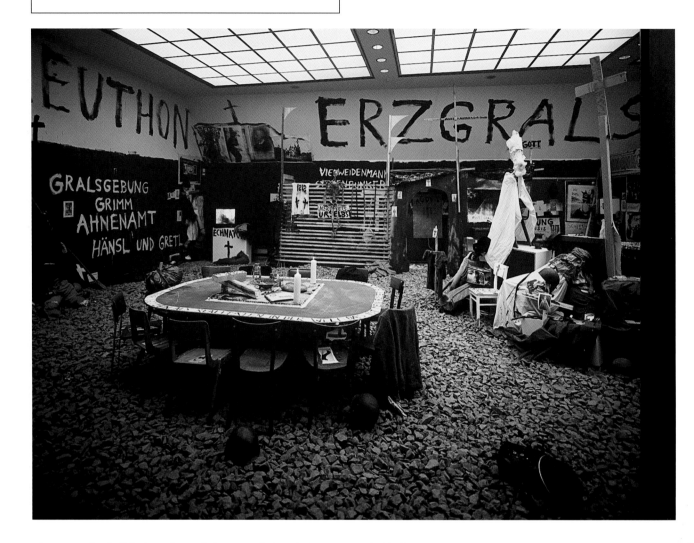

eine neue Radikalität formulierte. Anfangs noch kryptisch verschlossen und scheinbar ohne System, zeichnet sie sich inzwischen deutlicher ab am Horizont der Meeseschen Gedankenwelt. Und dieser Horizont ist düster und dunkel, hier braut sich einiges zusammen. Angefangen bei Meeses Heldenfiguren wie Caligula und Richard Wagner über Begriffe wie Staatssatanismus, Erzbayreuthon und Gralsgebung bis hin zu Saalschutz und Nationalspeisung: In archaisch-mythischen Parolen werden völkisch-germanische Rhetorik und ideologisch besetzte Figuren beschworen, werden semantisch aufgeladene Vokabeln mit echtem, sinnentleerten Sprachmüll aufgemischt und so relativierend gegenübergestellt – die letzte "Hardcore"-Performance von Meese im Kölnischen Kunstverein hat dies überdeutlich vorgeführt. Hier schleifte Meese seinen Mitspieler brutal durch eine düster-diabolische Szenerie, während er ihn gleichzeitig wüst röchelnd und

And before you know what is happening, a new, individual mythology is born in these edifices of ideas and cryptic, cult spaces – and with this mythology another, more serious, nastier Jonathan Meese appears. He suddenly stops indulging us and formulates a new, radical message amongst all the symbols, cuttings and fragments, the over-elaborate ornament and subtly encoded connotations. Initially cryptically reserved and apparently without a method, this message has recently become clearer on the horizon of Meese's mental world.

And this horizon is sombre and dark. A storm is brewing, beginning with Meese's heroes such as Caligula and Richard Wagner, using terms such as state Satanism, Erzbayreuthon, Gralsgebung, Saalschutz and Nationalspeisung: These archaically mythical slogans invoke popular Germanic rhetoric and ideologically weighted images. Semantically loaded expressions are mixed with gen-

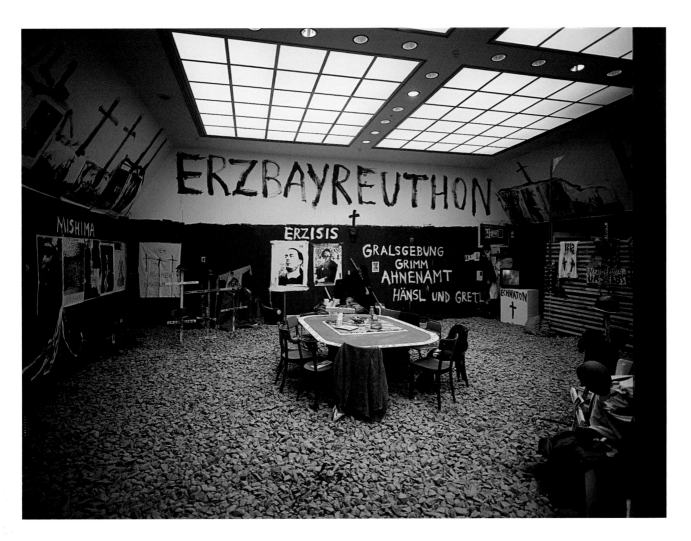

hantierend als Verräter und versagenden Saalschutz beschrie und beschimpfte. Das physisch berührte und befremdete Publikum stand, beziehungsweise saß recht rat- und sprachlos dieser Performance gegenüber, die über es kam wie ein Massaker an dem vergleichsweise umgänglichen, gebrauchsfertigen Kunstangebot unserer Tage.

Politische Korrektheit ist für Meese offenbar eine Devise von Vorgestern, das Aufbrechen von Tabus vielmehr das Gebot der Stunde. Der Künstler hat damit endgültig seinen Kosmos des Privaten erweitert und den öffentlich-staatlichen Raum "okkupiert" – und das vor allem auch in seiner historischen Dimension. In bekannter Aktionismustradition benutzt er dazu das Instrument des okkultistischen Rituals und der verkappt-pathetischen Heldenfeier, um sein Publikum entweder einzunorden oder endgültig abzuschrecken. Allein politisch-militärische Rhetorik kann daher dieses

uine, meaningless linguistic junk; this neutralises their meaning. Meese's most recent "hardcore" performance in the Kölnischer Kunstverein amply demonstrated this. Meese brutally dragged his fellow actor through diabolically sombre scenery, breathing stertorously and busily screaming at him, cursing him as a traitor and a failed Saalschutz. The speechless audience, physically repulsed and disturbed, were at a loss as to what to make of this performance, which rolled over them like a massacre of the art of our time – ready-to-use and usually comparatively affable.

For Meese, political correctness is obviously yesterday's news. Breaking taboos appears to be the latest precept. He has thus conclusively extended his private cosmos and "occupied" public, state space, particularly in its historical dimension. In the familiar action art tradition, he uses occult ritual and covertly pathetic celebration of the hero either to include or finally to put off his audi-

Phänomen greifen. Geradezu extremistisch, ja terroristisch geht Meese vor, um die Schmerzgrenze seiner Kunst zu erkunden und damit jede Vereinnahmung durch das (Kunst-)Publikum, jedes Mitläufertum, wie er es nennt, zu unterbinden. Er will kein Missionar sein, schon eher der Messias selber. In Wolfsburg verkündet Meese seine "Meessage" per Installation von einem schwarzen Holzturm aus, der ihm zugleich als wehrhafte Festung seiner kryptischen Kunst dient, für die bezeichnenderweise der Titel "Nulleid Isidor" steht. Ein Titel, der auf beides anspielt: auf sein solipsistisches Selbstverständnis wie auf seine Zugehörigkeit zu einem ähnlich lautenden Künstlerkollektiv.

"Ich will wissen, wer meine Feinde sind", "Es gibt keine Halbherzigkeit mehr", "Alles muß übel aufstoßen" – Mit diesen Durchhalteparolen beschwört Meese sein Publikum und vor allem sich selbst. Mit dem für ihn typischen Hang zur Manie schützt er jetzt eine aggressiv-feindliche Haltung vor und markiert so für sich eine neue Stoßrichtung. Es ist jetzt vor allem die Macht der Worte und Gesten, die er in seinen aktuellen Performances durchspielt. Das biografische Moment ist dabei in das historiografische eingemündet, seine adoleszenten Geschichten sind in das mythische Konstrukt einer kollektiven Geschichte eingeflossen.

Eines wird dabei deutlich: Es ist genau diese Schnittstelle von individueller und kollektiver Mythenbildung und -inszenierung, an der sich die Aura der Macht ausbildet. Mit ihren Möglichkeiten experimentiert der Künstler jetzt, in dem er sie überzieht – ein Künstler, der offenbar nie Angst hatte, seine Person in den Dienst einer Grenzüberschreitung, Enttabuisierung und Erwartungsenttäuschung zu stellen. Doch hinter aller Selbstentblößung ist seine Maskierung nicht gewichen. Im Gegenteil – weniger denn je wissen wir, woran wir mit ihm sind.

ence. For this reason, only politico-military rhetoric can adequately express this phenomenon. Meese adopts an extremist, even terrorist approach to explore the absolute limits of his art and thus avoids being monopolised by his audience, avoids the hangers-on, as he calls them. He does not want to be a missionary. He'd rather be the Messiah himself. In Wolfsburg, Meese proclaims his message in his installation on a black wooden tower, which also serves as a fortress for his cryptic art. The title is, tellingly, *Nulleid Isidor*. A title that alludes to both aspects: his solipsistic view of himself and his membership of a similar-sounding artist's collective. "I want to know who my enemies are." "There is no longer any half-heartedness." "Everything has to have a bitter aftertaste." Meese implores his audience with these slogans, but above all himself. With the tendency to mania that is typical of him, he presents an aggressively hostile attitude and thus marks a new direction. It is now above all the power of words and gestures that he acting out in his current performances. The biographical aspect of his work is part of historiography, his adolescent stories are integrated into the mythical construction of a collective history.

One thing becomes clear: it is exactly this interface between the individual and collective creation of myths which forms the basis of power. Meese is now experimenting with the possibilities of art by taking them to new limits. This is an artist who has apparently never been afraid of putting his own person in the service of crossing boundaries and destroying taboos, or disappointing expectations. Yet despite all his self-revelation, Meese's mask has not disappeared. Far from it: we now know less than ever who we're dealing with.

BIOGRAPHIE
WOLFSBURG
JONATHAN MEESE
①

geboren 1813 IM ERZISIS-STAAT
(AHNENAMT)

→ MÖNCH
1870: SAALSCHLACHT "MALDOROR"
1880: GEBRÜDER GRIMM II
1890: ERZBANN, RACHE, FEIND
1910: MITTELALTER (MACHIAVELLI)
1920: EVOLUTION "TAPFERKEIT"
 REVOLUTION "EHRE"
 EXEKUTION "TREUE"
1930: ECHNATON
 ERZSÖLDNER
 ERNTEPRODUKTIONSMELDUNG
1940: ISIS SELBST SEI ERZMORD
 ATON/VOLK/SCHWUR
1993: ERZMELDUNG
 ZARISMUS IV
 WALDEINSAMKEIT
1999: RICHARD WAGNERZ
 PRIVATARMEE LICHTERZ
 HAGEN V. TRONJE

2000: PHILEMON UND BAUCIS ②
2001: SAINT JUST III
2002: MIR IST's EKLIG (A.d.L.)
2008: GÖTZENDÄMMERUNG
 "WEIDENMANN"
2011: "LICHTGRAL
2013: ERZMÖNCH
 (INFORMATION, ERLÖSUNG,
 WIEDERKEHR) → ERZGOTT
2023: HOCHVERRAT/ERZRACHE
2025: METABAYREUTHONON
2027: VIEHGRAL UND EID

Jonathan Meese

Manfred Pernice

– **Wall**, 1997, 350 x 850 x 170 cm, Courtesy Galerie NEU, Berlin, Photo Colorfoto-Schlegel
– **Dresdner Stollen**, 1997, Installation view, ars viva 98/99, Courtesy Galerie NEU, Berlin

Manfred Pernice – *Yilmaz Dziewior*

Mit seinen ausgreifenden Installationen nimmt Manfred Pernice
Besitz vom jeweiligen Ausstellungsraum. Seine architektonischen
Einbauten und skulpturalen Setzungen lenken die Wege der
Besucher, führen sie mitunter in unvorhergesehene Richtungen
oder lassen kaum noch Platz zum Umschreiten der Arbeiten. Sie
bestimmen die Raumerfahrung, setzen Proportionen in Bezie-
hungen und vermitteln trotz ihres provisorischen, zuweilen fragilen
Charakters eine intensive körperlich erfahrbare Präsenz. Die hier
postulierte Besetzung von Raum sollte man jedoch nicht überbe-
werten, da die Ambivalenz von (architektonischen) Raumgrenzen,
also die Wirkung und Beschaffenheit raumdefinierender Ober-
flächen nicht weniger ausschlaggebend für das Werk von Pernice
ist. Wände und Fassaden verwandeln sich in den Modellen von
Pernice zur Membran zwischen Innen und Außen, dienen als
Träger von Nachrichten und thematisieren bzw. persiflieren die
Omnipräsenz von Werbe- und Nachrichtenträgern im urbanen
Bereich. Er nutzt die Oberflächen seiner Arbeiten, indem er sie mit
Abbildungen aus Zeitschriften versieht oder an die Wände seiner
großen Arbeiten kleine Collagen und Fotos plaziert. Die klare
Trennung von privatem und öffentlichem Bereich kollabiert im
Werk von Pernice. Größenverhältnisse werden ad absurdum ge-
führt, wenn auf den Wänden der kleinen Modelle winzige Zeitungs-
abbildungen zu gigantischen Plakatwänden mutieren. In diesem
Zusammenhang ließen sich Vergleiche mit den wandgroßen, digi-
talen Medienbildschirmen von Jean Nouvel anstellen, allerdings
widerspricht die von Pernice bevorzugte Low-tech-Ästhetik die-
sem Vergleich. Wie bei seinen kleinen Modellen aus Pappe, aus-
rangierten Behältern oder Verpackungen verzichtet Pernice auch
bei seinen großen Einbauten aus Sperrholz bewußt auf formale
Perfektion und läßt schroffe Übergänge und Arbeitsspuren deut-
lich sichtbar. Die Verwendung heterogener, unkonventioneller Ma-
terialien ließe sich eher mit der Haltung eines Rem Koolhaas in
Beziehung setzen. Sowohl bei Koolhaas als auch bei Pernice

Manfred Pernice – *Yilmaz Dziewior* – Translated by
Toby Alleyne-Gee

Manfred Pernice's large-scale installations take possession of the
rooms in which they are exhibited. His architectural installations
and sculptural arrangements direct the viewer, occasionally lead-
ing him in an unexpected direction, and hardly leaving space for
him to walk around the exhibits. The installations determine how
the viewer experiences a room, influence its proportions and, de-
spite their provisional, even fragile character, have an intensely
physical presence. However, the way the installations dominate a
room should not be overestimated, as the nature of the surfaces
that define the space and the effect they have are a no less deci-
sive element in Pernice's work. Walls and façades are transformed
into a membrane between inside and out, and serve as bearers of
messages, drawing our attention to and satirising the omnipres-
ence of advertising and news in an urban environment. Pernice
covers the surfaces of his creations with newspaper pictures, or
places small collages and photos on the walls of his large-scale
installations. Pernice's work blurs all distinctions between the pri-
vate and public sphere. Relationships between dimensions are
taken to extremes when tiny newspaper pictures are blown up
into gigantic posters on the walls of small installations. In this
sense, they are comparable with Jean Nouvel's wall-size digital
screens, though Pernice's low-tech aesthetic contradicts the com-
parison. In his small models made of cardboard, old containers or
packaging, as well as in his large plywood installations, Pernice
consciously renounces formal perfection, leaving sudden transi-
tions and the traces of his work clearly visible. The use of a mix-
ture of unconventional materials can be compared with Rem
Koolhas' artistic approach. Both artists have a potentially utopian
message, though Pernice relativises this with his at times ironic
approach. Yet precisely this ambiguity is one of his strengths, as
well as an awareness of the complexity of the themes he tackles.
His is a realist vision of architecture, but it also reveals the possi-
bility of changing attitudes towards social and personal circum-
stances. Language, expressed in the form of statements written
with a typewriter and attached to small-scale cardboard models
as well as being integrated into his collages and creations in
paper, is a further characteristic of his work. These statements
emphasise the appellative function of the pictures stuck onto his
models, or evoke an absurd, humorous mood, such as when the
world is to be put in a tin can or one learns that the twittering of
birds symbolises happiness (for Pernice?). In this sense, Pernice's
designs are communication models in which visual signs and writ-
ten phrases are combined as poeticised statements with ironic
undertones. Pernice succeeds in combining the social and politi-

klingt ein utopisches Potential an, das bei letzterem jedoch durch ironische Brechungen relativiert wird. Eine Stärke der Arbeit von Pernice liegt gerade in der Uneindeutigkeit und dem Bewußtsein um die Komplexität der von ihm angerissenen Themen. Keine reale Architekturvision, aber die Möglichkeit einer veränderten Sicht auf soziale und persönliche Gegebenheiten klingt hier an. Dabei fungiert Sprache, die bei ihm in Form von schreibmaschinengeschriebenen Sentenzen sowohl auf den kleinen Pappmodellen wie auch in seinen Papierarbeiten und Collagen zu finden sind, als zusätzliches Element. Sie unterstützt den appellativen Charakter der aufgeklebten Bilder oder evoziert eine absurde und humorvolle Stimmung, wenn etwa die Verdosung der Welt anberaumt wird oder man erfährt, daß das Zwitschern der Vögel für jemand (Pernice?) das Glück darstellt. In diesem Sinne handelt es sich bei den Entwürfen von Pernice um Kommunikationsmodelle, auf deren Oberflächen sich visuelle Zeichen und schriftliche Äußerungen zu poetisierten Aussagen mit ironischem Subtext vereinen. Es gelingt Pernice, die sozialen und politischen Implikationen, die jeder Architekturform per se eingeschrieben sind, mit sehr persönlichen Aspekten, die sich aus dem Kontext der Entstehung und dem seiner eigenen Erfahrungen speisen, zu vereinen. Für die Ausstellung im Kunstmuseum Wolfsburg hat Pernice eine neue Arbeit produziert. Der Entstehungskontext dieser Arbeit ist durch eine spezifische räumliche und inhaltliche Situation bestimmt; beispielsweise ermöglicht die Empore des Kunstmuseums eine Aufsicht auf die unten stehenden Arbeiten. Auch inhaltliche Fragen des Konzeptes, ihr Anliegen, Gegenwartskunst in Deutschland vorzustellen, finden in der neuen Arbeit von Pernice einen verhaltenen Rückhall. Er integriert die Diaserie einer Künstlerin, die den Titel "Walhalla Straße/Fortuna Allee" trägt. Bei allem für Pernice charakteristischen kritischen Pessimismus schimmert auch etwas Ungebrochenes, eine Vorstellung von Erfolg und Glück durch, die so überspitzt eingesetzt wird, daß man sie kaum glauben kann.

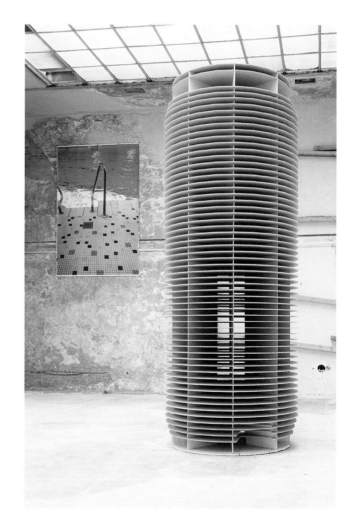

– **Sardinien**, 1996, 200 x 650 x 450 cm, European Art Forum Berlin, Stand Galerie Neu, Courtesy Galerie NEU, Berlin – **Platz**, 1998, Installation view, Courtesy Galerie NEU, Berlin – **Weinberg**, 1997, Holz, Preßspan, Farbe/Wood, pressboard, colour, 110 x 270 x 295 cm, Courtesy Galerie NEU, Berlin

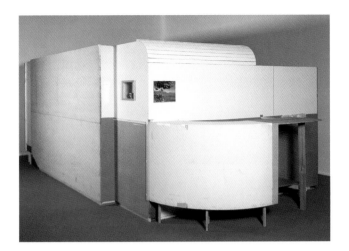

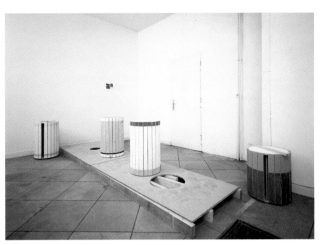

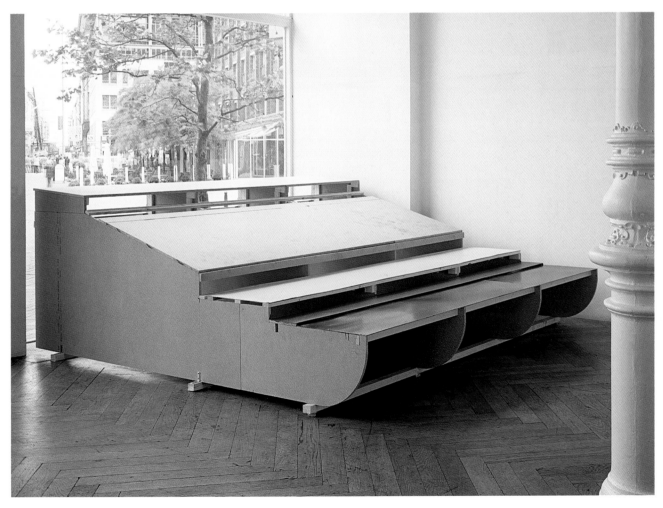

– **Klagenfurt u.a.**, 1999, Photo Angelika Hausenblas, Wien – **Klagenfurt u.a.**, 1999, Photo Angelika Hausenblas, Wien – **Fiat**, 1997, 300 x 650 x 150 cm, Courtesy Galerie NEU, Berlin

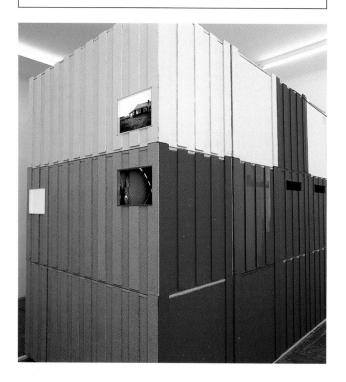

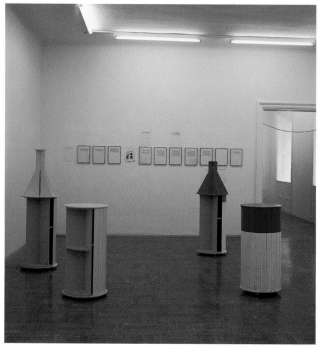

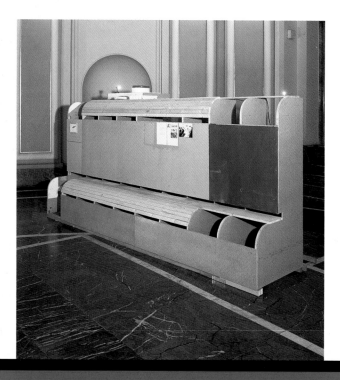

cal implications inherent to any form of architecture with deeply personal aspects related to the creation of the work and the artist's own experiences.

For the exhibition at the Kunstmuseum Wolfsburg, Pernice has produced a new work, the creation of which was determined by specific conditions regarding space and content. For example, the gallery of the museum enables the viewer to enjoy the artworks exhibited below. Conceptual issues, such as the museum's desire to present the works of contemporary artists in Germany, are discreetly echoed in Pernice's creation. He integrates the work of a woman artist, a series of slides entitled *Walhalla-Straße/Fortuna-Allee*, into his installation. Despite his characteristically critical pessimism, an idea of success and happiness also shines through in Pernice's work. Yet so it is expressed so exaggeratedly that it is hardly credible.

MANFRED PERNICE – Hildesheim, 1963 – Studium Grafik/Malerei, Braunschweig – Hochschule der Künste, Berlin – Wohnt/lives in Berlin

EINZELAUSSTELLUNGEN/ONE PERSON SHOWS: 1998 Galerie Konrad Fischer, Düsseldorf – E-Welten (maritim), Kunstverein Bremerhaven – A +J, London – Bad bath, Anton Kern Gallery, New York – Pilmut, Stella Lozhaus Galerie, Antwerpen – Migrateurs, Musée d'Art Moderne de la Ville de Paris, Paris (Katalog/catalogue) – Platz, Galerie NEU, Berlin **1997** Verkranzlerung, Kabinett für aktuelle Kunst Bremerhaven – D & A - Punkt, Galerie nächst St. Stephan, Wien **1996** Stralau 1, Kunsthalle Moabit, Berlin – Galerie Klemens Gasse, Köln **GRUPPEN-AUSSTELLUNGEN/GROUP SHOWS: 1998** Museum of Fine Arts, Warschau (Katalog/catalogue) – ars viva 98/99, Brandenburgische Kunstsammlung Cottbus, Kunstverein Braunschweig (1999), Portikus, Frankfurt am Main (1999) (Katalog/catalogue) – Berlin Biennale, Berlin (Katalog/catalogue) – Statement, Galerie NEU, Berlin, Art 98, Basel – Mai 98, Joseph Haubrich Halle, Köln (Katalog/catalogue) – Brytningstider, Norrköpingsmuseum, Norrköping (Katalog/catalogue) **1997** Urban living, Galerie Fons Welters, Amsterdam – Heaven, P.S.1 Museum, Long Island City, New York – Surprise II, Kunsthalle Nürnberg (Katalog/catalogue) – Biennale de Lyon (Katalog/catalogue) – Produzentengalerie Hamburg – Museu de Arte Moderna da Bahia, Salvador – Fiat, Künstlerhaus Stuttgart, Städtisches Museum Zwickau (Katalog/catalogue) – To show you what's NEU, Galleri Stalke, Kopenhagen (Katalog/catalogue) **1996** Etwas Besseres als den Tod findest du überall, Ladengeschäft Junghofstraße, Frankfurt am Main (Katalog/catalogue) – Something changed, Galerie Klosterfelde, Hamburg **1994** Steglitz I, FBK, Berlin **1993** exposition de cul, Ecole Nationale Supérieur des Beaux-Arts, Paris – Kunstausstellung Aufguß, Frontart, Berlin **1992** Benefizausstellung, Neue Gesellschaft für Bildene Kunst, Berlin – UNFAIR Köln, Spreefischer/TMF

Manfred Pernice

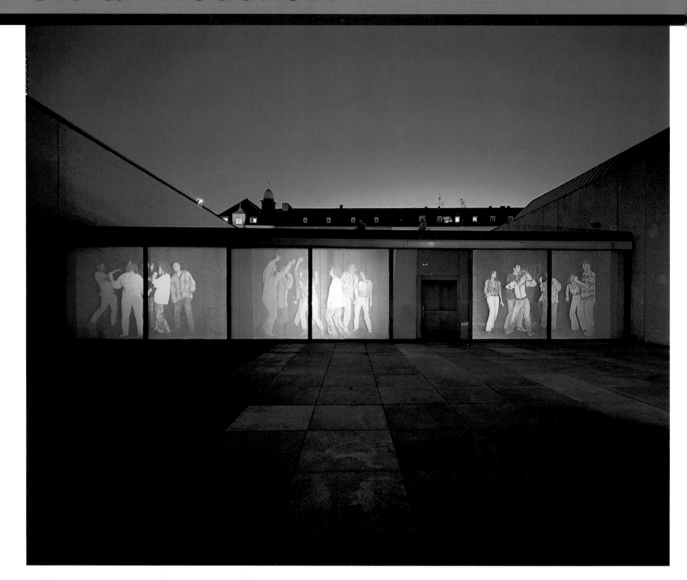

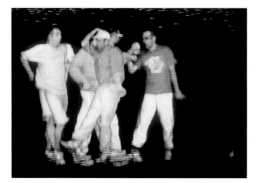
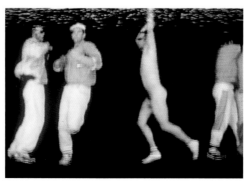

Stefan Hoderlein – *Catrin Backhaus und Georg Elben*

Kassettenhüllen, zerknickte Getränkedosen und Jägermeister-Fläschchen liegen in wüstem Durcheinander im Regal, die Wand ist tapeziert mit Programmen, Plakaten, Einladungskarten: "Birth of a Nation" (1995) ist eine Installation, die im siebten Jahr des Bestehens Techno ein Denkmal setzte. Als ruhiger Bildstrom dagegen verbinden sich in der Tonbildschau "Zauber der Operette" (1984–1986) Aufnahmen aus Südostasien, Standbilder aus Zeichentrick- und Kriegsfilmen, eigene Reiseaufnahmen und abfotografierte Fernsehbilder. Die Überblendung der Motive und der Klangteppich aus Musik, Filmdialog und Fernsehkommentar verschwimmen zu einer Geschlossenheit, die wie ein perfekt geschnittener Film wirkt.

Stefan Hoderleins Arbeit ist in ihrem Kern eine Sammlung von Kultur – Bildern, Gegenständen und Begriffen, zusammengesucht in seinem eigenen Leben oder dem gemeinsamen Alltag unserer Gesellschaft. In ihrer Anhäufung und Kombination entsteht ein inhärentes Beziehungsgeflecht, sie werden zum repräsentativen Kommentar über den ihnen eigenen Kontext und zum Spiegelbild einer künstlerischen Position.

Feuerzeuge und T-Shirts, Party-Flyer, Eintrittskarten, Drogenpapierchen, Fotos und Fernsehillustrierte: Im Wegwerfartikel manifestieren sich zeitgenössische Mythen im Sinne eines gesellschaftlichen Gebrauchs, der zu der reinen Materie hinzutritt. Stefan Hoderleins Sammlung enthält im verschwitzten T-Shirt die Erinnerung an eine selbst durchtanzte Nacht, wie seine Anhäufung und Ausstellung von Devotionalien der Techno-Szene über die Rave-Bewegung der neunziger Jahre hinaus auf Mode- und Pop-Phänomene verweisen. Als struktureller Bestandteil der westlichen Warengesellschaft verzahnen sich in der Jugendkultur abgrenzende Antihaltung und affirmativer Konsum. Hoderlein simulierte die auf weltweite Verbreitung zielenden massenkulturellen Erscheinungen mit der GKS, der Partei der Geheimnisvollen K-Strahlung. Als Student an der Düsseldorfer Akademie entwarf er einen Plastikausweis mit Paßfoto und Mitgliedsnummer und garantierte dem Träger nach dem Bekenntnis "Ja, ich begebe mich auf den Weg der Polydimensionalität" unsterbliche Verbundenheit mit der Organisation.

Dabei knüpft er als Künstler formal wie inhaltlich an existierende Mythen des Mainstream und dessen Medien. Videobilder Tanzender projiziert Hoderlein auf Schaufenster, Hausfassaden, Außenflächen. Das visuelle Material verwandelt Architektur und Raum in Skulptur. Die fließenden Körperbewegungen der "Old School Ravers/Mayday Posse" (1994) setzen schleichend das Zeitgefühl außer Kraft, die wie aufgezogen wirkenden Menschen scheinen für die Dauer des Tanzes in der Videoprojektion ausgestiegen aus

Stefan Hoderlein – *Catrin Backhaus and Georg Elben –* Translated by Toby Alleyne-Gee

There is an utter chaos of cassette boxes, crumpled cans and Jägermeister schnapps bottles on the shelves, and the wall is covered with programmes, posters and invitations: *Birth of a Nation* (1995) is an installation conceived as a memorial to seven years of techno. By contrast, the sound and image show entitled *The Magic of Operetta* (1984–1986) is a quiet stream of images consisting of photographs from Southeast Asia, stills from cartoons and war films, a few travel photos and images photographed directly from the television screen. The combination of images accompanied by music, film dialogue and television commentary blur into a unified whole not unlike a perfectly edited film. Stefan Hoderlein's work is basically a collection of cultures – images, objects and ideas that he has garnered bit by bit from his own life or from the common life of our society. By accumulating and combining them he creates an inherent network of relationships which in turn become a representative commentary on the specific context in which they arise, reflecting the attitude of the artist.

Lighters and T-shirts, party leaflets, tickets, paper wrappers from ecstasy pills, photos and television magazines: contemporary myths manifest themselves in disposable objects. This is a social attitude that embraces more than the merely material. Stefan Hoderlein's collection contains a sweaty T-shirt, the souvenir of a night he danced till dawn. The accumulation and display of devotional objects of the techno scene also refer to fashion and pop phenomena beyond the rave movement of the Nineties. As a structural component of western consumer society, youth culture combines an oppositional anti-attitude with affirmative consumption.

Hoderlein imitated the mass movements aiming at worldwide domination with his GKS (Geheimnisvolle K-Strahlung/Mysterious K-Radiation) party. As a student at the Dusseldorf Academy he designed a plastic identity card with a passport photo and membership number, guaranteeing the bearer, who affirmed his loyalty with the words "Yes, I shall tread the path of polydimensionality," eternal membership of the organisation.

In his work Hoderlein thus establishes a link with existing myths of the mainstream media, in terms of both form and content. He projects video images of dancers onto shop windows, the façades of buildings or walls. These images transform architecture and space into sculptures. The fluid movements of the *Old School Ravers/Mayday Posse* (1994) insidiously deprive us of our sense of time. For the duration of the dance, the dancers, who seem to be wound up like mechanical toys, appear to have turned their backs on the passage of time: time out. This is recorded in purely documentary style with a video camera on a fixed tripod,

– **Tanzende**, 1996, Württembergischer Kunstverein, Stuttgart – **Multiple Jack**, 1997, Videoprojektionen/Video projections

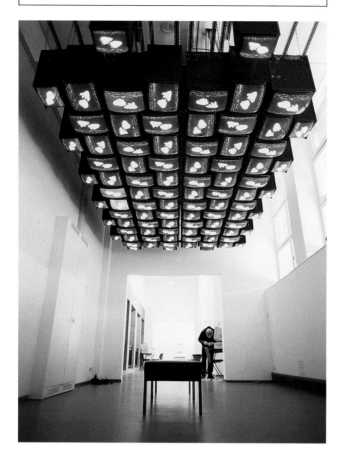

dem Weiterlaufen der Zeit: Time out. Dabei wird hier Lebenszeit als pure filmische Dokumentation mit einer unbewegt auf einem Stativ befestigten Videokamera festgehalten.

Es sind Freunde aus der Technoszene, die vor neutralem Hintergrund in einer künstlichen Aufnahmesituation die Party vortäuschen. Stefan Hoderlein tanzt selbst mit, während er parallel die Aufnahme überwacht – oder die Tanzfläche ist allein von ihm belebt, im Videoschnitt geklont als Party-Paroxysmus ("Multiple Jack", München 1997). Die Gruppe der Tänzer steht nicht beispielhaft für Mitglieder einer Szene, sondern wird zu einem aufgeladenem System in dem der rauschhaft-entgrenzte Tanz auch als Metapher für den glückseligen Moment eines Einklanges zwischen Menschen und Musik auf unendliche Dauer gedehnt wird. Die gleiche ununterbrochene durchtrainierte Beweglichkeit zeichnet auch das tanzende Auge aus, das Stefan Hoderlein als isoliertes Körperfragment auf großstädtische Fensterflächen projizierte (shift, Berlin 1999).

"20001 – Bilder aus der Jetztzeit" verspricht der Titel, die Wände der kleinen Kammer bestehen aus gefüllten Dia-Ordnern aus Plexiglas. Von hinten beleuchtet ist jedes einzelne Rähmchen

while Hoderlein supervises filming – or appears, a multiple clone, as the only dancer on the floor, the party paroxysm (*Multiple Jack*, Munich 1997). The group of dancers is not an example of members of a milieu, but becomes a system in which the ecstatically frenzied dance is extended to infinity as a metaphor for that blissful moment when people and music are in harmony. The same uninterrupted, well-conditioned agility can be observed in the dancing eye that Stefan Hoderlein projected onto windowpanes as the isolated fragment of a body (shift, Berlin 1999).

"20001 – Images of Now" is the promising title. The walls of the small room consist of full perspex slide boxes. Lit from behind, every single brightly coloured frame can clearly be seen. A mosaic of over forty thousand individual pictures: video stills, young dancers, exotic plants, individual garments. These images, arranged more or less coincidentally according to theme or colour, create an almost entirely closed curio room, a manic display of the artist's life's work to date. Its overwhelming size is a physical challenge to the viewer, forcing him to see the installation as a whole; on the other hand, it permits total freedom of interpretation of the individual images: the picture as a building block, in both senses of the word.

None of Stefan Hoderlein's works, be it a video projection onto the walls of a building or a windowpane, the arrangement of plastic lighters or slide boxes, the combination of garments or headlines, lays claim to eternity. What is displayed can be reorganised, the arrangement is never indissoluble. The fragmentary nature of the linguistic and visual levels discernible in his creations allows unlimited new combinations, infinite sampling of objects, word combinations, images …

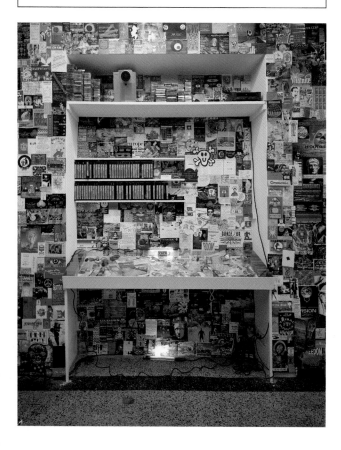

strahlendbunt erkennbar, ein Mosaik aus mehr als vierzigtausend Einzelaufnahmen: monochrome Videostills, tanzende Jugendliche, exotische Pflanzen, einzelne Kleidungsstücke. Sortiert mehr oder weniger zufällig nach Thema oder Farbigkeit, entsteht im Diaraum ein fast allseitig geschlossenes Panoptikum – die manische Ausbreitung eines vorläufigen fotografischen Lebenswerkes in der Installation. Eine körperlich herausfordernde Inszenierung, die in ihrer überwältigenden Statuarik die Möglichkeiten der Rezeption von Einzelbildern total freigibt: Bilder als Bausteine im doppelten Wortsinn. Keine Anordnung Stefan Hoderleins – sei es die Projektion auf Häuserwände oder Fenster, die Anordnung von Plastikfeuerzeugen oder Diakästen, die Kombination von Kleidungsstücken oder Schlagzeilen – beansprucht in ihrer Erscheinung Ewigkeit. Die Präsenz des Gezeigten trägt in sich die Möglichkeit der Re-Organisation, nie erscheint die Zusammenstellung unauflöslich. Die Fragmentierung der sprachlichen und visuellen Ebenen ermöglicht jede Neukombination, ein unendliches Sampeln von Gegenständen, Wortkombinationen, Bildern …

STEFAN HODERLEIN – Düsseldorf, 1960 – Kunstakademie Düsseldorf – Wohnt/lives in Düsseldorf

Photo Mike Schultz, Berlin

EINZELAUSSTELLUNGEN/ONE PERSON SHOWS: 2000 Parkhaus, Düsseldorf **1999** First Of A New Breed!, Shift e.V. & Transition, Berlin **1998** Love - Life - Mental, Kunstraum Heidelberg **1997** Anonyme Bekenntnisse – Private Ravers, Shift e.V. & Galerie Fricke, Berlin – Mental Mayhem, Windows 1997, Kunstverin NRW, Düsseldorf – Mach !, Galerie Lindig, Nürnberg – 20001 Bilder aus der Jetztzeit, Neuer Aachener Kunstverein (Katalog/catalogue) – Castello di Rivara, Rivara, Italien **1996** Zuspiel – Honert – Hoderlein, Württembergischer Kunstverein, Stuttgart, Arnolfini, Bristol (Katalog/catalogue) **1995** The Seven Years Itch - Techno 1989 – 1995, Bochynek, Düsseldorf **1993** Everything Starts Whizz an E, Schmidl & Haas Ausstellungsraum, Frankfurt – Forum Bilker Straße, Düsseldorf **1988** Planet Galerie, Düsseldorf **GRUPPENAUSSTELLUNGEN/GROUP SHOWS: 2000** Ich ist etwas anderes - Kunst am Ende des 20. Jahrhunderts, Kunstsammlung NRW, Düsseldorf **1999** Virtual TakeOver - Siemensstadt Schaltwerk, BerlinVideo Virtuale – Foto Fictionale, Museum Ludwig, Köln **1998** Glut, Kunsthalle Düsseldorf – How Low You Can Go …, Brückengang, Köln – Förderkoje, Art Cologne, Köln **1997** Blick von Innen, Galerie Reitz – Auto-Kino, Neuer Aachener Kunstverein – Mum's out – Die Mäuse auf dem Tisch, Theater am Halleschen Ufer, Berlin – Tanztendenzen, Greifswald – Deep Storage - Arsenale der Erinnerung, Haus der Kunst, München, Kulturforum, Berlin Kunstmuseum im Ehrenhof, Düsseldorf (1998), P.S.I, New York (1998) (Katalog/catalogue) – Art of Change, Hamburger Bahnhof, Berlin – Showroom im M>1, Nürnberg – Windows 1997, Kunstverein der Rheinlande und Westfalen, Düsseldorf (Katalog/catalogue) **1996** Projektionen, Kunsthalle Wien – Mixed Pixels - Students of Paik, Kunstmuseum Ehrenhof, Düsseldorf (Katalog/catalogue) – U. TV, Köln – Etwas besseres als den Tod findest du überall, Ladengeschäft Junghofstraße, Frankfurt am Main (Katalog/catalogue) – Letzter Aufguß, Dampfbad Grünstraße, Düsseldorf (Katalog/catalogue) **1995** 3-Lux, Essen – Club Berlin, Rahmenprogramm Biennale, Venedig – Belebung III, Chemnitz (Katalog/catalogue) – Es ist alles wahr, Galerie Fricke, Düsseldorf – Wie gemalt, Neuer Aachener Kunstverein – Kunstraum Heidelberg – Vorspiel II, Bochynek, Düsseldorf – How Is Everything, Wiener Session **1994** Korova Milchbar, Essen – Ideal Copy - Channel Open, Shiseido Gallery, Tokyo – Chromapark, E-Werk, Berlin – Zu Besuch bei…, Eisenstraße, Düsseldorf – Freundschaftsspiel, Kunsthalle Düsseldorf – Love To Thw Larynth, 4 Aces Dalston, London – Treibhaus VI, Kunstmuseum Düsseldorf **1993** Blumfeld, Anthology Film Archive, New York – Sammlung Brinkmann, Interims Galerie, München – Dank, Malerei 2000, Hamburg, Stockholm – Zu Besuch bei…, Kölner Straße, Düsseldorf – Everything Starts Wiz An E, Schmidl & Haas Ausstellungsraum, Frankfurt am Main **1992** Kunst und Ökonomie, Sammlung Brinkmann, Spielkasino Hohensyburg – Phase 270, Forum Bilker Straße, Düsseldorf – Schmidl & Haas Ausstellungsraum, Frankfurt am Main **1990** Wunder der Inspiration, Sammlung Brinkmann, Düsseldorf **1989** Jablonka Galerie, Köln – Goethe-Institut, London **1987** Die Anweisung, Berlin **1986** Art Magazin, Zürich – AVE, Mediafestival, Arnheim (Katalog/catalogue) – Kultur 90, Hansaallee 11, Düsseldorf

Stefan Hoderlein

Peter Friedl

– **Nothing can stop us**, 1999, 48. Biennale di Venezia, Photo Filippo Mastinu

Code als Köder – *Raimar Stange*

"... eine Ordnung entstellen, ohne sie zu verlassen." –
(Michel de Certeau)

"VEBA stellt Regierung Ultimatum" steht da als Headline in einer großen deutschen Tageszeitung. Wenige Tage zuvor hieß es: "Automobilindustrie ermahnt Schröder". Nicht um versehentliche "Dreher" der Nomen handelt es sich hier, sondern um recht präzise Beschreibungen der real-existierenden Machtverhältnisse in unserer sogenannten Demokratie. Nur allzu leicht gehen heute solche Formulierungen von der Zunge, auf das Papier und schließlich unreflektiert ins Hirn.

(Nicht zuletzt sprachlich konstituierte) Hegemonie ist das wohl zentrale Untersuchungsfeld der Kunst von Peter Friedl. Da steht z.B. eine Garage in der eigentlich autofreien Zone Venedig direkt vor dem Österreichischen Pavillon der Biennale 1999. Das Tor der wahrscheinlich ersten Garage Venedigs bleibt, entgegen des vom Kurator des Pavillons ausgegebenen Konzeptes der Öffnung, während der gesamten Ausstellungszeit geschlossen.

Gerade durch diese engagierte Abwehr erweist sich die Arbeit dann als tendenziell "offenes Handlungsfeld": Als sich querstellendes Objekt entwickelt das "Displacement" eine Kraft, die im Nichtmitspielen ihr eigenes Spiel spielt – ohne dabei sich oder dem Gegenüber eine verlogene Autonomie des Handlungsweisen vorzugaukeln. Auch der Titel der Arbeit "Nothing can stop us" transportiert genau diese Dialektik von Innen und Außen, von Dabeisein und Sich-Verweigern. Weist der Satz doch einerseits hin auf die US-imperialistische Losung Dennys aus dem Jahre 1930 "We shall not make Britain's mistake. Too wise to try to govern, we shall merely own it. Nothing can stop us". Andererseits zitieren die scheinbar euphorischen vier Worte den Titel des gleichnamigen Politpop-Projektes von Robert Wyatt aus den frühen achtziger Jahren. Hier wie da steht Hegemonie zur Disposition, im Durchkreuzen der Codes wird sie transparent und so für einem Moment lang nicht selbstverständlich, dadurch vielleicht gar verhandelbar.

Auch Peter Friedls wohl bekannteste Arbeit "KINO" (1997) nutzt Sprache als Köder, spielt mit der Geschichte der künstlerischen Arbeit "in situ" und bringt dabei sämtliche Codes selbstbewußt und gleichzeitig verwirrend durcheinander. In knallroten Helvetica-Lettern stand damals das Wort "KINO" auf dem Dach der documenta-Halle und betonte während der documenta X mit "präzisen Mißverständnissen" (Friedl) prominent sichtbar die Risse und Verschiebungen, die jede Wahrnehmung erst konstituieren. Die scheinbar beiläufig, letztlich aber überaus präzise plazierte Skulptur benannte in signifikanter Praxis plakativ ein Gebäude, in dem

Words as Bait – *Raimar Stange* – Translated by Toby Alleyne-Gee

"Distorting order without rejecting it."
(Michel de Certeau)

"VEBA presents the government with an ultimatum," read the headline in one of the major German newspapers recently. A few days earlier, it had been "Motor industry warns Schröder." These are not grammatical errors, reversals of subject and object, but very precise descriptions of the real balance of power in our so-called democracy. Such pronouncements are made all too easily nowadays, and are transferred without much consideration directly to our brains.

The main topic examined in Peter Friedl's work is hegemony, which after all is influenced considerably by language. For example, at the 1999 Venice Biennale a garage stands directly in front of the Austrian pavilion, and this in a car-free city. Contrary to the idea of openness postulated by the curator of the pavilion, the door of this garage remains closed throughout the exhibition. It is precisely this rebellious attitude that reveals the work as an "open field of action." As an obstructive object, the "displacement" becomes a powerful symbol of truculence, without pretending to itself or the viewer that it is an autonomously active entity. The title of the work, *Nothing can stop us*, contains this dichotomy between interior and exterior, taking part and refusing to cooperate. The title refers on the one hand to Denny's imperialistic American slogan of 1930, "We shall not make Britain's mistake. Too wise to try to govern, we shall merely own it. Nothing can stop us." On the other hand, these apparently euphoric four words are a quotation of the title of Robert Wyatt's politico-pop project of the early Eighties. In both works, hegemony is the theme. By crossing the linguistic codes it becomes transparent and thus, for a moment, no longer a matter of course, and hence perhaps even negotiable.

Peter Friedl's probably best known work, *KINO* ("CINEMA") of 1997 uses words as bait, refers to the history of works of art "in situ" and thus confidently confuses every code. The word *KINO* was mounted in bright red Helvetica script on the roof of the documenta exhibition. From its prominent position, the "precise misunderstandings" (Friedl) it engendered emphasised the cracks and shifts that are an integral part of perception. The sculpture, seemingly casually, yet extremely precisely positioned, served to name a building in which visual design is exhibited.

This time, however, what was at issue was not merely "contemptible" film, but art, ennobled (at least from a Eurocentric perspective) by its presence at one of the world's major art exhibitions, justifying its hegemonic claims. The font used for the

– **Ohne Titel (brothers in crime)**, 1998, Wandmalerei/Wall painting, 270 x 720 cm, Galerie Erna Hécey, Luxembourg, Photo Yvan Klein – CD-Cover, Robert Wyatt, Nothing Can Stop Us

visuelle Gestaltung wahrgenommen wird. Allerdings handelte es sich diesmal nicht bloß um "schnöden" Film, sondern vielmehr um von einer der – aus eurozentristischer Sicht – weltwichtigsten Kunstausstellung geadelten Kunst, die von hier aus ihren hegemonialen Anspruch begründet. Die besagte Typographie der Arbeit zitierte zudem das Corporate Design des dortigen Staatstheaters, und auch da werden ja bewegte Bilder gegen Eintritt zur so kritischen wie unterhaltenden Wahrnehmung angeboten. Doch damit nicht genug der sich generierenden Referenzen: KINO weist hin auf die weitläufige Medienpräsenz von kulturellen Großprojekten, hin auf den Unterhaltungswert von Kunst und auch auf die kommerziellen Interessen, die längst solche "Kulturevents" erst ermöglichen. Die Überfülle der Referenzen, die sich widersprechen, verstärken und verdrehen, löst sich letztlich auf in einen hierachie- und regellosen Raum, der Sinn macht, weil er diesen Sinn – auch in seiner politischen Dimension – entlarvt.

So ist Peter Friedls Kunst begründet in einer tiefen Skepsis gegenüber jedweder real-existierenden (sprachlichen) Ordnung – und in der Hoffnung auf pragmatische Handlungen, die diese produktiv für sich ummünzen: das Aufbegehren als vielschichtig-semantische Praxis vor Ort.

– **Kino**, 1997, Aluminium, Neon, Plexiglas, Stahl/Aluminum, neon, perspex, steel, 15 x 40 x 500 cm, documenta X, Kassel, Photo Dieter Schwerdtle – **De Salvio Playground**, 1999, New York City

sculpture was the same used for the corporate design of the city's state theatre, where critical audiences can, for a fee, enjoy moving pictures. But the references don't stop there: *KINO* also refers to the omnipresence of large-scale cultural projects in the media, to the entertainment value of art, and also to the commercial interests that have long since made such "cultural events" possible. The abundance of references that contradict, intensify and twist each other finally dissolve into a non-hierarchical, lawless space. This space makes sense, because it unmasks other aspects, including the political dimension.

Peter Friedl's art is based on a deeply sceptical attitude towards any kind of existing (linguistic) order – and on a hope for pragmatic action that will transform this to its own advantage: rebellion as a subtle, locally based semantic act.

EINZELAUSSTELLUNGEN/ONE PERSON SHOWS: 1999 Neuer Berliner Kunstverein, Berlin (Katalog/catalogue) – Neue Galerie am Landesmuseum Joanneum, Graz – Galerie Arndt & Partner, Berlin – FRAC Languedoc-Roussillon, Montpellier – The Living Art Museum, Reykjavik – Galerie Walcheturm, Zürich **1998** Peter Friedl, Palais de Beaux Arts, Brüssel (Katalog/catalogue) – MK Expositieruimte, Rotterdam – Museum Industrieller Arbeitswelt, Steyr (Katalog/catalogue) – Galerie Erna Hécey, Luxembourg – Gummi TV, Los Angeles Contemporary Exhibitions (mit/with Olav Westphalen), Los Angeles – Box, Galerie Pohlhammer, Steyr **1997** La Bohème, Kunstraum Mitte, Berlin **1996** City Projects Prague, Prag (Katalog/catalogue) – FRACK, W139, Amsterdam, Künstlerhaus Bethanien, Berlin (Katalog/catalogue) **1995** Hotel Mama, Kunstraum Wien, Wien – Akademie der bildenden Künste, Prag (Katalog/catalogue) **1994** MK Expositieruimte, Rotterdam – T.I.P., Galerie im Stifterhaus, Linz (Katalog/catalogue) – Museum Moderner Kunst, Passau **1993** Galleria Alberto Weber, Turin – Galerie Pohlhammer, Steyr – Galerie Theuretzbacher, Wien (Katalog/catalogue) – Galerie Na bidylku, Brno – HINAUS MIT UMS, Turin, Venedig, Brno – I SURVIVED THE GERMAN PAVILLION, Venedig **1992** Galerie Pohlhammer, Steyr (Katalog/catalogue) **1991** Galerie Na bidylku, Brno **1990** Christine König Galerie, Wien (Katalog/catalogue) **1989** Galerie Bleich-Rossi, Graz **1988** Galerie Bleich-Rossi, Graz (Katalog/catalogue) **GRUPPENAUSSTELLUNGEN/GROUP SHOWS: (Auswahl/selected): 1999** Children of Berlin, P.S.I, Contemporary Art Center, New York – Konstruktionszeichnungen, Kunst-Werke, Berlin – Galerie Voges + Deisen, Frankfurt am Main – 1999, P.S.1, Contemporary Art Center, New York – Dream City, München (Katalog/catalogue) – Rosa für Jungs – Hellblau für Mädchen, Neue Gesellschaft für bildende Kunst, Berlin (Katalog/catalogue) – Offene Handlungsfelder – Open Practices, Österreichischer Pavillon, 48. Biennale di Venezia (Katalog/catalogue) – Looselipssinkships, Galerie Erna Hécey, Luxemburg – Movin Images, Galerie für Zeitgenössische Kunst, Leipzig **1998** Galerie Anita Beckers, Darmstadt – Resolution, Galerie Arndt & Partner, Berlin – Do All Oceans Have Walls?, Bremen (Katalog/catalogue) – Don't look now, Galerie Walcheturm, Zürich – art club berlin, Pavelló Mies Van der Rohe, Barcelona – Cet été là…, Centre Régional d'Art Contemporain, Séte (Katalog/catalogue) – APC Galerie, Salzburg – Transformation, Teatro Miela, Triest (Katalog/catalogue) – 15. Kasseler Dokumentarfilm- und Videofest, Filmladen Kassel e.V., Kassel (Katalog/catalogue) – 1 + 3 = 4 * 1, Galerie für Zeitgenössische Kunst, Leipzig – La Macchina del Sognis, Belvedere di San Leucio, Caserta – Global Fun, Städtisches Museum Schloß Morsbroich, Leverkusen **1997** Nets, Galleria Lucio Amelio, Neapel – Zeitskulptur, Landesgalerie Linz (Katalog/catalogue) – Space Oddities, Canary Wharf, London – Contemporanea, Palazzo Pubblico, Siena – documenta X, Kassel (Katalog/catalogue) – Città aperta, Cittá Sant'Angelo – Gamblers, Palazzo Reale, Caserta – art club berlin, art forum, Berlin (Katalog/catalogue) – look, Künstlerhaus Bethanien, Berlin **1996** Casa di Giorgione, Castelfranco Veneto – Das doppelte Kleid, Schloß Ottenstein (Katalog/catalogue) – Natura Naturans, Museo Civico di Storia Naturale, Triest (Katalog/catalogue) – Palazzo con Vista, Palazzo Frangipane, Tarcento – Mutoidi, Castelnuovo Maschio Angioino, Neapel **1995** Na hrane, Galerie Václava Spály, PragThe Spring Project, Österreichische Galerie/Ambrosi Museum, Wien (Katalog/catalogue) **1994** Rien à signaler, Galerie Analix, Genève (Katalog/catalogue) – Inventario 3, Galleria Loft, Valdagno – My Car Is Black, And Yours Is White, KIC, Brno (Katalog/catalogue) – Positionen, Museum industrielle Arbeitswelt, Steyr, Kunstforum Hallein (Katalog/catalogue) – Ars Lux, Made in Bo, Bologna – Double Density, Galerie Pohlhammer, Steyr, Galleria Alberto Weber, Turin, Galleria Neon, Bologna (Katalog/catalogue) **1993** Wewerka Galerie, Berlin – Galerie Theuretzbacher, Wien – Einblick, Landesgalerie, Linz **1992** The Last Rose of Summer, Galerie Wanda Reiff, Amsterdam **1989** Congress Centrum, Hamburg (Katalog/catalogue) – Galerie Bleich-Rossi, Graz **1986** Castello di Rivara, Rivara/Turin (Katalog/catalogue)

Peter Friedl

Marc Brandenburg

– **Ohne Titel**, 1999, Bleistift auf Papier/Pencil on paper, 21,5 x 17 cm

Strahlende Leere – Marc Brandenburgs
doppelgängerische Bilderwelt – *Oliver Körner von Gustorf*

Bei Ohnmachtsanfällen wie auch in Sekunden extremer Todes-
angst rast das eigene Leben als ein sich rückwärtsspulender
Film am inneren Auge vorbei, während sich der Körper in einem
Auto überschlägt, ins Leere fällt oder bewußtlos liegenbleibt. Marc
Brandenburgs Bildserien erscheinen wie stroboskopartig auf-
flackernde Standbilder, die in der Umkehrung von Schwarz und
Weiß als halluzinogener Bilderbogen auferstehen.
"Snapshots" nennt Brandenburg die auf von ihm fotografierten
und kopierten Vorlagen basierenden Bleistiftzeichnungen der zwi-
schen 1998 und 1999 entstandenen Serie "meddle".[1] Branden-
burg zeigt vor allem eines: Körper in von wechselndem Licht
bestimmten Räumen. Körper – das sind ebenso Plastiktiere, Tee-
tassen, Aschenbecher wie die Körper seiner Freunde und Lieb-
haber. Roland Barthes hat Fotografie als "eine Art urtümliches
Theater, eine Art von 'Lebendem Bild': die bildliche Darstellung
des regungslosen, geschminkten Gesichtes, in dem wir die Toten
sehen"[2] gedeutet. Er bezog sich dabei auf die ursprüngliche Be-
ziehung zwischen Theater und Totenkult: "Die ersten Schauspie-
ler sonderten sich von der Gemeinschaft ab, indem sie die Rolle
der TOTEN spielten: Sich schminken bedeutete, sich zugleich als
einen lebenden und toten Körper zu kennzeichnen (…)."[3]
Immer wieder tauchen in "meddle" die grotesken Plastiknasen
auf, die Alex und seine Droogs während der Vergewaltigungs-
szene in Stanley Kubricks "A Clockwork Orange" aufsetzen. Die
Über- und Unterbelichtung der Vorlagen macht die Gesichter der
Porträtierten unkenntlich und läßt sie maskenhaft erscheinen.
Durch die möglichst detailgenaue Übertragung von fotografi-
schen Effekten in analoge zeichnerische Gesten entsteht ein
Vorgang, der dem Schminken nicht unähnlich ist. Schärfe und

– **Ohne Titel**, 1999, Bleistift auf Papier/Pencil on paper, 21,8 x 16,5 cm,
Sammlung/Collection Herbert Volkmann, Berlin

- **Ohne Titel**, 1999, Bleistift auf Papier/Pencil on paper, 21,8 x 16,9 cm

Glowing Void – Marc Brandenburg's Doppelgänger Imagery
– *Oliver Körner von Gustorf* – Translated by Toby Alleyne-Gee

In a faint or moments of extreme fear, the events of your life are replayed in flashback before your inner eye, while your body rolls over in a car, falls into an abyss or lies unconscious. Marc Brandenburg's pictures flash like stroboscopic stills that are resurrected as a series of hallucinogenic images. Black and white are reversed. Brandenburg describes the series of pencil drawings he photographed and copied between 1998 and 1999 for *meddle* as *snapshots*. *Meddle*[1] shows the body in spaces bathed in changing light. The bodies in the series are also those of plastic animals, teacups and ashtrays, as well as those of Brandenburg's lovers. Roland Barthes sees photography as "a kind of primeval theatre, a 'living picture': the representation of the motionless, made-up face in which we see the dead."[2] What he means is the basic relationship between theatre and the cult of the dead: "The first actors withdrew from the community by playing the role of the DEAD: wearing make-up meant characterising oneself as both a living and a dead body […]."[3]

The grotesque plastic noses worn by Alex and his accomplices in the rape scene in Stanley Kubrick's *A Clockwork Orange* recur constantly in *meddle*. By over- or underexposing the photographs of the original drawings, Brandenburg invests the faces of those portrayed with a mask-like quality that renders them almost unrecognisable. The effect of the transfer of highly detailed pho-

– **Ohne Titel**, 1999, Bleistift auf Papier/Pencil on paper, 21,5 x 16,8 cm

Belichtung wiederholen sich als Verdichtung und Ausdünnung von Graphit auf dem Papier. Als einsame totemistische Akteure vollziehen die abgebildeten Körper autistische Riten jugendlichen Begehrens, brechen sich in Spiegeln, zerfließen in Wasser oder dehnen sich in manieristischen Posen in den Raum.

"Meddle" beschreibt aus subjektiver Sicht Bewegungen, die sich aus Einzelbildern zusammensetzen: Das Kreisen um einen im Raum schwebenden Fußball, das Eintauchen ins Gebüsch, das Anrühren von Haarfarbe. Wie bei einem alchemistischen Prozeß sind für Brandenburg die Zerstückelung und Zergliederung des fotografierten Körpers notwendige Voraussetzung für dessen Reinigung, Verjüngung und Wiedergeburt.

Den Arbeiten Brandenburgs haftet trotz der ausschließlich figurativen Darstellung etwas Amorphes an. Organisches wandelt sich zu Unorganischem, Plastik zu Haut, Glühen zu Erlöschen. Die Physis erscheint als transparentes Behältnis oder illuminierter Scherenschnitt, durch dessen Auslassungen gleißendes Licht dringt. Da, wo zeitgenössische Kunst und Fotografie den Körper als authentisches Medium zelebrieren, läßt Brandenburg ihn gleichmütig zurück. Er stellt ihm jenseitige Doppelgänger entgegen, die mit ihrem Vorbild nichts mehr verbindet als die Erinnerung an eine flüchtige Hülle, die getragen wird wie ein Anzug, eine Armkette oder eine Maske. Auch wenn sich in Brandenburgs Bilderwelt Sex, Mode und Alltagskultur in verschiedenen körperlichen Formen manifestieren, gibt es hier nur eine Form – die des Hohlkörpers, der von strahlender Leere erfüllt ist.

– 1 "Meddle", engl. für: sich (unberufen) mit etwas befassen oder abgeben; "meddle" war auch der Titel, des 1971 erschienenen Albums von Pink Floyd. – 2 Roland Barthes, "Die helle Kammer – Bemerkung zur Photographie", Suhrkamp Verlag, Frankfurt am Main, 1989, S. 41. – 3 Ebd.

tographic effects into the drawings is not dissimilar to that of make-up. Focus and exposure are reflected in the varying thickness of the graphite on the paper. Like lonely, totemistic actors, the bodies depicted perform the autistic rituals of youthful desire, their reflections are split in mirrors, dissolve into water or strike expansive, mannerist poses. *Meddle* is a subjective description of movements, consisting of individual images: the camera circles a football hovering in space, dives into bushes or records the mixing of hair dye. As in an alchemistic process, dismemberment and dissection are a prerequisite to cleansing, rejuvenating and resurrecting the photographed body.

Despite its exclusively figurative style, there is something amorphous about Brandenburg's work. The organic becomes inorganic, plastic is transformed into skin, a blaze is extinguished. The physique appears as a transparent container, or as a silhouette illuminated by blazing light. While contemporary art and photography celebrate the body as an authentic medium, Brandenburg indifferently leaves it behind, confronting it with doppelgänger from another world who have no more in common with what they are imitating than the memory of a transient garment, worn like a suit, a bracelet or a mask. Even if sex, fashion and everyday culture manifest themselves in Brandenburg's images, there is only one form – that of a hollow body, filled with a glowing void.

– 1 *Meddle* was also the title of Pink Floyd's 1971 album. – 2 Roland Barthes, *Die helle Kammer – Bemerkung zur Photographie*, Suhrkamp Verlag, Frankfurt am Main, 1989, p. 41. – 3 Op. cit.

MARC BRANDENBURG – Berlin, 1968 – Wohnt/lives in Berlin

Photo Courtesy Theodore von Oppersdorff, Küsnacht/Schweiz

EINZELAUSSTELLUNGEN/ONE PERSON SHOWS: (Auswahl/selected): 1999 Meddle, XL Gallery (Xavier La Boulbenne), New York **1996** The Dangling Conversation – From Electric Lane to Lavender Hills, Moris Healy Gallery, New York **GRUPPENAUSSTELLUNGEN/GROUP SHOWS: (Auswahl/selected) 1999** Lovevolution, XL Gallery (Xavier LaBoulbenne), New York – Gallery Swap – Contemporary Fine Arts at Sadie Coles HQ, Sadie Coles HQ, London **1998** Draw Stranger, PLUG IN, Winnipeg, Kanada – Infected Culture, Cubitt Gallery, London

Marc Brandenburg

Daniel Richter

– Babylon Disco vs. Disco Babylon, 1999, Ölfarbe, Lack auf Leinwand/Oil and varnish
on canvas, 225 x 145 cm, Courtesy Contemporary Fine Arts, Berlin, Photo Jochen
Littkemann, Berlin

In ihrer Rhetorik ähneln Daniel Richters Bilder Baudelaires "Blumen des Bösen": als sei der durch inflationäre Fülle ungehöriger Informationen ausgelöste Kollaps des Betrachters die Voraussetzung künstlerischen Selbstbewußtseins und fortgesetzter ikonoklastischer Aktivität. Hier zwingt uns jemand, zuzusehen, wie ihm die Dinge über den Kopf wachsen, und zwar in selbstinszenierter und deshalb klar als Herausforderung zu wertender Weise. Der Kampf gegen die Verwirrung gewinnt exemplarischen Status. Daniel Richter hat beschlossen, durch eine Glasdecke hindurch auf die Unterwäsche der Dame Malerei zu blicken, um vielhändig und simultan auf solche Einsicht zu reagieren. Diese Neigung zu fundamentalistischer und despektierlicher Sicht hat vermutlich mit des Künstlers politischer Sozialisation in der Autonomenszene Hamburgs zu tun. Als Dreißigjähriger begann der 1962 in Eutin geborene Daniel Richter an der Hamburger Hochschule für Bildende Kunst ein Malereistudium bei Werner Büttner und arbeitete später als Assistent von Albert Oehlen. Das bestärkte ihn in der analytischen Haßliebe zur Malerei. Daniel Richter widmet sich seitdem der Frage, wie man entsprechende Argumente in die Bilder bringt, ohne der Abbildlichkeit oder Anekdote zu verfallen. Mit anderen Worten – wie sich relevant abstrakt malen läßt, ohne dabei ein gemütliches, nämlich schönheitsfixiertes und reduktives Verhältnis zur Tätigkeit einzunehmen. Richter hält seine Bilder von erläuternden Referenzen auf Außerkünstlerisches frei, er meidet die Illustration von Besserwisserei, die heute einige junge Künstler wie Sozialarbeiter erscheinen läßt. Natürlich steckt auch Richter in dem Dilemma jedes Malers, die jüngste und ferne Vergangenheit des Mediums zur Kenntnis nehmen zu müssen und sich kontrafaktisch darauf zu beziehen. Bei Richter wirken bestimmte Bezüge so profaniert, daß man Gefahr läuft, sich lächerlich zu machen, wenn man von der Zeitlichkeit signalisierenden Geste des Dripping spricht, von Bildebenen stabilisierender Geometrisierung, von lasierender Bewahrung vorgängiger Bildpläne, von verzückter Ausschmückung trivialer Motive. Obwohl Richters Bilder quallenartig auf den Betrachter eindringen und dies nur können, weil sie sich von anfänglicher Bodenhaftung lösen, um sich stoßweise und Ebenen durchmischend fortzubewegen, gibt es doch immer wieder die paradoxe Behauptung einer Ankunft – durch die "tags", die einen stabilisierten Tatbestand überziehen – als sei das Bild nur vollständig als Einschreibungsfläche einer anonymen Signatur und damit gruppenspezifischer Besitznahme. Doch auch die Graffiti-Geste selbst wird anonymisiert. In jeder Richtung verweigern Richters Bilder den weltanschaulich geordneten Zustand, sie organisieren statt dessen ein Kontinuum der Abstoßung, der fortgesetzten Rempelei, der beiläufigen Tilgung. Wenn der Maler mit

Crash Course in Painting – *Rudolf Schmitz* – Translated by Toby Alleyne-Gee

The rhetoric of Daniel Richter's paintings is similar to that of Baudelaire's *Les Fleurs du Mal*: as if the collapse of the viewer, provoked by an excessive amount of irrelevant information, were a prerequisite of artistic self-confidence and continued iconoclastic activity. The artist forces us to watch as things go beyond his control – though this is deliberate and hence to be interpreted as a challenge. The fight against confusion attains exemplary status. Daniel Richter has decided to look up the skirts of Lady Painting from under a sheet of glass, simultaneously reacting with many hands to what he sees. This tendency towards a fundamentalist, irreverent view of things is probably to do with the artist's political associations with Hamburg's left-wing activists.

Born in Eutin in 1962, Daniel Richter only started studying painting under Werner Büttner at the Hamburg School of Fine Art at the age of thirty, later becoming assistant to Albert Ohlen. This experience served to strengthen his analytical love-hate relationship with painting. Since then, Daniel Richter has dedicated himself to finding out how arguments can be expressed in paintings without merely reproducing them or telling anecdotes. Simply put: how abstract art can be made relevant without assuming a comfortable, i.e. over-aesthetic or simplistic attitude to painting. Richter's paintings avoid explanatory references to non-artistic topics or expressing the superior attitudes that make many young artists today seem like social workers. Of course, Richter also faces the dilemma of every painter – having to acknowledge the most recent and past developments in the medium whilst reacting to them in a contradictory manner. Certain references in Richter's paintings seem so mundane that anyone who talks about the use of the dripping technique to represent the passage of time or the geometrical stabilisation of levels within the picture, the preservation of previously planned images by varnishing them over, or the ecstatic embellishment of trivial motifs, is in danger of making himself look ridiculous. Although Richter's paintings, similarly to jellyfish, impose on the viewer and can do so only because they detach themselves from reality, moving forward by mixing various expressive levels, they still make the paradox statement of an arrival – through the "tags" which glaze over the facts of the matter. As if the painting were only complete as a surface on which an anonymous signature can be scribbled, and thus free for appropriation by a specific group. Yet the graffiti gesture itself becomes anonymous. Richter's paintings refuse to accept any

– **Der ewige Tagtraum der 3 IRREN vom Berg**, 1999, Ölfarbe, Lack auf Leinwand/Oil and varnish on canvas, 255 x 405 cm, Courtesy Contemporary Fine Arts, Berlin, Photo Jochen Littkemann, Berlin

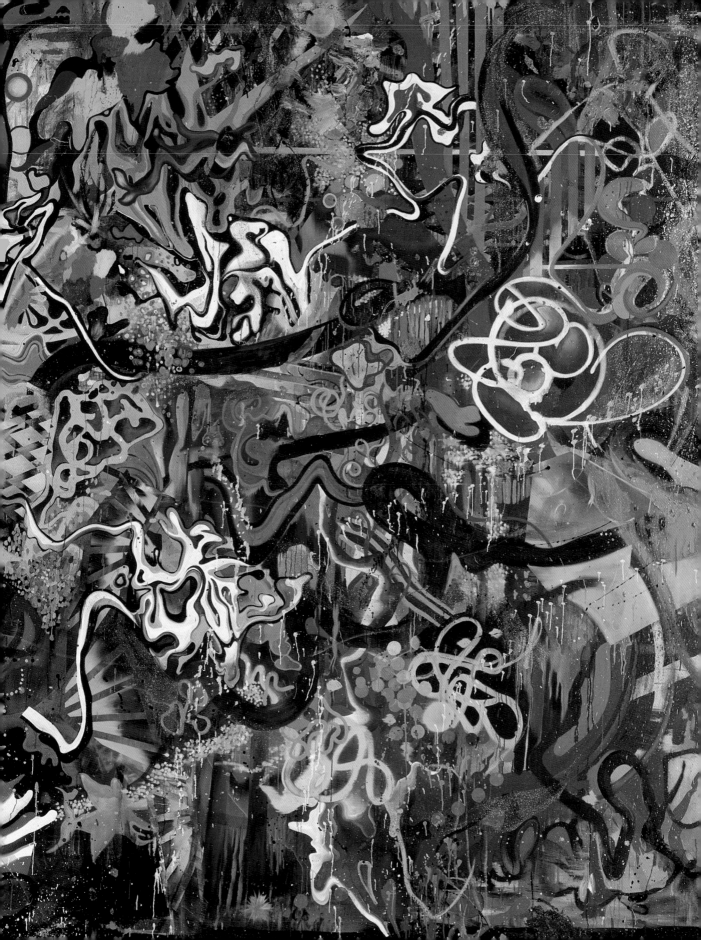

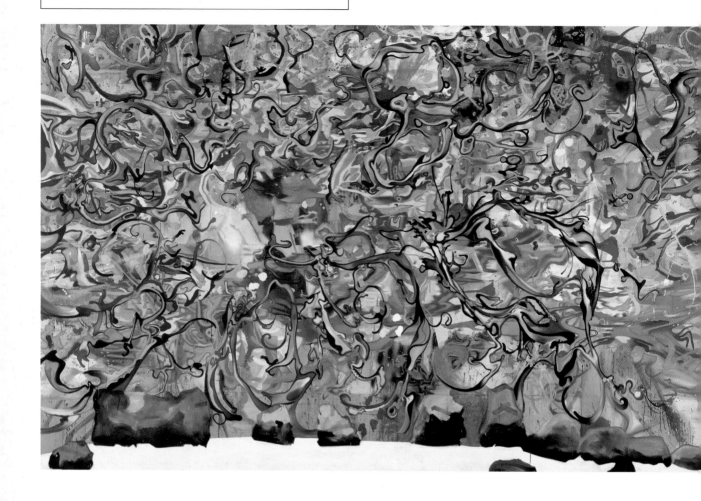

neuen Bildern in den schwarzweißen Bereich geht, so wirkt das wie die Abstraktion der eigenen, von Analyse und Kritik bestimmten Malimpulse. Richters Crashkurs in Sachen Malerei nimmt es mit dem Zeitalter der Digitalisierung auf, indem er die Treuherzigkeit von Malmaterie, Motorik und Semantik gegen programmierte Eingleisigkeit und Beliebigkeit von Erfahrung setzt. Er propagiert einen verblüffenden Konservatismus, indem er – über eine neue Form der Profanierung gewohnter Vorstellungen – sich in die Reihe der Maler stellt. Richter behauptet, daß auf der Leinwand immer noch genügend lohnender Angriff unterzubringen ist, um sich Freunde und Feinde zu machen.

kind of ideologically ordered state. Instead, they organise a continuing series of rejections, constantly jostling and casually destroying ideologies. The new paintings in black and white appear to be an abstraction of Richter's own critically analytical approach to painting. Richter's crash course in painting challenges the digital age by confronting the naivety of painter's materials, motor functions and semantics with the pre-programmed narrowness and arbitrariness of experience. He propagates an astonishing kind of conservatism by openly joining the ranks of painters. Richter says there is still enough space on canvas to make attacking accepted attitudes worthwhile: there are still friends and enemies to be made.

DANIEL RICHTER – Eutin, 1962 – Hochschule für Bildende Künste, Hamburg –
Wohnt/lives in Hamburg

EINZELAUSSTELLUNGEN/ONE PERSON SHOWS: 1999 Fool on the Hill, Johnen & Schöttle, Köln **1998** Organisierte Kriminalität, Contemporary Fine Arts, Berlin **1997** 17 Jahre Nasenbluten, Contemporary Fine Arts, Berlin (Katalog/catalogue) **1996** Galerie Jürgen Becker, Hamburg **1995** Contemporary Fine Arts, Berlin **GRUPPENAUSSTELLUNGEN/GROUP SHOWS: 1999** Kunstpreis der Böttcherstraße in Bremen, Kunsthalle Bremen (Katalog/catalogue) **1998** Dix-Preis '98, Kunstsammlung Gera (Katalog/catalogue) **1996** Sammlung Volkmann zeigt: Faustrecht der Freiheit, Kunstsammlung Gera und and Neues Museum Weserburg, Bremen (Katalog/catalogue) **1995** Scharfer Blick, Bundeskunsthalle Bonn (Katalog/catalogue)

Daniel Richter

Christian Jankowski

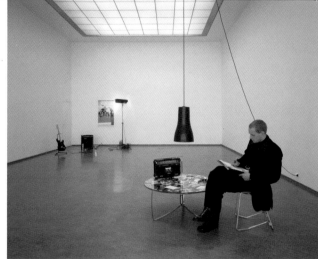

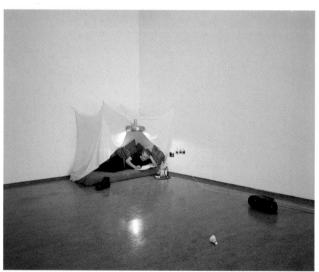

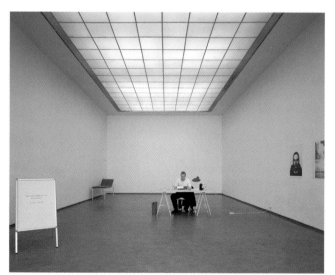

Christian Jankowski – *Daniel Birnbaum* – Übersetzung aus dem Englischen von Christian Quatmann

Christian Jankowski – *Daniel Birnbaum*

Maestro Vitale: Die Idee, die du hast, ist definitiv positiv.
Christian Jankowski: Ah!! Super!!
MV: Deine Person oder dein künstlerisches Schaffen steht unter dem Einfluß eines Menschen weiblichen Geschlechts.
CJ: Ja!!!
MV: Weißt du, diese Person ist sehr wichtig für deine Zukunft. Es gibt eine Art Neubeginn, und in Zukunft wirst du mit großem Geschick und Können zu Werke gehen. Die Karte mit dem Magier

Maestro Vitale: Your idea is definitely positive, Christian.
Christian Jankowski: Ah! Good!
MV: Something important surrounds you, or your artistic work – a member of the female sex?
CJ: Yes!
MV: You see. Because this is very important for your future. It is really a point of departure which will enable you to do things skilfully, dextrously. The card of the magician is also significant. The

– **Mein erstes Buch**, 1998, 1. Woche: Schriftsteller porträtiert Schriftsteller, 4. Woche: Kuß der Muse oder gemeinsame Produktion, 3. Woche: Parallele Welt, 5. Woche: Die Reise ins Innere, Installation view, Portikus, Frankfurt am Main, Courtesy Galerie Klosterfelde, Berlin, Photo Wolfgang Günzel

bedeutet aber auch: Der Magier markiert einen Startpunkt, er steht für Geschicklichkeit und Kunstfertigkeit, und tatsächlich sieht alles nach einem Neubeginn aus – ja, du wirst etwas fundamental Neues in Gang bringen.

CJ: Oh!! Danke!!

MV: Und du wirst dies mit viel Liebe tun.

Das ist nur ein winziger Ausschnitt aus einem Gespräch, das Christian Jankowski mit dem italienischen TV-Magier Maestro Vitale geführt hat. Für das Video "Telemistica" hat Jankowski fünf verschiedene kommerzielle Wahrsager angerufen, die alle im Privatfernsehen eigene Sendungen haben. Um ihre Ratschläge zu verstehen, mußte der Künstler erst Italienisch lernen, doch das ist angesichts der schwierigen Fragen, auf die er von ihnen Antwort erhielt, nur ein geringer Aufwand. Zum Beispiel: "Wenn meine Arbeit fertig ist, wird sie dann schön sein?" Oder: "Was wird das Publikum über meine Arbeit denken? Wird sie den Leuten gefallen?" Um über solche Dinge Klarheit zu erhalten, kann man schon mal ein bißchen Zeit und Geld aufwenden. Das gleiche gilt für die Stabilität des eigenen Selbstverständnisses als Künstler. Nachdem er eine Einladung erhalten hatte, an einer Gruppenausstellung in Graz teilzunehmen, geriet Jankowski rasch in eine künstlerische Krise und zweifelte massiv an seinem kreativen Potential als Mensch und Künstler. Was sollte er tun? Ein "Ausweg aus diesem Alptraum der Verwirrung und Verzweiflung" ließ sich nur "mit Hilfe eines Psychotherapeuten finden".

Jankowski hat in der Vergangenheit für seine Probleme stets großzügige Lösungen gefunden. Als er kürzlich im Portikus in Frankfurt am Main das Projekt "Mein erstes Buch" realisierte, kreierte er eine vielschichtige Ausstellung mit sechs verschiedenen Installationen, die sich von Woche zu Woche änderten. In ihnen untersuchte Jakowski den "genius loci" und erprobte gleichsam in der Rolle des Schriftstellers unterschiedliche Wege der Inspiration. Er lud außerdem wichtige Leute aus dem Literaturbetrieb ein, und schließlich verdichtete sich das ganze Geschehen zu seinem ersten Buch. Auch in anderen Zusammenhängen findet er stets eine Lösung, auch wenn sich die Dinge nicht zu seiner Zufriedenheit entwickeln. 1996, als er den Auftrag erhielt, das Titelblatt der Nummer 23 der Zeitschrift Texte zur Kunst zu gestalten, hat er es beispielsweise geschafft, bei diversen Firmen Geld lockerzumachen, in dem er versprach ihre Logos auf dem Cover abzubilden. Allerdings ging sein Versuch, das Geld im Kasino rasch zu vermehren – er setzte die gesamte Summe auf die Nummer 23 –, gründlich daneben. Ursprünglich war geplant, mit dem gewonnenen Geld ein aufwendiges Cover von einem Graphikbüro gestalten zu lassen. Trotzdem war das Projekt "Sponsor Money" ein Erfolg, weil nun die Logos der Firmen im Kartoffeldruck-Verfahren auf dem Cover reproduziert wurden.

magician is a starting point, and means dexterity and skill. You will experience a sense of renewal, as if you were embarking on something fundamentally new.

CJ: Ah! Thank you!

MV: And you will do it with much love.

This is just a tiny fragment of Christian Jankowski's discussion with the Italian television magician Maestro Vitale. For the video *Telemistica*, Jankowski called five different commercial fortune-tellers, all appearing on private channels. To be able to understand their advice, the artist had to learn Italian, but that is a small effort considering the difficult questions to which he received answers. For example: "About my work – when it's ready, will it be beautiful?" "What will the public think about my work? Will they like it?" It's worth spending time and money to have these kind of things straightened out. The same, I suppose, goes for one's physical well-being as an artist. Having been invited to a group show in Graz, Jankowski very soon seemed to be entering a creative crisis which involved his questioning himself as a creative human being, as an artist. What should he do? The only solution was to find "a way out of this nightmare of confusion with the help of a psychotherapist."

Jankowski has always found satisfactory solutions to his own problems in the past. While recently working on the project "My First Book" in the Portikus, Frankfurt on Main, he created a highly subtle exhibition consisting of six different installations which changed from week to week. With these installations, Jankowski examined the "genius loci" and experimented with different sources of inspiration in his role as a writer. He also invited important guests from the literature business – and the result was his first book. In other contexts, he still manages to find a solution, even if things do not work out to his satisfaction. For instance, when he was invited in 1996 to design the cover for the twenty-third issue of the Texte zur Kunst magazine, he managed to raise money from a number of firms by promising them that their logos would appear on the cover. However, his attempt to make the money grow quickly at the casino – he put everything on number 23 – failed disastrously. Nevertheless, the "Sponsor Money" project had a positive outcome, because there was still enough money to reproduce the logos using the potato print method.

Putting it simply, Jankowski's art is not only generous in that it involves the viewer in various kinds of dialogues; it is also very practical and could be of great use to you. For instance, after having seen some of his projects, I managed to get out of the difficult task of writing an essay for this catalogue. Instead, following his general mode of operation, I turned the text into a discussion with the artist:

Daniel: Tell me about your project for Wolfsburg.

Christian: I call it *Create Problems*, and the theme of the piece

– **Telemistica**, 1999, Videostills

Antonio Vitale
Studio 0423/30.29.10
solo per consulto
0368-29.15.41
Per la diretta
049/63.11.11
20.48
12 Maggio
Bolzano

My name is Christian.

Per informazioni e prenotazioni:
049/63.50.00

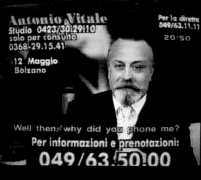

Antonio Vitale
Studio 0423/30.29.10
solo per consulto
0368-29.15.41
Per la diretta
049/63.11.11
20.50
12 Maggio
Bolzano

Well then, why did you phone me?

Per informazioni e prenotazioni:
049/63.50.00

Antonio Vitale
Studio 0423/30.29.10
solo per consulto
0368-29.15.41
Per la diretta
049/63.11.11
20.49
12 Maggio
Bolzano

... I would like to know if this idea
that came to me is good...

Per informazioni e prenotazioni:
049/63.50.00

BARBARA FERUGLIO
L'ALTRO MODO DI ESISTERE
STUDIO 040.390.160

Hello, good evening Barbara!

PER DIRETTA
0425.411.333

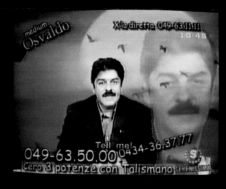

BARBARA FERUGLIO
L'ALTRO MODO DI ESISTERE
STUDIO 040.390.160

Will I realize my new work?

PER DIRETTA
0425.411.333

BARBARA FERUGLIO
L'ALTRO MODO DI ESISTERE
STUDIO 040.390.160

I make 3 stacks, you choose one.

PER DIRETTA
0425.411.333

medium Osvaldo
X la diretta 049-63.11.11
10.45

Hello, good morning Osvaldo!

049-63.50.00
Cero 3 potenze con Talismano
SERENISSIMA

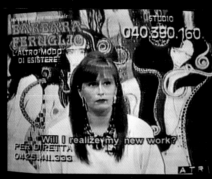

medium Osvaldo
X la diretta 049-63.11.11
10.45

Tell me!

049-63.50.00 0434-36.37.77
Cero 3 potenze con Talismano
SERENISSIMA

medium Osvaldo
X la diretta 049-63.11.11
10.46

I want to know, if my work,
when it finally is finished,

049-63.50.00
Cero 3 potenze con Talismano
SERENISSIMA

BRAHAMAN
Privato 0429/878.479
19.26

Can you read my cards?
What will the people think of my
work?

Per la diretta
049/63.11.11
SERENISSIMA

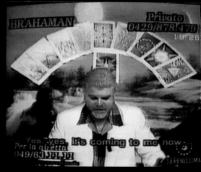

BRAHAMAN
Privato 0429/878.479
19.26

Yes, yes, it's coming to me now...

Per la diretta
049/63.11.11
SERENISSIMA

BRAHAMAN
Privato 0429/878.479
19.27

What you are doing will be very
well accepted...

Per la diretta
049/63.11.11
SERENISSIMA

per inform. e appunt.
041-52.46.764
0434-97.94.74
per la diretta
049/63.11.11
19.18

prenotazione
Talismani 049/63.50.00
Good evening Mrs. Chiara! My name
is Christian, I am calling from Venice.

per inform. e appunt.
041-52.46.764
0434-97.94.74
per la diretta
049/63.11.11
19.18

prenotazione
Talismani 049/63.50.00
Will this work be of great importance
for my life in the future?
SERENISSIMA

per inform. e appunt.
041-52.46.764
0434-97.94.74
per la diretta
049/63.11.11
19.18

prenotazione
Talismani 049/63.50.00
The work, is it a sculpture?
SERENISSIMA

Antonio Vitale
Studio 0423/30.29.10
solo per consulto
0368-29.15.41

12 Maggio
Bolzano

Per la diretta
049/63.11.11

20 51

There is really a point of departure

Per informazioni e prenotazioni:
049/63.50.00

The idea that you have,
Christian, is definitely positive.

Per informazioni e prenotazioni:
049/63.50.00

as if you would start to do
something fundamentally new.

Per informazioni e prenotazioni:
049/63.50.00

BARBARA
FERUGLIO
L'ALTRO MODO
DI ESISTERE!

studio
040.390.160

The central one please.

PER DIRETTA
0425.411.333

Listen, your career...
in the future you will gain success...

PER DIRETTA
0425.411.333

from these cards I can tell that you are
a winner. What does it mean?

PER DIRETTA
0425.411.333

ATR

medium
Osvaldo

X la diretta 049-63.11.11

Will go well!?

049-63.50.00

Cero 3 potenze con Talismano

Yes, yes it will go well, but will the
work be good, when the...

049-63.50.00

Cero 3 potenze con Talismano

Don't believe those who speak in a
negative fashion

049-63.50.00

Cero 3 potenze con Talismano

BRAHAMAN

Privato
0429/878.479
19.27

Ahh..., and the public?

Per la diretta
049/63.

...will be very, very happy!

Per la diretta
049/63.

but it will be difficult to realize
economically, you understand?

Per la diretta
049/63.

per inform. e appunt.
049/63.11.11

prenotazione
Talismani **049/63.50.00**
No, no; a video installation,
new art.

prenotazione
Talismani **049/63.50.00**
Good bye! Any, how an artist or a
painter is never satisfied with his work.

prenotazione
Talismani **049/63.50.00**
Good bye! Any, how an artist or a
painter is never satisfied with his work.

Kurz: Jankowskis Kunst ist nicht nur großzügig, weil sie den Betrachter in ganz unterschiedliche Dialoge verwickelt, sie ist auch sehr praktisch und könnte auch für dich von Nutzen sein. So ist es mir etwa, nachdem ich einige seiner Projekte gesehen hatte, gelungen, mich der schwierigen Aufgabe zu entziehen, für diesen Katalog einen Essay zu schreiben. Statt dessen habe ich aus dem Text in Anlehnung an seine übliche Vorgehensweise eine Diskussion mit dem Künstler gemacht:

Daniel: Erzähl mir was über dein Projekt für Wolfsburg.
Christian: Ich nenne es "Create Problems", und das Thema der Arbeit ist die Anziehung zwischen Mann und Frau. Es fängt an wie ein Pornofilm, doch dann macht das Paar keinen Sex, sondern fängt an zu streiten. Die beiden konstruieren ihre Probleme mit Worten.
Daniel: Pornographie ohne Sex, das klingt für mich ein bißchen wie Ingmar Bergmann …
Christian: Wie Bergmann – das ist witzig. Aber vielleicht hast du recht. Wenn du dir wirkliche Paare in der Kulisse eines echten Pornofilm Studios vorstellst und dann noch einen Psychotherapeuten, der ihre Verhaltens- und Argumentationsmuster kommentiert, dann kommen wir den Vorstellungen, die mich bei "Create Problems" bewegt haben, ziemlich nahe.
Daniel: Was findest du daran interessant?
Christian: Unter anderem interessieren mich besonders die Übergänge – wie sich Situationen verändern.
Daniel: Und wie möchtest du die Arbeit präsentieren?
Christian: Das ist noch offen. Eine große Projektionsfläche würde natürlich mächtig was hermachen, aber nicht jene voyeuristische Atmosphäre schaffen, an der mir gelegen ist. Dann hab' ich an einen kleinen Raum mit einem peinlich großen Monitor gedacht.

is the attraction between men and women – and the complications that can arise as a result. It begins like a porno film, but instead of having sex, the couple ends up in an argument. They try to solve their problems verbally.
Daniel: Pornography without sex, that sounds a bit like Ingmar Bergman to me …
Christian: Like Bergman, that's funny. But maybe you're right. If you imagine real couples on a real porno film set and introduce a psychotherapist who comments on their patterns of behaviour and argumentation, then we come pretty close to my idea of "Creating Problems".
Daniel: What interests you in particular?
Christian: Among many things, I'm interested in transitions – how situations could change.
Daniel: How do you intend to present your film?
Christian: A large projection would not create the voyeuristic sensation I'm interested in. I thought about a small room with an embarrassingly large monitor.

CHRISTIAN JANKOWSKI – Göttingen, 1968 – Hochschule für Bildende Künste, Hamburg – Wohnt/lives in Berlin und/and Hamburg

Photo Ingeborg Lüscher

EINZELAUSSTELLUNGEN/ONE PERSON SHOWS (Auswahl/selected): 1999 Videosalon, Videodrome, Kopenhagen – Paroles Sur Le Vif, Goethe-Institut, Paris – Telemistica, Kölnischer Kunstverein, Köln **1998** Videosalon, H.M. Klosterfelde, Hamburg – Let's get physical/digital, Klosterfelde, Berlin – Mein erstes Buch, Portikus, Frankfurt am Main (Katalog/catalogue) – 2097 Galerie der Gegenwart Hamburg, Statement art forum, Berlin **1997** Let's get physical/digital, Art Node, Stockholm (Katalog/catalogue) – 2097 Galerie der Gegenwart Hamburg, Kunsthaus Hamburg **1996** Mein Leben als Taube, Klosterfelde, Berlin **1994** Der sichere Ort; Westwerk/Friedensallee 12, Woche der Bildenden Kunst, Hamburg **1992** Die Jagd, Toom-Markt/Friedensallee 12, Hamburg – Schamkasten (mit/with F. Restle), Friedensallee 12, Hamburg **GRUPPENAUSSTELLUNGEN/GROUP SHOWS (Auswahl/selected): 1999** Talk.Show. Die Kunst der Kommunikation in den 90er Jahren, Haus der Kunst, München (Katalog/catalogue) 1999 vernice, Centro d'Arte Contemporanea Ticino, Bellinzona, 48. Biennale Venedig (Katalog/catalogue) – Change is good, Museum Fridericianum, Kassel – Fernsehabend 2, Galerie Meyer Riegger, Karlsruhe – VISA, Galerie Johnen & Schöttle, Köln **1998** Fast Forward – Trade Marks, Kunstverein Hamburg – gangbang, Galerie Margit Haupt, Karlsruhe **1997** Fasten Seatbelt, Galerie Krinzinger, Wien – Zonen der Ver-Störung, steirischer herbst, Graz (Katalog/catalogue) – Take Off, Galerie Krinzinger, Bregenz – l'autre, Biennale de Lyon (Katalog/catalogue) – Enter: Artist/Audience/Institution, Kunstmuseum Luzern (Katalog/catalogue) – punch in out, Kunsthaus Hamburg (Katalog/catalogue) – Künstlerhaus Stuttgart **1996** Guillaume Bijl stelt jonge kunstenaars uit Hamburg voor, Lokaal 01, Antwerpen – Kunst auf der Zeil, Schaufenster im Disney Store, Frankfurt am Main (Katalog/catalogue) – weil morgen, Eisfabrik, Hannover – … fra Hamborg og fra Kobenhavn, Globe, Kopenhagen – Spiel mit Sponsorengeld, Spielbank Bad Neuenahr **1995** Ebbe in der Freiheit, Club Berlin, Biennale Venedig – … aus Hamburg und Kopenhagen, Fahrradhalle, Offenbach

Christian Jankowski

– **o. T.**, 1998, Buntstift, Bleistift auf Papier/Crayon, pencil on paper, 35,2 x 47,2 cm,
Courtesy Galerie Christian Nagel, Köln, Privatbesitz/Private collection, Berlin

Modern sein – *Anke Kempkes*

Die Gattung der "Stil-Kunst" lebt von den kenntnisreichsten Distinktionen. Andy Warhol hatte das dekadente Image des Dekors, den Verdacht auf Affirmation gesellschaftlicher Verhältnisse, zur Strategie brillanter Komplizenschaft erhoben. In ihren emanzipatorischen Winkeln entwickelt diese künstlerische Gattung eine Präzision, die dem exklusiven Wissen bestimmter minoritärer Gruppen oder Individuen entspringt. Diese Camp-Form hat ihre fließenden Übergänge in die Erfindungen utopischer Stilwelten. Kai Althoff ist ein Bewohner dieser exotischen Dimension. Wie sich seine Arbeit ausnimmt in ihrem Umfeld von Kunst und Politik, erfordert einige Beschreibungen.

Das mehrdimensionale Arbeiten mit dem Ornamentalen, vor allem aber mit pop-modernistischen Stilzitaten, entwickelte sich zu einem der augenscheinlichsten künstlerischen Merkmale der 90er Jahre. Je verkürzter und allgemeiner die historisch "rebellischen" Formen verwendet werden – je unterbestimmter in der Folge auch die zeitgenössische Kunst – um so mehr trifft diese Kunst den Bedarf an kultureller Markierung von neuen Räumen, politischen Geographien, Technologien und Märkten. Es gibt also, relativ unabhängig von den Motivlagen, einen beweglichen affirmativen Faktor in der Arbeit selbst im Verhältnis zur gesellschaftlichen Situation. Daß seit einiger Zeit die Bestimmung "in Deutschland" der hiesigen aktuellen Kunst institutionell hinzugefügt wird, verlangt weitere Überlegungen.

Ein erfolgreiches Label-Phänomen wie die "Young British Art" vor zehn Jahren ist in der hiesigen Gegenwartskunst aus den spezifisch anderen Bedingungen heraus mit der nationalen Etikettierung eines "Szeneaufbruchs" nicht imitierbar. Dem britischen Nationalemblem haftete der subkulturelle Exorzismus der zurückliegenden Dekade an. Aktuell galt "British" als ein Synonym für die rigorose Wirtschaftspolitik der Thatcher-Ära. Dieses reformierte Zeichen wurde von den KünstlerInnen angeeignet und ausgespuckt. Sie "umarmten ihre Impotenz", parodierten den Nihilismus von Punk und veredelten alles, was ihnen an Abjektem in die Hände kam. Ob ökonomisch skrupellos oder nicht, man stach mit symbolischer Präzision in das Herzstück der aktuellen Gesellschaftsstruktur.

"Deutsch" eignet sich nun nicht – wie einst "Modern British" – zum abgetakelten Pop-Image. Aber ohne eine kulturgeographische Kennung ist bekanntlich eine erfolgreiche Ökonomie der 90er Jahre nicht denkbar. "Modern deutsch sein" geht heute auf in dem Bild der expressiven Techno-Metropole Berlin. Das Nationallabel erhält selbstredend die Bedeutung "des Neuen". Es ist nunmehr Teil einer Modernisierungssprache. Die von den KuratorInnen gewählte Bezeichnung "in Deutschland" beschreibt nicht

Being Modern – *Anke Kempkes* – Translated by Toby Alleyne-Gee

The "Stil-Art" genre depends on distinctions made by a well-informed elite. Andy Warhol raised the decadent image of décor, the suspected affirmation of social circumstances, to a strategy of brilliant connivance. Artists working in this genre, with its emancipatory angle, have developed a precision that arises from the exclusive knowledge of minority groups or individuals. This form of camp merges indistinctly with the inventions of stylistic Utopias. Kai Althoff is an inhabitant of this exotic dimension. The way in which his work stands out in its artistic and political environment requires some explanation.

Multidimensional work incorporating ornamental elements, particularly quotations from the pop-modernist movement, developed into one of the most obvious characteristics of the art of the Nineties. The more the traditionally "rebellious" forms are used in an abbreviated and generalised manner – the more undefined contemporary art becomes as a result – the more this kind of art satisfies the need for the cultural marking of new spaces, political geography, technologies and markets. Relatively independently of the layers of motifs, then, there is a moving, affirmative factor in this work, even when viewed in relation with the social situation. The fact that contemporary art in this country has been institutionally referred to as "contemporary art in Germany" for some time now requires some thought.

Due to the very different conditions in Germany, a successful label phenomenon such as "Young British Art" – a national label applied to a new artistic movement a decade ago – cannot be imitated. The British national emblem was associated with the subcultural exorcism of the previous decade. At the time, "British" was synoymous with the rigorous economic policy of the Thatcher era. Artists appropriated this reformed symbol, only to spit it out again. They "embraced their impotence", parodied the nihilism of punk and ennobled anything repulsive they could get their hands on. Whether they were economically unscrupulous or not, they stabbed at the heart of contemporary social structures with symbolic precision.

"Deutsch" simply doesn't suit the faded pop image as "Modern British" once did. But it is a well-known fact that a successful economy in the Nineties would be unthinkable without cultural and geographical distinctions. Nowadays, the idea of "being a modern German" is absorbed in the image of the expressive techno metropolis, Berlin. The national label automatically receives the significance of "the new." It is now part of the language of modernisation. The epithet "in Germany" chosen by museum curators

– **o.T.**, 1999, Stoff auf Resopal/Fabric on resopal, 64,5 x 120 cm, Courtesy Galerie
Christian Nagel, Köln

nur den Ort von Produktion. Sie ist selbst Teil einer Dynamik, also
eines Bewegungsmotivs. Das "Nationale" der Metropole ist das
Identischwerden ihres Images mit einer neuen Markt- und Re-
gierungskultur. Geschichte ist darin das offiziell Abjekte eines
ohnehin schon riesigen Partialobjekts globaler Zukünftigkeit. Eine
fortgeschrittene Form der "Normalisierung" vollzieht sich vor al-
lem in der abstrakten Hypostasierung des Extremen. Sie wird zum
semantischen Bestimmungsproblem für linke Kulturkritik.

Der Kölner Künstler Kai Althoff geht in dieser Situation den Weg
der Auffächerung, das ästhetische Prozessieren von Bedeutungs-
übergängen. Er führt uns in einen Resonanzraum von historisch,
aktuell und politisch labilen Figuren und Zeichen, ohne sie vorab
zu kategorisieren. Seine Welt speist sich aus vergangenen Ju-
gendkulturen, deren Idealen, sozialen Utopien und politischen
Umdeutungen. Seine Dekors verarbeiten Glamour und Camp, die
ästhetischen Revolten der 70er Jahre, und konfrontieren die vom
Kunstkontext begehrten Reliquien der Subkultur mit deren ambi-
valenten historischen Bedeutungen, mit ihren aktuellen politischen

– **o. T.**, 1999, Filzstift, Acryl, Aquarell, Bleistift, Wachs auf Papier/Felt-tip pen, acrylic, aquarelle, pencil, wax on paper, 34,9 x 38,7 cm, Courtesy Galerie Christian Nagel, Köln, Privatbesitz/Private collection, Berlin – **o. T.**, 1999, Filzstift, Acryl, Aquarell, Bleistift, Wachs auf Papier/Felt-tip pen, acrylic, aquarelle, pencil, wax on paper, 41,3 x 35,4 cm, Courtesy Galerie Christian Nagel, Köln, Privatbesitz/Private collection, Berlin

not only describes the place where art works are produced. It is itself part of a movement. That the metropolis should be described as "national" is due to the fact that its image has become identical with a new culture of markets and governments. History is the officially revolting part of a global future of enormous dimensions. An advanced form of "normalisation" can be found above all in the abstract hypostasis of the extreme. It has become a problem of semantic definition for left-wing cultural criticism.

In this situation, the Cologne artist Kai Althoff follows the path of separate disciplines, the aesthetic processing of transitional significance. He leads us into a resonant space of historic, current and politically unstable figures and signs without categorising them in advance. His world is nourished by the youth cultures of past times, their ideals, social Utopias and political reinterpretations. His décor creations work with glamour and camp, the aesthetic rebellions of the Seventies, and confront the relics of subculture with their ambivalent historic significance, with their current political opponents, their reactionary and regressive transitional forms. His work also poses the historic question as to whether fantasies of evil can be an option for socially critical homosexuals who stand as a bastion against the officially promoted historiography described above.

From his school of vision, the artist reveals a view of a fractal future of "defiled" aesthetic forms. The artist and musician are his own glamourous creation, a talented, eccentric individual hovering in a residual nostalgia. But Althoff's work refers to an artificially produced Bohème. And this field is a very fine, alert membrane; the circumstances to which it is subjected easily cause it to vibrate. To a certain extent, this is its Messianism changing its religious colours. He sometimes strolls around wearing Buddhist robes.

– **o.T.**, 1999, Filzstift, Pappe auf Resopal/Felt-tip pen, card board on resopal,
74 x 110 cm, Courtesy Galerie Christian Nagel, Köln

Gegnern und reaktionären und regressiven Übergangsformen.
Nicht zuletzt stellt er sich die historische Frage erneut, ob die
Phantasien des Bösen – "Meanness" – eine Option queerer
Gesellschaftskritik sein kann, die dem offiziell geförderten Ab-
jekten, das oben beschrieben wurde, als Bastion gegenübersteht.
Aus seiner Sehschule gewährt der Künstler den Ausblick in eine
fraktale Zukunft "befleckter" ästhetischer Formen. Der Künstler
und Musiker ist seine eigene glamouröse Kreation, das begabte
exzentrische Subjekt, das in den Residuen von Nostalgia schwebt.
Aber seine Referenzen verweisen auf gelebte soziale Daten einer
Bohème, deren Existenz sich künstlich erzeugt. Und dieses Feld ist
eine sehr feine aufmerksame Membran, die durch die Verhältnisse,
denen sie sich aussetzt, leicht ins Schwingen gerät. Das ist gewis-
sermaßen ihr Messianismus, der seine religiösen Farben wechselt.
Beizeiten wandelt er in buddhistischem Gewand.

KAI ALTHOFF – Köln, 1966 – Wohnt/lives in Köln

EIN- UND ZWEIPERSONENAUSSTELLUNGEN/ONE AND TWO PERSON EXHIBITIONS: 2000 ACME, Los Angeles **1999** Galerie Christian Nagel, Köln – Galerie Gabi Senn, Wien **1998** Bezirk der Widerrede, Galerie Daniel Buchholz, Köln – Reflux Lux, Galerie NEU, Berlin **1997** Hilfen und Recht der äusseren Wand (an mich), Anton Kern Gallery, New York – In Search of Eulenkippstadt, Robert Prime, London – Heetz, Nowak, Rehberger, Museo de Arte Contemporânea da USP, São Paulo, Brasilien (Katalog/catalogue) **1996** Heetz, Nowak, Rehberger, Museum Abteiberg (mit/with Cosima von Bonin und/and Tobias Rehberger), Mönchengladbach (Katalog/catalogue) – Hakelhug, Galerie Christian Nagel, Köln **1995** Hast Du heute Zeit, Ich aber nicht, Künstlerhaus Stuttgart (mit/with Cosima von Bonin) – Modern wird lahmgelegt, Daniel Buchholz, Köln – Kirsche-Jade-Block, Galerie Christian Nagel (mit/with Cosima von Bonin), Köln **1994** Zur Ewigen Lampe, Galleri Nicolai Wallner (mit/with Torsten Slama), Kopenhagen – Uwe: Auf guten Rat folgt Missetat, Lukas & Hoffmann, Köln **1993** Lukas und Hoffman, Berlin **GRUPPENAUSSTELLUNGEN/GROUP SHOWS: 1999** oLdNEWtOWn (Einladung von/invitation of Liam Gillick), Casey Caplan, New York **1998** ars viva 98/99 – Installationen, Brandenburgische Kunstsammlungen Cottbus, Kunstverein Braunschweig (1998/99), Portikus, Frankfurt am Main (1999) (Katalog/catalogue) – Galerie Daniel Buchholz, Köln **1997** time out, Kunsthalle Nürnberg (Katalog/catalogue) – HOME SWEET HOME, Interieurs-Einrichtungen-Möbel, Deichtorhallen Hamburg (Katalog/catalogue) – Symposion, ICEBOX/Venetia Kapernekas, Athen **1996** Glockengeschrei nach Deutz. Das Beste aller Seiten, Galerie Daniel Buchholz, Köln (Katalog/catalogue) **1995** 1. Grazer Fächerfest, Forum Stadtpark (organisiert von/organized by Cosima von Bonin), Graz (Katalog/catalogue) – Wild Walls, Stedelijk Museum, Amsterdam (Katalog/catalogue) **1994** Stonewall, White Columns, New York – Sonne München, Daniel Buchholz, Köln – Accrochage, Lukas & Hoffmann, Köln **1993** Aperto 93, Stand Schafhausen, Venedig (Katalog/catalogue) – E, Künstlerhaus Bethanien, Berlin (Katalog/catalogue) – 6 Wochen Brüssel, Lukas & Hoffmann, Brüssel.

Kai Althoff

Max Mohr

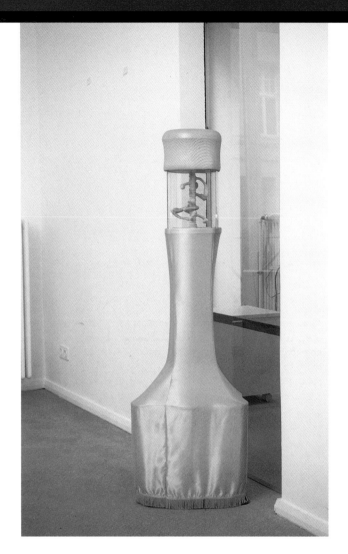

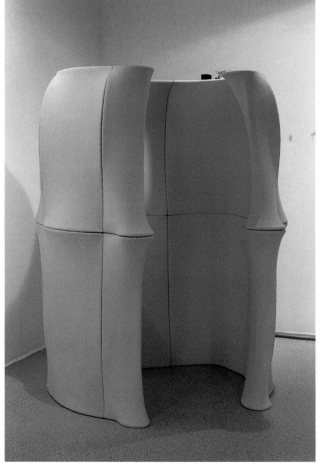

– **Teilchenbeschleuniger**, 1991-92, Holz, Glas, Metall, Stoff, Prothesenmaterial/Wood, glass, metal, fabric, prosthesis material, 148 x 50 x 50 cm, Sammlung/Collection Beer Hamburg, Courtesy Galerie Arndt & Partner, Berlin – **Labor**, 1998, Rahmen, 4 Objekte, Nylonstoff, Holz, Prothesenmaterial, Zahnarztgips/Nylon fabric, wood, prosthesis material, dentist's plaster, Sammlung/Collection Vanhaerents, Belgien,

Max Mohr – Perverse Plastik – *Knut Ebeling*

"Gelenk an Gelenk fügen, den Mulden sacht folgen, das Vergnügen der Wölbungen kosten, sich in die Muschel des Ohres verirren, Hübsches machen und ein wenig rachsüchtig auch das Salz der Deformation verteilen. Obendrein vor dem Inneren beileibe nicht stehenbleiben, die verhaltenen Mädchengedanken entblättern, damit ihre Untergründe sichtbar werden, durch den Nabel am besten, tief im Bauch als Panorama elektrisch beleuchtet. – Sollte nicht das die Lösung sein?" Hans Bellmer, "Die Puppe", 1939

Unter den zeitgenössischen deutschen Künstlern gehört Max Mohr sicher zu den eindringlicheren einer Generation, die mit Pop und Pepsi aufwuchs und bei Metaphysik und Muttermund noch nicht endete. Wenn man fragt, was die Skulptur Max Mohrs so unvergeßlich und bedrohlich werden läßt, gelangt man früher oder später zu einer gewissen Opazität, die seiner Plastik eigen ist. Es gibt bei Max Mohr nicht ein Konzept, das durch sie hindurchschimmern würde und das von der physischen Präsenz seiner Arbeit ablenken könnte. Die Skulptur Mohrs bleibt undurchdringlich und beunruhigend. Sie ist reine Skulptur – was ihr einen funkelnden Reiz und rätselhafte Ambivalenz verschafft.
Die Ambivalenz und die Unruhe werden hervorgerufen durch die Inkongruenz zwischen einem verhältnismäßig klassischen Begriff der Skulptur – es handelt sich hier durchaus um das, was man einmal mit dem Wort "Werk" bezeichnete – und einer völlig zeitgemäßen Sprache, derer sich das Werk bedient. Es ist diese Verschiebung zwischen der Statik eines skulpturalen Begriffes und der Flüssigkeit des Umgangs mit ihm, die einen bei Mohr alarmiert. Es kann ziemlich verwirrend sein, mit einer prächtig ausgebildeten künstlerischen Formensprache konfrontiert zu werden – die aber dennoch nicht verständlich ist. Es gibt genügend Überlieferungen von verstörten Rezipienten surrealistischer Kunst, die einige Zeit an deren Hermetik laborierten.
Es mag zu der Verstörung beitragen, daß die laborierungsreifen Zustände durch klinisch anmutende Materialien hervorgerufen werden. Nicht wenige seiner vorgefundenen Materialien löst Mohr aus einem chirurgischen oder orthopädischen Umfeld heraus – ein Umstand, der ihn zu Umschreibungen wie "private chemistry" oder "Paradiesprothesen" geführt hat. Bei den Versatzstücken handelt es sich jedoch weniger um *ready mades* der bekannten Tradition, also nicht um Objekte, deren Objektstatus sich nach der kontextuellen Codierung ändert. Sondern Mohr verwendet sein leicht fetischisierbares und leicht anzügliches Material – Dessous und Prothesenstoffe, Kinderkleider und Orthopädiezubehör – als

Max Mohr – Perverse Sculpture – *Knut Ebeling –*
Translated by Toby Alleyne-Gee

"Connect her limb by limb, gently follow her hollows, taste the pleasure of her curves, lose yourself in her ear, create something pretty, and, slightly vengefully, distribute the salt of deformation. But don't stop at her insides, unveil the subdued girl's thoughts, render their origins visible – preferably through her navel, electrically illuminated, like a panorama, in her belly. – Was that not the solution?"
Hans Bellmer, *Die Puppe*, 1939

Max Mohr is certainly one of the more forceful artists of a generation that grew up with pop and Pepsi, and did not stop at metaphysics and the cervix. If you ask what makes Mohr's sculptures so unforgettably threatening, you realise sooner or later that a certain opacity is unique to his work. No concept shows through to distract the viewer from the physical presence of Mohr's creations. His sculptures remain impenetrable and worrying. The fact that they are pure sculpture invests them with a sparkling charm and a mysterious ambivalence.
Ambivalence and discomfort are inspired by the incongruity between a relatively classic understanding of sculpture – these are definitely what, conventionally, used to be called "sculptures" – and an utterly contemporary vocabulary. It is this shift between the static nature of sculpture and the fluidity of the way it is handled that makes Mohr's work alarming. It can be quite confusing to be confronted with a perfectly schooled language of form that is nevertheless incomprehensible. There are enough anecdotes about distraught critics of surrealist art who spent quite some time trying to understand its hermetic symbolism.

Courtesy Galerie Arndt & Partner, Berlin – **Begehbare Paradiesprothese**, 1997,
Holz, Orthopädisches Material/Wood, orthopaedic material, 195 x 150 x 170 cm,
Fonds National d'Art Contemporain, Courtesy Galerie Arndt & Partner, Berlin

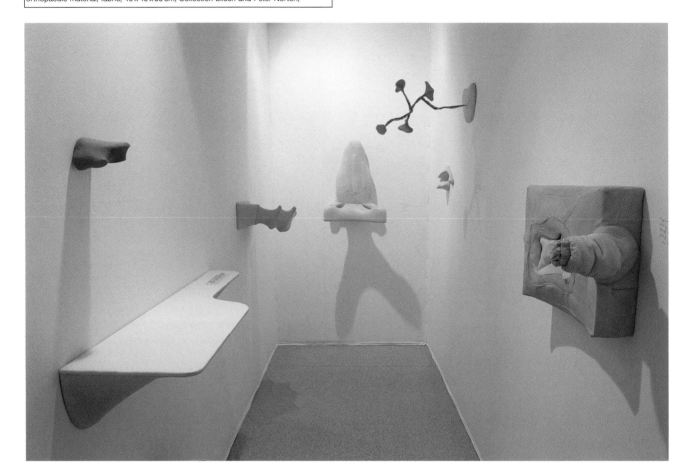

Substanz, der er als "alchimistischer Fummler" (Jean-Christophe Ammann) eine völlig neue Form gibt. Die neue und oft erschrekkende Form *verstärkt* den obszönen Charakter des ohnehin schon ambivalenten Materials. Es ist dieses Verfahren der *Verstärkung* – bekannt aus der Psychoanalyse – das es erlaubt, Mohrs Plastik als pervers zu beschreiben: insofern als sich die Perversion durch eine Überschreitung der Norm definiert.

Die perverse Plastik Mohrs travestiert jeden Nutzen gerade durch ihre scheinbare Funktionalität; die neugeschaffenen Objekte erinnern nur von Ferne an ihre Herkunft, zu der sie doch eine Verwandtschaftsbeziehung unterhalten. Diese Erinnerung an das Eigene läßt die Fremdheit des Perversen in um so grellerem Licht leuchten. In diesem Licht erscheint das Eigene als fremd und das Fremde assimiliert – womit die Unterscheidung zwischen Eigenem und Fremdem letztlich aufgehoben wird: was vielleicht das Perverseste an der perversen Plastik Mohrs ist. Sein "objet enchanté" versetzt die Welt der Objekte in den Zustand des Traums. Und so kann man den Assoziationen freien Lauf lassen und sagen, Mohr stelle Werkzeuge für unbekannte Wesen her, Prothesen

Santa Monica, CA, Courtesy Max Protech Gallery, New York – **Private Chemistry**, 1999,
Holz, Metall, Polsterwatte, verschiedene synthetische Stoffe, Prothesenmaterial/Wood,
metal, wad, various synthetic textiles, prosthesis material, 87 x 27 x 40 cm,
Sammlung/Collection Lindenberger, Frankfurt am Main, Courtesy
Galerie Arndt & Partner, Berlin, Photo Bernd Borchardt

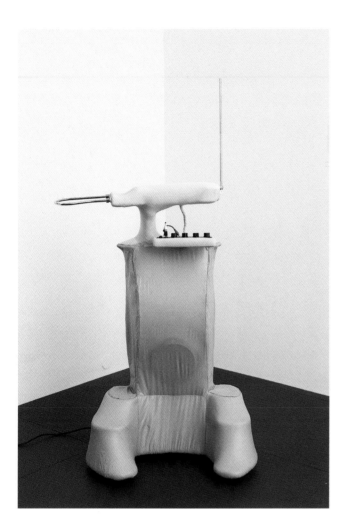

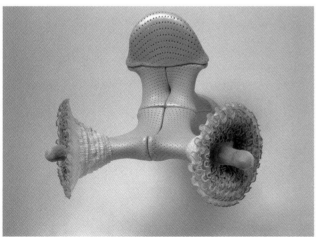

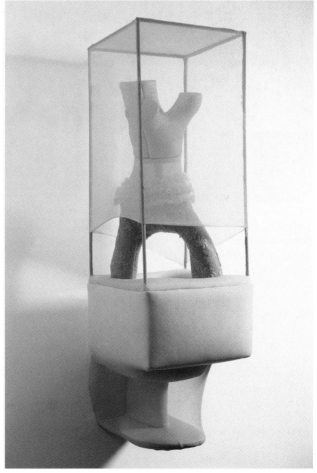

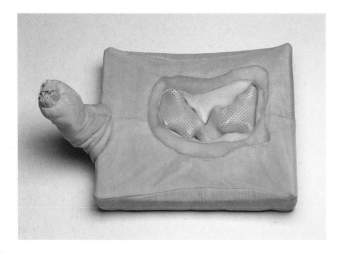

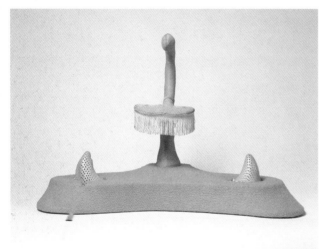

für fremde Körper – Räume für den virtuellen Menschen, der nicht mehr oder noch nicht ist. "Fast ließe sich vermuten", fragt Hans Bellmer seine "Puppe" von 1933 im Vorwort: "War etwa diese sagenhafte Distanz, ganz wie bei den Puppen, ein nötiger Bestandteil dieses Über-Süßen, das verfiel, wenn die Unerreichbarkeit verfiel? War nicht in der Puppe, die nur von dem lebte, was man in sie hineindachte, die trotz ihrer grenzenlosen Gefügigkeit zum Verzweifeln reserviert zu sein wußte, war nicht in der Gestaltung gerade solcher Puppenhaftigkeit das zu finden, was die Einbildung an Lust und Steigerung suchte?"

This state of confusion could be caused by the fact that Mohr's materials often seem clinical. Several of his works contain materials used in surgery or orthopaedics, inspiring titles such as *Private Chemistry* or *Paradiesprothesen* ("Artificial Limbs from Paradise'). However, Mohr's works are not ready-mades in the conventional sense, i.e. objects whose status (as objects) changes according to the context in which they are encoded. The "alchemist meddler" Mohr gives his slightly fetishistic, suggestive material – underwear and fabric for artificial limbs, children's clothes and orthopaedic equipment – a completely new form. This new and frequently startling form emphasises the obscene character of the materials used, which are in any case ambivalent. This process of *emphasis*, familiar from the world of psychoanalysis, is what entitles me to describe Mohr's work as perverse: perverse being defined in the sense of disregarding accepted norms.

Mohr's perverse sculpture parodies any sense of usefulness through its apparent functionalism; the newly created objects make only a vague reference to their origins, though they are still distantly related to them. This only serves to highlight the alien nature of the perverse. What is familiar thus appears alien, while the alien seems to have been assimilated, ultimately dissolving the distinction between the familiar and the alien: perhaps this is the most perverse thing of all about Mohr's perverse sculpture. His *objets enchantés* transport the world of objects into a dream-like state. So let your thoughts run wild and say that Mohr is producing tools for unknown creatures, artificial limbs for alien bodies, rooms for a virtual human being who no longer exists – or who has not yet come into being. In the foreword of *Doll* (1933), Hans Bellmer asks, "Was this incredible distance, so doll-like, perhaps a necessary part of her excessively sweet attraction, which disintegrated as soon as she became accessible? Did the doll, which only lived on the thoughts one projected into it, and which, despite its limitless docility, could be maddeningly reserved, not represent something that increased the illusion of desire and intensification?

MAX MOHR – in Frankfurt am Main, 1962 – Städelschule, Staatliche Hochschule für Bildende Kunst, Frankfurt am Main – Institut für Neue Medien, Frankfurt am Main – Wohnt/lives in Köln

Photo Barbara Wüllenweber

EINZELAUSSTELLUNGEN/ONE PERSON SHOWS: 1999 Space Party II, Galerie Arndt & Partner, Berlin – Adenine, Stiftung für Bildhauerei, Berlin **1998** Statement, Galerie Arndt & Partner, Berlin, Messe Basel – Otto Schweins (mit/with Douglas Kolk), Köln **1997** Galerie Art-Concept, Paris – 2.4 you 2.4 me, Galerie Arndt & Partner, Berlin – Attitudes, Geneve – Ausstellungsraum Hübner, Frankfurt am Main – Max Protetch, New York **1996** Galerie Art-Concept, Nizza **1995** Max Protetch, New York **1994** Galerie Gilles Peyroullet, Paris **1993** Galerie Transit, Leuven, Belgium **1992** Museum für Moderne Kunst, Frankfurt am Main (Katalog/catalogue) – Luis Campaña, Köln **1991** Luis Campaña, Frankfurt am Main – Luis Campaña, Köln **1989** Luis Campaña, Frankfurt am Main **1988** Galerie Uta Paduhn, Düsseldorf **GRUPPENAUSSTELLUNGEN/GROUP SHOWS: 1999** Hiroshima Art Document '99, Hiroshima, Japan – DACH, Galerie Krinzinger im Benger Part, Bregenz – Space Place, Kunsthalle Tirol, Hall, Österreich – Les Abattoirs – Espace d'art moderne et contemporain de Touloues et midi – Pyrenees, Frankreich **1998** Resolution, Galerie Arndt & Partner, Berlin – Mobile 2000, 619 KBB 75, Mobile Ausstellung, Berlin **1997** Prehension, Galerie Renos Xippas, Paris **1996** Cabines de Bain, Fri-Art, Centre d´art contemporain, Fribourg, Schweiz – 9th Dimension, Copenhagen Contemporary Art Center, Dänemark – Instant Reply, Galerie Arndt & Partner, Berlin – Szenenwechsel, Museum für Moderne Kunst, Frankfurt am Main – Jahresgaben, Frankfurter Kunstverein, Frankfurt am Main **1995** Szenenwechsel, Museum für Moderne Kunst Frankfurt am Main – Ambient, Art-Concept, Nizza – Galerie Gilles Peyroullet, Paris – Der gemalte Tod, Kapel van de Romaanse Poort, Leuven, Belgien – 444 & 222 Too, steam ironed, by Georg Herold, South London Gallery, Großbritanien – Folie, Nassauischer Kunstverein, Wiesbaden – face mind, mind body, Galerie Arndt & Partner, Berlin – Christa Näher & Schülerinnen und Schüler, Haus am Lützowplatz, Berlin – Jahresgaben, Kölnischer Kunstverein, Köln **1994** Produzentengalerie Hamburg, Hamburg – Drama, Max Protetch, New York – WM, Karaoke, Portikus, Frankfurt am Main – Once upon a time, Zeichnungen, Max Protetch, New York – Galerie Tranist, Leuven, Belgium – Guys who sew, University Art Museum Santa Barbara, California **1993** Plötzlich ist eine Zeit hereingebrochen, in der alles möglich sein sollte, Villa Franck, Kunstverein Ludwigsburg – Prospect, Frankfurter Kunstverein und Schirn Kunsthalle, Frankfurt am Main (Katalog/catalogue) – Le Principe de Réalité, Villa Arson, Nizza (Katalog/catalogue) **1992** Galerie Janine Mautsch, Köln – Goethe-Institut, Rom – Luis Campaña, Frankfurt am Main – Beteiligung: M. Baer, Ch. Näher, D. Hirst **1991** Kunstverein Frankfurt am Main **1990** Galerie Löhr, Frankfurt am Main **1989** Galerie a.k., Frankfurt am Main **1987** Galerie Uta Paduhn, Düsseldorf

Max Mohr

"A pleasant flight" – *Kea Wienand and Jose Presmanes* –
Translated by Toby Alleyne-Gee

When we remember certain events from the past, we usually do
so visually. We also imagine events that we ourselves have not
experienced visually. In his book, *Das kollektive Gedächtnis*
("The Collective Memory"), Maurice Halbwachs points to the fact
that memory is always dependent on social and cultural condi-
tions in which the event in question is reconstructed. He talks
about "frames" in which we see, think and remember. Memory
and history, then, are not only individual, but also always the prod-
uct of social and cultural construction. With their accelerated dis-
semination of photography and film, the mass media have extend-
ed the range of ways in which images can be transmitted. Our
collective "visual memory" is provided with new inputs every day.
Events that in fact are accessible to only a few individuals are also
transmitted on film worldwide. Every television viewer can thus
"remember" the war in Kosovo, without having actually been there.

– **Cheek to Cheek**, 1999, Videostills

"Ein angenehmer Flug" – *Kea Wienand und*
Jose Presmanes

Wenn wir uns an bestimmte Ereignisse aus der Vergangenheit erinnern, tun wir das vorwiegend in Bildern. Auch zu Ereignissen, die
außerhalb unseres Erfahrungsbereiches liegen, haben wir bildliche
Vorstellungen. Maurice Halbwachs hat in seinem Buch "Das kollektive Gedächtnis" darauf hingewiesen, daß Erinnerung immer
auch abhängig ist von sozialen und kulturellen Bedingungen, unter
denen die jeweiligen Ereignisse rekonstruiert werden. Er spricht
von "Rahmen", innerhalb derer wir sehen, denken und erinnern. Erinnerung und Geschichte sind demnach nicht nur individuell, sondern immer auch Produkte sozialer und kultureller Konstruktion.
Massenmedien, mit ihrer beschleunigten Verbreitung von Fotografie und Film, haben die Möglichkeiten der Vermittlung von
Bildern erweitert. Unser kollektives "Bildgedächtnis" wird täglich
mit neuen Inputs versorgt. Auch Ereignisse, die eigentlich nur
wenigen zugänglich sind, werden mittels Kamera global übertragen. So kann sich jeder Fernsehzuschauer an den Kosovo-
Krieg "erinnern", ohne dagewesen zu sein.

– Dein ist mein ganzes Herz, 1999, Videostills

Erinnerung und Archivierung von Geschichte mittels Medien sowie die Macht medial vermittelter Realität bilden das Spannungsfeld, in dem Sunah Choi sich mit ihren Videofilmen bewegt. Die Filme "Dein ist mein ganzes Herz" und "Cheek to Cheek" scheinen in ihrer Struktur Werbespots ähnlich – mit einer wunderbar leichten und beschwingten Atmosphäre. In "Dein ist mein ganzes Herz" sind Aufnahmen von Weltraumraketen aneinander geschnitten, count down, Flugphasen, Katastrophen, die wir seit den Übertragungen der ersten Mondlandung aus dem Fernsehen kennen. Anstelle des Originaltons hört man Franz Lehárs Evergreen. Wie in einer Tanzkür gleiten die Raketen im Takt der Musik durch die Luft. Diese Zusammenfügung bricht mit dem "Rahmen", in dem wir gewohnt sind, derartige Flugkörper zu sehen – zu erinnern. Gleichzeitig verweist diese übertriebene Ästhetisierung auch auf das Medium Film. Macht oder Ohnmacht der filmischen Inszenierung wird hier deutlich. Die Filmsequenzen sind meist in Farbe, wobei die Ästhetik der Aufnahmen auf Produktionen der sechziger/siebziger Jahre rekurriert. In Verbindung mit dem 1929 uraufgeführten Musikstück erscheint die filmische Darstellung als Dokument der Vergangenheit.

In "Cheek to Cheek" wird die Thematik der medialen Erinnerung noch verstärkt. Zur Musik von Irving Berlin scheinen die Kriegsflugzeuge, Flottenverbände, Fallschirmspringer, Panzer und Bombenteppiche gleichsam zu tanzen. Während die Sängerin "Heaven" intoniert und "Looking on the Hapiness I see" trällert, sieht man Geschwader von Bombern am Himmel, im choreographierten Formationsflug, und der Blick fällt von oben auf zerbombte Landschaften.

Bilder von brennenden Gebäuden und zerbombten Industriezonen reihen sich nahtlos aneinander und bilden mit der Musik einen Gleichklang, werden ästhetischer Genuß. Es ist die Faszination von "Schönheit in der Kriegsdarstellung" und die Suggestion von Harmonie, die sich durch die Musik ergibt. Doch diese Art der "Erinnerung" ist absurd, die Faszination des Zuschauers wird entlarvt und die mediale Manipulation aufgedeckt. Die Fetischfunktion dieser audiovisuellen Inszenierung wird mehr als offensichtlich.

Diese Arbeit ist subtile Medienkritik, sie zeigt ein Spiel mit dem Medium, das durch geschickte Eingriffe selbst die grausamste Wirklichkeit zu ästhetisieren vermag.

In beiden Arbeiten konfrontiert uns Sunah Choi auch mit medial produzierten Asienbildern. Bilder, die man meint dem Koreakrieg oder Pearl Harbor zuordnen zu können, und auch die begleitende Musik aus der Operette "Land des Lächelns" führen dem Betrachter ein Asienbild vor, das in Sunah Chois Szenario seine Künstlichkeit offenbart, ohne dabei an Reiz zu verlieren.

Sunah Choi's video films move between two poles: the use of the media to remember and store historical events, and the power of the reality conveyed by the media. In their wonderfully light and elated atmosphere, the structure of the films *Dein ist mein ganzes Herz* (*My Heart is All Yours*) and *Cheek to Cheek* is similar to that of an advertisement. *Dein ist mein ganzes Herz* shows the images of space rockets, countdowns, flight phases and catastrophes with which we have been familiar since the first landing on the moon was broadcast on television. The original sound has been replaced by Franz Lehár's *Evergreen*. The rockets glide through the air to the rhythm of the music as if they were taking part in a dance competition. This combination of image and sound marks a departure from the "frame" in which we are accustomed to seeing – remembering – these space vehicles. At the same time, this exaggeratedly aesthetic presentation is also a reference to film, demonstrating the power – or helplessness – of the medium. The film sequences are mostly in colour, while the style of the images reminds us of productions from the Sixties and Seventies. The musical accompaniment, which was first performed in 1929, renders the film a document of the past.

Cheek to Cheek emphasises the theme of memory in the media to an even greater extent. War planes, fleets, parachutists, tanks and carpet bombs also appear to be dancing, to the music of Irving Berlin. While the singer intones *Heaven* and *Looking on the happiness I see*, the film shows swarms of bombers flying in formation above a bombed landscape.

Images of burning buildings and bombed industrial zones are seamlessly linked in harmony with the music, thus becoming a source of aesthetic pleasure. The music arouses in the viewer a fascination with the beautified representation of war and the harmony it suggests. Yet this kind of "memory" is absurd, the fascination of the viewer is unmasked and the manipulation of reality by the media exposed. The fetishistic function of this audiovisual production becomes more than obvious.

This work is a subtle criticism of the media, demonstrating how the film medium can be cleverly manipulated in such a way that even the cruelest reality can be aestheticised.

In both films, Sunah Choi confronts us with media-produced images of Asia. Images that one thinks are derived from the Korean War or Pearl Harbor and the music that accom-panies them, from the operetta *Land des Lächelns* ("Land of Smiles"), show the viewer an image of Asia that, in Sunah Choi's scenario, is openly artificial. Yet it loses none of its charm.

SUNAH CHOI – Pusan, Korea 1968 – Städelschule, Staatliche Hochschule für Bildende Kunst, Frankfurt am Main – Wohnt/lives in Frankfurt am Main

GRUPPENAUSSTELLUNGEN/GROUP SHOWS: **1999** Women's art Festival '99: Patjes on Parade, Seoul Arts Center (Katalog/catalogue) – ScreeND Videoprogramm, Hessen Fernsehen, im Rahmen der Ausstellung >0-1/ and back again, Schirn Kunsthalle, Frankfurt am Main – Videoprogramm, Galerie Voges + Deisen, Frankfurt am Main – Videofestival, INM-Institut für Neue Medien, Frankfurt am Main **1998** Stuttgart, 17.07.1956 – Salem (Wis.)/USA, 03.03.1977, Portikus, Frankfurt am Main (Katalog/catalogue) **1996** Check up, Gallustheater-Probebühne, Frankfurt am Main

Sunah Choi

Alexander Györfi

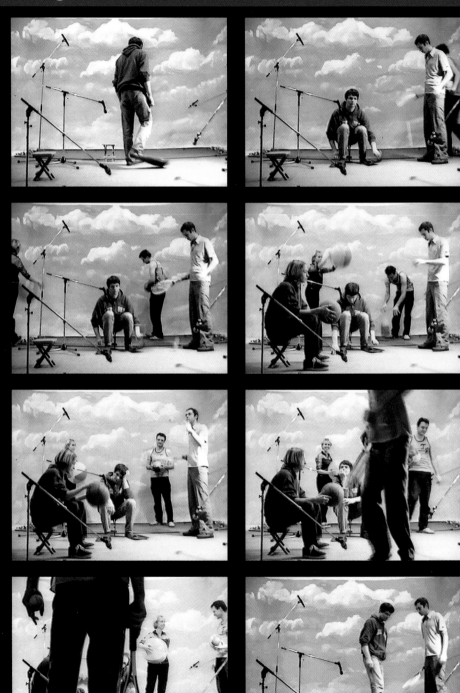

Mitgegangen, mitgefangen – zu Alexander Györfis künstlerischer Strategie der Kollaboration – *Doris Berger*

Eine Gruppe junger Leute erzeugt mit Bällen, Tennisschlägern und Taucherflossen einen Sound, der mit geschlossenen Augen genausogut ein elektronischer sein könnte, was er auch ist, denn die zu sehende "Ball-Musik" ist für das Video synchronisiert. "Beatballs and Flukes" (1998) zeigt die paradoxe Situation von "MusikerInnen" bei ihren Studioaufnahmen im künstlich angelegten Freien. Trotz Vogelgezwitscher und Kirchturmglocken kommt durch das konstruierte Außenraum-Setting der Verdacht auf, daß auch die aufgestellten Mikrophone nur Staffage sind und so der Ballspielsound keineswegs ein instrumentaler sein kann. In spielerischer Manier versuchen alle nacheinander, ihren Spieltakt zu finden, um eine neue Gelegenheit rhythmischen Einstiegs zu ermöglichen. Diese prozessuale Entwicklung fließt in das Endprodukt mit ein, das sich nicht durch Abgeschlossenheit des Musikstücks auszeichnet, sondern von einer begrenzten Zeit – oder Materialvorgabe bestimmt ist. Somit ist das Produkt nicht absolut zu setzen, sondern könnte durch die Modifikation einer der Rahmenbedingungen genausogut zu einer ganz anderen Endfassung führen. Dieses Prinzip ist auch in anderen Arbeiten Györfis zu finden: Alexander Györfis Arbeitsweise folgt einer Strategie der Kollaboration. 1997 gründete er das Label "Pimui", das als Dachorganisation für die unterschiedlichen Projekte fungiert. So richtete er für den Kunstverein Ludwigsburg unter "Pimui Collaboration" ein temporäres Tonstudio ein. Jeder Song hatte eine minimale musikalische Vorgabe, einen Rhythmus. Synthesizer, Misch- und Tonspurgeräte befanden sich auf einem runden Tisch, der die BesucherInnen einladen sollte, Györfis Vorgabe weiterzudenken, weiterzumusizieren oder weiterzusingen. Diese wörtlich verstandene Interaktivität brachte er jedoch ohne großen technologischen Aufwand zustande. Das Ergebnis zu diesem Projekt ist auch im nachhinein auf einer CD des Pimui-Mobilstudios zu hören. Györfi bietet Strukturen an, die benützt werden wollen. Die auf passive Rezeption eingeübten BesucherInnen einer Ausstellung werden motiviert, an einem künstlerischen Projekt mitzuarbeiten. Dadurch werden sie zu Mitwissenden und zum Teil auch zu Mitverantwortlichen des zu sehenden beziehungsweise zu hörenden künstlerischen Produkts. Diese Strategie läßt die Vorstellung des genuinen künstlerischen Schöpfers obsolet werden. Obwohl die Bedeutungsverschiebung von einer singulären zu einer kollektiven Autorenschaft bereits seit Aufkommen des Internets ein allerorts diskutiertes Thema ist, gewinnt es immer wieder an neuen Facetten. Auch Györfi arbeitet des öfteren im Medium Internet. So entwarf er 1998 den Prototyp einer Homepage für den Kunstverein Ludwigsburg, die aus einer bewußt farblich reduzierten schwarzweißen Oberflächenstruktur und bereits existie-

Alexander Györfi's artistic strategy of collaboration – *Doris Berger –* Translated by Toby Alleyne-Gee

A group of young people creates a sound with balls, tennis rackets and diving flippers that, if you closed your eyes, you could easily think was electronic – which it is, for the "Ball Music" you are seeing is dubbed. The sound video *Beatballs and Flukes* (1998) shows the paradoxical situation of "musicians" making studio recordings in an artificially created outdoor studio. Despite the sounds of twittering birds and church bells, the artificial outdoor situation arouses the suspicion that the microphones are only props, and that there is therefore no way that the sound of ball games can be instrumental. Playfully, all the participants try to find the right bar to join in the music. This development flows into the end product, which is not characterised by an isolated piece of music, but is determined by a time limit or guideline concerning the material used. Thus the product is not to be taken literally, but could lead to a completely different final result by modifying just one of the conditions in which it is recorded.

This principle can be observed in other works by Györfi: his work pursues a strategy of collaboration. With the *Pimui Collaborations* label founded in 1997 Györfi installed a mobile studio in the Kunstverein Ludwigsburg for a month. Every song was determined by a minimal musical guideline, a rhythm. Synthesisers, mixing and sound-tracking equipment were placed on a round table to encourage the museum visitors to pursue Györfi's directive, to continue making music or to sing. Yet the artist succeeded in realising this literal perception of interactive art without a great deal of technical equipment. The result of this project can be heard on a CD sampler. Györfi offers structures to be used. Visitors to exhibitions, accustomed to passive reception, are motivated to collaborate on an art project. They thus become accessories, and to a certain extent responsible for the visual or audio artistic product. This strategy renders the idea of a genuinely creative artist obsolete. Although the concept of authorship changing from a singular to a collective one has been widely discussed since the arrival of the Internet, new facets constantly emerge. Györfi works frequently with the Internet. For example, in 1998 he designed the prototype for a homepage for the Kunstverein Ludwigsburg, whose surface

– **Beatballs and Flukes**, 1998, Videostills

– **Pimui - mobilstudio**, 1998, 20 days recordingstudio, music presentation, Kunstverein
Ludwigsburg

– **Pimui - virtuell analog Synthesizer - patch for "temporary items\metro. fla\warmup pch"**, Video sequence, 1999 – **temporary items**, 1999, Videostills

renden, aber zur täglichen Orientierung fremden Piktogrammen bestand. Die einzelnen Symbole wurden animiert und mit Sound unterlegt, wodurch die ursprüngliche Bedeutung verfremdet wurde und für neue Codierungen offen stand. Dieses Projekt entwickelte er 1999 für den Kunstverein Wolfsburg weiter, wo er einen Link zu einem seiner neuen Projekte, einer Internet-Zeitschrift (www.pimui.de) aus Musik, Animationen, Texten und Bildern eingebaut hat. Die erste Ausgabe der Zeitschrift, die ebenfalls unter dem Label "Pimui Collaboration" agiert, dreht sich rund um das Thema "Country". Jeder ist eingeladen, eigene Beiträge per Post oder E-mail an ihn zu senden. Auch hier bietet Györfi den ästhetischen wie den funktionellen Rahmen und wirkt als Künstler aktiv innerhalb dieses Rahmens mit. Verglichen mit einem Architekten, würde Györfi nicht nur die Pläne eines Gebäudes zeichnen, sondern auch beim Bau mitarbeiten, um dann gemeinsam mit den anderen darin zu wohnen.

was mainly black and white and consciously abstains from the use of colour. The artist also used pictograms that already existed but were unfamiliar for daily use. The individual symbols were animated and put to music, which alienated them from their original meaning, leaving them open to new interpretations. Györfi pursued this project in 1999 for the Kunstverein Wolfsburg, incorporating a link to one of his new projects, an Internet magazine (www.pimui.de) containing music, animated images and texts. The first issue of the magazine, which is also published under the auspices of the *Pimui Collaboration* label, is dedicated to the theme of "country". Everyone is invited to send their own contributions to him by post or e-mail: Györfi offers his audience an aesthetic and functional framework, actively collaborating as an artist within this framework. To make a comparison with an architect: Györfi would not only draw the plans of a building, but have a hand in building it – and live in the house with other people.

ALEXANDER GYÖRFI – Sindelfingen, 1968 – Staatliche Akademie der Bildenden Künste, Stuttgart – Wohnt/lives in Stuttgart

AUSSTELLUNGEN, PROJEKTE/EXHIBITIONS, PROJECTS (Auswahl/selected): 1998 Pimui-Remix-System, Präsentation und Künstlergespräch im Kunstverein Ludwigsburg/Presentation and Discussion with the artist at the Kunstverein Ludwigsburg (Homepage - mobiles Tonstudio/Homepage mobile sound studio) **1997** Elastics, Peripherie-Sudhaus Galerie, Tübingen (CD-ROM Präsentation/CD-ROM presentation) – Einsame Anfänger brauchen Passfotos, Galerie Göyrfi, Herrenberg **1996** Wohnzimmern, MacGranston Atelier, Los Angeles (Videoarbeiten Videos) – Publishing Workshop, Derby-England (Mail Art - Interaktives Cassettenlabel Veröffentlichung von Tapeland/Mail art - interactive cassette label, produced by Tapeland) – Haus & Hof, Oberwelt e.V. 1996 (Soundinstallation, Objekte/Sound installation, objects) – Veröffentlichung der Musikkassette/Publishing of the music tape Pimui-Interieure? gogo **1995** Soundlabor, Stellwerk, Kassel (Installation, mobiles Tonstudio/Installation, mobile sound studio) – Lebensfreude-Just in Time, Stuttgart (Installation, mobiles Tonstudio/Installation, mobile sound studio) – Veröffentlichung der Musikkassette/Publishing of the music tape Pimui-3d Stereo

– Transarchitektur oder Psycho in Dresden, 1999, Videostills, Courtesy Galerie Eigen + Art, Berlin

Zerstückeln und Verkehren – *Peter Herbstreuth*

Meanings: Deconstructions, Reconstructions –
Peter Herbstreuth – Translated by Toby Alleyne-Gee

Es gibt eine wachsende Zahl von Künstlern, die nicht bloß Kunst-am-Bau-Projekte beliefern, sondern vom Entwurf bis zur Fertigstellung mit den Architekten in dem Sinn zusammenarbeiten, daß sie an Entscheidungsprozessen des Gesamtbaus beteiligt sind. Von einem abgrenzbaren Werk als Detail im Gebäude kann nicht mehr gesprochen werden. So arbeitet Rémy Zaugg mit den Architekten Herzog und de Meuron, Gerhard Merz mit Hans Kollhoff und Maix Mayer mit dem Frankfurter Architekturbüro Schneider + Schumacher, das durch die "Infobox" am Berliner Potsdamer Platz deshalb bekannt geworden ist, weil sie mit minimalem Aufwand ein Maximum an Funktionalität erreichten und der knallroten Kiste auf Stelzen mit einer Außentreppe wie eine verspielte Arabeske sogleich den Charakter eines Signets verliehen. Maix Mayer bekam auf Betreiben der Bauherren 1994 von Schneider + Schumacher einen Beratervertrag für den Bau des KPMG-Gebäudes in Leipzig und brachte seine Ideen und Vorschläge im Planungsprozeß zur Geltung. Jetzt, da das Gebäude bezugsfertig ist, gibt es kein umgrenztes Werk von Mayer vor Ort zu sehen, denn seine Beteiligung ging im Gesamtbau ebenso auf wie die der anderen Entwerfer. Der Dialog zwischen den Disziplinen war nicht strikt ergebnis-, sondern ideenorientiert. Mayer gehörte zum Team. Umgekehrt hatte er seine Arbeit als Künstler durch diesen Erfahrungsprozeß nicht architektonisiert. In einer Schule ließ er als Beitrag zur Kunst-am-Bau eine Vorrichtung mit Seifenblasen an die Computeranlage anschließen. Sobald die Rechner Kontakt mit dem WorldWideWeb aufnehmen, schweben Seifenblasen durch den Raum. Das amüsiert und inspiriert die Schüler und läßt Bilder aus der Comicwelt anklingen: ein Raum von denkenden jungen Leuten, in dem alles schwebend in Bewegung bleibt. Mayer paßte sich den Gegebenheiten an und reagierte nicht auf die Architektur, sondern auf die Situation derer, die mit der Zugabe des Künstlers in ihrem Raum fortan leben müssen. Sein Beitrag drängt sich nicht bedeutungsvoll als Kunst auf und kommt ohne didaktische Obertöne aus. Er bezieht sich auf das Gedächtnis derjenigen Schüler, die bei der Lektüre von Comics vergnügte Bildungserlebnisse hatten. Nach der Fertigstellung des KMPG-Gebäudes in Leipzig 1998 verfügte Mayer über zwölf Stunden Filmmaterial zum Werden des Baus und edierte es zu einem kurzen Film mit schnellen Schnitten. Nicht der Bau, sondern der Blick des Kameramanns ist das agens des Films mit dem zunächst rätselhaften Titel "Die Welt des Tropisten, ein Remake". Der Begriff "Trope" stammt vom griechischen Wort tropos und bedeutet Wendung und Weg, wird aber vor allem in der Sprachwissenschaft im übertragenen Sinn als Redewendung und Bedeutungswandel verwendet. Die wörtliche und übertragene Bedeutung kodieren die Machart des Films. Der Tropist, also

A growing number of artists not only provide works of art for public art projects, but cooperate with architects from the draft stage of a building to its completion, in the sense that they are involved in decision-making processes affecting the entire construction project. It is hence no longer possible to think of a work of art as a separate detail within a building. This is how Rémy Zaugg works with the architects Herzog and de Meuron, Gerhard Merz with Hans Kollhoff, and Maix Mayer with the Frankfurt architects Schneider + Schumacher, who came to prominence with their "infobox" on Berlin's Potsdamer Platz because they achieved maximum functionalism with minimum effort. A playful arabesque, the bright red box on stilts with an external staircase has assumed the character of a logo. At the instigation of their client, Schneider + Schumacher gave Maix Mayer a consulting contract for collaboration on the construction of the KPMG building in Leipzig in 1994. The artist was thus able to integrate his ideas and suggestions into the planning process. Now that the building is ready to move into, there is no separate work of Mayer's to be seen, as his participation was absorbed into the fabric of the building to the same extent as that of the architects. The dialogue between the two disciplines was not strictly oriented towards results, but towards ideas. Mayer was part of the team. On the other hand, this experience did not render his work as an artist "architectural". In a school, his contribution to a public art project was to have a bubble-blowing machine linked to the computer system. As soon as the computers make contact with the WorldWideWeb, soap bubbles float through the room. This amuses and inspires the pupils, and evokes images from the world of comics: a room of young thinkers in which everything hovers, constantly on the move. Mayer adapted his work to the circumstances; he did not react to the architecture, but to the situation of those who have to live with the artist's contribution to the space. Mayer's contribution does not claim to be a significant work of art and abstains from didactic overtones. It is a reference to those pupils who have enjoyed learning from comics.

By the time the KPMG building in Leipzig was completed in 1998, Mayer had collected over twelve hours' film material recording the development of the building. He edited it into a short film with brief sequences. Not the construction, but the view of the cameraman is the driving force of the film, which is mysteriously entitled *The World of the Tropist, a Remake*. The term "tropism" is derived from the Greek word tropos, and means turning or path, but is mostly used in linguistics in the figurative sense of an idiomatic expression or a change of meaning. The literal and figurative meanings of the word "tropism" describe the way the film is made. The "tropist" – the filmmaker Maix Mayer – cuts a path

– **Die Welt des Tropisten** – **ein Remake**, 1998, Videostills, © Maix Mayer, Courtesy Galerie Eigen + Art, Berlin

der Filmemacher Maix Mayer, bahnt sich einen scharf geschnitte-
nen Weg durch das KPMG-Gebäude und verkehrt die Bedeu-
tungen des Realraums in ein rein visuelles Ereignis post factum.
In der Galerie Eigen + Art in Berlin installierte er den Monitor in
eine knallrot gestrichene Wand als Zitat der Infobox. Die Grenze
zwischen Fiktion und Dokument verschwindet. Das Dokumentar-
material wird dramatisiert und neigt sich dem Fiktionalen zu, wäh-
rend das Fiktionale sich durch den Bezug zur Realität beglaubi-
gen will. Dem entspricht Mayers Vorgehen insgesamt. Er fotogra-
fiert, filmt, zeichnet, sammelt Belegstücke, stellt Filmplakate von
Filmen her, die es nie gab und sucht andererseits die Orte seiner
Kindheit auf, um die Bäume zu fotografieren, wo er einst seine
Initialen eingekerbt hatte. In diesem Sinne ist auch der Film über
das KMPG-Gebäude zu verstehen: als Teil der Lebensgeschichte;
daher ein formalisiertes, doch wiedererkennbares "Remake".

Die Architektur gab vier Jahre den Ton an. Und der Künstler tanz-
te danach ein Solo, rhythmisierte den Blick im Gebäude und setz-
te es als Collage zu einem atmosphärischen Eindruck zusammen,
der einem Traum von dem Gebäude ähnlicher ist als dem Real-
bau. Dies ist ganz zweifellos architekturbezogene Kunst; doch
eher in dem Sinne wie François Truffaut Hitchcocks "Psycho"
beschreibt: "Die Stadt, ein Gebäude in dieser Stadt, ein Zimmer
in diesem Gebäude, das ist der Anfang". Der Rest ist eine Schnitt-
folge durch die Räume.

through the KPMG building and transforms the significance of the
real space into a purely visual event post factum. In the Eigen +
Art gallery in Berlin, Mayer installed a television monitor in a wall
painted bright red as a quotation of the "infobox". The boundary
between fiction and documentation disappears. The documentary
material is dramatised and tends towards the fictional, while the
fictional seeks credibility through its relationship to reality.

This reflects Mayer's general approach. He photographs, films,
draws, collects documentary evidence, produces posters for films
that never existed, yet he also returns to the places of his child-
hood to photograph the trees into which he once carved his ini-
tials. The film of the KPMG building should also be interpreted as
part of the story of the artist's life; it is thus a formalised and yet
recognisable "remake".

For four years, architecture set the tone. And the artist danced a
solo, created visual rhythms within the building, and assembled a
collage of atmospheric impressions that render it more dreamlike
than real. This is undoubtedly architecture-related art, but more in
the sense that François Truffaut describes Hitchcock's *Psycho*: "A
city, a building in that city, a room in the building, that's the begin-
ning." The rest is a series of scenes documenting the rooms.

MAIX MAYER – Leipzig, 1960 – Diplom der Marinen Ökologie, Rostock – Wohnt/lives in Leipzig

EINZELAUSSTELLUNGEN/ONE PERSON SHOWS: (Auswahl/selected): 1999 Galerie Waltraud Matt, Eschen, Lichtenstein – Mind. Map. Rap. III, Galerie F.M. Schwarz, Köln – Mind. Map. Remix, Biennial Art Invitational `99, Los Angeles **1998** Plaza Gallery, Tokio – ZaMoca Foundation, Tokio – TROPE, Die Strategie, Galerie EIGEN + ART, Berlin **1996** Galerie Bott, Köln **1995** Galerie EIGEN + ART, Leipzig – Galerie Weißer Elefant, Berlin **1994** Goethe-Institut, Paris – Die Domestizierung ist noch nicht abgeschlossen, Galerie Etienne Ficheroulle, Brüssel **1993** Phantom, Galerie EIGEN + ART, Berlin – via regia, Stadtgeschichtliches Museum, Leipzig **GRUPPENAUSSTELLUNGEN/GROUP SHOWS (Auswahl/selected): 1999** Studiocity, Institut für Gegenwartskunst, Wien – Humboldt's Wiederkehr, Goethe-Institut Caracas, Venezuela, (Katalog/catalogue) – Studiocity, Kunstverein Wolfsburg **1998** Karl Schmidt - Rottluff Stipendiaten, Kunsthalle Düsseldorf (Katalog/catalogue) – Go East, Wollongong City Gallery, Australien (Katalog/catalogue) – Mütter, ACC Galerie, Weimar **1997** Lust und Last, Germanisches Nationalmuseum Nürnberg, Museum der Bildenden Künste, Leipzig (Katalog/catalogue) – Fotografie als Geste, Staatliches Museum Schwerin (Katalog/catalogue) – Papertrail, Pievogie 2000, New York **1996** Der Blick ins 21ste, Kunstverein Düsseldorf – unikumok, Ernst Múzeum, Budapest **1994** Otto-Dix-Preis `94, Kunstsammlung Gera (Katalog/catalogue) – Junge Kunst, Saar Ferngas Förderpreis, Pfalzgalerie, Kaiserslautern – Minima Media, Medienbiennale Leipzig (Katalog/catalogue) – Museum Schaffhausen (Katalog/catalogue) **1992** 2. Internationale Foto -Triennale Esslingen, Villa Merkel, Esslingen (Katalog/catalogue) Humpty Dumpty´s Kaleidoscope: A new generation of German Artists, Museum of contemporary Art, Sydney (Katalog/catalogue) – **1991** Junge Kunst aus Sachsen, Frankfurter Kunstverein (Katalog/catalogue)

Maix Mayer

Christian Flamm

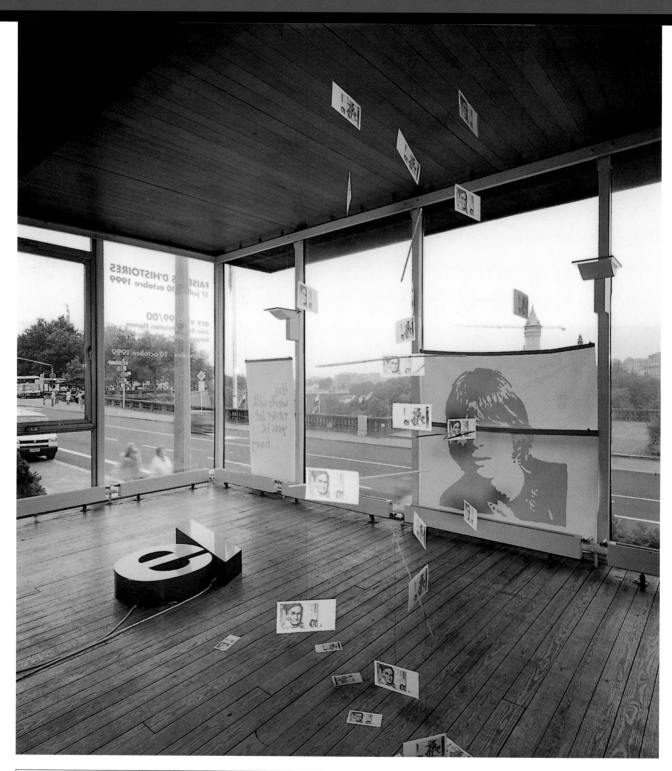

– Installation view, ars viva 99/00, Casino Luxembourg, 1999

Christian Flamm – *Axel John Wieder*

Christian Flamm – *Axel John Wieder* – Translated by
Toby Alleyne-Gee

Geld-Out. In der Werbewirtschaft existiert ein sehr eigener Begriff: das Buy-Out. Es bezeichnet die vertraglich fixierte Abtretung des Rechtes am eigenen Bild, was notwendig ist, um eine Person als Werbeträger nutzen zu können. Für Modelle ist diese Klausel lukrativ, denn sie vermehrt das eigentliche Honorar für die Werbeaufnahmen erheblich – in Spitzenfällen um 600 Prozent, wenn die Rolle das Image der Person nachhaltig negativ festlegen könnte. Der Konterpart des Buy-Outs, das Sell-Out, beschreibt Prozesse der Veräußerung identifikatorischer Angebote als Inbesitznahme von Außen. Der Begriff legt nahe, daß sich mittels Geld eine ehrliche Struktur in Unaufrichtigkeit verwandeln könnte. Er verkennt dabei die kulturelle Logik, die sich nicht allein ökonomisch fassen läßt. Institutionen wie Firmen sind permanent auf Bilder und Namen angewiesen, um hegemoniale Geschichtsschreibungen zu etablieren. Zwangsläufig geraten sie dabei mit Selbstbeschreibungen in Konflikte, die nicht bezahlbar sind, sondern nur als Politikum zu verhandeln wären.

Eine Ausstellungssituation von Christian Flamm könnte so aussehen: Der Blick in die große Halle verspricht Handlungsmöglichkeiten, mit dem Raum etwas anfangen zu können. Es sind Bierflaschen zu sehen, eine Musikanlage und davor verstreut liegende Musikkassetten. Die Gegenstände sind ausgedruckt oder als Scherenschnitt aus bunten Pappbögen gefertigt. Sie sind also Repräsentationen, der nähere Blick klärt das deutlich, manchmal auch anhand technisch mangelhafter Details. Sie spielen auf sozial stark kodierte Orte an, auf Situationen zwischen politischer Demonstration und kenntnisreichem Musikhören unter Freunden. Die Bebilderung der Wünsche nach emanzipativen Möglichkeiten kehrt sich ins Private. Den Term "Jugendzimmer" verwirft man lieber gleich, denn zu sehr hängen einem noch die eigenen Erfahrungen nach und verlangen nach Präzisierungen. Eine weiße Papierbahn, die eine zimmerartige Raumgröße vorschlägt, bietet sich als Projektionsfläche und führt einen Interpretationsmaßstab ein: Orte, an denen man sich gerne aufhalten würde, vielleicht mit Personen, mit denen man gerne wohnen, arbeiten und reden möchte.

In einem abgetrennten Bürohäuschen der großen Halle setzt sich die Installation als Galerie fort und spielt verschiedene Präsentationsmodi durch. Technisch stellt sich eine Reihe von Computerzeichnungen über handwerkliche Malereien und Scherenschnitte bis zu frei auf fundstückhafte Zeichen wie Aufkleber zurückgreifende Arbeiten her. Die Bilder, allesamt günstig produziert, arbeiten mit einer enormen Zeichendichte. Anders als die simulativen Elemente der Rauminstallation bestehen die Bilder

Money-out. In the world of advertising there is a very odd term: the buy-out, which means contractually relinquishing one's rights to one's own image. This is prerequisite to being able to use a person as an advertising medium. For models, this clause can be lucrative, as it increases fees for advertising photographs considerably – in extreme cases by up to 600 percent, if the assignment could exercise a lastingly negative influence on the person's image. The counterpart of the buy-out, the sell-out, describes the process of offering identity for sale. Others take possession of a person's identity. The term sell-out suggests that money can transform an honest structure into something insincere. Yet it fails to recognise the logic of culture, which cannot be grasped purely in terms of economics. Both institutions and companies are permanently dependent on images and names to establish the hegemony of their view of history. They cannot help but come into conflict with self-descriptions that are not for sale, but can only be negotiated as political issues.

This is how an exhibition of Christian Flamm's work could look: the view into the generous exhibition space promises the possibility of being able to do something with the room. The visitor will see beer bottles, music cassettes strewn in front of a stereo system. The objects are printouts or cut-outs made of colourful cardboard. As closer inspection will reveal, they are representations; sometimes technical imperfections are the give-away. Flamm's work hints at places that have strong social connotations, ranging from a political demonstration to a group of knowledgeable friends listening to music. The illustration of the desire for emancipatory possibilities enters a private sphere. We should reject the term "young people's room" immediately, for it reminds us too much of our own experience, and demands precise explanations. A length of white paper suggesting a room-like space serves as a surface for projection and introduces a standard for interpretation: places we would like to stay, perhaps with people we would like to live with, work with and talk to.

In a small separate office in the large hall, Flamm's installation continues as a gallery, serving to demonstrate various modes of presentation. A series of technical computer drawings is shown, handcrafted paintings and silhouettes, as well as work based on indicators that appear simply to have been found, such as stickers. The pictures were all produced cheaply and work with an enormous density of indicators. Unlike the simulated elements of the installation, however, the pictures insist on their status as pictures. They are both the surrogates of other (possible) pictures and

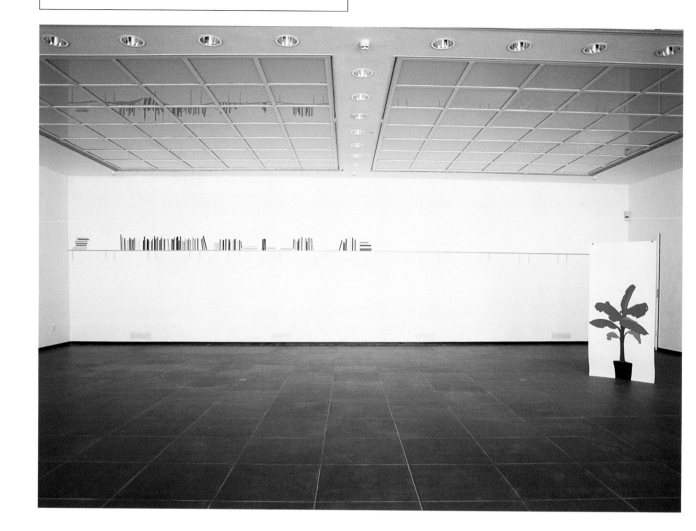

aber auf ihrem Bildstatus. Sie sind gleichzeitig Surrogat anderer (möglicher) Bilder und Teil eines sentimentalen Wissens um die Politizität und Relativität der Zeichen. Als solche sind sie die Dokumentation eines Jetzt als Situation, die auch Ungehaltenheit und Ärger kennt.

Der 1974 in Stuttgart geborene Christian Flamm setzt auf die Möglichkeiten, die sich nicht allein in Produktionsmitteln ausdrükken. Seit 1997 lebt er in Berlin und arbeitet unter anderem als Künstler. Neben anderen ist Kunst eine Offerte, die partizipative Strukturen mit eingeladenen Personenzusammenhängen ermöglicht. Musik oder Grafik sind andere und sehen weitere Rollenangebote vor, die den eigenen Wünschen ebenfalls häufig entgegenlaufen. Nicht in den Angeboten aufgehen zu wollen, be-

part of a sentimental knowledge of the political nature and relativity of the indicators. As such, they are the documentation of now as a situation that is also familiar with indignation and annoyance. Christian Flamm, born in Stuttgart in 1974, uses means of expression which are not only found in productive methods. Flamm has lived in Berlin since 1997 and works among other things as an artist. Music or graphic design frequently coincide with one's own desires. For Flamm, not wanting to be absorbed by the offers he receives has meant that he sees himself not so much as an identity, but as an agent. Thus he often invites others to participate, giving them the opportunity to act within a defined framework. This approach risks disappointing at least people's preconceptions about role play. Somebody else could be meant. Flamm's

deutet für Flamm, sich darin weniger als Identität denn als Agent zu sehen. So arbeitet er häufig mit weiteren, selbst eingeladenen TeilnehmerInnen, die im gesteckten Rahmen handeln können. Dieses Verfahren riskiert zumindest, daß Rollenvorstellungen enttäuscht werden. Es könnte sich auch um jemanden anderes handeln. Die selbst angefertigten Bilder und Raumelemente handeln tatsächlich von anderen Menschen, von ihren Produkten, Stilen und Ansichten, die sich in Flamms kenntnisreichem Archiv der Anspielungen treffen. Dort funktionieren sie ohne Geld, auf der Basis von Freundschaft, Fan-Sein und Verständnis, vielleicht auch, weil sich eine ausstellende Institution das erforderliche Buy-Out nicht im geringsten leisten könnte.

pictures and installations really are about other people, their products, styles and attitudes, which converge in Flamm's archive of knowledgeable allusion. There, they function without money, on the basis of friendship, of being fans and understanding, perhaps also because an institution planning an exhibition could never afford a buy-out.

CHRISTIAN FLAMM – Stuttgart, 1974 – Wohnt/lives in Berlin

EINZELAUSSTELLUNGEN/ONE PERSON SHOWS: 1999 Umsonst ist das Leben, Frankfurter Kunstverein, Frankfurt am Main **1998** Der Apfel fällt nicht weit vom Stamm, Künstlerhaus Stuttgart **1997** Freihand, Kunstakademie Stuttgart **GRUPPENAUSSTELLUNGEN/GROUP SHOWS: 1999** ars viva 99/00, Casino Luxembourg, Kunstverein Freiburg (2000), KunstHaus Dresden (2000) (Katalog/catalogue) **1998** 40 Kalorien, Galerie Nomadenoase (mit/with Abel Auer), Hamburg – Christian Flamm trifft Birgit Megerle und André Butzer in der Galerie Kienzle und Gmeiner, Galerie Kienzle und Gmeiner, Berlin – Akademie Isotrop, in G. Reskis Laden, Berlin – **1997** Galerie Gmeiner, Stuttgart (mit/with Interfaces, Symposium über Schrift und Sprache) **1996** Bewegung jetzt, Umbauraum, Künstlerhaus Stuttgart – Lebensfreude, Zepplincarré Stuttgart **1994** Aroma 2000, ehemaliges Regierungspräsidium, Stuttgart – Saftig, Stadthaus Backnang – Soundlabor, Galerie Stellwerk, Kassel

Christian Flamm

Heidi Specker

"Häuser sind Behälter für Gedankengänge" – Zu den Fotografien von Heidi Specker – *Annelie Lütgens*

Architektur als Bildthema ist eng verknüpft mit bildtechnischen Darstellungsmitteln. Seit der Renaissance haben Künstler, die sich anschickten, Architektur oder gebaute Umwelt auf die zweidimensionale Fläche von Holztafel, Leinwand oder Papier zu bringen, die technischen Hilfsmittel ihrer Zeit benutzt. Mit Zirkel und Lineal ließen sich im 15. und 16. Jahrhundert Gebäude perspektivisch richtig ins Bild bringen und sogar Phantasiearchitektur und Luftschlösser überzeugend darstellen. Im 17. Jahrhundert benutzte Vermeer die Camera obscura für sein berühmtes Gemälde "Ansicht von Delft". Im 18. Jahrhundert perfektionierte Piranesi die Radierung für seine Vision einer heroischen Antike. Und mit dem Blick auf Gebäude erforschten die ersten Fotografen im 19. Jahrhundert die aufregenden Materialisierungen von Licht und Schatten. Diese neue Technik der Bildproduktion stand dem sachlichen, dokumentarischen wie dem subjektiven, emotionalen Blick gleichermaßen zur Verfügung. Die malerische Kunstfotografie des 19. wurde erst zu Beginn des 20. Jahrhunderts von einer eher sachlichen Sichtweise abgelöst, die sich bekanntlich gegen jeden Vergleich mit der Malerei verwahrte und mit Bildschärfe und Kameratechnik die fotografischen Mittel in den Vordergrund stellte.
Mir scheint, daß in den mit einer digitalen Kamera aufgenommenen und im Computer bearbeiteten Fotografien von Heidi Specker diese einstmals gegensätzlichen Auffassungen aufgehoben sind. Ihre Arbeiten enthalten sowohl Elemente der atmosphärischen, malerischen Kunstfotografie um 1900 als auch der sachlich-dokumentarischen Fotografie der zwanziger Jahre.
Die Motive ihrer "Speckergruppen" von 1995/96 sind nüchterne Architekturaufnahmen. Damit grenzt sie sich sowohl von digitaler Fotografie im Sinne von rein computergenerierten Bildern als auch vom manipulativen Bildjournalismus ab.
Speckers Fotografien erhalten durch die flächendeckende digitale Nachbearbeitung im Computer eine malerische Anmutung. Die Haut der Architektur, ihre Fassade, wird aufgeweicht. Dadurch wirken die Häuser wie in Kunstharz eingegossen, seltsam artifiziell, etwa wie Architekturmodelle, die in einer Fotografie reale Gebäude suggerieren und doch ihre Unwirklichkeit nicht verbergen können. "Speckergruppen" und "RGB Routine" sind so komponiert, daß extreme Anschnitte und steile Blickwinkel eine Räumlichkeit erzeugen, die auf das Neue Sehen der Bauhausfotografie zurückgeht. In dem tiefen Betrachterstandpunkt wird diese subjektive Sicht deutlich. Die Fotografin strebt keine dokumentarische Erfassung eines Gebäudes an, sondern inszeniert Ausschnitte. Himmel ist oft, Erde nur selten zu sehen, so wird allzu Topografisches vermieden und der neutrale blaue Himmel als monochrome Ergänzung zur kleinteiligen Struktur der Fassaden genutzt.

"Buildings House the Corridors of the Mind" – On Heidi Specker's Photographs – *Annelie Lütgens* – Translated by Toby Alleyne-Gee

Architecture as the subject of a picture is closely linked with technical means of representation. Since the Renaissance, artists preparing to represent architecture or a constructed environment on the two-dimensional surfaces of wooden panels, canvas or paper have used the respective technical aids of their time. In the 15th and 16th centuries, compass and ruler allowed artists to show buildings in the correct perspective, and even fantasy architecture and castles in the air could be represented convincingly. In the 17th century, Vermeer used the *camera obscura* for his famous painting, *View of Delft*. In the 18th century, Piranesi perfected the etching technique to express his vision of a heroic antiquity. And the first photographers in the 19th century examined the exciting play of light and shade on buildings. This new technique of producing pictures was equally suited to producing both matter-of-fact, documentary images and expressing a subjective, emotional view. Only at the beginning of the 20th century did the earlier picturesque style of artistic photography give way to a more objective approach. Representatives of this style protested against any comparison with painting and emphasised the photographic nature of their work by producing images in sharp focus requiring the use of specifically photographic techniques.
I think that Heidi Specker's photographs, which she takes with a digital camera and processes in a computer, have dissolved the boundaries between these once contradictory attitudes. Her work contains both elements of the atmospheric, picturesque photography around 1900 and of the documentary photography of the Twenties.

Her *Speckergruppen* ("Specker Groups") of 1995/96 are sober photographs of architecture, and distinguish the artist's work both from digital photography in the sense of purely computer-generated images and from manipulative photojournalism. Digitally processing the entire image in the computer lends Specker's photographs a painterly quality. Specker softens the skin of the buildings – their façades – making them look as if they have been preserved in resin. They thus seem strangely artificial, like architectural models that, in a photograph, suggest real buildings and yet are unable to hide their unreality. *Speckergruppen* and *RGB Routine* are composed in such a way that the images, taken from extremely sharp angles, create a sense of space which derives from the New Vision of Bauhaus photography. The fact that Specker takes her photographs from a low viewpoint emphasises their subjective nature. The photographer does not attempt to produce a documentary record of a building, but stages excerpts of it. While the sky is often visible, the earth is rarely to be seen,

...ektur der sechziger ...tionalen Funktiona- ...a der fordistischen ... Arbeiten, Wohnen ...n befinden wir uns ...rung, in der unsere ...entarchitektur ge- ...hitekturkritiker Neil ...ge, als vornehmlich Circulation ...s Bild konzipiert. Auch bei Speckers digitalem Piktu-ralismus wird Architektur zum Bild. Damit gelingt ihr das Paradox, Bilder von bildloser Architektur zu schaffen. Erst in der Unschärfe, so scheint es, wird die rationalistische, funktionale Architektur wieder ansehnlich.[2]

Die 1998 entstandene Serie "Teilchentheorie" markiert jedoch einen neuen Schritt – weg vom Weichzeichner. Specker druckt diese Motive als Irisprints und erzielt damit im Gegensatz zu den

thus avoiding an all too topographical view and using the neutral blue sky as a monochrome complement to the fragmented structure of the façades.

Specker is interested in the mono-architecture of the Sixties and Seventies, the low point of international functionalism. The topics of her photographs thus derive from the era of Fordist town planning, which was based on the separation of work, accommodation and recreation.[1] Since the Eighties we have been in a phase of postmodernist rebuilding in which our inner cities are characterised by stylistically pluralist "event" architecture. As the architecture critic Neil Leach remarks, more than ever nowadays, architecture is conceived as a mainly aesthetic image. Architecture also becomes an image in Specker's digitally processed pictures. She thus successfully achieves the paradox of creating images from architecture devoid of image. It would appear that rationalist, functional architecture only regains its attractiveness when it is blurred.[2]

– **Plaza**, RGB Routine, 1997, 188 x 125 cm, Digital Print, Courtesy Galerie Ulrich Fiedler, Köln – **Bank**, RGB Routine, 1997, 180 x 125 cm, Digital Print, Courtesy Galerie Ulrich Fiedler, Köln

– **Hotel**, RGB Routine, 1997, 180 x 125 cm, Digital print, Courtesy Galerie Ulrich Fiedler, Köln – **Fassade**, RGB Routine, 1997, 180 x 125 cm, Digital print, Courtesy Galerie Ulrich Fiedler, Köln

großformatigen, malerischen Tintenstrahldrucken der "Specker-gruppen" eine eher grafische Wirkung. Hier geht sie näher an die Fassaden heran und greift einzelne Motive heraus, um sie mit anderen Gebäudeperspektiven oder Stadtansichten aus der Vogelschau zu kombinieren. Es geht ihr nicht länger um das Einzelbild, sondern um die Kombination von Motiven analog zu den Modulen einer seriellen Architektur. Diesmal erforscht sie weniger die malerischen als die plastischen Qualitäten von Betonblumen, Trapezstrukturen oder runden Glasfenstern. Während Specker in manchen Ornamenten formale Ähnlichkeiten mit Computerchips findet, ist ihre additive Vorgehensweise selbst in Analogie zum Rechner gewählt. Motiv, Komposition und bildtechnische Bearbeitung lassen sich also auf einen gemeinsamen Nenner bringen: Es geht um Codes.

Wenn Heidi Specker Fassadenschmuck, Verkleidungen oder Ummantelungen von Gebäuden in den Blick nimmt, so erinnert sie auch daran, wie ein in den sechziger Jahren von Künstlergruppen

The 1998 series of photographs entitled *Teilchentheorie* ("Particle Theory"), however, marks a move away from the soft-focus approach. Specker prints these images as Iris prints and thus achieves a graphic effect that is in contrast with the large-format, painterly inkjet prints of the *Speckergruppen*. In *Teilchentheorie* she moves closer to the façades and focuses on individual elements which she combines with other views of the building or bird's eye views of the city. She is no longer concerned with the individual image, but with the combination of elements, by analogy with the modules of serial architecture. This time, Specker is exploring not so much the picturesque as the sculptural qualities of concrete flowers, trapezium structures or round windows. While she finds formal similarities with computer chips in several architectural ornaments, the cumulative method of her work has itself been chosen as an analogy with the computer. Subject, composition and picture processing can thus be reduced to a common denominator: Specker is concerned with codes.

wie Zero oder Nul entwickeltes, reduziertes Formenrepertoire als Dekor für Massenarchitektur in die Alltagswelt überführt wurde. Über diesen Prozeß der Trivialisierung utopischer Gedankengänge führt der Weg auch zurück: vom puren Formenkanon der "Teilchentheorie" etwa zu Jan Schoonhovens gipsernen Quadratreliefs mit ihren feinen Licht- und Schattenwirkungen.

So abstrakt und seriell Speckers Arbeiten einerseits anmuten, so lassen sie sich doch zugleich auch als historische Dokumente lesen. Dann nämlich, wenn man versucht, die "Speckergruppen" von 1995/96 im Berlin von 1999 aufzuspüren. Im Osten sind inzwischen viele Fassaden renoviert worden. Statt heruntergekommener Betonrippen und abblätternder Farbe, die bei Specker zu onyxfarben schimmernden Oberflächen verschmelzen konnten, haben die Plattenbauten nun neue Verkleidungen erhalten, an denen Schmutz und Blick gleichermaßen abgleiten. Wie postmoderne Pflaster wirken die in Pastelltönen lackierten Alufassaden mit Rustika- und Quaderimitation, hinter denen die Betonreliefs

When Heidi Specker focuses on the ornamentation of a façade, the lining or facing of buildings, she is also reminding us of how the simple repertoire of forms developed for use as decoration for mass architecture by artist groups such as *Zero* or *Nul* was transferred into the everyday world. This process of trivialising utopian ideas also leads the way back from the exercise in pure form of the *Teilchentheorie* to Jan Schoonhoven's square plaster reliefs with their subtly nuanced effects of light and shade.

Although Specker's photographs seem serially abstract, they can still be read as historic documents – especially when you try to find the *Speckergruppen* of 1995/96 in the Berlin of 1999.

In the eastern part of the city, many façades have been renovated. Instead of shabby concrete skeletons and peeling paint, which Specker transformed into onyx-coloured, shimmering surfaces, the panelled buildings have received new façades which reject dirt and the eye of the beholder in equal measure. The aluminium façades painted in pastel shades with imitation rusticated stone

verschwinden. Nur im denkmalgeschützten Hansaviertel aus den fünfziger Jahren lassen sich auch die rätselhaftesten Speckermotive, wie beispielsweise der externe Fahrstuhlturm des Hauses von Oskar Niemeyer Soares Filho mit seinen Querriegeln zum Wohntrakt ohne weiteres identifizieren. Sie sind nämlich auch in Wirklichkeit von einer rätselhaften, kühnen Schönheit, diese Behälter für Gedankengänge, die Neubeginn wagten durch Rückkehr zur Moderne.

– **1** Siehe dazu Ursula von Petz, Metropole, Weltstadt, Global City. Zur Diskussion über neue Formen von Urbanisierung und Urbanität, in: Außenhaut und Innenraum. Mutmaßungen zu einem gestörten Verhältnis zwischen Photographie und Architektur, herausgegeben von Gerda Breuer, Henry van de Velde-Gesellschaft e.V., Hagen, Frankfurt am Main 1997, S. 29. – **2** Der japanische Fotograf Hiroshi Sugimoto hat in seiner jüngsten Serie "Modernism" Schlüsselwerke modernistischer Architektur ebenfalls durch Unschärfe weichgezeichnet.

blocks concealing the concrete reliefs behind them seem like postmodern plasters. Only in the Hansa quarter built in the Fifties and now a protected monument, can the most mysterious subjects of Specker's photography, such as the external lift tower on the house of Oskar Niemeyer Soares Filho, with its Querriegeln to the residential wing, be easily identified. These buildings housing the corridors of the mind dared to start afresh by returning to Modernism. They, too, have a mysterious, cool beauty.

– **1** See Ursula von Petz, Metropole, Weltstadt, Global City. Zur Diskussion über neue Formen von Urbanisierung und Urbanität, in: Außenhaut und Innenraum. Mutmaßungen zu einem gestörten Verhältnis zwischen Photographie und Architektur, edited by Gerda Breuer, Henry van de Velde-Gesellschaft e.V., Hagen, Frankfurt on Main 1997, p. 29.
– **2** In his most recent series of photographs, Modernism, the Japanese photographer Hiroshi Sugimoto has also blurred the contours of key works of modernist architecture.

HEIDI SPECKER – Damme, 1962 – Hochschule für Grafik und Buchkunst, Leipzig – Fachhochschule Bielefeld, Fachbereich Design, Fotografie-/Film-Design – Wohnt/lives in Berlin

EINZELAUSSTELLUNGEN/ONE PERSON SHOWS: 1999 Teilchentheorie, Galerie Barbara Thumm, Berlin **1998** Teilchentheorie, Künstlerhaus StuttgartJames van Damme Galerie, Brüssel **1997** RGB Routine, Galerie Ulrich Fiedler, Köln – Heidi Specker, Galerie Gebauer und Thumm, Berlin – Heidi Specker, APP.BXL, Brüssel – Neue Fotografie, Galerie Matthias Kampl, München **1996** Speckergruppen Bildings, Galerie Ulrich Fiedler, Köln **1995** Bildings, Kunstverein Elsterpark e. V., Leipzig **1993** RGB, galerie de fabriek, Rotterdam (Katalog/catalogue) **1992** Fotoarbeiten, Galerie Kunst und Raum, Hannover **GRUPPENAUSSTELLUNGEN/GROUP SHOWS: 1999** Unschärferelation, Kunstverein Freiburg – Appliance of Science, Frith Street Gallery, London – Reconstructing Space, Contemporary German Photography and Architecture, Architects Association London (Katalog/catalogue) – Digitale Photographie, Deichtorhallen Hamburg **1998** Un/built, Galerie Akinci, Amsterdam – Blurzone, Galerie Charim Klocker, Wien – Urban Living, Galerie Fons Welters, Amsterdam – Technoculture Computerworld, Fri-Art, Centre d'Art Contemporain-Kunsthalle, Fribourg – Digital Image Manipulation, Centro d'Arte Contemporanea Ticino, Bellizona – realer raum bild raum, Institut für Auslandsbeziehungen e.V., Stuttgart (Katalog/catalogue) **1997** Gallery by Night, Studio Galería, Budapest – Wechselstrom, Galerie Ulrich Fiedler, Köln – Whisper and Streak, Galerie Barbara Thumm (Katalog/catalogue) – ars viva 97/98 - Medienkunst, Staatsgalerie Stuttgart, Städtisches Museum Abteiberg, Mönchengladbach (1998), Hamburger Bahnhof - Museum für Gegenwart, Berlin (1998), Kunsthalle Kiel (1998) (Katalog/catalogue) – Another&Another&Another Act of Seeing (Urban Space), deSingel, Antwerpen (Katalog/catalogue) **1996** Frozen Time, Galerie Gebauer und Günther, Berlin – Junge Kunst, Wilhelm-Hack-Museum, Ludwigsburg – Laboratorium Berlin - Moskau, Contemporary Art Center, Moskau – Geben und Nehmen, Schloß Plüschow, Mecklenburgisches Künstlerhaus (Katalog/catalogue) – RaumZeit - BildRaum, Museum Folkwang, Essen, Finnish Photographic Museum, Helsinki, Göteborgs Konstmuseum (Katalog/catalogue) – Digital territories, DEAF 96, Nederlands Fotoinstitut, Rotterdam (Katalog/catalogue) – Europäischer Fotopreis 1996, Englische Kirche, Bad Homburg **1995** 1 to 6, Aberdeen Art Gallery, Aberdeen **1994** Fotografinnen der Gegenwart, Museum Folkwang, Essen **1992** Fotoarbeiten, Galerie Kunst und Raum, Hannover **1990** LEIPZIGNEUNZIG, Hochschule für Grafik und Buchkunst, Leipzig **1989** Orte, Zeiten und Geschichten, Hochschulgalerie der Fachhochschule Bielefeld – Photogalerie, Wedding, Berlin – Staatliche Lehranstalt für Fotografie, München

Heidi Specker

Tilo Schulz

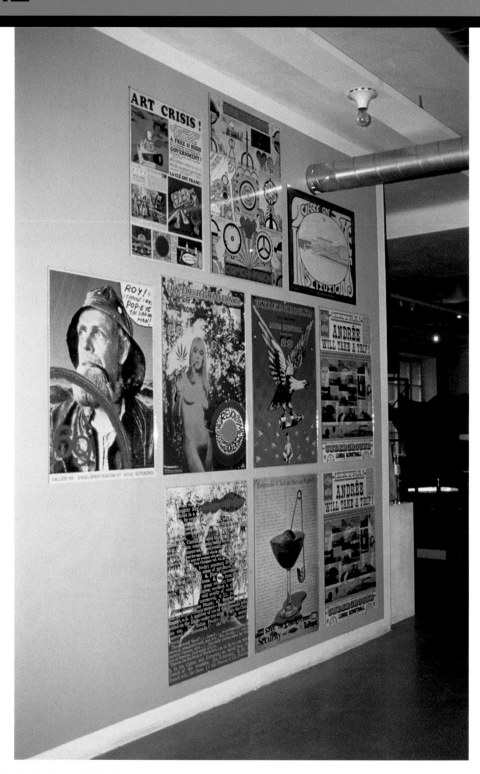

– **Reopening of Sture Johannesson**, 1999, Stockholm, Y1, Installation view, Courtesy
Dogenhaus Galerie Leipzig, Photo Christine Ödlund, Stockholm

Vermittlung als künstlerische Praxis – *Jan Winkelmann*

Im Zentrum des Werks von Tilo Schulz steht die Frage nach den systemspezifischen Bedingungen der Kunstproduktion und deren Vermittlung. Ausgangspunkt für Schulz' Interesse an der Mediatisierung anderer künstlerischer Positionen ist die Beobachtung, daß in den neunziger Jahren viele Künstler vermehrt losgelöst von einer "reinen" Objektproduktion arbeiten und sich in erster Linie Strategien aus anderen, meist kunstfremden Produktionssystemen bedienen, um diese in ästhetische und funktionale Prozesse bzw. Inszenierungen innerhalb des Kunstkontexts umzusetzen. Auf diese Grenzüberschreitungen in andere Bereiche kultureller und nicht-kultureller Produktion antwortet Schulz mit einer dezidiert kunstimmanenten Vorgehensweise. Seine Handlungsmodelle erweitern den üblichen Vermittlungsansatz, wie er im jeweiligen institutionellen Rahmen vorgegeben ist, oder reagieren auf ein diesbezüglich bestehendes Defizit, indem sie eine diskursive Vermittlungspraxis einführen. Im einen wie im anderen Fall geht Schulz' Projekten eine intensive kritische Analyse der jeweiligen existierenden Struktur voraus, um dann in entsprechender Weise auf die vorgegebenen Parameter zu reagieren.

Tilo Schulz' Konzept im Rahmen des Kunst-am-Bau-Projekts in der Neuen Messe in Leipzig bestand darin, die jeweiligen, den ausgeführten Arbeiten zugrundeliegenden künstlerischen Positionen bzw. Strategien auf unterschiedlichen Ebenen – inhaltlich den entsprechenden Zielgruppen angepaßt – zu kommunizieren. Neben einer Einführung für die Beschäftigten der Neuen Messe fand ein Workshop für Schulklassen statt, wohingegen in Vorträgen an der Universität spezifische inhaltliche Aspekte einem "Fachpublikum" erläutert wurden. Ergänzend sind durch unterschiedliche Maßnahmen im medialen Raum (Anzeigen in regionalen Zeitungen und Zeitschriften, Gratispostkarten etc.) Informationen zu den Projekten einem breiten "anonymen Publikum" zugänglich gemacht worden.

Wo der Künstler hier auf eine ästhetische Umsetzung der eigenen Arbeit gänzlich verzichtete, materialisierte sich in seinem Beitrag für ONTOM^TWC, der Eröffnungsausstellung der Galerie für Zeitgenössische Kunst Leipzig, die Vermittlungsstrategie in Form von Polohemden, deren Vorderseite durch ein von Schulz entworfenes Logo eine Art Corporate Design erfuhr; deren Rückseite hingegen mit einem von den teilnehmenden Künstlern gestalteten Statement zu dem von ihnen in der Ausstellung realisierten Projekt bedruckt war. Als eine Art "Uniform" wurden sie von allen Mitarbeitern der Galerie während der Dauer der Ausstellung getragen. Daneben initiierte Schulz eine Promotion-Aktion, bei der Werbematerial über die Ausstellung selbst und die im Zusammenhang mit ihr stattfindenden Sonderveranstaltungen von Pro-

Communication as Artistic Practice – *Jan Winkelmann* –
Translated by Toby Alleyne-Gee

Central to Tilo Schulz's work is the issue of how he brings across the conditions specific to the system of artistic production. Schulz's interest in media coverage of other artists was aroused by the observation that increasing numbers of artists in the Nineties are no longer working "purely" as producers of objects, but are mainly using strategies from other, usually non-artistic production systems to transform these into aesthetic and functional processes, and present them within an artistic context. Schulz responds to this crossover into other areas of cultural and non-cultural production with a resolutely artistic approach. This approach also embraces communication as usually defined within an institutional framework, or is a reaction to a lack of communication, by introducing discursive communication. In both cases, Schulz's projects are preceded by an intensive, critical analysis of the existing structure. He then reacts correspondingly to the predetermined parameters with which he is confronted.

Tilo Schulz's concept for the art in public areas project at Leipzig's *Neue Messe* (new trade fair complex) consisted of communicating artistic attitudes or strategies at various levels – adapted in terms of content to various target groups. Apart from an introductory course for employees of the *Neue Messe*, there was also a workshop for schoolchildren, while lectures given at the university explained specific content-related aspects to a "specialist audience". Advertisements in regional newspapers and magazines, free postcards etc. provided a wider "anonymous public" with complementary information.

While the artist in this case completely abstained from aesthetic implementation of his own work, his communicative strategy materialised in his contribution to the ONTOM^TWC, the inaugural exhibition of the *Galerie für Zeitgenössische Kunst Leipzig* (Gallery for Contemporary Art), in the form of poloshirts printed on the front with a logo designed by Schulz. By contrast with this

motionteams in der Innenstadt Leipzigs verteilt wurden. Während er im Projekt für die Neue Messe Leipzig auf ein defizitäres strukturelles Element reagiert, wird in diesem Projekt der institutionelle Vermittlungsrahmen mit Merchandising- und Promotion-Strategien, die üblicherweise hauptsächlich außerhalb des Kunstkontexts Anwendung finden, erweitert.

"e.w.e. – exhibition without exhibition" ist der Titel seines jüngsten "work in progress". Schulz lud sechs Künstler zu einer Ausstellung ein, die alle konstitutiven Funktionsteile einer Ausstellung beinhaltet, außer die Ausstellung selbst. Es wurden Anzeigen geschaltet, Pressemitteilungen verschickt, Interviews publiziert, Einladungen gedruckt, Poster gestaltet, eine Publikation herausgegeben etc., die eigentliche Ausstellung hingegen gab es nicht. Schulz verläßt mit diesem Projekt nicht nur den institutionellen Rahmen, vielmehr erweitert er den Begriff der Ausstellung ebenso ins konzeptuelle, wie bei den eingeladenen künstlerischen Positionen eine materialisierte Umsetzung ihrer Konzepte nicht notwendigerweise vorgesehen ist. In diesem Projekt bringt Schulz zeitgenössische künstlerische Strategien mit den für sie optimalen Vermittlungsansätzen zusammen und greift damit einerseits auf die Strategien der kritischen Analyse von Ausstellungspraktiken aus den siebziger Jahren zurück, erweitert diese jedoch gleichzeitig um eine aktive Vermittlungshaltung, womit der analytischen Dekonstruktion des Instruments "Ausstellung", ein konstruktiver Ansatz gegenübertritt.

In seinem Langzeitprojekt "body of work – the ideal exhibition" deduziert Schulz allgemeinere Kriterien und Charakteristika künstlerischer Praxis modellhaft anhand verschiedener medialer Kategorien: Neben traditionellen künstlerischen Ausdrucksformen wie Malerei, Skulptur und Fotografie werden zeitgenössische Kommunikationsträger (Poster, Buch, Einladungskarte etc.) in bezug auf ihre medienspezifischen Eigenschaften analysiert. Als eine Art "kleinster gemeinsamer Nenner" dienen diese als Ausgangspunkt für vom Künstler gestaltete "Modelle", die mit der Bezeichnung der jeweiligen Kategorie und hierfür relevanten und symptomatischen Referenzmaterialen präsentiert werden. Im Vergleich mit den eingangs beschriebenen Projekten wird hier nicht der institutionelle Funktionsapparat hinterfragt, vielmehr verläßt der Künstler den Bereich der "konkreten" Kunstvermittlung zugunsten einer Hinwendung zu allgemeineren Analysen der spezifischen systemimmanenten Grundbegriffe zeitgenössischer Kunstproduktion.

"corporate design", statements made by artists participating in the exhibition on their particular project were printed on the back. The polo shirts were worn for the duration of the exhibition by gallery staff as a kind of "uniform". Apart from this, Schulz initiated a promotional campaign; advertising material on the exhibition itself and special events related to it was distributed in the centre of Leipzig by promotional teams. While Schulz is reacting to a deficient structural element in his project for the *Neue Messe Leipzig*, for ONTOM[TWC] he extends the institutional communicative framework to include merchandising and promotional strategies that are normally employed outside the art world.

e.w.e. – exhibition without exhibition is the title of Schulz's most recent "work in progress". He invited six artists to an exhibition that contains all the functional elements of an exhibition – apart from the exhibition itself. Advertisements were printed, press releases sent out, interviews written, invitations printed, posters designed, a catalogue published. But there was no actual exhibition. With this project, then, Schulz not only departs from the institutional framework, but transforms the idea of an exhibition itself into a concept. It is not necessarily planned that the artists invited to participate should realise their concepts in a material sense. In this project, Schulz combines contemporary artistic strategies with the optimum relevant communicative approach, thus returning to the strategy of critical analysis pursued by exhibition organisers during the Seventies. However, he extends this strategy to include active communication, offering a constructive approach to the analytical deconstruction of the "exhibition" tool.

Schulz's long-term project entitled *body of work – the ideal exhibition* uses various media categories to deduce more general criteria and characteristics of artistic practice: besides traditional forms of artistic expression such as painting, sculpture and photography, the media-specific characteristics of contemporary communication (posters, books, invitation cards etc.) are also examined. As a kind of "lowest common denominator", these media-specific characteristics serve as the point of departure for "models" designed by the artist. These models are presented with the relevant, symptomatic reference materials. In comparison with the projects described earlier, the institutional system is not called into question, but the artist abandons "concrete" artistic communication in favour of more a general analysis of specifically system-related fundamental concepts of contemporary art.

– body of work: the ideal exhibition, category: poster, design, 1999, Installation view, Kunsthalle Bremen, Courtesy Dogenhaus Galerie Leipzig, Photo Lars Lohrisch, Bremen **– body of work: the ideal exhibition, category: poster, painting, announcement**, 1998, Installation view, Leipzig, Dogenhaus Galerie, Courtesy Dogenhaus Galerie Leipzig, Photo Uwe Walter, Berlin

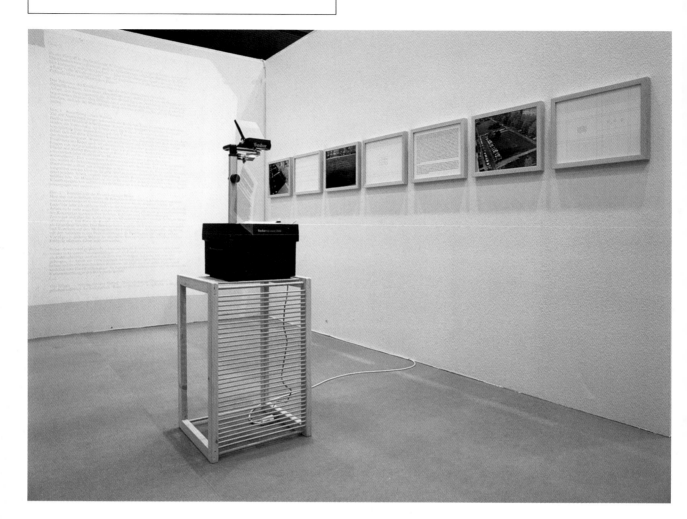

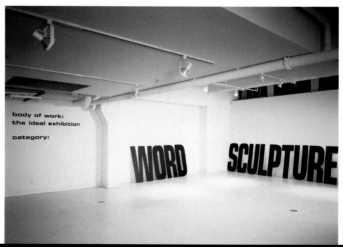

TILO SCHULZ – Leipzig, 1972 – Wohnt/lives in Leipzig

EINZELAUSSTELLUNGEN/ONE PERSON SHOWS: 2000 galerie paula böttcher, Berlin **1999** Y1, Stockholm **1998** Dogenhaus Galerie, Leipzig – Refusalon, San Francisco **1996** Dogenhaus Galerie, Leipzig (Katalog/catalogue) **1995** Dogenhaus Galerie, Berlin – point of view, Leipzig (mit/with Otto Reitsperger) **1994** Dogenhaus Galerie, Berlin (Katalog/catalogue) – Dogenhaus Galerie, Leipzig (Katalog/catalogue) **1992** Galerie Quadriga, Leipzig **1991** Das Boot, Leipzig **GRUPPENAUSSTELLUNGEN/GROUP SHOWS: 2000** Kunstverein, Münster **1999** after the wall, Moderna Museet, Stockholm (Katalog/catalogue) – Collection 99, Galerie für Zeitgenössische Kunst, Leipzig – Kunsthalle Bremen **1998** Manifesta 2, Luxembourg (Katalog/catalogue) – Junge Szene, Wiener Secession, Wien (Katalog/catalogue) – ontom, Galerie für Zeitgenössische Kunst, Leipzig (Katalog/catalogue) **1997** kunst in der leipziger messe, Leipzig – Dogenhaus Galerie, Leipzig **1996** nach Weimar, Kunstsammlungen Weimar (Katalog/catalogue) – erworben, Dresdner Schloss, Dresden (Katalog/catalogue) **1995** Kum-River-Symposium, Südkorea **1994** Raum, BWA, Wroclaw – Medienbiennale Leipzig (Katalog/catalogue) **1993** abstrakt, Dresdner Schloss (Katalog/catalogue) **1992** Farbtafelinstallation I, Leipzig – Farbtafelinstallation II, Köln – Farbtafelinstallation III, Leipzig **PROJEKTE/PROJECTS: since 1997** e.w.e. - exhibition without exhibition (ein Ausstellungsprojekt mit/an exhibition project with Jens Haaning, Sandra Hastenteufel, Nathan Coley, Plamen Dejanov & Swetlana Heger, Olaf Nicolai) (Katalog/catalogue) **1996** Strukturen der Malerei, Konzept und Organisation der Ausstellung und des Kolloquiums/concept and organisation of the exhibition and of the colloquium

Tilo Schulz

Cosima von Bonin

– Installation view **"PUSH-UPS"**, 1996, Athen – **Yves Saint Laurent**, 1997,
Privatsammlung/Private collection, Wien, Photo Courtesy Galerie Hoffmann & Senn,
Wien

Der begehbare Schrank – *Isabelle Graw*

Als ich Cosima von Bonin zum ersten Mal sah, kellnerte sie im "Königswasser", einer Kneipe, die Ende der achtziger Jahre von der Kölner Kunst- und Musikszene frequentiert wurde. Ihr Haar trug sie damals sehr kurz im Stil der Schauspielerin Jean Seberg. Was die Kleidung betrifft, so erinnere ich mich vage an eher unauffällig wirkende Kombinationen aus Jeans und weißen T-Shirts. Wobei sich dieser Eindruck von Unauffälligkeit natürlich auch inszenieren läßt. Als Künstlerin trat sie etwa 1989 in Erscheinung – vorher hatte sie sich noch selbstbewußt als "Groupie" bezeichnet. Daß der weibliche Fan nicht notwendig mit Passivität geschlagen ist, sondern durchaus konsumierend Sinn produziert, darauf haben die Cultural Studies, insbesondere Angela Mc Robbie hingewiesen. Dementsprechend konnte sich die eigentlich dienende Tätigkeit des Bierzapfens bei Cosima in eine souveräne Geste verkehren. Diese demonstrative Gelassenheit, mit der sie ausschenkte, schien den Gästen das Signal auszusenden, daß sie nicht in die Identität des Thekengirls zu pressen war. Ganz im Gegenteil: Sie agierte auf EINER Ebene mit den an der Theke Stehenden – und dies waren in der Mehrzahl Männer.

Wollte man sich Respekt verschaffen, so war es in der Kölner Kunstwelt Ende der achtziger Jahre durchaus hilfreich, mit einer gewissen Entschlossenheit aufzutreten. Auch das öffentliche Auftreten von Cosima war häufig an Gesten gekoppelt, die Entschiedenheit signalisierten. Ihr Habitus schien sich tendenziell an dem von Männer-Künstlern zu orientieren. Mit einem klassischen Rollenspiel (à la Georges Sand) sollte dies jedoch nicht verwechselt werden. Vormals als "männlich" identifizierte Attribute stehen heute auch Frauen zur Verfügung. In demselben Maße wie Cosima ein mit Männern assoziiertes Verhalten selbstverständlich praktizierte (Trinken, laut sprechen, Raum einnehmen), konnten sich sowohl in ihrem öffentlichen Bild als auch in ihren künstlerischen Arbeiten Zeichen für die Anerkennung ihrer künstlerischen Position als Frau finden. Man denke nur an die frühe Collage, wo der Name ihres Lebenspartners (Michael Krebber) dem Körperbild einer Frau richtiggehend eingeschrieben wurde oder an die in den letzten Jahren entstandenen Wandbilder aus zusammengenähten Herrentaschentüchern.

Auch auf der Ebene ihrer Kleidung findet sich dieses komplexe Zusammenspiel von männlich kodierten Kleidungsstücken und diese wiederum brechenden Fashionitems. Beispielsweise läßt sich Cosima seit 1986 Herrenanzüge schneidern nach einem Schnittmuster, das sie immer wieder verwendet und erst kürzlich modifizierte. Prinzipiell gilt, daß Outfit und Selbststilisierung in diesem Fall als Faktoren zu betrachten sind, die die Interpretation der künstlerischen Arbeit mitbestimmen. Darauf deutet nicht zuletzt

Walk - In Wardrobe – *Isabelle Graw* – Translated by Toby Alleyne-Gee

The first time I saw Cosima von Bonin, at the end of the Eighties, she was working as a waitress in the "Königswasser", a bar frequented by Cologne artists and musicians. She wore her hair short in the style of the actress Jean Seberg. As far as her clothes were concerned, I vaguely remember unobtrusive combinations of jeans and white T-shirts. Of course, this impression of unobtrusiveness can be consciously created. Von Bonin saw herself officially as an artist from about 1989 – before then she confidently referred to herself as a "groupie". Cultural studies, particularly those of Angela McRobbie, have shown that a female fan is not necessarily a passive being, but can be productive as a consumer. Correspondingly, what was in fact a waitressing job – pouring beer at the bar – could in Cosima's case be transformed into a commanding gesture. The demonstrative composure with which she poured beer seemed to show her clientele that she could not be pressed into the mould of the barmaid. Far from it: she worked on the same level as those standing at the bar – most of whom were men.

To gain respect in the Cologne art world at the end of the Eighties, the most helpful thing to do was to adopt a determined manner. Cosima's public appearances were frequently combined with decisive gestures. Her wardrobe tended to be oriented towards that of her male colleagues. However, this should not be confused with classic role play (à la George Sand). What used to be considered "masculine" attributes are now also available to women. Just as Cosima quite naturally behaved in a manner normally associated with men (drinking, talking at the top of one's voice, occupying space), her public image and her work demonstrated to the same extent that her position as a female artist had been recognised. One need only think of her early collage, in which the name of her partner (Michael Krebber) is written into the image of a woman's body, or the wall hangings of recent years, which were created by sewing together men's handkerchiefs.

The way she dresses is also a complex interplay of garments encoded with male symbolism – and accessories that contradict this symbolism. For example, Cosima has been having men's suits made for her since 1986 to a pattern she has always used and only recently modified. It is important to realise in this case that outfit and self-stylisation are factors that should be considered when interpreting her artistic work. This is demonstrated by the role fashion and clothes in general play in her installations and films, her wall hanging made of bikinis, the Yves Saint Laurent display window in her 1991 film *Die fröhliche Wallfahrt* ("The Happy Pilgrimage") or the fashion show held in Mönchengladbach in 1997 at which she and Kai Althoff presented sack-like garments.

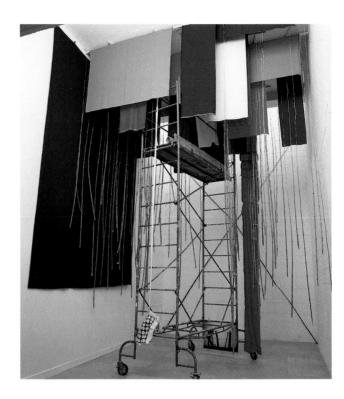

die Rolle von Mode und Kleidung in ihren Installationen und Filmen hin, der Bikini-Wandbehang, das Yves-Saint-Laurent-Schaufenster in ihrem Film "Die fröhliche Wallfahrt" (1991) oder die Modenschau mit sackartigen Gewändern, die sie in Mönchengladbach (1997) zusammen mit Kai Althoff inszenierte. Für einen Zusammenhang zwischen künstlerischen und modischen Entscheidungen spricht auch die Tatsache, daß das neue Schnittmuster für die Anzüge bei jener Frau (Ute Paffendorf) in Auftrag gegeben wurde, die auch jene Kleider mit überlangen Ärmeln für besagte Modenschau schneiderte.

Zunächst ist man verleitet, bei den Anzügen, die Cosima so gerne trägt, von einer Uniform zu sprechen. Allerdings nicht im Sinne eines Rückzugs aus der Mode: Herrenanzüge gelten schließlich in Frauenzeitschriften in jeder Saison wieder als modische Basics. Daß diese Anzüge von Modebewußtheit zeugen, darauf deuten auch die mit ihnen kombinierten Accessoires hin: modische Schlappen (von Diesel, Birkenstock, Gucci) und Sneakers (Adidas, Puma) – je nach Jahreszeit. Oder die Markensonnenbrillen (Armani, Porsche, Ray Ban). In diesen "ungewöhnlichen" Kombinationen hallen natürlich auch jene aktuellen Anrufungen der Modezeitschriften nach, die Mut zur unkonventionellen Zusammenstellung empfehlen – man solle doch einfach mal Klamotten vom Flohmarkt mit High-Fashion mischen. An diesem Trend scheint der Look von Cosima zu partizipieren, um jedoch einen entscheidenden Unterschied zu markieren: Denn klassische Herrenschuhe, die nicht als modisch – auch nicht in einem erweiterten Sinne – gelten oder eine Billigbrille von "Next am Ring" manifestieren eine Form der Eigenwilligkeit, die von dieser konventionalisierten Eigenwilligkeit abweicht.

Weit entfernt ist der Herrenanzug bei Bonin auch von Androgynitätskonzepten, weil die von Cosima getragenen Anzüge eher knit-

– **Peter aus Basel**, 1999, Filz, Schaumstoff, Holz/Felt, Foamed Plastics, Timber, Höhe/Height ca. 95 cm, Privatsammlung/Private collection, Frankfurt, Photo Courtesy Galerie Christian Nagel, Köln – **"Requisite Fortitude"**, 1998, s/w-Print/b/w-print, 160 x 120 cm, Privatsammlung/Private collection, Zürich, Photo Cosima von Bonin

The fact that von Bonin ordered the new pattern for her suits from the woman (Ute Paffendorf) who made clothes with extra-long sleeves for her fashion show is also evidence of how artistic and fashion-related decisions are interlinked.

At first it is tempting to refer to the suits Cosima so likes to wear as a uniform. But these should not be seen as a rejection of fashion: after all, men's suits are shown as fashion staples in women's magazines every season. The accessories Cosima wears with her suits show that she is fashion-conscious: fashionable slipper-style shoes (Diesel, Birkenstock, Gucci) or sneakers (Adidas, Puma) – according to the season – or designer sunglasses (Armani, Porsche, Rayban). Of course, these "unusual" combinations also reflect the current dictates of the fashion press, which recommends unconventional combinations: mix flea market finds with high fashion, they say. Cosima's look would appear to be following this trend, but with one major difference: she wears classic men's shoes that are not considered fashionable, even in a wider sense, and cheap spectacles from the "Next am Ring" chain, demonstrating a single-mindedness that has nothing to do with the current trend for institutionalised eccentricity.

Nor do Bonin's men's suits have anything to do the idea of androgyny, because the suits she wears are creased and undisciplined. They fall in soft folds, but do not flatter the body as elegant suits would do. Shoulder pads, which give the body clear contours, are nowhere to be found. This distinguishes Bonin's suits from those associated with the image of the power woman. At the end of the Eighties, these suits, designed by Romeo Gigli or Jil Sander, were a must for many women working in the art business. Perhaps the trouser pleats or the generous cut of Cosima von Bonin's suits ensure that they never seem strict or official. Especially not when they are combined with camouflage or safari jackets, or an unexpected green Klepper raincoat. Every fashion statement is thus soiled from the outset: the fashion pundits do not envisage this kind of contamination, which may take the form of a Burberry trench coat or a cashmere winter coat. Taken as they are, these may appear to be part of the uniform of the "upper class girl." However, combined with sportswear or bespoke suits, which communicate contradictory messages, Cosima's image becomes more complex. It follows that the language of fashion is no less complicated than the language of art: the more complex and dense Cosima von Bonin's objects appear, the more fun it is to go about the critical, interpretative process of unravelling them.

trig und undiszipliniert wirken. Sie fallen zwar weich, ohne aber den Körper zu umschmeicheln, wie es elegante Anzüge tun würden. Nach Schulterpolstern, die dem Körper klare Konturen verleihen, sucht man auch vergeblich. Auch an diesem Punkt ist die Differenz zu jenem Typ Anzug ausschlaggebend, der mit dem Bild der Powerfrau einhergeht. Ende der achtziger Jahre waren diese Anzüge von Romeo Gigli oder Jil Sander ein Muß für zahlreiche Frauen, die im Kunstbetrieb arbeiteten. Vielleicht liegt es an den Bundfalten oder daran, daß sie groß ausfallen, daß die Anzüge von Cosima niemals streng oder offiziell wirken. Vor allem dann, wenn sie mit Camouflage- oder Safari-Jacken kombiniert werden. Ein darüber getragener grüner Klepper-Regenmantel vermag auch zu irritieren. Jedes Fashionstatement trägt auf diese Weise seine spezifische Verunreinigung bereits in sich: Eine Verunreinigung, die in den Fashioncodes nicht vorgesehen ist. Etwa in Form eines Burberry-Trenchcoats oder eines Wintermantels aus Cashmere, die für sich genommen mit "Höhere Töchter"-Assoziationen belegt sind. In Kombination mit Sportswear oder den widersprüchlich aufgeladenen, maßgeschneiderten Anzügen verkompliziert sich das Bild. Daraus folgt, daß die Sprache der Mode der der Kunst an Komplexität nicht nachsteht: Je überladener und dichter ihre Objekte funktionieren, desto mehr Spaß macht die kritische Arbeit der entwirrenden Auslegung.

EIN- UND ZWEIPERSONENAUSSTELLUNGEN/ONE AND TWO PERSON EXHIBITIONS (Auswahl/selected): 1999 Wyoming, Kunsthalle St. Gallen – Galerie Mikael Andersen (mit/with Michael Krebber), Kopenhagen **1998** Steirischer Herbst 1998, Löwe im Bonsaiwald, Palais Attems, Graz – Justus, Galerie Ascan Crone (mit/with Michael Krebber), Hamburg **1997** Löwe im Bonsaiwald, Galerie Christian Nagel, Köln – Galerie Hoffmann & Senn, Wien – Heetz, Nowak, Rehberger, Museu de Arte Contemporânea da USP (mit/with Kai Althoff und/and Tobias – Rehberger), São Paulo, Brasilien (Katalog/catalogue) **1996** Heetz, Nowak, Rehberger, Museum Abteiberg (mit/with Kai Althoff und/and Tobias Rehberger), Mönchengladbach (Katalog/catalogue) **1995** The Museum of Modern Art (mit/with Christopher Williams und/and Stephen Prina, organisiert von/organized by Martin Kippenberger), Syros, Griechenland – Hast Du Heute Zeit? - Ich Aber Nicht, Künstlerhaus Stuttgart (mit/with Kai Althoff) – Kirsche-Jade-Block, Galerie Christian Nagel (mit/with Kai Althoff), Köln **1994** Museum Fridericianum, Kunstverein Kippenberger, Kassel **1993** MUSEE AUTODEMOLITION, K-raum Daxer, München (Katalog/catalogue) – Galleria Emi Fontana, Mailand – American Fine Arts, New York – Galerie Samia Saouma (mit/with Ingeborg Gabriel und/and Michael Krebber), Paris **1992** Ingeborg Gabriel, Galerie Christian Nagel, Köln – Galerie Bleich-Rossi, Graz – Achim Kubinski, Stuttgart **1991** Andrea Rosen Gallery, New York **1990** Galerie Christian Nagel, Köln – Ausstellungsraum Münzstrasse 10 (mit/with Josef Strau), Hamburg **GRUPPENAUSSTELLUNGEN/ GROUP SHOWS (Auswahl/selected): 1999** Die Schule von Athen – deutsche Kunst heute (organisiert von/organized by Veit Loers), Athen – How will we Behave? Robert Prime, London – Who - if not we?, Elisabeth Cherry Contemporary Art, Tuscon-Arizona – Photographie, Galerie Ascan Crone, Hamburg – oLdNEWtOWn, Galerie Casey Kaplan, New York – **1998** Entropie zu Hause. Sammlung Schürmann, Suermondt Ludwig Museum, Aachen – mai 98, Kunsthalle Köln, Köln (Katalog/catalogue) **1997** Display Charlottenborg Ausstellungshalle, Kopenhagen (Katalog/catalogue) – La Saison 1, Neu Galerie, Berlin – Home Sweet Home, Deichtorhallen, Hamburg (Katalog/catalogue) – La modernité et la Côte d´Azur, Villa Arson, Nizza – Glockengeschrei nach Deutz. Das Beste aller Seiten, Galerie Daniel Bucholz (organisiert von/organized by Daniel Buchholz, Christopher Müller & Cosima von Bonin), Köln (Katalog/catalogue) – NowHere, (Incandescent), Louisiana Museum of Modern Art (organisiert von/organized by Laura Cottingham), Humlebæk (Katalog/catalogue) – Push-Ups, Athens Fine Art School, Athen (Katalog/catalogue) **1995** Inaugural Filmscreening, ACNE (organisiert von/organized by Sharon Lockhart, mit/with Morgan Fisher, Eo Harper, Daniel Marlos), Los Angeles – Aufforderung in schönster Weise, Galerie Christian Nagel, Köln – 1.Grazer Fächerfest, Forum Stadtpark (organisiert von/organized by Cosima von Bonin), Graz (Katalog/catalogue) **1994** Teilnahme am Woodstock-Festival in Saugherties, New York – von Bonin von Heyl Fine Tyson, Borgmann-Petzel Gallery, New York – Sonne München, Galerie Daniel Buchholz (mit/with Tillmans, Althoff, Höller, Hempel), Köln **1993** Parallax View: New York – Köln, P.S.1 Museum, New York & Goethe House, New York (Katalog/catalogue) – Kontext Kunst, Neue Galerie am Landesmuseum Johanneum & Künstlerhaus Graz (Katalog/catalogue) – Peccato di Novità, Galleria Emi Fontana, Mailand (Katalog/catalogue) **1992** Passagen – Werk. J. Kosuth – Documenta – Flanerie, Galerie Kubinski, Köln **1991** Fareed Armaly, Cosima von Bonin, Michael Krebber & Christian P. Müller, Kunstraum Daxer, München (Katalog/catalogue)

Cosima von Bonin

Silke Wagner

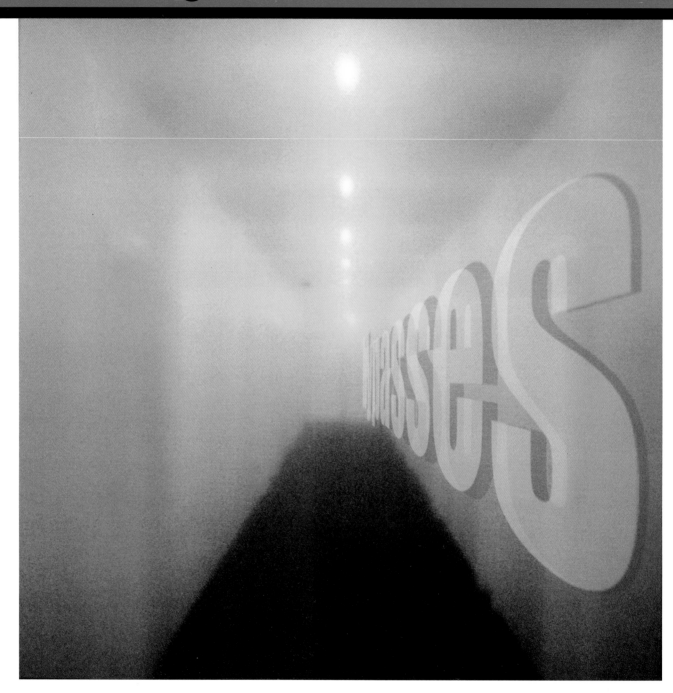

– bypasses, 1997, Abbildung Nr. 5, Leporello Silke Wagner, Stefan Wieland erschienen
zur Ausstellung "bypasses" Illustration no. 5, leaflet on Silke Wagner, Stefan Wieland
published for the "bypasses" exhibition, Computer Consulting Firma Pass, Frankfurt am
Main, 18,5 x 18,5 cm, Offsetdruck, cellophaniert/Cellophane-covered offset print,
Courtesy Meyer Riegger Galerie, Karlsruhe

Wenn der Rezipient zum produzierenden Fan wird –
Raimar Stange

Nur als "Signifying Monkey" (Henry Louis Gates)[1], also als aktiver und selbst sinnstiftender (Neu-)Interpret inmitten einer latent repressiven Gesellschaft, kann das Individuum sich heute noch behaupten. Als "Pawlow'scher Hund", als bloß reaktiv rezipierendes Subjekt – wie etwa Theodor W. Adorno ihn in seiner Kulturkritik voraussetzte –, hat er keine Chance mehr gegen vorgeschriebene, beziehungsweise längst verinnerlichte Verhaltensmuster und weltweit angeordnete Lustversprechen. Silke Wagner gelingt in ihrer Arbeit genau dies: den Rezipienten zur aktiven Interpretation anzustiften. Der Künstler ist nicht mehr "Statthalter" verschütteter Erfahrung – wie Adorno ihn zwangsläufig positionieren mußte –, sondern der Initiator noch nicht gemachter Erfahrung. Keine "in sich ruhenden" Werke präsentiert die Künstlerin, sondern sie bietet offene Benutzeroberflächen an, die das Gegenüber miteinbeziehen in den ästhetischen Prozeß.

Da ist zum Beispiel die Arbeit "Roland" (1998): ein hölzernes Stecksystem aus sechzig 1 x 1 m großen Platten. Jede Platte ist so mit Schlitzen versehen, daß sie sich variabel mit anderen Platten kombinieren läßt. Ein Käufer kann sich also in bester Heimwerkertradition aus diesem System ein Möbelstück, einen Stuhl, Tisch oder Schrank etwa, "basteln". Oder er kann aus den Holzplatten eine funktionslose Skulptur konstruieren. So wird mit "Roland" nicht nur die in den neunziger Jahren vehement geäußerte Frage nach der sozialen Funktion von Kunst oder die nach der Differenz von Design und "autonomer" Ästhetik gestellt, zudem werden hier in der consumer culture geläufige Strategien zitiert und dann im Kunstkontext emanzipativ verwendet.

In dem Buchprojekt "home and away" (1998)[2] sind neun "Fußballposter" gebunden, die sauber herausgetrennt, aufgefaltet und dann, wie unter Fans üblich, stolz an die Zimmerwand gehängt werden können. Von der fast privaten Horizontalen des Buches wandern die Poster hin zu der eher öffentlichen Vertikalen der Wand. Dabei werden verschiedene, sich sonst ausschließende, Optionen wie Lesen und Sehen, tiefgründige Kontemplation und quicke Oberflächlichkeit sowie die von reflektierender Distanz und unkritischer Begeisterung möglich gehalten. Aber eins nach dem anderen: Auf den Postern sind umfunktionierte Embleme europäischer Fußballklubs beziehungsweise deren Fanclubs zu sehen. Die vorgeführten Clubs wurden von Silke Wagner aufgrund der politischen Brisanz (ihrer Geschichte) zusammengestellt. Und aufgrund der sehnsuchtsvollen Obsessionen, die ihre Fans für sie entwickeln. Das "Poster #1" zum Beispiel zeigt vierblättrige Kleeblätter in den Farben Rot, Blau, Weiß und Grün. Diese Kleeblätter sind dem Emblem des schottischen Traditionsclubs Celtic Glasgow entwendet, die Farben dagegen referieren auf das Emblem

From Passive Viewer to Productive Fan – *Raimar Stange* –
Translated by Toby Alleyne-Gee

Nowadays, the individual can only assert himself as a "signifying monkey" (Henry Louis Gates)[1], as an active (re-)interpreter of art in a latently repressive society. As a "Pavlovian dog," a merely reactive recipient of art – as Theodor W. Adorno's cultural criticism saw it – the individual no longer has a chance against established behavioural patterns that have long since been internalised, or globally prescribed promises of pleasure. Silke Wagner succeeds in encouraging the passive viewer actively to interpret what he sees. The artist is no longer the "governor" of submerged experience – as Adorno had to position him – but the initiator of experience that is as yet unlived. Wagner does not present us with "harmonious" works of art, but offers her audience open surfaces that involve the viewer in the creative process.

For example, *Roland* (1998): a system of sixty interlocking wooden 1 x 1 m panels. Every panel can be combined with other panels by means of slits cut into the wood. A buyer can thus create a piece of furniture – perhaps a chair, table or cupboard – in the best DIY tradition. Or he can construct a sculpture devoid of function. Thus *Roland* raises the issues – already so vehemently discussed before the Nineties – of the social function of art, and of the difference between design and "autonomous" aesthetics. The strategies usually employed by consumer culture are also quoted and used in the artistic context in an emancipatory fashion.

The book *home and away* (1998)[2] contains nine "football posters" which can be hung proudly on the wall of a room – in the way that fans usually do. The posters are removed from the almost private, horizontal dimension of a book to be displayed in the public, vertical dimension of the wall. This makes various, otherwise incompatible, combinations possible: reading and watching, profound contemplation and animated superficiality, pensive detachment and uncritical enthusiasm. But first things first: the posters show the emblems of European football clubs, or their fan clubs, in a new light. The clubs shown were selected from Silke Wagner for the political explosiveness of their history, and because of the obsessions their fans develop for them. *Poster #1*, for example, shows four-leaf clover in red, blue, white and green. The clover leaves are derived from the emblem of the traditional Scottish club, Celtic Glasgow, but the colours refer to the emblem

– **Roland**, 1998, Holz/Wood, Variable dimensions, Platte je/each board 100 x 100 cm, Courtesy Meyer Riegger Galerie, Karlsruhe, Photo Silke Helmerdig

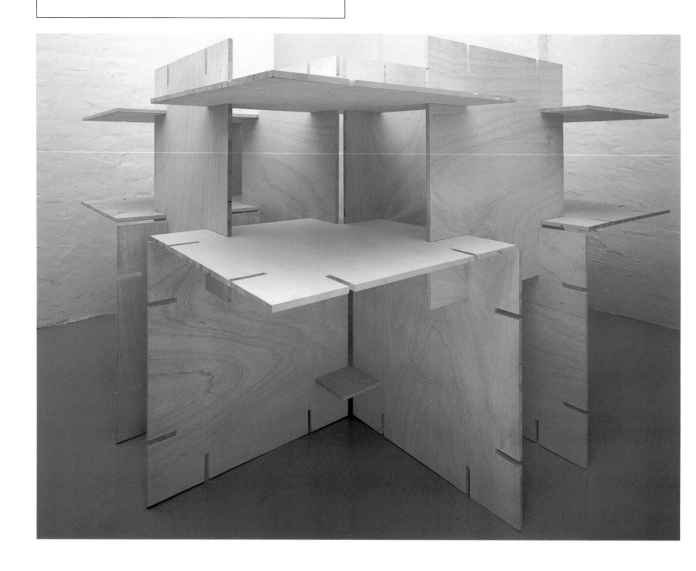

der Glasgow Rangers. Die aus Glaubensfragen verfeindeten Clubs sind so auf diesem Poster friedlich vereint. Noch der Untertitel dieses Posters "Porträt eines Katholiken (Maurice Johnston) und eines Protestanten (Jimmy Johnstone)" betont genau diesen Aspekt: Maurice Johnston war der erste Katholik, der bei den protestantischen Rangers gespielt hat, Jimmy Johnstone der erste Protestant, der bei dem katholischen Club Celtic unter Vertrag war. Daß die Decodierung solcher Kunst Insiderwissen von seinen Betrachtern verlangt, ist klar – ist dies aber nicht immer so?! Der spezielle, gewissermaßen "proletarische" Charakter dieses Insider-

of the Glasgow Rangers. The two clubs are enemies for religious reasons, but here they are peacefully united. The subtitle of this poster – *Portrait of a Catholic (Maurice Johnston) and a Protestant (Jimmy Johnstone)* emphasises precisely this aspect: Maurice Johnston was the first catholic to play for the protestant Rangers, while Jimmy Johnstone was the first protestant to be taken under contract by the Catholic Celtic club. It is obvious that insider knowledge is expected of the viewers of such art – but isn't that always the case? The special, to a certain extent "proletarian" character of this insider knowledge renders the book, the

– home and away, 1998, No. 3, Posterbuch/Poster book, Silke Wagner, Stefan Wieland
17,5 x 19,5 cm, 18 Blätter/18 pages – pro Künstler 9 Poster/9 posters per artist
(29,5 x 39 cm), vierfarbiger Offsetdruck/4-colour offset print, Courtesy Meyer Riegger
Galerie, Karlsruhe, Photo Achim Lengerer

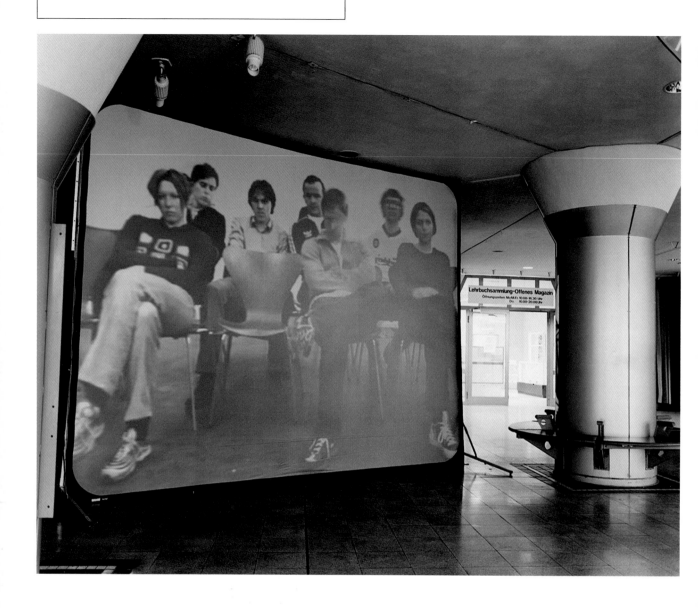

– 7 Vorträge, ein Bild, ein Auditorium, 1998, Video projection, Ausstellungsraum der Universitätsbibliothek Frankfurt am Main, Courtesy Meyer Riegger Galerie, Karlsruhe, Photo Achim Lengerer

wissens aber macht hier aus dem bildungsbürgerlichen Medium Buch ein Zeichensystem für Nutzer, die ansonsten von unserer "kulturellen Landschaft" und deren Insiderwissen eher ausgeschlossen sind. Umgekehrt wird der "Kunstfreund" hier zum aktiv resemantiserenden Fan, der nur mit Liebe, Kennerschaft und Haltung zugleich eine adäquate Beziehung zur Welt einnehmen kann.

– 1 The Signifying Monkey, Henry Louis Gates, New York/Oxford 1988. – 2 Für das Buchprojekt "home and away" gestalteten Silke Wagner und Stefan Wieland jeweils neun Poster.

typical medium of middle class intellectuals, accessible to users otherwise excluded from our "cultural landscape" and its related insider knowledge. Conversely, the "art lover" becomes the fan who actively interprets what he sees and is only able to forge an adequate relationship with the world through love, connoisseurship and composure.

– 1 The Signifying Monkey, Henry Louis Gates, New York/Oxford, 1988. – 2 For the bookproject *home and away* Silke Wagner and Stefan Wieland designed nine posters each.

SILKE WAGNER – Göppingen, 1968 – Städelschule, Staatliche Hochschule für Bildende Kunst, Frankfurt am Main – Wohnt/lives in Frankfurt am Main

EINZELAUSSTELLUNGEN/ONE PERSON SHOWS: 1999 Drehbücher, Galerie Meyer Riegger, Karlsruhe **1998** 7 Vorträge, ein Bild, ein Auditorium, Ausstellungsraum der Universitäts-bibliothek Frankfurt, Frankfurt am Main home and away, Buchpräsentation/bookpresentation, loop-Raum, Berlin – home and away, Buchpräsentation/book presentation, loop-Raum, Berlin **1997** bypasses (mit/with Stefan Wieland), Computer Consulting Firma Pass, Frankfurt am Main (Leporello) **GRUPPENAUSSTELLUNGEN/GROUP SHOWS: 1999** amAzonas, Villa Minimo, Hannover **1998** FORDE'S NEEDLES, Galerie FORDE, Genf – 1998 LINK, Shift e.V., Berlin

Silke Wagner

Peter Pommerer

– Ohne Titel, 1998, Wandzeichnung mit Farbstift/Wall drawing with crayon, Ausstellung/
Exhibition "Glut", Kunsthalle Düsseldorf, Courtesy Meyer Riegger Galerie, Karlsruhe,
Photo Horst Kolberg

Die "Zeichnungmaschine" – *Raimar Stange*

In der linken unteren Ecke der auf Textil gedruckten Zeichnung "Zigarren rauchen wir in Wien" (1997) schweben kristalline Formen. Gezackt und gleichsam "implodiert" brechen sie die eigene Struktur auf und verletzen dabei gleichsam die Oberfläche des Textils. Daneben schweben schlanke Füllhörner, die ihre blumige Fracht eher friedfertig und großzügig FRAUEN QUÄLEN NEGER verteilen. Fast realistisch gezeichnete Wurzeln und Pflanzenstengel füllen dann das Bild, von Peter Pommerer in unterschiedlichen Größen präsentiert, aus unterschiedlichen Perspektiven gesehen und sich zuweilen zart umschlingend. Im scheinbar ständig sich verschiebenden Zentrum leuchtet mal eine flüchtig hingekritzelte, seltsam hohle Sonne auf, mal glänzt dort der stilisierte Gipfel eines fast schon kubistischen Gebirges. Und dann ist dort, knapp unter dem oberen Randes des Bildes, noch LUTZ ICH LIEBE DICH ein fauchender Tiger. Im Sprung kopfüber definiert das Tattoomuster die Papieroberfläche so elegant wie aggressiv als Haut, als sensible Einschreibefläche, die Gefahr abwehrt und benennt im selben Moment.

Peter Pommerers Kunst scheinen Gilles Deleuze und Felix Guattari gleich zu Anfang ihres "Anti-Ödipus" (1972) zu beschreiben: "Eine Maschine SPUKENDE TEMPEL HURE aus Chlorophyll oder aus Protoplasma sein, oder doch wenigstens seinen Körper wie ein Teilchen in ähnliche Maschinen gleiten lassen können.

Lenz hat die Ebene des Bruchs von Mensch und Natur hinter sich gelassen und befindet sich damit außerhalb der von dieser Trennung bedingten Ordnungsmuster. Er erlebt die Natur nicht als Natur, sondern als Produktionsprozeß. Nicht Mensch noch Natur sind mehr vorhanden, sondern einzig Prozesse, die das eine im anderen erzeugen und die Maschinen aneinanderkoppeln. Überall Produktions- und Wunschmaschinen".

Gleiches gilt B. IST DOOF für die "Zeichnungmaschine" Peter Pommerer: Nichts ist in seinem Werk getrennt, diverse Systeme werden an- und ineinandergekettet, alles ist durch eine nichtendenwollende Wunschproduktion verbunden. In diesem obwohl engverknüpften, gleichzeitig aber auch weitverzweigten Werk funktioniert, wie von Deleuze/Guattari gefordert, "alles überall, bald rastlos, dann wieder mit Unterbrechungen". Pommerer ent-

The Writing Machine – *Raimar Stange* – Translated by Toby Alleyne-Gee

Crystalline forms hover in the lower lefthand corner of the 1997 drawing entitled *Zigarren rauchen wir in Wien* ("We smoke cigars in Vienna") printed onto fabric. Both jagged and "imploded", they break down their own structure, and injure the surface of the fabric. Next to them, cornucopiae float, peacably, generously distributing their largesse – FRAUEN QUÄLEN NEGER ("Women torment niggers"). The rest of the picture is filled with almost realistically portrayed roots and the stems of plants, shown in differing sizes, from different perspectives, some of them gently embracing one another. At the epicentre of the picture, which appears to move constantly, shines a strangely hollow sun, looking as if it has been hurriedly scribbled, or the stylised peak of an almost cubist mountain. And just below the upper edge of the picture, a snarling tiger – LUTZ ICH LIEBE DICH ("Lutz, I love you"). Aggressively elegant, the tattoo is drawn on the surface of the paper as if on skin, suggesting a sensitive writing surface that both repulses and names danger.

At the very beginning of *Anti-Oedipus* (1972), Gilles Deleuze and Felix Guattari seem to be describing Peter Pommerer's art: "One ought to be a machine – HAUNTING TEMPLE WHORE – made of chlorophyll or protoplasm, or at least to be able to slide one's body into similar machines like part of a mechanism. Lenz has rejected the divide between man and nature behind him, and is hence no longer part of the order that depends on it. He does not experience nature as nature, but as a process of production. Neither man nor nature exists, only processes that procreate the one in the other and join the machines together. Production and wishing machines everywhere." The same is true – B. IST DOOF (B. IS STUPID) – of the "drawing machine" Peter Pommerer: nothing is divided in his work, various systems are chained to each other, and everything is linked by a never-ending cycle of wish production. In his work, which is closely linked and diverse at the same time, everything functions "everywhere, constantly, then with interruptions," as demanded by Deleuze/Guattari. Pommerer casts his net over paper and on photographs – LOVE IS A NAME, SEX IS A GAME – directly on walls or on objects such as vases or children's toys. This network consists of outbursts of realised imagination, the birth of exotic animals and plants, and bizarre architecture. It also consists of rhythmic sequences of geometric stencilling and the abrupt switch between diversely coded, ornamental layers – PUNK.

Rich colours alternate with sketchy sections, poetic visual language with almost brutal renunciation.

Pommerer incorporates emotionally loaded drawings from subculture, such as crude latrine drawings and gaudy GRAFFITI,

spannt sein Netz auf Papier und neuerdings LOVE IS A NAME, SEX IS A GAME auch auf Fotos, direkt auf der Wand oder auf bezeichneten Objekten wie Vasen oder Kinderspielzeug. Dieses Netz setzt sich zusammen aus Ausbrüchen einer gelebten Phantasie, aus dem Aufleben von exotischen Tieren und Pflanzen sowie der Konstruktionen bizarr-ordnender Architekturen. Und dann aus der rhythmischen Abfolge geometrischer Schablonen und dem abrupten Switchen zwischen unterschiedlich codierten und übereinandergelegten PUNK ornamentalen Layer. Satte Farbflächen wechseln sich dabei ab mit gestrichelten Partien, eine poetisch angehauchte Bildsprache mit beinahe brutalen Entäußerungen.

Gefühlsbeladene Aufzeichnungsflächen aus der "low culture", zum Beispiel krude Toilettenzeichnungen und grelle GRAFFITI, pornographische Klischees und infantile Bildmuster, setzt Pommerer in seinem Werk ebenfalls in Form, verbindet diese filigran mit eigenen, gezeichneten Wunschproduktionen und läßt so nach Herzenslust Neues und Immerwiederkommendes, Ungewohntes und Bekanntes zugleich sich ereignen: Neues FREE DOPE! Wünschen, Alles Wahr/Nehmen, stetes Variieren – die Ewige Wiederkehr der Seh(n)sucht. Daß diese künstlerische Haltung auch das kritische Hinterfragen aller seiner verwendeten Wunschmaschinen, also eine Reflexion über das, was man den "künstlerischen Prozeß" oder "Kreativität" zu nennen pflegt, impliziert, dies ist für Peter Pommerer eine Selbstverständlichkeit. Nicht zuletzt darum gibt er BIN GEIL! BLASE FÜR 5 DM im Zitieren immer wieder Autorenschaft ab: "Die Phantasie ist niemals individuell, sondern (…) Gruppenphantasie" (Deleuze/Guattari).

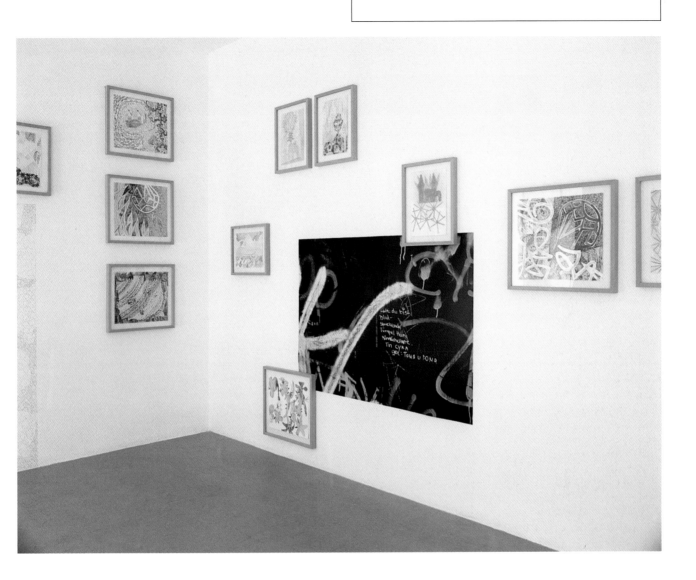

pornographic clichés and infantile patterns into his work. By com-
bining them delicately with his own fantasy drawings, he makes
the new, the recurring, the unusual and the familiar happen to your
heart's content. Wish for the new – FREE DOPE! – perceive
everything, vary constantly. The recurrence of longing. For Peter
Pommerer, it is obvious that this artistic attitude implies a critical
analysis of all his wish machines, a reflection on what is usually
referred to as the "artistic process" or "creativity". This is why,
when he quotes lavatory graffiti – BIN GEIL! BLASE FÜR 5 DM
(I'M HORNY! SUCK FOR 5 DM) – he repeatedly denies author-
ship: "The imagination is never individual, but […] a 'collective
imagination'" (Deleuze/Guattari).

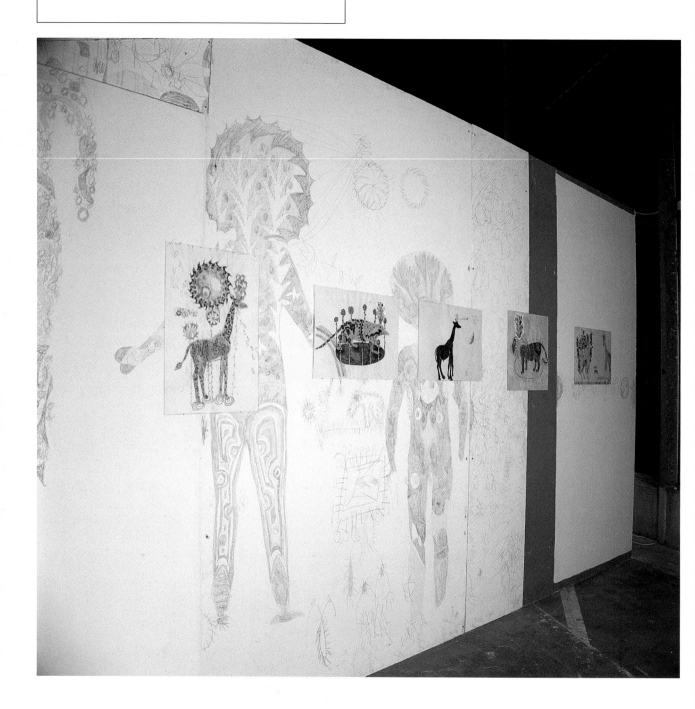

PETER POMMERER – Stuttgart, 1968 – Hochschule für Bildende Künste, Braunschweig – Wohnt/lives in Wien und/and Stuttgart

Photo Christiane Dierenbach

EINZELAUSSTELLUNGEN/ONE PERSON SHOWS: 1999 Taro Nasu Gallery, Tokyo – Meyer Riegger Galerie, Karlsruhe – Work_web.art, Köln (kuratiert von/curated by Uta Grosenick) **1998** Emily Tsingou gallery, London – Wiener Kunstverein im Volksgartenpavillon – Raum Aktueller Kunst Martin Janda, Wien **1995** Hinter Glas, Kunstraum Wohnraum, Hannover – **GRUPPENAUSSTELLUNGEN/GROUP SHOWS (Auswahl/selected): 1999** missing link 2, Aktionsforum Praterinsel, München – From B to A and Back, Arti et Amicitiae, Amsterdam – AmAazonas, Künstlerbücher, Villa Minimo und and Sprengel Museum (kuratiert von/curated by Florian Waldvogel und/and Raimar Stange), Hannover – Künstlerbücher, HBK Galerie, Braunschweig – Get together Art As An Team Work, Kunsthalle Wien **1998** nach vier kommt fünf, Raum Aktueller Kunst, Wien – Glut, Kunsthalle Düsseldorf (kuratiert von/curated by Marie Luise Syring), Düsseldorf – Surfacing Institute of Contemporary Arts, London – absolute secret, Royal College of Art, London – Songs from a room, Meyer Riegger Galerie, Karlsruhe **1997** Kunststudenten stellen aus, Kunst- und/and Ausstellungshalle, Bonn (Katalog/catalogue) – Time Out, Kunsthalle Nürnberg (kuratiert von/curated by Stephan Schmidt Wulffen), Nürnberg (Katalog/catalogue) – 1968 Goldsmiths College (kuratiert von/curated by Stephan Kalmar), London **1996** Now Here, Lousiana Museum of Modern Art, Humlebæk (Katalog/catalogue) – Kleine Universen, BMG Hallen, Deutschland **1995** Just Do It, Cubitt Gallery, London – Artservice, Kunstraum Via 113, Hildesheim **1994** Children in crises, Mönchehaus Museum Moderne Kunst, Goslar – ReklamARTion, Stadtgebiet Hannover (Katalog/catalogue) **1993** Zimmer Frei, Krowstrab 5, Braunschweig – Prince Rocks North, Atlantis, Braunschweig

Peter Pommerer

Neo Rauch

Neo Rauch – *Christina Bylow*

Neo Rauch war zuerst nicht mehr als ein Fototermin. Einer, der sich gerade noch einschieben ließ, am Ende einer Reportage-Reise nach Leipzig von München aus. Ein Plakat hatte die Entscheidungsprozedur in der Redaktion beschleunigt. Im Mai 1994 hing es an den Litfaßsäulen Münchens und kündigte eine Ausstellung an. Fünf oder sechs Paar Füße waren darauf zu sehen, in spitzen schwarzen Schuhen standen sie im Halbkreis über dem Schriftzug "Leipzig kommt". Die Füße gehörten Leipziger Künstlern. Neo Rauchs Füße waren nicht dabei. Er war auch nicht auf der Liste, die ich nach Leipzig mitnahm, er war ein Name, den mir jemand zuraunte, so wie sich Literaturstudenten die Namen von Schriftstellern zuraunen, über deren Lektüre sie miteinander in eine geheime, kostbare Verbindung treten.

Neo Rauch und seine Frau Sibylle arbeiteten damals Zimmer an Zimmer in einer leerstehenden Wohnung. Ich erinnere mich an einen ausgestopften Falken auf dem Fenstersims, an flatternde, vergilbte Vorhänge, an ein Buch von Ernst Jünger und daran, daß der Fotograf ununterbrochen herumprahlte mit einer eingebildeten Weltläufigkeit. Neo Rauch schwieg. Das Foto zeigte das Paar in klassischer Anordnung, er stehend vor der Staffelei, sie sitzend im Halbprofil. Sein Blick forderte den Fotografen heraus und überging ihn zugleich als unwürdigen Gegner. Sicher, das kann man sich ausdenken, aber das Unbehagliche der Situation fand nachher seine Fortsetzung in einer hilflosen Bildunterschrift, die das Wort "Bohème" enthielt. Bohème war Neo Rauch nie. Im Telefonbuch stand hinter seinem Namen der Eintrag "Maler" wie das Bekenntnis zu einer Zunft mit strenger Ordnung. Nach seiner Treue zur Malerei befragt, sagte Rauch vor seiner Ausstellung in der Overbeck-Gesellschaft Lübeck: "Es ist die hohe Schule, ich bin vielleicht ein bißchen albern in dieser Hinsicht. Ich kann mir nicht vorstellen, was man auf einem anderen Wege, auf elektronischem etwa, einem wirklich tiefgreifenden Gedanken noch hinzufügen sollte." Meine Besuche im Atelier in den vergangenen fünf Jahren förderten solche fundamentalen Sätze nicht zu Tage. Ich wollte mich hineinstehlen in den Prozeß der Entstehung eines Bildes, aber ich hätte wissen müssen, daß Neo Rauch niemanden so leicht in die Töpfe seiner alchimistischen Küche gucken läßt – um eine der von ihm geliebten Metaphern zu verwenden. Noch immer arbeiten er und Sibylle Raum an Raum, inzwischen sind es Hallen in der Leipziger Baumwollspinnerei. Der Falke ist nicht mehr da, auch kein Ernst Jünger, aber ein Selbstbildnis, das Neo Rauch an seine Initiation erinnert. Ein Jüngling mit langen Armen, den rechten in die Hüfte gestemmt, eine schmale gespannte Figur, die aus blauvioletten Tiefen hervortritt. Es war sein erstes Bild auf

Neo Rauch – *Christina Bylow* – Translated by Toby Alleyne-Gee

Initially, Neo Rauch meant little more to me than a photo session – someone I had managed to squeeze in at the end of a trip to Leipzig. Munich had been my point of departure. A poster had accelerated the decision-making process in our editorial offices. In May 1994, it had announced an exhibition on the advertising columns of Munich. On it could be seen five or six pairs of feet in pointed black shoes standing in a semi-circle above the slogan "Leipzig is coming". The feet belonged to Leipzig artists. Neo Rauch's feet were not among them. Nor was he on the list I took with me to Leipzig. He was a name that somebody whispered to me in the way students of literature whisper the names of authors to each other, entering into a precious, secret relationship through having read their works.

Neo Rauch and his wife Sibille were working in rooms next to each other in an empty apartment. I remember a stuffed falcon on the windowsill, fluttering, yellowed curtains, a book by Ernst Jünger, and the fact that the photographer, who imagined he was terribly cosmopolitan, boasted without interruption. Neo Rauch said nothing. The photograph showed the couple in classic pose, Rauch standing in front of the easel, his wife seated in semi-profile. Rauch's gaze simultaneously challenged and ignored the photographer as an unworthy opponent. Of course, one can read these things into a picture, but the awkwardness of the situation is revealed further by the helpless caption, which contained the word "Bohème". Neo Rauch was never "Bohemian". In the telephone book, like a declaration of faith, he was listed simply as a "painter", member of a strictly regimented guild. When asked about his loyalty towards painting before his exhibition at the *Overbeck-Gesellschaft* in Lübeck, Rauch said, "Perhaps I'm rather silly in this respect, but painting is the highest art form. I cannot imagine what one could possibly add to a really profound idea in any other way, for example electronically." My visits to his studio over the past five years have not provoked any such fundamental utterances. I wanted to infiltrate the process of creating a picture, but I ought to have known that Neo Rauch does not easily let anyone peer into the pans in his alchimist kitchen – to quote one his beloved metaphors. He and Sibille still work in rooms next to each other, although these are now halls in the Leipzig cotton mills. The falcon is no longer there, nor is Ernst Jünger, but there is a self-portrait that reminds Neo Rauch of his initiation into the world of painting. A long-armed youth, his right hand on his hip, a slender, taut figure stepping out of a bluish violet background. It was his first painting on canvas, and he was surprised how the material was flexible in his hands.

– **Isola**, 1999, Öl auf Papier/Oil on paper, 65 x 94 cm, Courtesy Galerie Eigen + Art, Berlin/Leipzig, © VG Bild-Kunst, Bonn 1999 – **Stellwerk**, 1999, Öl auf Leinwand/Oil on canvas, 200 x 300 cm, Privatsammlung/Private collection, Courtesy Galerie Eigen + Art, Berlin/Leipzig, © VG Bild-Kunst, Bonn 1999

– **Geschäft**, 1998, Öl auf Leinwand/Oil on canvas, 200 x 300 cm, Privatsammlung/ Private collection, Hamburg, Courtesy Galerie Eigen + Art, Berlin/Leipzig, © VG Bild-Kunst, Bonn 1999 – **Quelle**, 1999, Öl auf Leinwand/Oil on canvas, 228 x 480 cm, Courtesy Galerie Eigen + Art, Berlin/Leipzig, © VG Bild-Kunst, Bonn 1999

Leinwand, und er war überrascht, wie das Gewebe nachgab unter seiner Hand.

Was gibt er preis von den Voraussetzungen seiner Malerei? Er sagt, daß er ein Erzähler ist, aber kein Moralist. Er überträgt Heiner Müllers Satz, "ich kann nicht moralisch lesen, und ich kann nicht moralisch schreiben" auf das ihm eigene Medium. Er erlaubt sich heute Lüste, die er sich früher verbot. Sich einer bestimmten Frisur hinzugeben, Physiognomien zu studieren, bis hin zum strumaverdächtigen Kehlkopf. Seine "Befreiung in die Gegenständigkeit" nennt er das, und wenn jemand seinen Industrielandschaften nachtrauert, jenen ausgreifenden Szenarien, die im Moment vor einer Entladung verharren, entgegnet Rauch: "Wer draußen war, muß auch wieder reinkommen." Das war voriges Jahr, jetzt hat er die Figuren wieder ins Freie geschickt. Frauen mit Springerstiefeln und Schwesternschurz gesellen sich zu seinen "Burschen", eines dieser staubstarrenden Worte, in denen die dienstteifrige Inferiorität der Ordonnanzen nachhallt. Rauch hat nie verleugnet, daß er eine Armee von innen kannte. Seine Kasernen sind Spielplätze leerlaufender Übungen, Arsenale, die sich ins Unendliche ausdehnen. Neo Rauch hat inzwischen ein Vokabular zur Verfügung, das sich wie durch Selbstzeugung fortpflanzt. Seine Figuren, von denen er sagt, er müsse sie gerade noch ertragen können, bewegen sich im lichten Dickicht der Schleusen, Wachtürme, Bergwerke und Schießplätze. Egal ob sie Fähnchen schwenken, mit Stangen aufeinander losgehen oder mit imperialer Armbewegung auf den mutmaßlichen Brennpunkt des Geschehens deuten, für mich sind es Schlafwandler denen die große Geste geblieben ist – sonst nichts. Sie irrlichtern zwischen den Zeiten, markiert mit den Emblemen fiktiver Wahnsysteme. Man kann jede Empathie verweigern, ignorieren kann man sie nicht.

What does he reveal about the philsophy behind his painting? He says he is a narrator but not a moralist. He applies Heiner Müller's words "I can't read morally, and I can't write morally" to his own medium. He permits himself to nurture desires he previously denied himself. To devote himself to a particular hairstyle, to study physiognomies to the point of precisely depicting a goitrous Adam's apple. Rauch calls this his "liberation in representationalism", and when somebody bemoans the passing of his industrial landscapes, those large-scale, detailed scenarios that capture the tense moment before an eruption, he counters, "Anyone who has been out there has to come back in." That was last year. Now he has sent his figures outside again. Women wearing jackboots and nurses' aprons march out to join his servile "orderlies". Rauch has never denied that he is familiar with an army from the inside. His barracks are the scene of pointless exercises, arsenals extending to infinity. Neo Rauch has developed a vocabulary that multiplies itself as if by auto-reproduction. His figures, which he says must be just about bearable, move within sparse thickets of sluice gates, watchtowers, mines and firing ranges. Whether they are waving little flags, attacking each other with poles or gesturing with imperious arm movements towards the supposed heat of the action is irrelevant. For me, Rauch's figures are somnambulists who have retained their grand gestures – if nothing else. They wander aimlessly through time, going through the motions of ideologies that have lost their meaning. One can refuse to empathise with them, but ignore them one cannot.

NEO RAUCH – Leipzig, 1960 – Wohnt/lives in Leipzig

Photo Rosa Loy

EINZELAUSSTELLUNGEN/ONE PERSON SHOWS: 2000 Galerie für zeitgenössische Kunst Leipzig **1998** Galerie EIGEN + ART, Berlin, Leipzig – Galerie der Stadt Backnang (Katalog/catalogue) **1997** Manöver, Galerie EIGEN + ART, Leipzig (Katalog/catalogue) – Ausstellung zur Verleihung des Kunstpreises der Leipziger Volkszeitung 1997, Museum der Bildenden Künste Leipzig (Katalog/catalogue) **1995** Galerie EIGEN + ART, Berlin – Goethe House (mit/with Maren Roloff), New York – Dresdner Bank, Leipzig – Marineschule, Overbeck-Gesellschaft Lübeck (Katalog/catalogue) **1994** Projekt Galerie, Kunstverein Elsterpark, Leipzig **1993** Galerie Alvensleben, München (Katalog/catalogue) – Galerie Voxx, Chemnitz – Galerie EIGEN + ART, Leipzig – ImKabinettGalerie, Berlin **1989** Galerie am Thomaskirchhof, Leipzig (Katalog/catalogue) **GRUPPENAUSSTELLUNGEN/GROUP SHOWS: 1999** The Golden Age, ICA, London – Drawing and Painting, Galerie EIGEN + ART, Berlin – Malerei und Zeichnung, INIT, Kunst-Halle-Berlin, Berlin **1998** Transmission, Espace des Arts, Chalon-sur-Saône – Die Macht des Alters - Strategien der Meisterschaft, Deutsches Historisches Museum Berlin, Kunstmuseum Bonn, Deutsches Hygiene Museum Dresden (Katalog/catalogue) **1997** Lust und Last, Germanisches Nationalmuseum Nürnberg, Museum der Bildenden Künste Leipzig (Katalog/catalogue) – DG Deutsche Gesellschaft für Christliche Kunst, München – group show, Galerie EIGEN + ART, Berlin – Vitale Module, Plauen, Dresden, Prag, Ludwigshafen, Wrozlaw – Figural. Figürlich. Figurativ:, Bankhaus Trinkhaus & Burkhardt, Düsseldorf – Need for Speed, Steirischer Herbst 1997, Grazer Kunstverein, Österreich (Katalog/catalogue) **1996** Der Blick ins 21ste, Kunstverein Düsseldorf **1995** Goethe House (mit/with Maren Roloff), New York **1994** 1. Sächsische Kunstausstellung, Dresden **1993** Leipziger Jahresausstellung – Künstler träumen Berlin, Marstall Berlin – Dresdner Bank, Frankfurt am Main **1992** Der Harz, Galerie am Kraftwerk/Dependance Specks Hof, Leipzig – Galerie Alvensleben, München – Leipziger Sezession, Krochhochhaus, Leipzig – Junge Künstler aus Leipzig, BASF, Ludwigshafen – RENTA Preis, Nürnberg, Noris-Halle (Katalog/catalogue) – Reflex Ost-West, Potsdam **1991** Das Gewitter, Galerie am Kraftwerk (mit/with Klaus Killich), Leipzig – Große Kunstausstellung NRW, Düsseldorf – Galerie Utermann, Dortmund **1990** Galerie Maerz, Linz (mit/with Roland Borchers und/and Gerhard Petri) – Große Kunstausstellung NRW, Düsseldorf (Katalog/catalogue) **1989** Große Kunstausstellung NRW, Düsseldorf (Katalog/catalogue) – Zwischenspiele, Künstlerhaus Bethanien, Berlin (Katalog/catalogue) – Junge Künstler der DDR und Kubas, Havanna/Kuba, Berlin (Katalog/catalogue) **1988** X. Kunstausstellung der DDR, Dresden (Katalog/catalogue) – Arbeiten aus vier Kunsthochschulen Leipzig, Warschau, Wien, Berlin – Hofer Gesellschaft, Bahnhof Westend, Berlin – Neuerwerbungen des Ludwig-Instituts für Kunst der DDR, Ludwig-Institut Oberhausen **1986** Junge Künstler im Bezirk Leipzig, Staatliches Lindenau-Museum, Altenburg

Neo Rauch

Michel Majerus

– enough, 1999, Acryl auf Leinwand/Acrylic on canvas, 250 x 400 cm, Courtesy neugerriemschneider, Berlin **– no more**, 1999, Acryl auf Leinwand/Acrylic on canvas, 250 x 400 cm, Courtesy neugerriemschneider, Berlin

Michel Majerus – *Robert Fleck*

In wichtigen Ausstellungen der letzten Jahre stieß man in steter Regelmäßigkeit auf großzügige und großräumige Bildlösungen eines jungen Malers aus Berlin, die einzig aus Malerei aufgebaut waren, den jeweiligen Raum und die zeitgenössische Zeichenwelt aber höchst persönlich und kraftvoll in Dialog versetzten. Michel Majerus' Malerei tritt auf den ersten Blick sanft und unspektakulär in Erscheinung. Da gibt es nachgemalte oder malerisch vereinfachte Warenzeichen, Fragmente aus verschiedenen Stilen der Malerei, Anklänge oder freie Kopien von Einzelwerken moderner und zeitgenössischer Kunst, Designerklischees, Fotografien, die auf die Bildfläche übertragen wurden, grafisch säuberlich gemalte Slogans usw. Auf einer inhaltlichen Ebene vermengen sich hochkulturelle Elemente, etwa Zitate aus Museumsbildern mit Versatzstücken verschiedenster Populärkulturen. Man könnte dies für einen postmodernen Diskurs halten, für eine zynische Haltung gegenüber der neueren Kunstgeschichte und den Möglichkeiten von Malerei in der Welt der elektronischen Medien. Eine solche Vielfalt der Bildstatute könnte auch auf eine relativistische Einebnung der Werte deuten mit der Vorstellung: Da alles Denkbare schon gemalt wurde und die übrige visuelle Umwelt heute stärker und interessanter ist als Malerei, sei es einerlei, was und wie man malt – es gehe bloß um das Medium und um sein Fortleben in sich selbst. Beides sind legitime Haltungen zur Malerei, die gegenwärtig einen großen Teil jüngerer Künstler motivieren. Bei Michel Majerus ist eher das Gegenteil der Fall. Diese beiden Haltungen seien sie nur zitiert, um zu erläutern, was Majerus' persönliche Position ausmacht: Er kehrt den Spieß dieser diskursiven Alternative um und macht aus der konstitutiven Schwäche von Malerei in der gegenwärtigen visuellen Umwelt eine Stärke, indem er die Unverfrorenheit der postmodernen Zitat- und Samplingmethoden zielgerichtet und bewußt für ein malerisches Ziel einsetzt. Dieses ist jedoch weder naiv noch nostalgisch und neoklassizistisch. Majerus versucht die malerische Konsequenz aus dem Umstand zu ziehen, daß nach Pollock, De Kooning und Warhol eine kontemplative Haltung nicht mehr möglich sei.

Michel Majerus fertigt Einzelbilder verschiedenster Motive und Zeichencharakter mit unterschiedlichsten Techniken an. Die einen sind klassisch, andere projiziert auf Leinwand gemalt, wieder andere per Siebdruck und Computerausdruck auf technoide Oberflächen gesetzt. Ihre spätere puzzleartige Kombination wird meist schon mitgedacht. Die Einzelbilder sind nur Bausteine für die Hängung. Diese erfolgt Kante an Kante. Die ausgestellte Arbeit erscheint damit wie ein einziges, aus widersprüchlichen Teilen zusammengesetztes Bild. Dieses führt meist einen intensiven Dialog mit dem Raum, den das Bild transformiert oder im

Michel Majerus – *Robert Fleck* – Translated by Toby Alleyne-Gee

In recent years, the large-scale works of a young painter from Berlin have regularly been seen at major exhibitions. His creations consist solely of paintings, yet they establish a highly personal, powerful dialogue between the rooms in which they are exhibited and the contemporary world of artistic expression. At first glance, Michel Majerus' paintings are tranquil and unspectacular. There are copies or simplified copies of trademarks, fragments from different styles of painting, hints at or free copies of individual works of modern and contemporary art, designer clichés, photographs transferred onto the surface of the picture, perfect, meticulously painted copies of slogans, and so on. As far as content is concerned, cultural elements such as quotations from museum pieces are mixed with clichés from a variety of popular cultures. One could see this as a postmodern discourse, a cynical attitude towards recent art history and the possibilities of painting in the world of electronic media. Such a varied visual vocabulary could also be a reference to a relativistic levelling of values: since everything imaginable has already been painted and the rest of today's visual environment is more arresting and interesting than painting, it is of no importance what one paints, and how. The only thing that matters is the medium and its survival. Both these points of view are legitimate and are currently motivating a large number of young artists.

In the case of Michel Majerus, the opposite is true. I have only mentioned these two attitudes to illustrate what constitutes Majerus' personal position: he turns this all around on itself, transforming painting's currently weak position in the contemporary visual environment into a strength. He does this by deliberately using the brazen postmodern method of quotations and sampling to achieve a painterly objective. This is neither naïve, nostalgic nor neoclassical. Majerus' art is the result of the realisation that, since Pollock, De Kooning and Warhol, a contemplative attitude is no longer possible.

Michel Majerus produces individual pictures containing a wide variety of subjects and styles, using a broad range of techniques. Some are painted classically on canvas, others are projected, and others are screen-printed onto high-tech surfaces. How they are later to be combined, puzzle-like, is usually planned at this stage. The individual pictures are only building blocks for hanging the finished product, and are hung edge to edge. The work thus exhibited appears to be a single image made up of contradictory parts. There is usually an intense dialogue between picture and exhibition space, which is either transformed or to the contrary only slightly affected. The powerful effect Michel Majerus' pictures

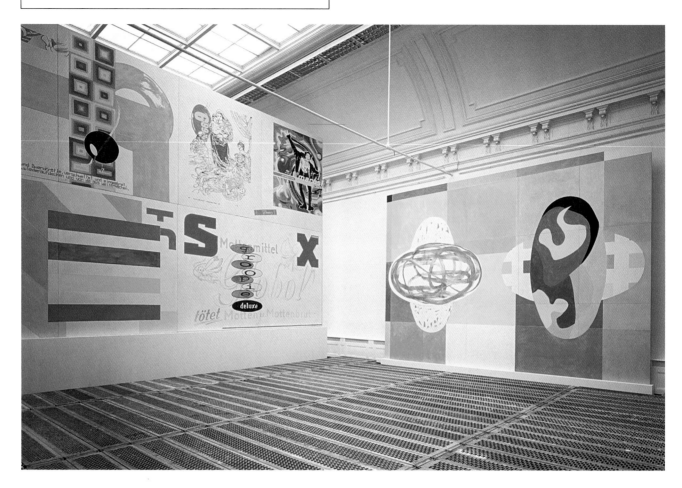

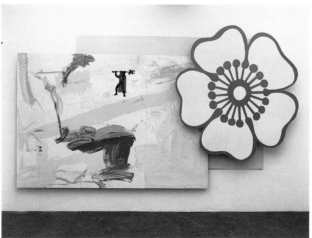

have on the space in which they are exhibited can be explained by the artist's supremely self-confident approach each work. Every picture is an expansive space extending beyond the space offered by the canvas. Majerus is concerned with producing images that can easily be understood. However, like our environment, these consist of a series of extremely heterogeneous parts.

Michel Majerus' fresh approach to painting is a perfect example of the relaxed attitude towards reproduction typical of the younger generation of artists. To make a comparison, one could say that Majerus is one the few painters to succeed in putting Sigmar Polke's attitude into practice. The mechanical reproduction of images as a new approach to painting is itself the topic of Sigmar

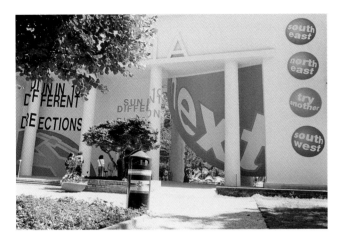

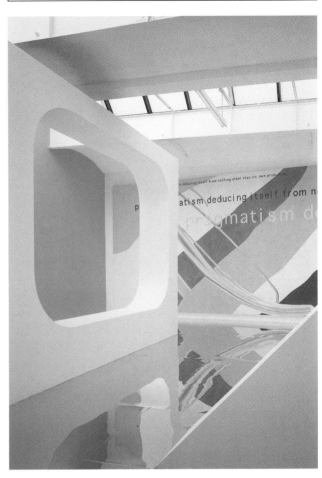

Gegenteil nur punktuell berührt. Die starke Raumwirkung der Arbeiten von Michel Majerus rührt daher, daß der Maler über eine große Sicherheit im Herangehen an das Bild verfügt – jedes Einzelbild weist einen expansiven Bildraum auf, der den reinen Zeichenraum der Leinwand überschreitet. Es geht Majerus um visuell schnell erfahrbare Bilder, die jedoch aus – in jedem Sinn – extrem heterogenen Teilen bestehen wie unsere Umwelt. Michel Majerus' frischer malerischer Ansatz ist ein Paradebeispiel für das überaus lockere Umgehen mit Reproduktion, das die jüngere Künstlergeneration kennzeichnet. Will man einen Vergleich ziehen, so könnte man sagen, Michel Majerus gelinge es als einem von wenigen Malern, die Haltung von Sigmar Polke sehr eigenständig umzusetzen. Bei Sigmar Polke ist die mechanische Bildrepro-duktion als neues Element malerischer Praxis noch selbst das Thema und der Anlaß für die Intensivierung des Bildbegriffs. Maje-rus übernimmt Polkes ineinander verschränkte Techniken, zerlegt sie aber gleichsam und gibt ihnen eine ungeahnte Frische, indem er sie in Einzelbilder auflöst wie im Film oder Video und auf hellen Gründen schweben läßt. Der Maler geht von den Rändern des Tafelbildes aus, von der scheinbar systemlosen oder im Gegenteil geordneten Accrochage, von hierarchielosen Sequenzen, abrup-ten Konfrontationen, von Reihen identischer Bilder, von Gemälde-collagen, filmähnlichen Verfahren, Werbungsfragmenten usw. – alles Dinge, die im klassischen Sinn mit der Ausstellung zu tun haben und nicht mit der Malerarbeit im Atelier. Indem er gerade dies neuerlich zu einem Bildbegriff zusammenzwingt, erreicht er eine intelligente und offene Position heutiger Malerei, die ohne Zynismus und historischen Relativismus auskommt.

Polke's work, and serves to intensify the pictorial concept. Majerus adopts Polke's combined techniques, yet takes them apart and gives them an unexpected freshness by "fading" in them in cinematic style so that they appear to float on a pale background. As a starting point the painter uses the edges of the picture, apparently unsystematic or indeed orderly accrochage, unhierarchical sequences, abrupt confrontations, rows of identical pictures, collages of paintings, cinematic procedures, fragments of advertisements etc. All this is usually associated with exhibi-tions rather than painters working in their studio. By combining all these elements to create a single pictorial concept, he has arrived at an intelligent, open form of contemporary painting that does without cynicism and historical relativism.

– **Beschleunigung I**, 1998, Installation view, Hauptbahnhof München, Siebdruck, Lack und Computerprint auf Aluminium/silk-screen print, lacquer and computer print on aluminum, 900 x 1400 x 130 cm, Courtesy neugerriemschneider, Berlin – **Reminder**, 1998, Installation view, Manifesta 2, Luxembourg, 650 x 1600 x 150 cm, Courtesy neugerriemschneider, Berlin

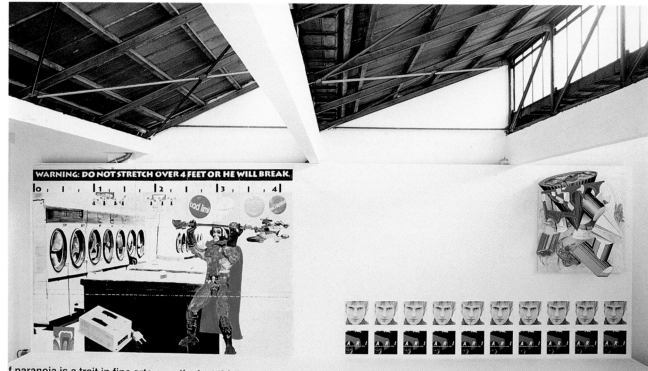

MICHEL MAJERUS – Esch, 1967 – Staatliche Akademie der Bildenden Künste, Stuttgart – Wohnt/lives in Berlin

Photo Albrecht Fuchs

EINZELAUSSTELLUNGEN/ONE PERSON SHOWS: 1999 neugerriemschneider, Berlin – Thai-Ming, Asprey Jacques, London – Galerie Rüdiger Schöttle (mit/with Jenny Holzer), München – Galleria Giò Marconi, Mailand **1998** never trip alone. always use 2 player mode, Eleni Koroneou Gallery, Athen **1997** Space Safari, Anders Tornberg Gallery, Lund – qualified, Galeria Gio Marconi, Mailand – Produce-Reduce-Reuse, Galerie Karlheinz Meyer, Karlsruhe **1996** Aesthetic Standard, Grazer Kunstverein – Monika Sprüth Galerie, Köln – Fertiggestellt zur Zufriedenheit aller, die Bedenken haben, neugerriemschneider, Berlin – Kunsthalle, Basel (Katalog/catalogue) – The Museum of Modern Art Syros, Syros, Griechenland – Aquarell, Hamburger Kunstverein, Hamburg **1994** neugerriemschneider, Berlin **GRUPPENAUSSTELLUNGEN/GROUP SHOWS: 1999** kraftwerk BERLIN, Aarhus Kunstmuseum, Aarhus (Katalog/catalogue) – zoom, Museum Abteiberg, Mönchengladbach (Katalog/catalogue) – Le Capital: tableaux, diagrammes, bureaux d'études, Centre Régional d'Art Contemporain, Languedoc-Roussillon, Meudon (Katalog/catalogue) – Originale echt/falsch, Neues Museum Weserburg, Bremen (Katalog/catalogue) – Nach-Bild, Kunsthalle Basel (Katalog/catalogue) – Objects in the Rear View Mirror may Appear Closer than They Are, Galerie Max Hetzler (kuratiert von/curated by Wolfram Aue), Berlin – dAPERTutto, 48. Esposizione Internazionale d'Arte, La Biennale di Venezia (Katalog/catalogue) – Galleri Nicolai Wallner, Kopenhagen – zoom, Sammlung Landesbank Baden-Württemberg, Stuttgart – Galeria Mário Sequeira, Praga – expanded design, Salzburger Kunstverein – de coraz(i)on, Tecla Scala, Barcelona (Katalog/catalogue) – Made in Berlin, House of Cyprus, Athen (Katalog/catalogue) **1998** Malerei, Galerie Karlheinz Meyer, Karlsruhe – Made in Berlin, Rethymnon Centre for Contemporary Art, Kreta (Katalog/catalogue) – manifesta 2, Luxemburg (Katalog/catalogue) – Das Jahrhundert der künstlerischen Freiheit. 100 Jahre Wiener Secession, Wien (Katalog/catalogue) – Tell Me a Story: Narration in Contemporary Painting and Photography, Magasin, Centre National d'Art Contemporain de Grenoble (Katalog/catalogue) **1997** Topping Out, Städtische Galerie,Nordhorn (Katalog/catalogue) – Imbiß, Künstlerhaus Stuttgart – Faustrecht der Freiheit, Sammlung Volkmann, Kunstsammlung, Gera **1996** Alle Neune, ACC Galerie, Weimar – Wunderbar, Hamburger Kunstverein – something changed, Helga Maria Klosterfelde, Hamburg **1993** Malerei III, 1996, Monika Sprüth Galerie, Köln – Wunderbar, Kunstraum, Wien **1992** Under Thirty, Galerie Metropol, Wien (Katalog/catalogue)

Michel Majerus

Olafur Eliasson

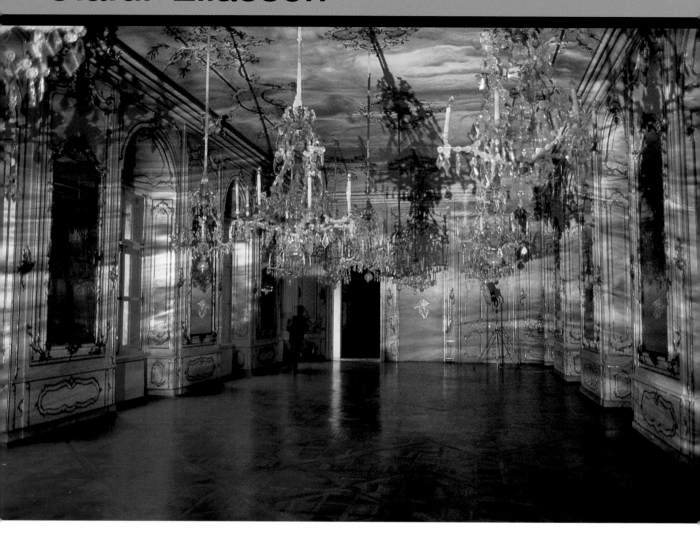

– Installation, 1996, Variable dimensions, Courtesy neugerriemschneider, Berlin

My days are shorter than your T-shirt – *Philippe Parreno* –
Übersetzung aus dem Französischen von Stefan Barmann

"Die Reise zum Mittelpunkt der Erde" von Jules Verne beginnt in Island. Die Expedition bricht von Edinburgh aus auf, nimmt ihren wirklichen Anfang jedoch im Krater des Jökull Snæffels im Westen Islands. Auf ebendenselben Hängen dieses Vulkans wird später die Eroberung des Weltraums beginnen. Die ersten Bilder von Neil Armstrong, der in seinem Raumanzug durch die verödete Landschaft hüpft, die Bilder eines zögernd die Grate der Krater abfahrenden "Lunar Module", alle diese ersten Bilder des Weltraumabenteuers sind in Island gedreht worden. Bevor sie diese Bilder auf dem Mond produzierte, hatte die NASA Sorge getragen, einen Pilotfilm zu machen, der im voraus ablichtete, was man alsbald entdecken sollte: Staub. Denn nichts anderes gibt es auf dem Mond zu sehen als Staub. Galt es demnach, die Ausrüstung zu testen, so haben diese Bilder, außer daß sie zur Finanzierung des Programms Apollo 11 beitrugen, uns auch auf den Anblick der Ödnis eingestimmt. Die Hoffnung auf eine etwaige Flucht zu den Sternen ging in die Brüche. Die Eroberung des Weltraums, die bis dahin ein Traum gewesen war, wurde fortan zur Illusion. In diesem Sinne sind diese Bilder traumatisierend. Es gibt nur einen einzigen bewohnten Planeten im Gefüge eines sich stetig ausdehnenden Universums, und dieser Planet ist der unsere. Den Astrophysikern zufolge gilt kein weiterer Planet als bewohnbar. Möglicherweise – das ist eine Frage von Wahrscheinlichkeit – gibt es irgendwo Tausende bewohnbarer Planeten, aber für eine gute Weile noch wird sich alles hier bei uns abspielen. "Ihr seht nicht, was hier auf dem Spiel steht, doch das ist das Ziel, das alle Wissenschaft erreichen will: ins Unbekannte vorstoßen. Ist euch klar, daß wir weniger über die Erde wissen, auf der wir leben, als über die Sterne, die Galaxien im Raum? Das größte Mysterium liegt hier, unter unseren Füßen!", erklärte der Professor Otto Lidenbrock in der "Reise zum Mittelpunkt der Erde". Sind die Sterne auch heute noch attraktiv, so deshalb, weil sie uns einen Ausblick auf die Erde bieten. Letztlich unterrichtet das Universum uns über uns selbst. Die Eroberung des Weltraums ist seltsam geozentrisch geworden.

Zurück auf der Erde, im Zeitalter von Jules Verne und zu einer Zeit, da der Fortschritt die große Bewegung genannt wurde, führte die Eisenbahn die erste zeit-räumliche Revolution herbei. Aus dem Bauerntum wurde Proletariat, und aus dem Land wurde Landschaft. Rund um die Freizeitgestaltungen entwickelte sich auch eine Demokratisierung des Verkehrs – ein Zug fährt ja in beide Richtungen. Im Pariser Gare de Lyon kann man noch heute die ersten Werbungen besichtigen, Fresken, auf denen die verschiedenen Zielorte dargestellt sind. Eine Art gesellschaftliche

My days are shorter than your T-Shirt – *Philippe Parreno* –
Translated by Toby Alleyne-Gee

Jules Verne's *A Journey to the Centre of the Earth* begins in Iceland. The expedition sets out from Edinburgh, but begins effectively in the crater of the Jökull Snæffels volcano in the west of Iceland. Years later, the conquest of space will also begin on the slopes of the very same vulcano. The first images of Neil Armstrong hopping through the barren landscape in his space suit, the pictures of a lunar module tentatively making its way down the ridges of the crater – all these first images of the great space adventure were filmed in Iceland. Before NASA shot these images on the moon, it was careful to make a pilot film that would show in advance what the astronauts were about to discover: dust. For there was nothing to see on the moon but dust. If the film was intended to test the equipment, apart from contributing to the financing of the Apollo 11 programme, it prepared us for the sight of desolation. Hopes of perhaps fleeing to the stars were dashed. The conquest of space, which until then had been a dream, now became an illusion. In this sense, these images have a traumatic effect. There is only one inhabited planet in the ever-expanding structure of the universe, and that planet is our own. According to the astrophysicists, no other planet is habitable. Possibly – it is a matter of probability – there are thousands of habitable planets somewhere, but here on earth is where things will be happening for a good while yet. "You don't realise what is at stake, but this is what every scientist wants to achieve: to venture into the unknown. Are you aware that we know less about the earth in which we live than about the stars and galaxies in space? The greatest mystery of all is here, under our feet!" declares

– **The curious garden**, 1997, Installation view, Kunsthalle Basel, Courtesy neugerriemschneider, Berlin

Reklame für Freizeit. Reisen, das Weite suchen, so lautet der Wahlspruch der Freizeitindustrie. Daraus wurde sogar der Garant seelischen Gleichgewichts. Das Weite suchen.

Seither entsteht die Einrichtung der Zeit durch die neuen Technologien tendenziell über eine Weltzeit, wogegen die Geschichte stets von einer örtlichen Zeit, einer urbanen Zeit durchzogen ist. Die Geschichte ist zu einer Quelle von *bugs* geworden. Den *bug* des Jahres 2000 verdanken wir dem Kalender, aber, versprochen, das wird ab jetzt nicht mehr vorkommen. Dafür braucht man nur die Weltzeit der Astronomie als Urmeter. Uhren mit Federwerk müssen aufgezogen werden, was die Zeit von einer Person zur anderen differieren läßt; mit den Batterien schwinden dann schon die Verschiebungen. Die Uhr geht bis zu dem Zeitpunkt, wo sie nicht mehr geht. Heute verkaufen Werbungen für Uhren die Idee der Weltzeit; die Uhren sind mit einer mechanischen oder elektronischen Unruh ausgerüstet, einem Foucaultschen Pendel. Daher braucht man nur in Bewegung zu bleiben, damit die Uhr sich aufzieht. Es kommt darauf an, ständig den Ort zu wechseln. Die Einrichtung einer absoluten Zeit schließt uns in derselben Welt ein, einer Welt von 40.000 Kilometern Umfang, die zu bereisen wir nicht mehr aufhören können. Die Zeit, die Suche des Weiten oder das Freizeitwesen sind neurotisch.

Manchen vermittelt sich das Interesse an der Landschaft durch die Entdeckung einer Ereignislandschaft. Soll die Landschaft ein

Professor Otto Lidenbrock in *A Journey to the Centre of the Earth*. If the stars still attract us, it is because they offer us a view of the earth. Ultimately, the universe teaches us about ourselves. The conquest of space has become strangely geocentric.

Back on earth, in the age of Jules Verne and a time when movement was synonymous with progress, the railways ushered in the first revolution in time and space. The peasant class became the proletariate, the "countryside" became "landscape". The way people spent their free time eventually led to the democratisation of travel – a train moves in both directions, after all. The first advertisements for rail travel, frescoes representing various destinations, can still be seen at the Gare de Lyon in Paris. A kind of social advertising for leisure time. Travel, *wanderlust*, is the slogan of the leisure industry. Travel has even become a guarantee of emotional balance. *Wanderlust.*

Since then, the arrangement of time by the new technologies has tended to be based on global time, whereas local, urban time has always been the leitmotif of history. History has become a source of bugs. We owe the millennium bug to the calendar, but we promise it won't happen again. Yet all one really needs to measure time is the global time of astronomy. Watches with a spring mechanism have to be wound, making time differ from one person to another; but thanks to batteries, these differences will eventually disappear. A watch carries on functioning until it ceases to function. Today, advertisements for watches sell the idea of global time; watches are equipped with a mechanical or electronic balance-wheel, Foucault's pendulum. This is why it is enough to keep in motion, and your watch will wind itself. A constant change of location is the important thing. Applying absolute time makes us all part of the same world. This world has a circumference of 40,000 kilometres' – and we just can't stop travelling round it. Time, *wanderlust* and leisure are neuroses.

Many people become interested in the landscape by discovering the landscape as an event. If the landscape is to contribute something to history, something eventful must be discernible in it. In an urban environment – this is what makes it so strange – there are always more events than landscape. Sportsmen are interested in revealing the eventfulness of the landscape, and sport has rules which must be observed. This became sufficiently clear last winter in Switzerland and France, when the newspapers constantly reported on the avalanches. One hardly needed to be able to read between the lines to hear statements that still have a moralising aftertaste: be careful, leave the marked slopes at your peril. An accident has something of the lay miracle about it, something that bonds people. Apart from the stock-market crash we have never experienced an accident that could be considered a complete accident, an accident that would affect the whole world at the same time. Natural catastrophes offer us this drama. Armageddon,

– no nights in summer, no days in winter, 1994, Metallreifen, Propangas/Metal ring, propane, Ø 60 cm, Courtesy neugerriemschneider, Berlin

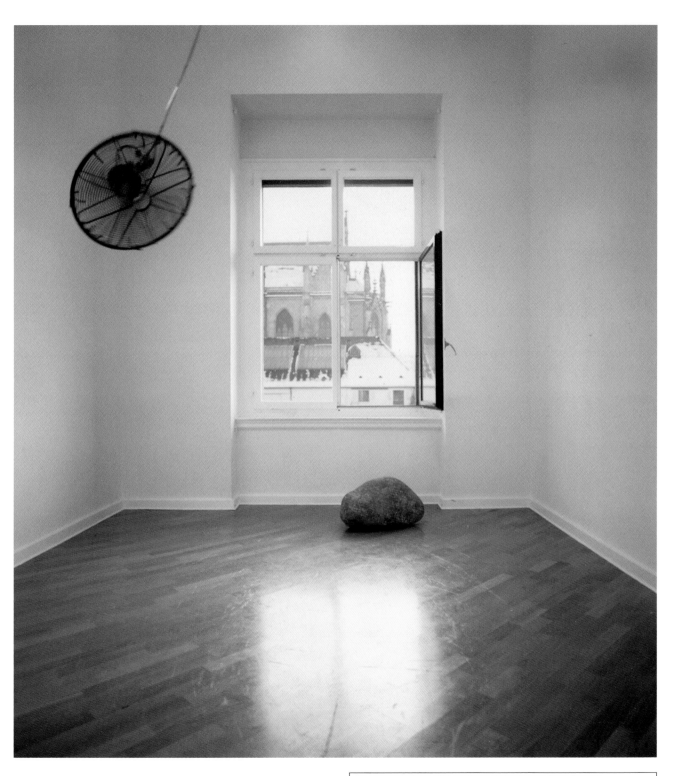

– **The curious garden**, 1997, Installation view, Kunsthalle Basel, Courtesy
neugerriemschneider, Berlin

wenig zur Geschichte beitragen, so gilt es, darin etwas Ereignis zu finden. In einer Stadtlandschaft – das macht ihre große Eigenart aus – gibt es stets mehr Ereignisse als Landschaft. Mit dem Ausweisen von Ereignislandschaften beschäftigt sich der Sport, und der Sport hat Regeln, auf deren Einhaltung man sich verstehen muß. Hinreichend deutlich wurde uns dies letzten Winter in der Schweiz wie in Frankreich, als die Zeitungen nicht mehr aufhörten, Lawinen zu titeln. Es bedurfte kaum der Fähigkeit, zwischen den Zeilen zu lesen, um Sätze zu vernehmen, die noch als subliminale Morallektion nachhallen: Gebt acht, außerhalb der abgesteckten Pisten setzt man sich der Bestrafung aus. Der Unfall hat etwas Laienwunderhaftes, etwas Verbündendes. Bis auf den Börsenkrach haben wir nie einen Unfall erlebt, der ein vollständiger Unfall sein könnte, ein Unfall, der alle Welt zum selben Zeitpunkt beträfe. Die Naturkatastrophe bietet uns dieses Drama. Armageddon, Deep Impact, Day Light, Ice Storm: In allen diesen Filmen schafft die Natur das Ereignis und die Geschichte. Eine Geschichte ganz besonderer Art, denn das Drehbuch ist eine Falle. Der Held gerät vom Beginn des Films an in die Falle, und die ganze Geschichte beruht dann darauf, seinen Kopf aus der Schlinge zu ziehen, sich buchstäblich aus der Geschichte herauszuwinden.

Vielleicht gibt es noch eine andere Lösung, die uns gestattet, uns einen Begriff von der Landschaft zu machen, bei der zu berücksichtigen ist, was eigentlich dort vonstatten geht, wo sich wenig oder gar nichts bewegt. Kann man einen Raum, eine Landschaft als eine Bühne auffassen und nicht bloß als einen Gegenstand mehr oder minder nostalgischer Kontemplation oder als Vektor kosmischer Katastrophen? Olafur Eliasson bietet andere Landschaftswahrnehmungen als jene, die das Objektiv einer Kamera oder eines Fotoapparates vermitteln. Wahrnehmung von Landschaft ebnet den Tiefenraum nicht ein. Wir bleiben in einer euklidischen Perspektive, in der das Nahe das Nächste ist. Wahrnehmung von Landschaftsempfindung ist definitionsgemäß antimedial, denn der große Trick des Nachrichtenwesens besteht ja im Gegenteil darin, das Ferne nahezurücken. Kann man Wahrnehmung von Landschaft im städtischen Umraum aufspüren? Das ist eine Arbeit für den Urbanisten, keineswegs für den Visionär. Eine Landschaft ist definitionsgemäß noch keine Welt, nur ein Bruchteil davon.

Deep Impact, Day Light, Ice Storm: in all these films, nature creates an event and a story. A very special kind of story, because a script is a trap. From the beginning of the film, the hero falls into a trap, and the entire plot is then concerned with getting his head out of the noose, as it were.

Perhaps there is another solution that allows us to create our own understanding of landscape, bearing in mind what is actually happening in places where little or nothing moves. Can one perceive a space or a landscape as a phase, rather than as the mere object of more or less nostalgic contemplation, or as the vector of a cosmic catastrophe? The perception of landscape Olafur Eliasson offers us is different from the images communicated by a camera lens. The perception of landscape does not eliminate a sense of depth. We continue to observe from a Euclidean perspective in which proximity is closest to us. Perceiving the way we feel about landscape cannot, by definition, be communicated via the media, for the great trick of news reporting is the way it brings what is far away closer. Can the landscape be perceived in an urban environment? This is a task for the urbanite, but certainly not for the visionary. A landscape is by definition not a world, but a mere fragment.

OLAFUR ELIASSON – Dänemark, 1967 – Königlich Dänische Kunstakademie, Kopenhagen – Wohnt/lives in Berlin

Photo Albrecht Fuchs

EINZELAUSSTELLUNGEN/ONE PERSON SHOWS: 2000 Institute of Contemporary Art, Chicago (Katalog/catalogue) **1999** Dundee Contemporary Arts, Dundee – Your Double Day Diary, Frankfurter Kunstverein, Frankfurt am Main – Your Circumspection Disclosed, Castello di Rivoli, Turin – Riflessi di una certa importanza, Emi Fontana, Mailand – beauty, Marc Foxx, Los Angeles **1998** Galerie für Zeitgenössische Kunst, Leipzig – Yet Untitled, neugerriemschneider, Berlin – Tell Me about a Miraculous Invention, Århus Kunstmuseum – Aquarium, Galerie Enja Wonnenberger, Kiel – Bonakdar Jancou Gallery, New York – Kjarvalstadir Museum Iceland, Island – Galerie Peter Kilchmann, Zürich **1997** Stalke Out of Space, Kopenhagen – Your sunmachine, Marc Foxx, Los Angeles – The Curious Garden, Kunsthalle Basel (Katalog/catalogue) **1996** Kunstmuseum Malmö – Your Foresight Endured, Galleria Emi Fontana, Mailand – Your Strange Certainty Still Kept, Tanya Bonakdar Gallery, New York – Tell me about a miraculous invention, Galleri Andreas Brändström, Stockholm **1995** Eine Beschreibung einer Reflexion, oder aber eine angenehme Übung zu deren Eigenschaften, neugerriemschneider, Berlin – Künstlerhaus Stuttgart – Thoka, Hamburger Kunstverein – Tommy Lund Galerie, Odense **1994** Stalke Out of Space, Kopenhagen – Einige erinnern sich, daß sie auf dem Weg waren diese Nacht, Lukas & Hoffmann, Köln – No Days in Winter, no Nights in Summer, Forumgalleriet, Malmö **1991** Overgarden Galleri, Kopenhagen
GRUPPENAUSSTELLUNGEN/GROUP SHOWS: 2000 Wonderland, Saint Louis Art Museum, Saint Louis **1999** Carnegie International 1999/2000, Carnegie Museum of Art, Pittsburgh (Katalog/catalogue) – Arte All'Arte, Arte Continua, Casole d'Elsa (Katalog/catalogue) – Skulptur-Biennale 1999, Münsterland (Katalog/catalogue) – dAPERTutto, 48. Esposizione Internazionale d'Arte, La Biennale di Venezia (Katalog/catalogue) – Overflow, Anton Kern Gallery, New York – Galería Heinrich Ehrhardt, Madrid – Focused, Galerie Tanit, München – Schöpfung, Diözesanmuseum Freising (Katalog/catalogue) – Next Stop, Kunstfestivalen Lofoten (Katalog/catalogue) – Photography: An Expanded View, Recent Acquisitions, Solomon R. Guggenheim Museum, New York – Konstruktionszeichnungen, Kunst-Werke, Berlin – Landscape: Outside the Frame, MIT List Visual Art Center, Cambridge, Massachusetts **1998** Wanas 1999, Malmö Konstmuseum, Malmö – Light x Eight: The Hanukkah Project, The Jewish Museum, New York – Dad's Art, neugerriemschneider, Berlin – Fast Forward – Trade Marks, Hamburger Kunstverein, Hamburg – Auf der Spur, Kunsthalle Zürich – Sharawadgi, Felsenvilla, Baden – The 7th Triennal of Contemporary Art. Cool Places, Contemporary Art Centre, Vilnius, Litauen – New Photography 14, Museum of Modern Art, New York – Berlin Biennale, Berlin (Katalog/catalogue) – Round About Ways, Ujazdowski Castle, Warschau – The Edstrand Foundation Art Prize 1998, Rooseum, Malmö – The Erotic Sublime (Slave to the Rhythm), Galerie Thaddeus Ropac, Salzburg – The Very Large Ice-Floor, São Paolo Biennale, São Paolo, Brasilien (Katalog/catalogue) – Waterfall, Sidney Biennale, Sidney, Australien (Katalog/catalogue) – Something is rotten in the State of Denmark, Fridericianum, Kassel (Katalog/catalogue) – Brytningstider, Norrköping Konstmuseum, Norrköping (Katalog/catalogue) – Stadt-Landschaften, Sabine Knust Galerie & Edition, München – Momentum, Nordic Festival of Contemporary Art, Moss (Katalog/catalogue) /Villa Medici, Academie de France a Rome, Rom – Do All Oceans Have Walls?, Künstlerhaus, Bremen (Katalog/catalogue) – Mai '98, Kunsthalle Köln (Katalog/catalogue) – Transatlantico, Centro Atlantico de Arte Moderna, Las Palmas – Nuit Blanche, Musée d'Art Moderne de la Ville de Paris, Paris – Reykjavik Municipal Art Museum, Bergen Billedgalleri, Porin Taidemuseo, Göteborg Konstmuseum (Katalog/catalogue) – Warming, The Project, New York – Interferencias, Museo de Arte Contemporanea, Madrid (Katalog/catalogue) – Seamless, De Appel, Amsterdam (Katalog/catalogue) – Sightings. New Photographic Art, ICA London (Katalog/catalogue) – undergrund, (kuratiert von/curated by Jacob Fabricius), Kopenhagen – Stalke Anniversary Show, Kopenhagen **1997** Heaven, P.S.1, New York – été 97, Centre genevois de gravure contemporaine, Genf – Kunstpreis der Böttcherstraße in Bremen, Bonner Kunstverein (Katalog/catalogue) – On life, beauty, translations and other difficulties, 5th International Istanbul Biennial, Istanbul (Katalog/catalogue) – alikeness, Centre for Contemporary Photography, Fitzroy – Trade Routes, 2nd Johannesburg Biennale, Johannesburg, Südafrika – Truce: Echoes of Art in an Age of Endless Conclusions, Site Santa Fe (Katalog/catalogue) – New Art from Denmark and Skåne, Louisiana Museum, Humlebæk, Dänemark (Katalog/catalogue) – 3rd Symposium on Visual Arts, LANDART, Amos, Kanada – Vilnius Center of Art, Litauen – The Scream, Borealis 8. Arken Museum, Kopenhagen – Platser, Public Space Projects, Stockholm – Kunsthalle Wien **1996** Views of Icelandic Nature, Kjarvalstadir Museum, Reykjavik – The Scream, Nordic Fine Arts 1995–96, Arken Museum for Moderne Kunst, Ishøj, Dänemark – Prospect 1996, Schirn Kunsthalle/Kunstverein, Frankfurt am Main (Katalog/catalogue) – Glow: Sublime Projected and Reflected Light, New Langton Art, San Francisco – Alles was modern ist, Galerie Bärbel Grässlin, Frankfurt am Main – Provinz-Legende, Samtidsmuseet, Roskilde, Dänemark – tolv, Schaper Sundberg Galleri, Stockholm – Summer Show, Tanya Bonakdar Gallery, New York – remote connections, Neue Galerie, Graz, Wäino Aaltonen Museum of Art Turku, Finnland, Artfocus, Tel Aviv – nach weimar, Kunstsammlungen zu Weimar (Katalog/catalogue) – Manifesta1, Rotterdam (Katalog/catalogue) **1995** Landschaft, Mittelrheinmuseum Koblenz, Haus am Waldsee, Berlin (Katalog/catalogue) – Campo 95, Venedig, Turin, Malmö (Katalog/catalogue) – Kunst & Ökologie, Kunstverein Schloß Plön **1994** Europa, Ausstellung Münchner Galerien, München (Katalog/catalogue) **1993** 1700 CET, Stalke Out of Space, Kopenhagen – Black Box, GLOBE Kuratorengruppe, Kopenhagen **1992** Paradise Europe - billboard project, KopenhagenOverdrive, 10 Young Nordic Artists, Kopenhagen – Lightworks, Demonstrationslokalet for Kunst, Kopenhagen **1991** Young Scandinavian Art, Stalke Out of Space, Kopenhagen **1990** Street Signs - billboards, BIZART, Kopenhagen **1989** Ventilator Projects, Charlottenborg Konsthall, Kopenhagen

Olafur Eliasson

Christian Hoischen

Formel 1 – Zu den "Gemälden" von Christian Hoischen –
Thomas Wulffen

Jedes Bild ist auch Material, Material der Oberfläche und des Trägers. Ein wesentlicher Entwicklungsschritt der modernen Malerei war der Hinweis auf diese Materialität und deren Thematisierung. Die ersten Collagen im Umkreis des Kubismus oder die Frottagen von Max Ernst sind auch eine Referenz auf das Material, wogegen schon die Combine Paintings von Robert Rauschenberg eine Thematisierung darstellen. Die kulminiert im "Erased de Kooning" von Rauschenberg und findet einen weiteren Höhepunkt in Lucio Fontanas "pittura concettuale". Der Austritt aus dem Bild ist ohne den Bezug auf das Material nicht vorstellbar.

Diese Beschreibung liefert eine Folie für das Werk von Christian Hoischen. Nur sind die Zeiten heute ganz andere. Daß sie so anders sind, muß im Zusammenhang mit einer digitalen Kultur gesehen werden. Denn in ihr sind aus der Perspektive der Bits und Bytes die gewohnten Gattungsgrenzen des Bildes, sei es Malerei, Foto oder Video aufgehoben worden. Die Reduktion der Materialkomponente im digitalen Code auf die Grundsubstanz Sand beziehungsweise Silizium, Grundbestandteil des Halbleiterchips, ermöglicht gleichzeitig eine Umsetzung in verschiedenste Medien. Das entscheidende Moment dabei bleibt die Transformation in ein jeweiliges Medium. Dabei mag sich der Transformationsschritt als wesentlicher erweisen als das Medium selber. Es gilt, die Waage zwischen beidem zu halten.

Die Arbeiten von Christian Hoischen nehmen darauf Bezug. Sie präsentieren sich als Gemälde, aber ihre Materialität ist eine hybride, und sie halten damit die Waage. Damit geht der Künstler über die eindeutige Materialität früherer Arbeiten hinaus, die gleichzeitig auch im Modus der Selbstreferenz das Material thematisierten. Diese spezifische Materialität zeigte sich auch in den mehr malerisch bezogenen Arbeiten. Abgebildet wurden einfache Möbel. Die fertigen Arbeiten wurden danach laminiert. Daß das Laminat nicht plan aufliegt, sondern Wellen bildet, ist intendiert. Damit kommen im Bild zwei verschiedene Materialitäten zueinander und stoßen aufeinander. Zum einen die Oberfläche des gemalten Objekts, zum anderen die Oberfläche des Laminats.

Durch die neugewonnene Glätte wird die malerische Oberfläche verborgen und damit in dem Akt des Vermissens verdeutlicht. Wenn man die Oberflächenstruktur des Möbelobjekts dazu nimmt, eröffnet sich dem Betrachter die Tiefe der Oberfläche. Das abgebildete Objekt korrespondiert mit dem Objekt des Laminats und läßt das eine wie das andere sowohl als Bild als auch als Objekt verstehen. Diese Ambiguität ist bedeutsam, weil sie den Blick auf das Verhältnis von Rekonstruktion und Konstruktion eröffnet. Was sich in diesen Arbeiten auf zwei unterschiedlichen Ebenen zeigt, wird in den neueren Werken zusammengezogen in eine Ebene.

Formula 1 – On Christian Hoischen's "Paintings" –
Thomas Wulffen – Translated by Toby Alleyne-Gee

Every picture is also a substance, the substance of the canvas and of the frame. A major step towards the development of modern painting was a new awareness of this materiality and the fact that it was taken as a theme in itself. The first cubist collages and Max Ernst's frottages are also a reference to material, as are Robert Rauschenberg's combine paintings. In Rauschenberg's work, materiality as a subject in its own right is most clearly expresssed in *Erased de Kooning*, reaching another climax in Lucio Fontana's "pittura concettuale". Stepping out of a painting would be inconceivable without referring to the substance of the picture.

This description could apply to Christian Hoischen's work, except that times have changed considerably. The fact that times are so

– Strecke, 1999, 270 x 177 cm, Öl, Lack auf Tintenstrahldruck/Oil, varnish on inkjet print

Die deutlichen Differenzen verschwinden. Oder sie sind verschoben wie in dem Video "Übel" von Christian Hoischen. Es zeigt vier verschiedene Gewaltszenen, denen wir in den üblichen Nachrichtensendungen begegnen. Begleitet werden diese Ereignisse von der Stimme eines coach-potatoes, der gelangweilt-irritiert sich zu dem Kommentar aufrafft: "Oooh-scheiiße–üüübel-buah-was ist dasss denn?"

In einer Art negativen Dialektik legt Bild und Stimme zusammen das Verhältnis des distanzierten Beobachters zum Bild offen. Das zeigt sich schon in den Videobildern, die kaum die gewohnte Qualität, sondern schon eine malerische Anmutung besitzen. In der ständigen Wiederholung entleert sich die Information, und nur die Stimme erinnert den Betrachter an das, was er wahrnimmt. Aber das kann die Furie des Verschwindens nicht zum Verschwinden bringen. Abrieb führt zur Beschleunigung.

Davon spricht Christian Hoischen. Das eine ist Effekt des ande-

different must be the result of our digitalised culture, whose bits and bytes have destroyed the conventional generic limitations of the picture, be it a painting, photograph or video. The digital reduction of material components into their constituent parts, such as sand, or rather silicon, a basic component in a semi-conductor chip, also allows expression in a wide range of media. The decisive factor is the transformation into another medium, although the actual transformation stage may prove to be more significant than the medium itself. The important thing is to maintain the balance between the two.

Christian Hoischen's work refers to this. His creations present themselves as paintings, but theirs is a hybrid materiality, and so they maintain the balance. The artist thus goes a step further than the unequivocal materiality of his earlier works.

This specific materiality also manifested itself in Hoischen's more "painterly" works, which represented simple pieces of furniture.

– **Rede**, 1999, 133 x 180 cm, Öl, Lack auf Tintenstrahldruck/Oil, varnish on inkjet print

...................................Oooohhaaaaaaa.....................................Scheeeiiiiiiiiiße...............................

..........................ohoohoi.........hohe...........................was ist das denn.......................hsss.........ssh

...............hoo...........hoh......ho....h...........................üüüüüüübel.............zzhhz.....................

...ouii..............

– **Übel**, 1998, Video

ren. Ohne Abrieb gibt es keine Beschleunigung, weil erst die Überwindung des Rollwiderstandes zur Beschleunigung führt. Der Rollwiderstand aber ist Bedingung der Möglichkeit für eine beschleunigte Bewegung. Der Abrieb ist damit nicht nur Verlust, sondern Ausgangspunkt für weitere Ergebnisse.

Ein ähnliches Verhältnis findet sich in den jüngsten Arbeiten von Christian Hoischen. Ausgegangen wird dabei von einem gefundenen Foto, das der Künstler einscannt und dann auf einem gewöhnlichen Drucker zum Ausdruck bringt. Die Vorgangsweise erinnert an das oben erwähnte Video. Das Hintergrundbild, das zur Bearbeitung ausgewählt wurde, wird aufgrund der Größe aus vielen DIN-A4-Blättern zusammengesetzt. Ausdruck und Größe geben dem Bild eine spezifische Materialität. Hintergrund dafür ist die Beschleunigung der Bilder in einer digitalen Kultur. Durch die spezifische Umsetzung des digitalisierten Bildes erzeugt Christian Hoischen eine Retardierung, einen Rollwiderstand. Der Vorgang der Beschleunigung wird durch den malerischen Eingriff in Gang gesetzt, denn in ihm werden Elemente des ursprünglichen Bildes verstärkt, verdeckt oder ganz neu bestimmt. Das Bild kommt an.

The finished paintings were laminated, the surface of the laminate being deliberately structured in wave-like curves. Two differing materials – the surface of the painting and that of the laminate – thus collide with each other.

Concealing the surface of the painting with a smooth layer of laminate in fact serves to emphasise it. Consider the surface structure of the piece of furniture, and the depth of the surface will be revealed. The object shown corresponds to the layer of laminate, investing both substances with the double meaning of picture and object. This ambiguity is significant because it reveals the relationship between reconstruction and construction. What in these works is shown on two different levels is compressed onto one level in Hoischen's more recent works. The clear differences disappear, or are repositioned, as in the video entitled *Übel* ("Disgusting"). It shows four different scenes of violence of the type we often encounter in news broadcasts. These events are accompanied by the voice of a bored couch potato, who manages to comment: "Oh shit! How disgusting! What's that?"

Image and voice reveal the relationship of the detached observer to what he is seeing in a kind of negative dialectic. This is also apparent in the video images, which are not of the usual sharpness, but already have a painterly quality. The constant repetition of these images deprives them of their informative function, and only the voice reminds the viewer of what he is seeing. But this cannot make the fury of disappearance disappear. Friction leads to acceleration.

This is Christian Hoischen's message. The one is the result of the other. Without friction there can be no acceleration because only by overcoming resistance is acceleration possible. Resistance, however, is what makes accelerated movement possible. Friction is thus not only a loss, but also a starting point for further results. Christian Hoischen's most recent works also reveal similar internal relationships. He uses a photograph that he has found as a starting point, scans it and prints it on a normal printer. This procedure reminds me of the video mentioned above. Due to its size, the background image is composed of several sheets of A4 paper. The printout and size of the image give it a specific kind of materiality. The reason for this is the acceleration of images in a digital culture. Through the specific transformation of a digitalised image, Christian Hoischen creates a delay, resistance. Painterly intervention initiates the process of acceleration. Through this painterly intervention, certain elements of the original image are emphasised, concealed – or completely recreated. The picture works.

CHRISTIAN HOISCHEN – Köln, 1966 – Hochschule für Kunst, Bremen – Hochschule der Künste, Berlin – Wohnt/lives in Berlin

EINZELAUSSTELLUNGEN/ONE PERSON SHOWS: 1999 Übel, Neuer Aachener Kunstverein, Aachen **1998** Strecke, Galerie Bischoff Schönthal, Berlin **1997** und diesmal geht's um Klinsmann, SOMA Galerie (mit/with Martin Dammann, Guardini Stiftung), Berlin **GRUPPENAUSSTELLUNGEN/GROUP SHOWS: 1999** Bremer Förderpreis, Städtische Galerie, Bremen – Sommeraccrochage, Kunst-Werke, Berlin **1998** Sehen sehen, loop-Raum für aktuelle Kunst, Berlin – Ceterum Censeo, Galerie im Marstall, Berlin – Kommunikation und ihr Scheitern, Inter-Trans, Berlin **1997** Kunst und Technik Galerie, Berlin – 11 Videos, Galerie Michael Kapinos, Berlin **1996** Cluster Images, Medienbiennale, Werkleitz

Christian Hoischen

Andree Korpys & Markus Löffler

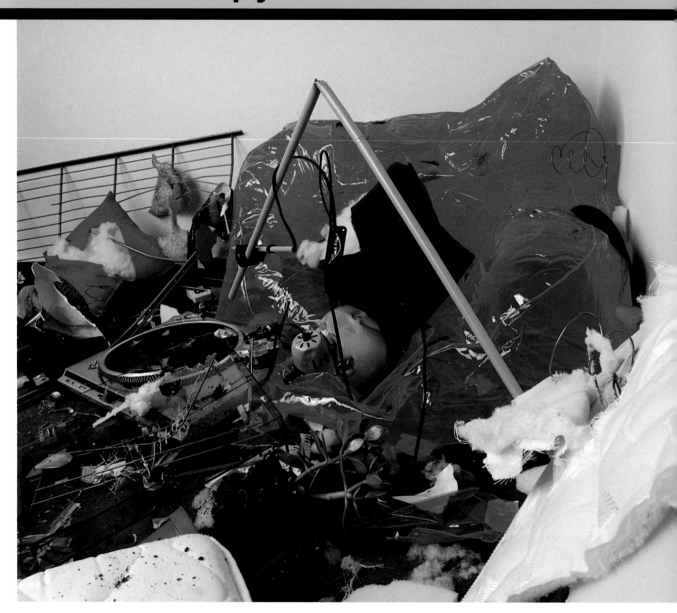

– **Designrecherche**, 1998, Fotografie/Photography, 186,5 x 143,5 cm, Courtesy Galerie
Otto Schweins, Köln, Photo Korpys & Löffler

Andree Korpys & Markus Löffler – *Joachim Homann*

Seit dem Tod der Mutter sind schon fast zwanzig Jahre vergangen. Ich habe keinen Moment lang das Bedürfnis gespürt, Fotos von ihr anzusehen. Von den vielen Fotos, die sie seit der Studentenzeit von sich gesammelt hatte, sind einige immer noch nicht in die Alben eingeklebt. In den Schubladen liegen stapelweise die Aufnahmen, die sie vor den ersten Bestrahlungen hatte machen lassen. Sie wollte sich noch einmal mit ihren Haaren dokumentieren, bevor sie ausfallen würden. Wenig später gehörte ihre Perücke zu ihr dazu. Diese Perücke gibt es noch. Sie fliegt auf unserem Dachboden herum, mittlerweile ziemlich zerzaust, im Augenblick unauffindbar, weil man in der Dunkelheit zwischen den Dachschrägen unmöglich Ordnung halten kann. Die Fotos interessieren mich nicht. Anders ist es mit den Sachen, die wir ab und zu wiederfinden. Zuletzt haben wir ein Schließfach in der Bank geöffnet, in dem der Schmuck verwahrt wurde, den sie meiner Schwester vermacht hatte. Das ist Geschmackssache. Ich könnte mich mit diesen Drachenringen, groben Halbedelstein-Klunkerketten, den amorphen Broschen in Handtellergröße nicht anfreunden. Was sie daran wohl fand? Hatte sie überhaupt keinen Sinn für Eleganz? Sah sie sich selbst als eine Art ungeschliffenen Edelstein, der der Heimaterde entrissen war? Wenn ich an meine Mutter denke, dann an ihre Stimme und an die skurrilen Kleider und den Schmuck, den sie trug, an die Farben, mit denen sie sich umgab. Unser Treppenhaus war mit riesigen lila-gelbgoldenen Mustern tapeziert, am Treppengeländer hingen Rentierfelle.

Was wurde eigentlich aus der Sammlung von Jean Des Esseintes nach dessen Tod? Wer konnte etwas anfangen mit den kostbaren Büchern der spätrömischen Dekadenz, den Duftessenzen, mit dem Aquarium und den künstlichen Blumen aus Stoff, Papier, Porzellan und Metall und mit den echten exotischen Pflanzen, die noch künstlicher aussahen? Wer konnte das Stück Schiffstau gebrauchen, das Des Esseintes mit in die Badewanne genommen hatte, um sich zu suggerieren er sei am Meer? Huysmans schreibt in "A Rebours" nichts darüber. Des Esseintes' Körper verfiel zwar schon seit der Zeit, als er begonnen hatte, sich in die Einsamkeit von Fontenay zurückzuziehen, seinen Tod konnte er sich trotzdem nicht vorstellen. Deswegen braucht Huysmans auch nicht darüber

Andree Korpys & Markus Löffler – *Joachim Homann* – Translated by Toby Alleyne-Gee

Almost twenty years have passed since my mother died. Not for a moment have I felt the need to look at photographs of her. Of the many photos she had collected of herself since her student days, several still have not been stuck into albums. In drawers there are piles of pictures that she had taken of herself before her first radiotherapy. She wanted a record of herself with her hair, before it fell out. A little later, her wig was to become an integral part of her. This wig still exists, flying about our attic, rather dishevelled. At the moment I can't find it because it's impossible to keep things tidy in the dark under that pitched roof. I'm not interested in the photos, but I am interested in the things we occasionally come across. Recently we opened a safe at the bank where the jewellery she had left to my sister was kept. It's a question of taste. Those dragon rings, clumsy chains of semi-precious stones and amorphous brooches the size of a hand just don't appeal to me. What did she like about them? Did she have absolutely no taste whatsoever? Did she see herself as a kind of unpolished gem, torn from the earth of her homeland? When I think of my mother, I think of her voice and the eccentric clothes and jewellery she used to wear, the colours with which she surrounded herself. Our staircase was hung with wallpaper in a huge mauve and golden yellow pattern, and deerskins were draped over the banisters.

What became of Jean des Esseintes' collection after his death? Who had any use for his precious books on the decadence of the late Roman empire, the perfume essences, the aquarium and the artificial flowers made of fabric, paper, porcelain and metal, or the real exotic plants that looked more artificial than genuine? Who had any use for the piece of rope that des Esseintes used to take with him into the bathtub to give himself the feeling he was by the sea? Huysmans does not write anything about this in A Rebours. Des Esseintes' body had been decaying since the time he had begun to withdraw to the solitude of Fontenay, but he still could not imagine what dying would be like. This is why Huysmans does not need to describe it. *He describes not so much the agony of the dying as the moral agony of the survivor.* Does the world change when I die? No, it ceases to exist.

– **Designrecherche**, 1998, Voltmerstr. 45, Appartment Nr. 75, 14. OG., Zeichentusche auf Papier/Drawing ink on paper, 116,5 x 189 cm, Courtesy Galerie Otto Schweins, Köln und/and Meyer Riegger Galerie, Karlsruhe, Photo Korpys & Löffler

zu berichten. *Er beschrieb weniger die Agonie des Sterbenden als vielmehr die moralische Agonie des Überlebenden.* Verändert sich die Welt, wenn ich sterbe? Nein, sie hört auf zu existieren.

Es gibt eigentlich niemanden, der sich traut zu sagen, daß er nicht an den eigenen Tod glaubt. Nach außen versucht man das besser zu kaschieren. Man muß versuchen, irgendwie normal auszusehen, auch wenn man sich für etwas Besonderes hält. Vielleicht ist das heute leichter als früher. Zuerst muß man die Leute genau beobachten und lernen, wie sie sich bewegen. Dann geht man in die gleichen Geschäfte wie sie und deckt sich mit angesagten Sachen ein. Aus Kleinigkeiten kann man dann schließen, daß man vermutlich für normal gehalten wird. Allerdings kann man schwer abschätzen, ob die anderen nicht doch einen Verdacht haben, daß etwas nicht stimmt, und sich nur so lange nichts anmerken lassen, bis man einen Fehler begeht.

Die Wohnungen der RAF waren mit IKEA-Möbeln ausgestattet. An den Wänden hingen Plakate mit den damals gängigen Motiven. Wenn man Fotos von den Verstecken sieht, dann weiß man sofort, wie die Möbel sich anfühlen und wie sie riechen.

Fotografien taugen als Beweis, daß man es geschafft hat, eine normale Existenz anzunehmen, eine Paßbild-Existenz. Sie zeigen die ganze Banalität eines Augenblicks. Ein Foto ist wie ein Katalog von Dingen angelegt, eine Aufzählung von Sachen, die für einen Moment in einen Zusammenhang gesetzt werden. Es kann nicht gelingen, dieser Sammlung eines Augenblickes einen Sinn zu geben. Im Video sieht es manchmal so aus, als ob es doch eine Interpretation gäbe, wenn die Schnitte eine Argumentation zu erzeugen scheinen. Aber die Bilder entgleiten gleich wieder. Die unaufhebbare Banalität der fotografischen Dokumentation kann man den Versuchen entgegenhalten, eine verbindliche Geschichte von etwas zu erzählen. Sobald ich etwas verstehe, bin ich gezwungen, für andere zu sprechen. Ich weiß nicht, wie das gehen soll.

– Konspiratives Wohnkonzept eines Einrichtungsbüro, 1998, Zeichentusche auf Transparentpapier/Drawing ink on transparent paper, 52 x 72 cm, Courtesy Galerie Otto Schweins, Köln, Photo Korpys & Löffler **– Designrecherche, Konspiratives Wohnprojekt "Spindy"**, Revolver Verlag Stuttgart, 1998, Photo Bundeskriminalamt, Wiesbaden

– **Bundesanwaltschaft**, Januar 1999, Karlsruhe, Photo: Korpys & Löffler – **Mietwohnung Karlsruhe**, Januar 1999, Fotografie/Photography, 60 × 80 cm, Courtesy Meyer Riegger, Karlsruhe, Photo Korpys & Löffler

No one actually dares to say he doesn't believe in his own death. It's better to hide this from the outside world. You somehow have to try to appear normal, even if you think you are something special. Perhaps this is easier nowadays than it used to be. First, you have to observe people closely and learn how they move. Then you go to the same shops as they do and kit yourself out with the right togs. On the basis of minor details, you can assume that you are considered normal. However, it is difficult to determine whether other people might still suspect that something is not quite the way it ought to be, and are just pretending everything is all right until you make a mistake.

The members of the *Rote Armee Fraktion* filled their apartments with IKEA furniture. The fashionable posters of the time hung on the walls. When you see photos of their hideaways, you immediately know how the furniture feels and smells.

Photographs successfully function as proof that one has managed to lead a normal, passport photograph life. They show the entire banality of a moment. A photo is constructed like a catalogue of objects, a list of things that are interconnected at a specific moment. It is impossible to invest this momentary collection with any kind of significance. When the images of a video appear to be creating some kind of argumentation, they would seem to be offering an interpretation. But those images soon slip away.

Any attempts to tell a definite story about something can be countered by the irrevocable banality of photographic documentation. As soon as I understand something, I am forced to speak for others. I don't know how I should go about it.

ANDREE KORPYS & MARKUS LÖFFLER – Bremen, 1966 und/and 1963 – Fachhochschule für Fotografie und/and Film, Bielefeld – HfG/ZKM, Medienkunst postgraduiert, Karlsruhe – Wohnen/live in Bremen

EINZELAUSSTELLUNGEN/ONE PERSON SHOWS: 1999 Meyer Riegger, Karlsuhe – Galerie Otto Schweins, Köln **1998** Gartenlaube, Stuttgart Stammheim – Projektraum Solitude/ZKM, Berlin **1997** Galerie Cornelius Hertz, Bremen – Roemerstrasse (mit/with Achim Bitter), Akademie Schloss Solitude, Stuttgart **1996** Galerie Otto Schweins, KölnGalerie Vorsetzen, Hamburg **1995** Kunstverein Bremerhaven (Katalog/catalogue) – Justizvollzugsanstalt Kiel (Katalog/catalogue) **1992** Kunst-Werke Berlin **GRUPPENAUSSTELLUNGEN/GROUP SHOWS: 1999** Forum Stadtpark, Graz – Ars viva 99/00, Casino Luxembourg, Kunstverein Freiburg (2000), KunstHaus Dresden – Centre pour l'image contemporaine, Genf (Katalog/catalogue) – Fototriennale, Graz (Katalog/catalogue) **1998** Lux Cinema, London – Städtische Galerie Delmenhorst (Katalog/catalogue) **1996** Discord, Kunstverein Hamburg (Katalog/catalogue) **1994** Städtische Galerie Bremen, Förderpreis **1991** Forum junger Kunst, Kunsthalle Kiel, Kunstverein Wolfsburg, Museum Bochum (1992) (Katalog/catalogue)

Andree Korpys & Markus Löffler

Simone Böhm

CowboySpielen und ConvoyFahren – Zwei Ereignisse im öffentlichen Raum – Gespräch zwischen Justin Hoffmann und Simone Böhm

Justin: Du hast Dich während Deines Studiums intensiv mit der Funktion der privaten Erinnerungsfotografie beschäftigt, wobei Du vor allem auf eigenes Material zurückgegriffen hast. Verliert man da nicht irgendwann die Lust, den Auslöser überhaupt zu betätigen?

Simone: Also im Urlaubsgepäck habe ich meine Kamera ganz bestimmt nicht mehr. Ich bin aber trotzdem neidisch auf alle, die völlig unbefangen drauflosknipsen können. Spannend finde ich die grundsätzlich sentimentale Aktion von im Prinzip jeder fotografischen Aufnahme, das selbstbetrügerische Spiel, ein idyllisches Bild der Gegenwart zu entwerfen, das, in Zukunft betrachtet, die Illusion einer schönen Vergangenheit bescheren soll. Mit Hilfe der Fotografie bzw. des Films ist es dann möglich, wichtige private Ereignisse so oft und wann immer man möchte, wiederholt stattfinden zu lassen.

Justin: Während Deines Aufenthalts in London hast Du angefangen, Ereignisse zu inszenieren. Zu "Can't see Texas from here" hast Du mich ja auch eingeladen. War schon ein schönes Erlebnis, sich mit Dir und Deinen Freunden auf "experimentellen Country Western" einzulassen, vom nächtlichen Ausritt zu Pferde durch eine Londoner Vorortgegend ganz zu schweigen. Du hast damals davon gesprochen, daß es Dir darum ginge, Ereignisse zu wiederholen, die Dir als angenehm in Erinnerung geblieben sind und die Du gegenwärtig vermißt. Aber ist es nicht das Spezifische an Ereignissen, daß sie gar nicht wiederholbar sind? Oder warst Du Country-Western-Fan und vermißt diese Musikrichtung in zeitgenössischen Clubs?

Simone: Nein, natürlich nicht. Der "Marlboro Man" war sicher nie mein Idol. In der Inszenierung von Ereignissen sehe ich vielmehr eine erfolgversprechende Strategie gegen die Horror erzeugende Tatsache des Älterwerdens bzw. gegen die negativen Begleiterscheinungen, die mit dem Erwachsenwerden verknüpft sind. Als Kind wollte ich nicht akzeptieren, daß es mit dem Spielen irgendwann vorbei sein soll, und als Teenie wollte ich nie darauf verzichten, mit meinen Freunden zusammen unterwegs zu sein. Das Leben der Erwachsenen um mich herum schien mir dermaßen von Langeweile und Fremdbestimmtheit in fast allen Bereichen des täglichen Lebens geprägt zu sein, daß ich es nie besonders eilig hatte, auch dort zu landen.
Die englische Tradition, spleenige Fancy-Dress-Partys zu feiern, um so der eigenen kindischen Lust am Verkleiden nachzugeben, beweist Mut zur Selbstironie, und das wiederum finde ich sympathisch. Es geht wohl mehr darum, bestimmte Identitäten anzuneh-

Playing the Cowboy, Driving in Convoy – Two public events – Justin Hoffmann and Simone Böhm in conversation – Translated by Toby Alleyne-Gee

Justin: During your studies you took a close look at the function of private photography as a souvenir, mostly using your own material. Doesn't there come a point where you lose all desire to take pictures?

Simone: Well, I certainly don't carry a camera in my holiday luggage any more, but I'm still envious of anyone who can just take snaps uninhibitedly. What I find exciting is the basically sentimental act of practically every photo: the self-deceptive attempt at designing an idyllic image of the present which, looked at from the future perspective, is intended to create the illusion of a beautiful past. With the help of photography or film you can make important private events happen again and again, as often as you like.

Justin: During your stay in London you started staging events. You invited me to *Can't see Texas from here*. It was a great experience to be drawn into "experimental country and western" with you and your friends, not to mention the ride on horseback through a London suburb by night. At the time you said that you wanted to repeat events that you remembered fondly and that you missed at that moment. But isn't it the very nature of an event that it's impossible to repeat? Or were you once a country and western fan and miss this style of music in the clubs?

Simone: No, of course not. The Marlboro Man was certainly never my idol. I see the staging of an event more as successful way of counteracting the horror of aging and the negative side effects associated with growing up.
As a child I never wanted to accept that playtime was over, and as a teenager I never wanted to give up going out with my friends.

men, die einem zumindest für einen gewissen Zeitraum erlauben, eine Leichtigkeit bzw. Distanz dem Alltag gegenüber einzunehmen. Mit den spießig verklemmten Karnevalsfeiern hierzulande hat das übrigens gar nichts zu tun.

Justin: Worin bestand Dein konzeptueller Hintergrund für die Mini-Love-Parade, dem von Dir über Internet und Mundpropaganda organisierten Treffen Londoner Mini-Cooper-Fahrer mit anschließender Konvoi-Fahrt? Wieder eine Reaktion auf den englischen Spleen? Oder wolltest Du Dich als Deutsche outen?

Simone: Autoenthusiasten gibt es überall, und zwischen dem Mini und dem Käfer gibt es viele Gemeinsamkeiten. Beide waren aufgrund ihrer "Größe" eine technische Meisterleistung und das Lieblingsauto der Wenigerverdienenden, und beide genießen schon seit einiger Zeit Kultstatus. Am intensivsten wird der Minikult übrigens in Japan betrieben, was eigentlich logisch ist. Natürlich ging es mir bei beiden Ereignissen auch darum, meine eigenen "Nationalitätskomplexe" zu verarbeiten. Beim Country-Western-Ereignis wollte ich mich eher als "Heidi from the Mountains" outen, das heißt, mich zu meinem "ländlichen Background" bekennen, weil mich die Arroganz der Großstädter schon immer genervt hat und ich auch nicht viel von einem "Kulturzentralismus" halte.

Justin: München zählt also nicht zu den Großstädten?

Simone: Bestimmt nicht. Dazu leben zu wenig Ausländer in der Stadt, von einer Integration in allen gesellschaftlichen Schichten ganz zu schweigen. Wieder in München, vermisse ich die Möglichkeit, mein eigenes Bewußtsein im Spannungsfeld von möglichst vielen kulturellen Identitäten erweitern zu können. Vor allem zwei britische Deutschlandklischees waren mir unangenehm. Der schlechte, wenig ausgeprägte deutsche Humor und das angeblich nationale Vergnügen, sich als Bestandteil einer Masse wohl zu fühlen.
Die Love Parade dient hierfür als das negative Beispiel schlechthin. Mehr als eine Million ausgelassener Deutsche in Berlin, das bereitet manchen Briten schon ein leichtes Unwohlsein. Dasselbe Phänomen eines bestimmten sozialen Bedürfnisses scheint mir jedoch aufzutreten, wenn sich einmal im Jahr 5000 Minibesitzer zusammenfinden, um gemeinsam den legendären "London Brighton Convoy" zu fahren. In beiden Ereignissen denke ich, spiegelt sich vor allem die Sehnsucht nach sozialer Interaktivität als Kontrastprogramm zur "virtuellen Arbeitswelt". Der Mini Convoy war auf jeden Fall ein Ereignis, das ich und alle Beteiligten nicht vergessen werden, und wieder ein schöner Erinnerungsfilm mehr für uns. Gleichzeitig gab es ein gutes Urlaubsmotiv für die Touristen in den Straßen.

The life the adults around me led seemed so boring and so dependent on the will of others that I wasn't in a great hurry to reach that stage. The tradition the English have of giving excentric fancy dress parties to celebrate their own childish desire to dress up proves that they don't take themselves so seriously. I like that.
These parties are about assuming certain identities that allow you, at least for a certain time, to adopt a frivolous or detached attitude to everyday life. By the way, these parties have nothing in common with the inhibited, petit bourgeois carnival parties we have in Germany.

Justin: What was the idea behind the Mini Love Parade, the London Mini Cooper meeting and convoy drive you organised via the Internet and word of mouth? Was it another reaction to English eccentricity? Or did you want to out yourself as a German?

Simone: There are car enthusiasts all over the place, and the Mini and the Beatle have a lot in common. When they first appeared on the market, both were a technical masterpiece as far as their size was concerned. They were a favourite with low-income buyers, and both have enjoyed cult status for some time. The Mini is especially popular in Japan, which I suppose is logical. Of course, these events also helped me to deal with my own "nationality complexes". At the country and western event I was more interested in outing myself as "Heidi from the mountains", i. e. to declare my country background, because the arrogance of urban dwellers has always annoyed me and I don't think much of the idea of "cultural centralism".

Justin: So Munich isn't a major city?

Simone: Certainly not. There aren't enough foreigners in the place for that, and they certainly aren't integrated into all social classes. In Munich I miss being able to broaden my horizons by coming into contact with as many different cultural identities as possible. Two clichés the British have about Germany I found particularly unpleasant: a lack of a sense of humour and the apparently national pleasure in group dynamism.
The Love Parade is *the* negative example of this. The idea of over a million boisterous Germans in Berlin is enough to make a lot of Brits feel uneasy. But to me, the same social phenomenon seems to occur every year when 5,000 Mini owners meet to drive the legendary London to Brighton Convoy. I think that both events reflect people's longing for social intercourse as a relief from the "virtual workplace". The Mini Convoy was certainly an event that I shan't forget , and nor will any of the other participants, and again made a pleasant souvenir film. The convoy also gave the tourists on the streets a great opportunity for a good holiday snap

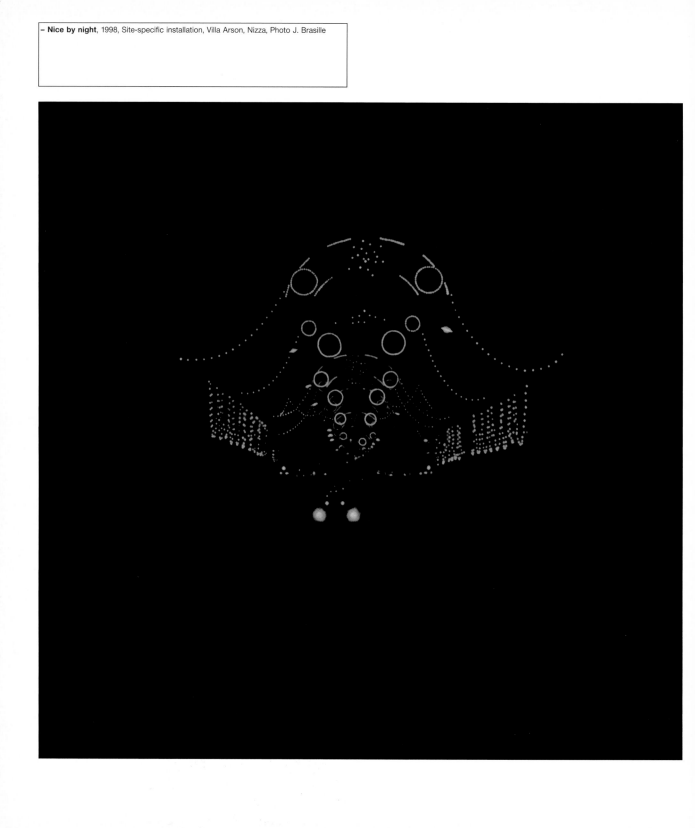

SIMONE BÖHM Burglengenfeld, 1971 – Universität Regensburg – Akademie der Bildenden Künste München – Chelsea College of Art London – Wohnt/lives in München

AUSSTELLUNGEN/EXHIBITIONS: 1999 Rundgang III, Fridericianum, Kassel – Schöpfung, Diözesanmuseum, Freising **1998** Personne sait plus, Villa Arson, Nizza **1997** Studenten und Absolventen der Kunstakademie München, Kunstverein Frankfurt am Main **1996** Pater Noster, 26 KünstlerInnen in einem Aufzug, München **1995** München liegt am Meer, Interventionen in leerstehendem Wohnraum, München **1994** Anvisiert, Photographie in der Flugwerft Schleißheim

Simone Böhm

Elmar Hess

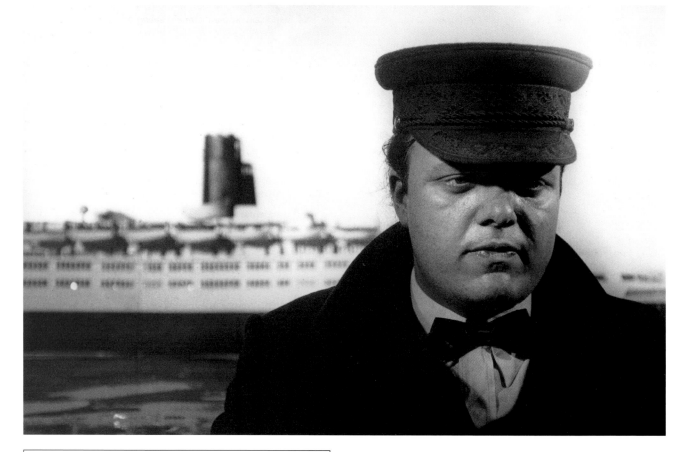

– **Kriegsjahre**, 1996

Elmar Hess – *Nikolaus von Wolff*

In "Kriegsjahre" wird ein Tabu gebrochen: Die Bilder und Töne, die Figuren und Landschaften der nationalsozialistischen Diktatur und des Krieges sind verblaßt zu Zeichen unter vielen. In einem jeder Theorie entgleitenden Zustand technologischen und kulturellen Wandels erscheinen sie ebenso verschiebbar wie die "alte Welt" der Dinge.

Während sich die Essenzen in die Räume des Online verlagern, verlieren die realen Dinge ihre kompakte Eindeutigkeit und sind nicht mehr prominente Bezugsgröße für den Zugang zur Welt. Die Zerschlagung von Proportionen und physikalischen Zwängen im virtuellen Raum verändert massiv die Wahrnehmung der Dingwelt und den Umgang mit ihr. Die Objekte werden fremd und gleichzeitig freischwebend im Raum der Bedeutungen und Funktionen. Ein Stück Sachertorte wird zum sperrigen Transportgut, verladen auf die Güterwaggons einer Modelleisenbahn, plaziert zwischen Toastbroten, erspäht aus der Kanzel eines Bomberflugzeugs und kommentiert von der schneidigen Stimme eines Nachrichtensprechers.

Gerade weil das Augenmerk auf den Dingen beharrt, bemerkt man sehr präzise den Verlust ihrer Bedeutungen: wenn sich das gemeinsame Essen und Trinken – als eines der ältesten Rituale überhaupt – loslöst von den Gegenständen, die es benötigt. Wenn die Dinge sich sperren gegen das lebendige Ritual, das mit ihnen verknüpft ist: tarnfarbene Tassen neben Thermoskannen, die zur Ölraffinerie werden und zum Kriegsziel. In "Kriegsjahre" werden Gegenstände, Figuren, Landschaften und Töne umgewertet, umgeschichtet und neu besprochen. Glanzlose Gegenstände des Alltags, wie Gabeln, Tassen und Toastbrote, fügen sich beinahe unbemerkt in die Montage historischer Kriegsaufnahmen. Salatschüsseln werden zu Ruhmeshallen, rustikale Kerzenleuchter fügen sich zur monumentalen Allee.

"Kriegsjahre" zeigt Streifzüge, Überflüge und Momentaufnahmen einer entseelten Dingwelt. Elmar Hess unternimmt dabei nicht den Versuch, die angegriffenen Objekte zu rehabilitieren, sie werden nicht auf den Sockel gehoben oder reanimiert, sie werden nicht herausgeputzt oder umgestellt. Sie werden mitgerissen im formalen Fluß tradierter Erzählweisen (Kriegsberichterstattung, Abenteuerbericht, Rückblick), wo auch die Menschen in die geistigen Quergänge seriöser Kommentarstimmen gedrückt werden. Sie sind eingebunden in die gefräßige Maschinerie eines Krieges, der im Vakuum zwischen sozialen, historischen und dinglichen Beziehungen tobt. Sie sind entweder Figuren, die sich wie groteske Zerrbilder historischer Gestalten bewegen, oder sind nur Körper, die wie eine funktionierende Mechanik in die Kriegsmaschinerie integriert sind. Die wenigen Individuen, die zu Wort kom-

Elmar Hess – *Nikolaus von Wolff* – Translated by
Toby Alleyne-Gee

In *Kriegsjahre* ("War Years"), a taboo is broken: the images and sounds, figures and landscape of the nazi dictatorship and the war fade to mere tokens. In a state of technological and cultural flux defying any theoretical definition, they seem to be as adjustable as the "old material world."

While the essence of things shifts into online space, real things lose their compact unambiguousness and are no longer important for access to the world. The destruction of proportions and physical constraints in virtual space is changing both our perception of the material world and the way we deal with enormously. Objects become alienated, and at the same time float freely in the space of meanings and functions. A slice of Sachertorte becomes a bulky load transported on the freight carriages of a model railway, placed between pieces of toast, espied from the cockpit of a bomber plane and commented on by the slick voice of a newsreader. Precisely because we concentrate on objects, their loss of meaning is especially apparent when, eating and drinking together – one of our most ancient rituals – we lose our relationship with the utensils we need to do so. Their loss of meaning is also apparent when objects balk against the living ritual they were designed for: camouflaged cups beside thermos flasks transformed into an oil refinery and a war aim.

In *War Years* the value and position of objects, figures, landscapes and sounds are altered and reexamined. Unglamorous everyday objects such as forks, cups and slices of toast are incorporated almost unnoticed into the montage of historical war photographs. Salad bowls become halls of fame, rustic candlesticks are arranged as a monumental avenue.

War Years shows expeditions, reconnaissance flights and snapshots of a lifeless material world. Elmar Hess is not attempting to rehabilitate the objects under attack. He does not put them on pedestals or reanimate them, nor does he decorate or rearrange them. They are swept along on the formal tide of handed down narrative methods (war reporting, adventure reports, retrospectives) where human beings are also squeezed into the lateral thoughts of respectable commentators. They are integrated in the greedy machinery of a war that rages in the vacuum between social, historical and material relationships. They are either figures moving like grotesque caricatures of historical figures, or they are merely bodies that are incorporated into the war machinery like a functioning mechanism. The few individuals who are permitted to express themselves do so in clichés. They have been degraded to the ruminants of pre-formed doctrines and attitudes.

War Years shows a drama of relationships in which physical human relationships have been replaced by the autonomous

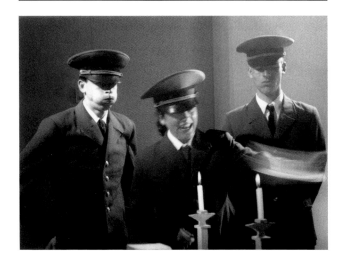

men, sprechen phrasenhaft. Sie sind zu Wiederkäuern vorgeformter Doktrinen und Berachtungsweisen degradiert.

"Kriegsjahre" zeigt ein Beziehungsdrama, in der die menschlichkörperlichen Beziehungen durch den autonomen Verlauf einer (Kriegs-)Maschinerie ersetzt werden. Wenn sich drei Darstellerinnen und der Protagonist in einer WG-Küche zur "Konferenz der Verbündeten" treffen, um anschließend zu einer Adaption des berühmten Fotos der Konferenz von Jalta zu posieren, entläßt der brachial-professionelle Ton des Kommentars die Menschen nicht eine Sekunde aus dem System. Mann und Frau mutieren zu Hitler und Churchill, bleiben aber letztlich nur marionettenhafte Ausprägung eines übergeordneten Vorgangs.

Der Krieg in "Kriegsjahre" ist von Anfang an verselbständigt, seine Protagonisten sind zu Randfiguren degradiert. Analog offenbart der Geschlechterkonflikt in dem Film eine Geschlechterbeziehung, deren Konflikte Resultat technologischer und systembedingter Zugkräfte sind. Wenn die "Diktatorin" die Ausstellung "Entartete Kunst" abschreitet, wenn sie sich im Halbdunkel auf einer Schaukel über einer monumentalen Geisterstadt bewegt, dann agiert sie nicht als Individuum, sondern wird geführt durch die Hohlformen bekannter Zeichen des Krieges und der Diktatur.

"Kriegsjahre" ist ein komplexes Geflecht aus verschobenen, teilweise nur nuancierten Zeichen, deren Mythologien tief verwurzelt sind (der Ozeanriese, der zum Straußwalzer in einem Alpensee zur Reparatur eintrifft). Die Elemente addieren sich wie eine Klangfolge zu irritierenden, dissonanten Akkorden. Madonnas "Justify my Love" erklingt dazu wie eine bittere Parodie, Churchills "our

process of a (war) machine. When three actresses and the protagonist meet in the kitchen of their shared flat for a "conference of the allies", posing afterwards in an adaptation of the famous photo of the Yalta conference, the violently professional tone of the commentary does not release them for one second from the system. Man and wife mutate into Hitler and Churchill, but remain, puppet-like, subject to a higher order.

The war in *War Years* is an independent entity from the very beginning. The protagonists are degraded to the status of minor figures. The conflict of the sexes in the film reveals an analogous relationship in which conflicts are the result of technological and system-related forces. When the "dictatress" strides through the exhibition of "degenerated art", when she moves in the semi-darkness on a swing above a monumental ghost city, she is not acting as an individual, but is being led through the hollow symbols of war and dictatorship.

War Years is a complex weave of altered, subtle indicators of deeply rooted myths (the giant of the ocean who arrives for repairs in an Alpine lake to the strains of a Strauß waltz). The elements of the film combine in a succession of sounds to create irritating, dissonant chords. Madonna's *Justify my love* sounds like a bitter parody, Churchill's "Our faith will rise again" like the helpless rebellion of all those under threat.

In Hess's work, the distressed individual assumes grotesque, tragicomic forms: the original sound of a Churchill speech is played to the beseeching gestures of the protagonist as he disappears on the horizon in a paddleboat: "We are sure that in the

faith will raise again" wie ein hilfloses Aufmucken aller Bedrohten. Das bedrängte Individuum bekommt bei Hess groteske, tragikomische Formen: Der Originalton einer Rede Churchills legt sich über die beschwörende Gestik des Protagonisten, der auf einem Tretboot am Horizont verschwindet: "We are sure that in the end all will be well".

Komplementär zu "Kriegsjahre" behandelt Elmar Hess in seinem neuen Filmentwurf "State on Wave" (Staat im Wanken) Individualität dagegen nicht als bedrohte Dimension, sondern selbst als Keim neu entstehender, unterdrückender Systemdynamik: Die Parabel "State on Wave" schildert die Biografie des Diplomatensohns Nikolaus Maron, der aus seinen jugendlichen Tagträumen ein utopisch anmutendes Gesellschaftsmodell entwirft, das den bedingungslosen Individualismus fordert. Maron versucht seine Vision zunächst als Gesellschaftskritiker, später als Parlamentsabgeordneter in die Realität umzusetzen. So wird er zum Protagonisten einer paradoxen Diktatur, die die "Selbstentfaltung" zum Dogma erklärt. Nonkonformismus wird zur totalitären Ideologie.

Das Dilemma der Durchsetzung politischer Ideale und selbstgesteckter Ziele, die dazu neigen, sich in ihrer Realisierung ad absurdum zu führen, indem sie repressiv werden, bezeichnet eine Form der "Rückkopplung" des Individuums an den Systemzwang: Obsession wird in der Konsequenz zur Repression. Elmar Hess reflektiert die Wechselwirkung individueller Welt und kollektiver Forderung, ohne ideologisch zu sein. Die Opposition gegenüber dem Realitätsprinzip bleibt in seinen Arbeiten spielerisch und stellt den Konsequenzialismus als totalitär bloß.

end all will be well." Unlike *War Years*, Elmar Hess's new film, *State on Wave*, examines individuality not as a threatened dimension, but as the germ of a newly created, suppressive system. The parable *State on Wave* describes the biography of the son of a diplomat, Nikolaus Maron, who designs a seemingly utopian model of society that demands absolute individualism. Maron initially tries to realise his daydream vision as a social critic, then as a member of parliament. He thus becomes the protagonist of a paradox dictatorship that declares "self-realisation" as its dogma. Non-conformism becomes a totalitarian ideology.

In *State on Wave*, the individual changes from unsuccessfully defending his individual sphere to successfully attacking prevailing reality. Thrown back on himself, between a fascist class society in heaven (during a dream sequence) and an ignorant, stupid culture on earth, Maron takes up the fight against the prevailing social order after his return from heaven. Abstrusely identifying himself as a ship, Maron mows down all resistance as he passes through the institutions, until he finally arrives at the empty space where his own paradox power is based. Grotesque situations such as the scene in which Maron goes to the dry dock rather than to the dentist to have his teeth treated raise the issue of the current concept of individuality, reflecting its closed character in the sealed off personality of the protagonist.

Only the pop singer Lesha offers Maron a way out of his closed world, which, precisely because it is so closed, is so eager to expand. In the course of the story, however, her success becomes a threat to his ideology: after her last triumphant concert, at which she arrives in a helicopter, Maron has her arrested. Idols are damaging to the development of the ego. The protagonist thus finally closes himself off from the world. The dilemma between implementing political ideals and personal objectives which tend to be taken ad absurdum when they are realised, as they become repressive, is a way for the individual to get his own back on a constrictive system. Obsession taken to extremes becomes repression. Elmar Hess reflects the interaction between the world of the individual and collective demands, without being ideological. In his work, opposition to the principle of reality is always playful, and unmasks extremist ideologies as totalitarian.

– State on Wave, 1998

ELMAR HESS – Saarbrücken, 1966 – Staatliche Akademie der Bildenden Künste, Stuttgart – Hochschule für Bildende Künste, Hamburg – Wohnt/lives in Hamburg

EINZELAUSSTELLUNGEN/ONE PERSON SHOWS: 1996 Kriegsjahre - Some sunny day we'll meet again, Kunstverein Hamburg **GRUPPENAUSSTELLUNGEN/GROUP SHOWS: 1999** Video und Lebensart, Kunsthalle Hamburg, Galerie der Gegenwart **1998** Passage, Kunsthaus Hamburg (Katalog/catalogue) **1997** Sehfahrt, Norddeutsches Landesmuseum, Hamburg (Katalog/catalogue) **1996** Surfing Systems, Kunstverein Kassel **1995** Diplomaten, Kampnagel/K3, Hamburg **1994** Trumpf, Kunst im öffentlichen Raum, Hamburg – Lost Paradise, Kunstraum Wien, Museumsquartier **1991** Quer fällt ein, Kunsthaus Hamburg

Elmar Hess

Joseph Zehrer

Joseph Zehrers – Ordnung des Sehens – *Astrid Wege*

Joseph Zehrer's Visual Order – *Astrid Wege* **–** Translated by Toby Alleyne-Gee

Gesetzmäßigkeiten zu erkennen und Zusammenhänge zu behaupten, ist eine Methode der Wirklichkeitsaneignung: Der Willkür der gegebenen Ordnung wird die subjektive Logik der eigenen Wahrnehmung entgegengesetzt. In diesem Spannungsfeld bewegt sich Joseph Zehrers künstlerische Arbeit. Ausgangspunkt zahlreicher seiner Arbeiten sind die verschiedenen Wahrnehmungsmuster und Ordnungssysteme unserer Kultur wie Sprache, Archiv, Museum oder Enzyklopädie.

So verspricht auch sein fünfjähriges Projekt bis zum Jahr 2000 zunächst einen Anspruch auf Systematik und enzyklopädische Vollständigkeit: Seit dem 1. Januar 1995 nimmt er nahezu täglich ein Foto auf. Beschriftet und datiert, wird es in ebenfalls datierten Videohüllen archiviert, die, nach Monaten geordnet, in einem Schuber verwahrt werden. Einzelne Momente werden aus dem

Recognising natural laws and putting them into context is a way of taking possession of reality: confronting the arbitrariness of the prevailing order with the subjective logic of one's own perception. Joseph Zehrer's work is situated between these two poles. Several of his works are based on our culture's various patterns of perception and organisational systems such as language, archives, museums or encyclopediae.

Zehrer's five-year project, which will be completed in the year 2000, appears to be systematic and encyclopedically complete. He has taken a photograph practically every day since January 1, 1995. Each photo is labelled, dated and filed in video cassette boxes, which are also dated and filed by the month in a filing cabinet. He selects individual moments, fixes and arranges them as "stills" to create a kind of film – the medium he believes depicts

– Korridor, 1997, art forum Berlin 1998, Stand Galerie Christian Nagel, Photo Simon Vogel **– Korridor**, 1997, Installation, Kunstverein Heilbronn, 1999, Photo Kunstverein Heilbronn

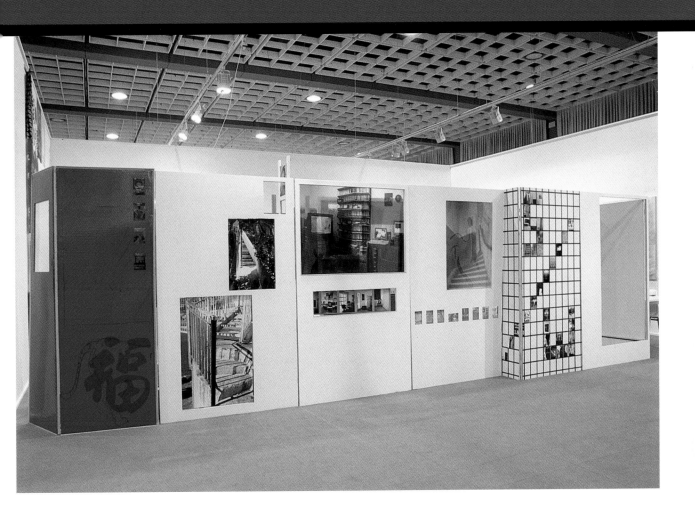

Kontinuum der Zeit herausgerissen, fixiert und als "Standbilder" zu einer Art Film aneinandergereiht – jenem Medium, das Zehrer zufolge die Welt am authentischsten abbilden könne. Ein "Film", der, so die konzeptuelle Vorgabe Zehrers, am 31. Dezember 1999, dem Ende dieses Jahrtausends, enden wird.[1]

In dieser Visualisierung und Verräumlichung zeitlicher Prozesse ebenso wie der Befolgung vorher definierter Regeln knüpft Zehrer an Vorgehensweisen der Konzeptkunst am Ende der sechziger und Anfang der siebziger Jahre an, wie etwa On Kawaras "Date Paintings". Doch im Gegensatz zu der in der Wahl der Mittel häufig reduzierten Formensprache damaliger Vorgehensweisen und ihrer Tendenz zu quasi wissenschaftlichem Positivismus, die Benjamin Buchloh 1989 in seinem bekannten Aufsatz "From the Aesthetic of Administration to Institutional Critique (some aspects

life most authentically. According to Zehrer's concept, this "film" will end on December 31, 1999, the last day of this millennium.[1]

By visualising chronological processes, investing them with a three-dimensional quality and adhering to predefined rules, Zehrer is making a reference to the procedures of conceptual art in the late Sixties and early Seventies, such as On Kawara's *Date Paintings*. Yet unlike the artists of this period, who frequently reduced their formal expression to a minimum and tended towards an almost scientifically positivist approach – as criticised by Benjamin Buchloh[2] – Zehrer works with an abundance of personal associations and references, and heterogeneous materials and forms. These include sculptural arrangements, films, photographs, drawings and watercolours. There are some fixed elements as far as content is concerned, such as the concept that all

– **Korridor**, 1997, art forum Berlin 1998, Stand Galerie Christian Nagel, Photo Simon Vogel

of conceptual art 1962–1969)" kritisierte, setzt Zehrer auf eine Fülle von persönlichen Assoziationen und Anspielungen sowie auf die Heterogenität von Materialien und Formfindungen: Diese umfassen skulpturale Arrangements ebenso wie Filme, Fotografien, Zeichnungen und Aquarelle. Zwar gibt es einige inhaltliche Fixpunkte, etwa daß im Laufe des Projektes alle fünf Kontinente oder verschiedene Körperteile des Menschen Gegenstand von Zehrers fotografischer Recherche werden. Dennoch läßt sich in der Abfolge der Themen keine durchgängige Programmatik erkennen.

Häufig überlagern sich in Zehrers Arbeiten Fremd- und Eigenperspektive; objektivierte Wahrnehmungsmuster verschränken sich mit der Sicht des Künstlers. So skizziert zum Beispiel seine Arbeit "Ein Satz roter Ohren" von 1991 eine Art Selbstporträt, vermittelt durch die Beobachtungen anderer: Zu sehen ist eine Aufnahme von Zehrers Hinterkopf, der auf eine Reihe leerer Videohüllen collagiert ist; wie Filmtitel sind diese mit Einschätzungen von Zehrer durch Freunde und Bekannte beschriftet – konkrete

five continents or various parts of the human body are to be included in Zehrer's photographic research. Yet there is no recognisably consistent order in the thematic sequence.

External and personal perspectives are often layered in Zehrer's work; objective perceptive patterns are combined with the artist's subjective view. The 1991 picture, *Ein Satz roter Ohren* ("A Pair of Red Ears"), for example, is a kind of self-portrait, seen through the eyes of others. It consists of a photo of the back of Zehrer's head mounted as a collage on a row of empty video boxes. These are labelled with comments on the artist written by his friends and acquaintances. Specific statements serve as inspiration for a film in the viewer's imagination. Similarly, *Brockhaus, den 27. September 1994* ("Brockhaus, September 27, 1994") combines different areas of reference: information produced for daily consumption and rapidly circulated in newspapers and cultural knowledge collected and ordered in encyclopediae. Zehrer used the 1994 new edition of the *Brockhaus*, the epitome of the bourgeois encyclo-

– **April 1998: Pistolen**, Ausstellung zum Steirischen Herbst/Exhibition for Steirischer Herbst, Graz, 1998, Galerie Bleich-Rossi, Graz, Farbphotografien/Colour photographs, 90 x 60 cm

Aussagen werden zum Auslöser für einen "Film" in der Vorstellung der Betrachter. In ähnlicher Weise verbindet "Brockhaus, den 27. September 1994" unterschiedliche Bezugsfelder: die für den alltäglichen Gebrauch produzierten und schnell zirkulierenden Informationen in Tageszeitungen und das in Enzyklopädien angehäufte und geordnete kulturelle Wissen. Der 1994 wieder neuaufgelegte Brockhaus als Inbegriff einer bürgerlichen Enzyklopädie diente Zehrer als Matrix für seine Arbeit. Das Breitenmaß der 24 Bände gab den formalen Rahmen für insgesamt 40 Videohüllen vor. Die Seiten des Lexikons, an denen jeweils eine Videohülle endete, ließ Zehrer auf deren Cover drucken; die auf den Brockhausseiten versammelten Stichworte wiederum lieferten ihm die Themen für 40 "Filme", deren Titel und "Standbilder" er schließlich 40 internationalen Tageszeitungen vom 27. September 1994 entnahm. Unterschiedliche Maßeinheiten werden hier übereinandergeblendet, die scheinbare Rationalität von Quantifizierung

pedia, as a point of reference for his work. The width of all twenty-four volumes served as a formal framework for a total of forty video boxes. Zehrer printed those pages of the encyclopedia immediately adjacent to a video box onto the covers of the respective boxes. The references on those pages served as the topics of forty "films" whose titles and "stills" he took from forty international daily newspapers. Different units of measurement are projected over each other and the apparent rationalism of quantifications is ironically exaggerated. Zehrer thus introduces a factor of arbitrariness into these systems, making them accessible for personal interpretation.

Zehrer's film programmes, which are an important part of his artistic approach, the subjective view and the preferences of the artist are always present. Frequently, coincidences and details lead to his choice of theme, such as "basic geometric forms". With occasionally eccentric humour, Zehrer shows us that reality

– Nichtsnutze und Brechtleser, 1998, Holzbox/Wooden box, 23 x 86,5 x 11,5 cm,
31 Videohüllen/31 Video wrappings, ca. 31 Photos, 13 x 9 cm, 2 Zeichnungen/2 drawings
je/each 102 x 73 cm, Filzstift, Leinöl, Weidenstöcke/Felt-tip pen, linseed oil, wicker
Ausstellung zu/Exhibition parallel to Steirischer Herbst, Graz, 1998, in der Galerie
Bleich-Rossi, Graz

ironisch überspitzt. Dadurch führt Zehrer ein Moment der Willkür
in diese (Bedeutungs-)Systeme ein und öffnet sie für persönliche
Sicht- und Leseweisen.

Auch bei Zehrers Filmprogrammen, die einen wichtigen Aspekt
seiner künstlerischen Vorgehensweise darstellen, sind der subjek-
tive Blick und die Vorlieben des Künstlers immer präsent. Oft sind
es Zufälle und Details, die zu der Wahl des Themas – wie etwa
"geometrische Grundformen" – führen. Mit bisweilen skurrilem
Humor zeigt Zehrer uns, daß die Realität letztlich nicht systema-
tisch zu erfassen ist und alle Versuche in diese Richtung mißlin-
gen müssen: Die Inszenierung eines konstitutiven "Scheiterns",
die das immer auch komische Moment umfassender Weltsichten
vorführt und unseren Blick als einen immer schon vermittelten.

– **1** Bisher waren verschiedene Teilaspekte dieses Projekts zu sehen: im Frühjahr 1996
bei Christian Nagel in Köln unter dem Titel "Kalender", im Herbst des gleichen Jahres
unter der Überschrift "Januar im Herbst" im Künstlerhaus Stuttgart und unter dem Titel
"Vorhänge – Eingeklemmtes – Nichtsnutze – Pistolen" im Frühjahr 1998 bei Bleich-
Rossi in Graz.

cannot be recorded systematically and that any attempt to do so
must fail. It is the staging of a "failure", revealing the comical side
of philosophies that see themselves as comprehensive, and point-
ing to the fact that our way of looking at things is, and always has
been, influenced by our social environment.

– **1** Various parts of this project have already been exhibited: as *Kalender* ("Calendar")
at Christian Nagel in Cologne, spring 1996; as *Januar im Herbst* ("January in the
autumn") at the Künstlerhaus Stuttgart, autumn 1996; and as *Vorhänge –
Eingeklemmtes – Nichtsnutze – Pistolen* ("Curtains – Sandwich –
Good-for-nothings – Pistols") in the spring of 1998 at Bleich-Rossi in Graz.

– **2** In his well-known essay, *From the Aesthetic of Administration to Institutional
Critique (some aspects of conceptual art, 1962–1969).*

JOSEPH ZEHRER – Perbing, 1954 – Akademie der Bildenden Künste, München – Wohnt/lives in Köln

Photo B. Freund

EINZELAUSSTELLUNGEN/ONE PERSON SHOWS: 1998 Vorhänge - Eingeklemmtes – Nichtsnutzer & Brechtleser - Pistolen, Galerie Bleich-Rossi, Graz **1996** Wer am Weg spart, muß an Kraft zulegen, Galerie Daniel Buchholz (mit/with Isa Genzken), Köln – Januar im Herbst, Künstlerhaus Stuttgart (Katalog/catalogue) – Kalender, Galerie Christian Nagel, Köln **1994** Galerie Christian Gögger (mit/with Martin Gostner), München **1993** Art Chicago/The New Pier Show, Stand Galerie Christian Nagel – Galerie Christian Nagel, Köln – Forum Stadtpark (mit/with Wilfried Petzi), Prag **1992** K-Raum Daxer, München (Katalog/catalogue) – Fettstraße 7a, Birgit Küng, Zürich **1991** Jack Hanley/Trans Avant-Garde Gallery (mit/with Michael Krebber, Hans-Jörg Mayer), San Francisco, Galerie & Edition Atelier, Graz**1990** Galerie Bleich-Rossi, Graz (Katalog/catalogue) – Galerie Christian Nagel, Köln (Katalog/catalogue) – Birgit Küng, Zürich **1989** Galerie Wernicke, Stuttgart **GRUPPENAUSSTELLUNGEN/GROUP SHOWS: 1999** Schedhalle Zürich – archives laboratoire, Kunstverein Heilbronn **1998** liquid beauty, Halle für Kunst, Lüneburg – art forum berlin, Stand Galerie Christian Nagel, Köln, art sculpture, Basel, Stand Galerie Christian Nagel, Köln **1997** Symposion, ICEBOX/Venetia Kapernekas, Athen – HOME SWEET HOME, Interieurs-Einrichtungen-Möbel, Deichtorhallen Hamburg (Katalog/catalogue) – La signature des artistes, Nice Fine Arts (mit/with Uwe Gabriel und and Vincent Tavenne), Nizza – Zeichnungen I, Galerie Der Spiegel, Köln **1996** DADAMÜNCHEN?, Mosel & Tschechow, Galerie und Verlag KG, München – Der Umbau Raum, Künstlerhaus Stuttgart – Etwas besseres als den Tod findest du überall, Ladengeschäft Junghofstraße, Frankfurt am Main – Übertragung. Vier Abende für ein anderes Fernsehen, Kunstraum München e.V. (mit/with Hans-Christian Dany und/and Stephan Dillemuth, UTV), München **1995** Editionen, Multiples, Videos, Galerie Christian Nagel, Köln – filmcuts, neugerriemschneider, Berlin – Aufforderung in schönster Weise, Galerie Christian Nagel, Köln – oh! Reserve-Lager-Storage, Brüssel – Icons, Ladengalerie Lothringer Str. 13 (kuratiert von/curated by Christian Nagel), (Parallelprogramm der Ausstellung/parallel to the exhibition Kräftemessen, München), München – East International, Norwich Gallery, Norfolk – Nzet Projekt, Gent **1994** on line, Stand Galerie Christian Nagel, Gent – The Media & Art Exhibition, Magic Media Company, Köln-Hürth – AusZeit oder Moment Mal, eine Ausstellung zum Thema Zeit, interimsgalerie 2, Galerie der Künstler, München **1993** Grafica 1, Innsbruck – Die Arena des Privaten, Kunstverein München **1992** Unfair - Die richtige Kunstmesse, Stand Galerie Christian Nagel (mit/with Dillemuth, Krebber, Mayer, Schaufler), Köln – Wohnzimmer/Büro, Galerie Christian Nagel, Köln – eine soziale Plastik, Institut für Kunstgeschichte, Universität Innsbruck (mit/with Hans-Jörg Mayer) **1991** 36e Salon de Montrouge, Paris – Gullivers Reisen, Galerie Sophia Ungers, Köln **1990** Galerie Christian Nagel, Köln – Galerie Bleich-Rossi, Graz **1990** Birgit Küng, Zürich – Armaly, Bonin, Krebber, Müller, Zehrer, Galerie Wernicke, Stuttgart – The Köln Show, Köln **1989** Schaufler, Weißleder, Zehrer, Galerie Bleich-Rossi, Graz **1988** Graphic's, Galerie Mosel & Tschechnow, München – Skulpturenprojekt Dürr, Galerie Christoph Dürr, München **VIDEOFILMVORFÜHRUNGEN: 1999** Asta di Aste, Link, Bologna **1996** Geometrie im Film, Künstlerhaus Stuttgart **1995** Räusche, Künstlerhaus Stuttgart **1991 – 1994** Thematische Videoabende bei B.O.A. (zusammen mit/with Karl Bruckmeier) in München **VIDEOFILMVORFÜHRUNGEN/VIDEO PRESENTATION: 1999** Asta di Aste, Link, Bologna, **1996** Geometrie im Film, Künstlerhaus Stuttgart, **1995** Räusche, Künstlerhaus Stuttgart, **1991 – 1994** Thematische Videoabende bei B.O.A. (zusammen mit/with Karl Bruckmeier), München

Joseph Zehrer

Stefan Exler

– **Ohne Titel**, 1994, laser exposed silver dye bleach print, Diasec,
150 x 125 (100 x 100) cm, Privatbesitz/Private collection, Frankfurt © VG Bild-Kunst,
Bonn 1999

Wie Zeit aussieht – *Kerstin Kartscher*

What Time Looks Like – *Kerstin Kartscher* – Translated by Toby Alleyne-Gee

Der Blick aus dem Helikopter, er steht schwirrend in der Luft. An einem Drahtseil lassen wir uns herab, wir haben etwas gesehen, wir kommen näher… Es wird immer schärfer, wir können die Stadtkarte lesen. Die liegt auf dem verrutschten Couchtisch vor dem Sofa. Da sind junge Leute und haben ihre Sachen mitgebracht. Sie dürfen da übernachten in ihren Karotten-Schlafsäcken auf dem Boden. Die Dinge liegen so, als hätten die kleinen Ausreißer ungeniert in die Nacht hineingeblödelt. Die Gastgeber sind vermutlich nicht da oder machen keine Vorschriften. In der Ecke steht ein kleiner Traktor. Auf jeden Fall wohnt hier ein kleines Kind. Eine neugegründete Kleinfamilie. Das Liebesnest ist schnell zusammengebastelt, noch etwas planlos. Oder könnte es nicht sein, daß hier die große Schwester von einem der zwei jungen Mädchen als Alleinerziehende wohnt? Vielleicht ist sie Sportlehrerin. Da krümmt sich ein Streifenhandtuch gegen die karierte Richtung auf dem Schlafsack. Der junge Bursche hat vermutlich keinen familiären Bezug. Er liegt eingeschüchtert im sicheren Eck in Besucherschlafstellung. Aber vielleicht ist es die erste Nacht, die er mit Mädchen in einem Raum verbringt. Und gibt es noch eine vierte Person, die nicht auf dem Bild ist? Laß uns die Anzahl der Rucksäcke und Schuhe zählen. Wir wollen auch unter dem Tisch nachschauen. Der Hubschrauber reagiert nicht auf unser Zeichen, so baumeln wir weiter und schauen uns um.

Die Räume auf den Fotos haben keine Fenster, keine Wände und keine Türen. Wir denken, wir sehen einen abgeschlossenen Raum, aber eigentlich sind gar keine Wände da. Und vielleicht sind wir ja auf einer Insel über einem Geschehen auf einem Flecken-Teppich irgendwo, etwa auf einem 1000-qm-Gelände, im Parkhaus 2. Stock, rechts rum. Ups. Und wo sind eigentlich die Schatten? Der Raum ist sehr hell, und die Dinge leuchten in ihren Farben. Jeder kleine Fleck, jedes Detail, die ganze gezeigte Situation gibt Hinweise in Form von Kürzeln, an welches andere Teil es gerne angepuzzelt werden möchte. Sie geben feinsinnig und bescheiden Signale, welche Vorlieben und Beziehungen sie am liebsten pflegen (und worin sie sich verfangen haben). Die Zusammenhänge sind vielzählig kombinierbar. Verschieden bunte Ketten ausdenken, Stoff für eine Million Romane. Die Bilder sind weise Chamäleons. Und dann gibt es Beziehungen. Komplexes drunter und drüber. Welche Beziehung mag dieser Gegenstand zur Person im Raum haben, und wie steht die Person zur anderen Person? Das Spinnennetz, die Fäden der Beziehungen und des Sozialen legen sich wie eine Straßenkarte vor unsere Netzhaut. Das Auge wird sachte herumgeschubst, auf Schnellstraßen und auf so manch holperigem Weg. Und dann sehen wir, daß es ein

The view from the helicopter as it hovers, buzzing, in mid-air. We climb down the cable, see something, and move closer… We see things increasingly clearly, and can read the map of the city lying on the coffee table in front of the sofa. We see young people who have brought their things with them. They are allowed to stay overnight in their carrot-shaped sleeping bags on the floor. Things are lying around as if the little runaways have uninhibitedly fooled around all night. The hosts presumably aren't here or haven't made any rules for their guests. A little tractor stands in the corner. A small child certainly lives here.
A newly established nuclear family. The love nest has hastily been thrown together, and still seems rather unsystematic. Or could it be that the elder sister of the two young girls is living here as head of the single-parent family? Perhaps she's a sports teacher. A striped towel lies in a curve against the checked pattern on the sleeping bag. The young boy probably has no relationship to the family. Intimidated, he lies in a secure corner, the position of his body betraying his status as a visitor. But perhaps it's the first night he's spent in the same room with girls. And is there a fourth person who isn't in the picture? Let's count the number of rucksacks and shoes. Let's look under the table, too. The helicopter doesn't react to our signals, so we carry on dangling and take a look around.

The rooms in the photographs have neither windows, walls nor doors. We think we are seeing a closed space, but in fact there are no walls. And perhaps we're on an island, hovering above a spot of action on a patch of carpet somewhere – on a site of 1,000 square metres, on the right hand side of floor two in the multi-storey car park, for example. Oops. And where are the shadows? The room is very light and the objects glow with colour. Every little stain, every detail, the entire situation shown makes hints in the form of abbreviations that look as if they would like to be joined together in a puzzle. They transmit subtle, modest signals as to which preferences they have and which relationships they like to cultivate most (and those in which they have become entangled). The interrelationships can be combined in several different ways. Think of different coloured chains, the stuff of a million novels. Pictures are wise chameleons. And then there are relationships. A complex confusion. What kind of relationship does this object have to the person in the room, and how does this person get on with the other? The spider's web, the threads of relationships and society spread out like the streets on a map before our retina. The eye is gently pushed around, along motorways and several bumpy paths. And then we see that there is a

– **Ohne Titel**, 1995, laser exposed silver dye bleach print, Diasec,
150 x 125 (100 x 100) cm, Privatbesitz/Private collection, Frankfurt, © VG Bild-Kunst,
Bonn 1999

Vorher gibt, und daß es vorher ganz anders war, und noch mal eins davor auch. Wir sehen, wie Zeit aussieht. Jetzt schwirren wir schon eine Weile über diesem Bild, wir wohnen beinahe darin. Es ist aufregend, einen Raum betreten zu können und selbst unsicht-

"before", and that things used to quite different, and were even more so before that time. We see what time looks like. Now we have been buzzing over this picture, we almost live in it. It's exciting to be able to enter a room while remaining invisible. Without

bar zu bleiben. Wir können alles unbemerkt und unverhohlen anstarren, ohne daß uns Augen zurückanschauen, uns dabei beobachten, wie wir das so machen. Niemand vermutet uns hier. Der Helikopter ist sehr leise, nur die Atemzüge sind zu hören.

being noticed, we can stare openly at everything, without any eyes looking back at us, without any eyes observing what we're doing. Nobody suspects we're here. The helicopter is very quiet. Only our breathing is audible.

– **Ohne Titel**, 1994, Laser exposed silver dye bleach print, Diasec,
150 x 125 (100 x 100) cm, Privatbesitz/Private collection, Frankfurt, © VG Bild-Kunst,
Bonn 1999

STEFAN EXLER – 1968, Gießen – Hochschule für Bildende Künste, Hamburg – Wohnt/lives in Hamburg

Photo Volker Hobl

GRUPPENAUSSTELLUNGEN/GROUP SHOWS: 1998 de très courts espaces de temps, Centre national de la photographie, Paris (Katalog/catalogue) – Dinge und Gesichter – Zeitgenössische Fotografie, NGBK, Berlin (Katalog/catalogue) – domestique – zu Hause, attitudes, Genf – fire 1000, Schillerstraße 32, Berlin **1997** automobiles, Tokio Sportschule, Hamburg – Szenenwechsel XII, Museum für Moderne Kunst, Frankfurt am Main **1996** Views from abroad 2, Whitney Museum, New York (Katalog/catalogue) **1995** Bildmaterial Generationenvertrag II, Oberwelt e.V. Stuttgart **1994** Dank – sei dabei, Kunstverein München und Westwerk Hamburg – Bildmaterial Generationenvertrag I, Weltbekannt e.V. Hamburg

Stefan Exler

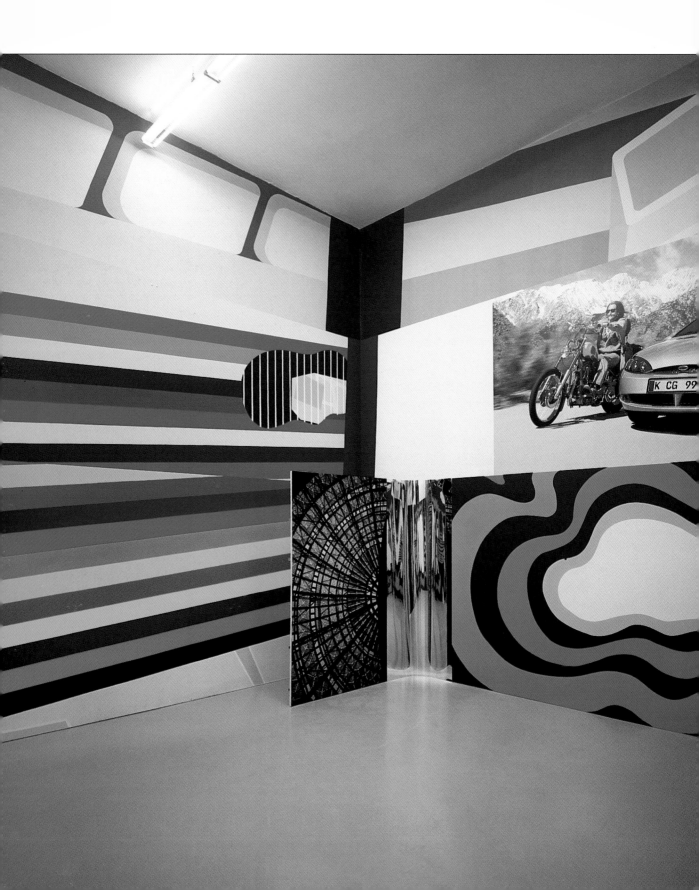

Kartographie als negative Utopie? – *Raimar Stange*

Berlin am Ende der neunziger Jahre: Wir kommen vom "Potsdamer Platz". Zurück lassen wir einen prägnanten Ausdruck unserer spätkapitalistischen Gesellschaft: kalt, rücksichtslos, zersplittert, scheinbar geschichtslos, protzig. Kaum um einen Lebensraum handelt es sich hier, wenn es hoch kommt um einen Arbeitsplatz – vor allem aber um ein glänzendes Display potenter Global Player, einem Display für stolze Konsumenten, irritierte Touristen und prestigebewußte Haupstadtgewinnler. Daß Straßenmusikanten am "Potsdamer Platz" keinen Spielort mehr finden, das ist nur eine der harmloseren Konsequenzen dieser perfiden, aber längst typischen Konstellation.

Um eben solche Konstanten der Ortsbesetzung im ausgehenden Jahrtausend dreht sich die künstlerische Arbeit des Wahlberliners Franz Ackermann: die Dialektik von An- und Abwesenheit, der Prozeß der Aneignung von Realität durch (Kapital-)Bewegung, schließlich die Dekonstruktion von Welt durch Geschwindigkeit und Gewalt, Simulation und Tourismus wird in seinen Malereien und Zeichnungen, Rauminstallationen und Diashows so aggressiv wie analytisch verhandelt. Dabei legt der Künstler den Schwerpunkt eindeutig auf die destruktiven Potentiale dieser Entwicklung, aber auch ein utopischer Rest, der durch die Befreiung aus der Zwangsjacke Zeit und Raum begründet ist, feiert in seinem Werk im Delirium von greller Farbe und vibrierenden Flächen ausgelassene Feste. Wie in seinen kleinformatigen Farbzeichnungen, den "mental maps", mixt Franz Ackermann auch in seinen meist großflächigen Malereien, den sogenannten "Evasionen", verschiedene Stile, Motive und Erzählebenen zu einer furiosen Kartographie. Zu einer Kartographie, die, wie Christine Buci-Glucksmann über den kartographischen Blick notiert hat, "mit einem Schlag einen abstrakt-konkreten Raum definiert und ein ständiges Oszillieren zwischen ästhetischer Betrachtung und politischem Eingriff" vorführt, "… denn es genügt eine Karte, um die Welt zu überwachen und zu kontrollieren, um alles auf jede Weise zu sehen". Abstrakte, farbig-aggressive Farbflächen wechseln sich in Ackermanns Bildern ab mit floral-psychedelischen Mustern, architektonische Konstruktionen mit beinahe realistischen Ansichten, oftmals dynamisieren stilisierte "Stadtpläne" das Geschehen. Immer wieder verändert sich die perspektivische Ausrichtung des Bildraumes, immer wieder prallen unterschiedliche Darstellungsmodi aufeinander. Subjektive Sehweisen und vermeintlich objektve Momente durchdringen sich so im ästhetischen Prozeß, (individuelle) Erfahrung wehrt sich erfolgreich gegen die Ideologie der scheinbar rationalen, "wissenschaftlichen" Ortsvermessung und -beherrschung. Eine Kolonialisierung der Welt durch Kartographie hat

Cartography as a Negative Utopia? – *Raimar Stange* –
Translated by Toby Alleyne-Gee

Berlin at the end of the Nineties: we have just come from Potsdamer Platz, leaving behind us a succinct expression of our postcapitalist society: cold, inconsiderate, fragmented, apparently without history, flashy. This is not really a place to live, a workplace at the most, but above all a showy display of powerful global players, a display for proud consumers, hot and bothered tourists and yuppy metropolitan profit-makers. The fact that there is no place for buskers on Potsdamer Platz is one of the more harmless consequences of this unjust, yet typical situation.

The work of Franz Ackermann, who has chosen Berlin as his home, examines precisely such problems of distribution of space at the end of the millennium: the dialectic of presence and absence, the process of taking possession of reality through movement (of capital), the deconstruction of the world through speed and violence, simulation and tourism. All these themes are aggressively and analytically examined in his paintings and drawings, installations and slide shows. The artist unambiguously emphasises the destructive potential of these developments, but he still celebrates a certain utopian attitude, liberated from the strait-jacket of time and space, in a delirium of garish colour and vibrant brush strokes. As in his "mental maps", small-format colour drawings, Franz Ackermann mixes various styles, subjects and narrative levels in his paintings, which are mostly large-format. These "evasions" are wild cartographic exercises that, as Christine Buci-Glucksmann puts it, "define an abstract-concrete space in one blow, oscillating between aesthetic observation and political intervention […]; for a map suffices to keep the world under surveillance and control it, to see everything in every way." Ackermann's paintings combine abstract, aggressive colour with psychedelic floral patterns, architectural constructions with almost realistic views, and stylised "city maps" frequently add a dynamic note. The perspective of the picture changes constantly, differing modes of representation clash over and over again. Thus the subjective and the objective are mixed in the aesthetic process – individual experience successfully defends itself against the ideology of apparently rational, "scientific" cartography – and the domination it implies. Here, cartography has no chance of colonising the world.

Franz Ackermann samples a variety of media in his installations, such as *Untitled, One Time Only* (1999) created for the *Dream City* exhibition in Munich: three walls of differing height are arranged like an amphitheatre, creating a limited space within a space. To reach the amphitheatre, the viewer must pass along a narrow corridor around the installation. He passes shelves filled with innumerable tourist brochures. Once he has reached the inner space, he sees wall paintings, confronted with large-format

– **Haus der Sehenswürdigkeiten**, 1999, Installation view, Dream City, Kunstverein München, Courtesy neugerriemschneider, Berlin

– Installation view, 1998/99, Sammlung/Collection Volkmann, Berlin – **b2 (barbecue with the duke)**, 1999, Öl auf Leinwand/Oil on canvas, 240 x 400 cm, Courtesy neugerriemschneider, Berlin

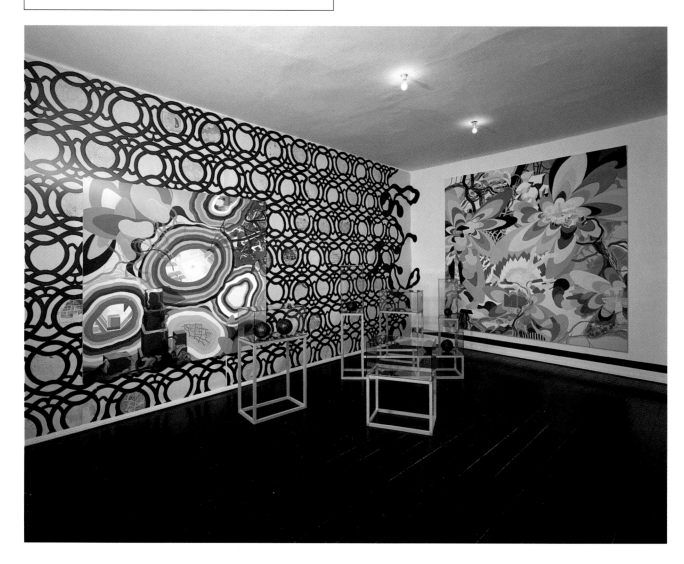

hier keine Chance. Unterschiedlichste Medien sampelt Franz Ackermann in seinen Rauminstallationen z.B. in seiner Arbeit "Untitled, One Time Only" (1999), die er für das Münchener Ausstellungsprojekt "Dream City" realisiert hat: Einem Amphitheater gleich, steigen da in drei Etagen Wände nach oben auf, die im Ausstellungsraum einen neuen, eingegrenzten Raum bilden. Um diesen zu erreichen, muß man einen schmalen Gang rund um die Installation abgehen. Dabei kommt der Betrachter an Regalen vorbei, in denen unzählige Tourismusprospekte lagern. Hat man den Innenraum erreicht, weitet sich der Blick hin auf Wandmalereien des Künstlers, die er mit großformatigen Fotos konfrontiert. Abstrakte Formen der Malerei, kreisförmige Farbringe etwa, korrespondieren mit ähnlichen Strukturen auf den Fotos, die moder-

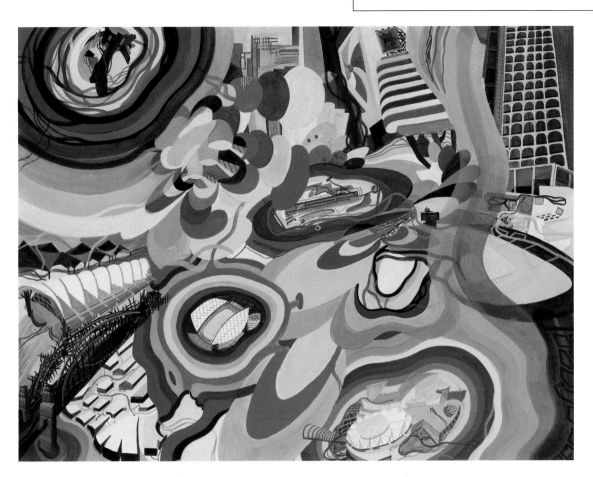

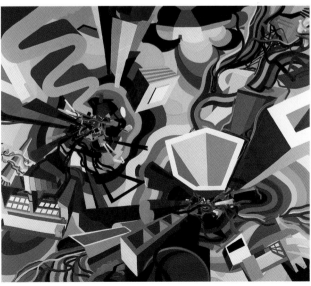

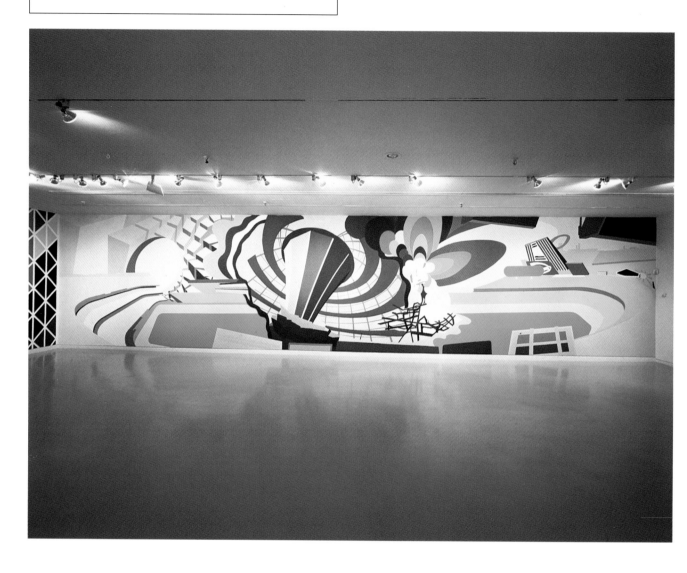

– **Untitled (call yourself city)**, 1999, Acrylfarbe auf Wand/Acrylic on wall,
330 x 1520 cm, ICA Boston "Frieze", Courtesy neugerriemschneider, Berlin

nistische Architektur zeigen. Aber auch Motive aus der Werbung, etwa ein für eine Autowerbung genutztes Bildzitat aus dem Film "Easy Rider" oder ein trampendes Fotomodell finden sich in der von Ackermann inszenierten Bilderflut. Die Zerstörung des realen Raumes durch seine mediale Simulation – die die Installation selbst ganz konkret vorführt – steht in dieser Arbeit ebenso zur Disposition, wie der "Abbau von Welt" (Paul Virilio) durch Tourismus und Globalisierung.

photographs. Abstract forms such as coloured rings correspond with similar shapes in the photographs, which show modernist architecture. The flood of images also includes motifs from the world of advertising, such as a car commercial quoting the film *Easy Rider*, or the picture of a model hiking. This work not only examines the idea of destroying real space by simulating it – as the installation itself amply demonstrates – but also of "dismantling the world" (Paul Virilio) through tourism and globalisation.

FRANZ ACKERMANN – Neumarkt St. Veit, 1963 – Akademie der Bildenden Künste, München – Hochschule für Bildende Künste, Hamburg – Wohnt/lives in Berlin

Photo J. Becker

EINZELAUSSTELLUNGEN/ONE PERSON SHOWS: 1999 works on paper, Los Angeles – OFF, Kasseler Kunstverein (Katalog/catalogue) – Trawler, Mai 36, Zürich **1998** neugerriemschneider, Berlin – Das Haus am Strand und wie man dorthin kommt, Meyer Riegger Galerie, Karlsruhe – Pacific, White Cube, London – Songline, Neuer Aachener Kunstverein **1997** unexpected, Gavin Brown's enterprise, New York – unerwartet, Kunstpreis der Stadt Nordhorn (Katalog/catalogue) – Mai 36 Galerie, Zürich – Portikus, Frankfurt am Main (Katalog/catalogue) – Gió Marconi, Mailand **1996** Das weiche Zimmer, (kuratiert von/curated by Florian Waldvogel), Hann. Münden – neugerriemschneider, Berlin **1995** Thomas Solomon's Garage, Los Angeles – Gavin Brown's enterprise, New York **1994** Ackermanns Wörterbuch der Tätigkeiten, Buchpublikation/publication – Dialo(o)g, Belgisches Haus, Köln (Katalog/catalogue) – condominium, neugerriemschneider, Berlin **1991** Art Acker, Berlin **1990** Galerie Fischer, Hamburg **1989** Galerie Komat, Braunschweig **GRUPPENAUSSTELLUNGEN/GROUP SHOWS: 1999** mirror's edge, BildMuseet Umeå – Carnegie International 1999/2000, Carnegie Museum of Art, Pittsburgh (Katalog/catalogue) – Drawn from Artists' Collections, The Drawing Center, New York (Katalog/catalogue) – amAzonas Künstlerbücher, Villa Minimo, Hannover – zoom, Sammlung Landesbank Baden-Württemberg, Stuttgart – go away: artists and travel, Royal College of Art, London (Katalog/catalogue) – Dream City, Kunstverein München (Katalog/catalogue) – Otto & Otto, Kopenhagen – <Anderswo 1>, Kunstraum, Kreuzlingen – Frieze, ICA Boston (Katalog/catalogue) **1998** Franz Ackermann und Jonathan Meese, Sammlung Volkmann, Berlin – Ferien, Utopie, Alltag, Künstlerwerkstatt Lothringer Straße, München – Osygus, Produzentengalerie, Hamburg – Deep Thougt. Part II, Basilico Fine Arts, New York – Painting: Now and Forever. Part I, Pat Hearn Gallery & Matthew Marks Gallery, New York – Hanging, Galeria Camargo Vilaça, São Paolo, Paco Imperial, Rio de Janeiro, Museum of Modern Art, Recife, Brasilien (Katalog/catalogue) – sehen sehen, loop-raum für aktuelle kunst, Berlin – Atlas Mapping, Kunsthaus Bregenz (Katalog/catalogue) **1997** Urban Living, Galerie Fons Welters, Amsterdam – Kunst…Arbeit, Südwest LB, Stuttgart (Katalog/catalogue) – Heaven, P.S.1, New York – Kunstpreis der Böttgerstraße in Bremen, Bonner Kunstverein (Katalog/catalogue) – Time Out, Kunsthalle Nürnberg (Katalog/catalogue) – Atlas Mapping, Offenes Kulturhaus Linz (Katalog/catalogue)

Franz Ackermann

Stefan Kern

– **Mein Nachbar ist Künstler**, 1997, Holz, Lack, Glas/Wood, enamel, glass, Ø 44,6 cm

Der kathartische Purismus von Stefan Kerns Skulpturen –
Jan Winkelmann

Stefan Kern ist ein Wahnsinniger. Er steht samstags um vier Uhr früh auf, an Sonntagen schläft er aus und wird erst um halb sieben wach. Womöglich ist es eine Art innere Unruhe oder besser gesagt eine entfesselte Energie, die ihm den oft so gepriesenen gesunden "Langschlaf" verwehrt. Jedenfalls lernt man selten Künstler kennen, die in ähnlicher Weise kompromißlos und unerbittlich mit sich und den eigenen Ressourcen umgehen, wie es bei Stefan Kern zu erleben ist. Ich bin weit davon entfernt, ein romantisierendes Klischee vom Künstler als einem Rastlosen, weil vom ungezügelten Schaffensdrang Getriebenen, zu konstruieren. Vielmehr erwähne ich es, weil sich damit symptomatisch eine Haltung vermittelt, die sich auch in den Werken von Stefan Kern artikuliert und die mit kathartischem Purismus vielleicht am sinnfälligsten umschrieben werden kann.

Kerns Skulpturen sind schön, erhaben und vor allem unbequem. Die exakte Verarbeitung der auf ein Minimum ihrer Funktionen reduzierten Form unterstreichen das Statische ihrer dezidiert skulpturalen Erscheinung. In ihrer einheitlichen neutralen Farbigkeit, die den Charakter der industriellen Fertigung zusätzlich unterstreicht, löst sich jedoch die geschlossene, in sich ruhende Form zugunsten einer Öffnung und Entgrenzung in Richtung des sie umgebenden Raumes. Selten entstehen seine Arbeiten als autonome Einheiten, und obwohl man ihnen ihren Ortsbezug oftmals nicht unmittelbar ansieht, liegen der spezifischen Form präzise analytisch-formale wie inhaltliche Bezüge zum Ort, für den sie entstehen, zugrunde. Diese verorteten Qualitäten bedingen die Skulptur zwar einerseits, sind jedoch gleichzeitig keine werkimmanenten Bestandteile, die eine Präsentation in einem anderen Kontext unmöglich machen würden.

Der die visuelle Erscheinung wie die materielle Präsenz der Werke prägende Purismus ist den formalen Errungenschaften der Minimal Art ebenso entlehnt, wie das Bewußtsein um die Wahrnehmung und Rezeption eines Werkes von der wechselseitigen Beziehung zwischen Betrachter und Kunstwerk, zwischen Objekt und Subjekt bestimmt sind. Die von den Minimal-Künstlern erstmals reflektierte Abhängigkeit der Wahrnehmung eines Kunstwerkes über dessen formale Eigenschaften hinaus (Raum, Licht und die Perspektive des Betrachters u.a.) wird in Kerns Skulpturen in Richtung performativer Eigenschaften erweitert. Neben diesen und ihren skulpturalen sind ihnen aber vor allem funktionale Qualitäten zu eigen, da sie auf eine konkrete körperliche Erfahrung hin – durch den Betrachter und mit ihm – konzipiert sind, gleichwohl sich ihre Funktionalität einer schmeichelhaften Bequemlichkeit widersetzt. Die sich ergebende Ambivalenz von autonomer Skulptur einerseits und der auf eine Benutzbarkeit ausge-

Stefan Kern – Sculpture as Catharsis – *Jan Winkelmann –*
Translated by Toby Alleyne-Gee

Stefan Kern is a maniac. On Saturdays he gets up at four in the morning, on Sundays he sleeps in until half past six. It could be an inner restlessness – or unbridled energy – that denies him the supposedly so healthy eight hours' sleep. In any case, few artists are as uncompromising and ruthless with themselves and their own resources as Stefan Kern. Far from constructing a romanticised cliché of the artist as a restless being driven by boundless creativity, I only mention this because it reveals an attitude – also evident in Kern's work – best described as cathartic purism.

Kern's sculptures are beautiful, noble and above all disturbing. The precisely finished forms, reduced to a functional minimum, emphasise the static quality of their decidedly sculptural appearance. However, harmonious shapes and monochrome, neutral colours underline their industrial character, blurring their contours and making them part of the environment in which they are situated. Kern's sculptures are rarely conceived as autonomous units, and although their relationship to a location is not always immediately obvious, their precise forms are based on a formal analysis of the place for which they are created. This relationship to a specific location naturally influences the sculpture, but is not so much an integral part of the work that it could not be exhibited in another context.

The purism characterising both the visual appearance and the material presence of Kern's work owes as much to the formal achievements of the Minimal Art movement as it does to an awareness of the way art works are perceived as an interconnected relationship between viewer and work of art, object and subject. In Kern's sculptures, the minimal artists' idea that a work of art is perceived not only for its formal characteristics, but also in the context of the space in which it is exhibited, the way it is lit and the perspective of the viewer, is extended to include a performative dimension. Apart from these performative and sculptural characteristics, Kern's works also have functional qualities, as

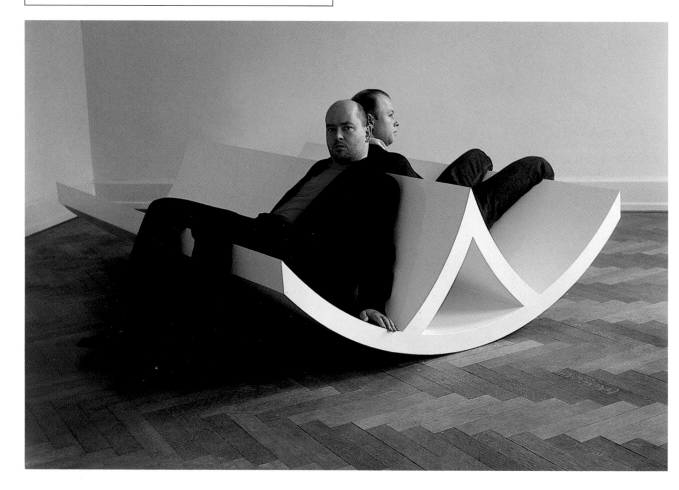

richteten Funktion andererseits läßt den Betrachter sich nicht nur seiner physischen Präsenz bewußt werden, er wird darüber hinaus im Akt der Benutzung durch und mit seiner Handlung exponiert und somit selbst zum temporären Bestandteil des Werkes. Neben diesen performativen Qualitäten sind Kerns skulpturale Nutzungsangebote zugleich aber immer auch auf kommunikative Prozesse angelegt. In der Benutzung von mehreren Personen gestalten sich interaktive Situationen, die die Erfahrung des Werkes von der individuellen Perzeption zur kollektiven Kommunikation verlagert. Weil dies hingegen in einem hauptsächlich von ästhetischen Konstanten geprägten Kontext stattfindet, durchbrechen sich die Erfahrung der den Skulpturen inhärenten formalen und funktionalen Eigenschaften und die Wahrnehmung der kommunikativen Situation. Dieser mehrstufige Perzeptionsprozeß erlaubt eine Erfahrung des Werkes in der Zeit. In diesem Sinne wird die visuell-rezeptive Wahrnehmung um eine Erlebnisdimension erweitert. Ganz im Sinne Merleau Pontys: "Zeit ist kein realer Prozeß […]. Sie entsteht durch meine Beziehung mit den Dingen."

they are conceived as a physical experience for and with the viewer. But flatteringly comforting they are not. The resulting ambivalence between autonomous sculpture on the one hand and user-friendly functionalism on the other not only makes the viewer aware of his own physical presence; interaction with the sculpture exposes him, temporarily making him part of the work.

Apart from possessing these performative qualities, Kern's sculptures are also always oriented towards communicative processes. When several people interact with his creations, individual perception becomes a collectively communicative experience. Yet because this takes place in a context characterised by aesthetic constants, the formal, functional characteristics of the sculptures and the perception of a communicative situation are combined in a joint experience. This subtle perceptive process enables the viewer to experience Kern's work in the context of time. In this sense, another dimension is added to the visual and receptive perception of his work. As Merleau Ponty expressed it: "Time is not a real process […]. It is created by my relationship to things."

STEFAN KERN – Hamburg, 1966 – Städelschule, Staatliche Hochschule für Bildende Kunst, Frankfurt am Main – Wohnt/lives in Hamburg

EINZELAUSSTELLUNGEN/ONE PERSON SHOWS: 2000 Portikus Frankfurt am Main – Galerie Michael Neff, Frankfurt am Main **1999** Ernst Barlach Museum Wedel – Philomene Magers Projekte, München **1998** Galerie Hammelehle und Ahrens, Stuttgart **1997** Mein Nachbar ist Künstler, Frankfurter Wohnung **1995** Künstlerhaus Hamburg **1994** Galerie Hammelehle und Ahrens, Stuttgart **GRUPPENAUSSTELLUNGEN/GROUP SHOWS: 2000** Over the Edges – the Corners of Ghent, Stedelijk Museum voor Actuele Kunst, Gent (Katalog/catalogue) – Aussendienst, Kunstverein Hamburg, Kulturbehörde Hamburg (Katalog/catalogue) – Stroom hcbk, den Haag **1999** Köln Skulptur 2, Skulpturenpark Riehlerstraße, Köln (Katalog/catalogue) – Dream City, München, Projekt der Villa Stuck, des Kunstraum München e.V., – des Kunstverein München und des Siemens Kulturprogramm (Katalog catalogue) **1998** Lifestyle, Kunsthaus Bregenz (Katalog/catalogue) – Minimalisms, Akademie der Künste, Berlin (Katalog/catalogue) – Fastforward – Trade Marks, Kunstverein Hamburg – 1 + 3 = 4 x 1, Galerie für zeitgenössische Kunst, Leipzig **1997** Plastik, Württembergischer Kunstverein, Stuttgart, Städtische Ausstellungshalle am Hawerkamp, Münster (Katalog/catalogue) – Pool Room, Kunstverein Hamburg – It always jumps back and find its way, De Appel, Amsterdam (Katalog/catalogue) – Take off, Galerie Krinzinger, Bregenz (Katalog/catalogue) – Galerie Philomene Magers, Köln – Galerie Krinziger, Wien – Köln Skulptur 1, Skulpturenpark Riehlerstraße, Köln (Katalog/catalogue) **1996** Der Umbau-Raum, Künstlerhaus Stuttgart – Galerie Lukas und Hofmann, Köln – Fishing for shapes, Künstlerhaus Bethanien, Berlin **1995** junger westen, Kunsthalle Recklinghausen (Katalog/catalogue) **1994** Galerie Paul Sties (mit/with Andreas Exner), Frankfurt am Main – Junge Kunst, Pfalzgalerie Kaiserslautern – Amand Schmidt Ausstellungen, Düsseldorf **1993** Skulpturen Symposion, Langen (Katalog catalogue) – Raum Franz West, Museum Fridericianum, Kassel

Stefan Kern

Gregor Schneider

Gregor Schneider – *Yilmaz Dziewior*

Thomas Bernhard beschreibt in seinem Buch "Das Kalkwerk" die fortschreitende Isolierung des Protagonisten Konrad nach dessen Einzug in ein über Jahrzehnte umgebautes und mit vielen Unterkellerungen ausgestattetes Kalkwerk. Die akustisch erfahrbare Abschottung zur Außenwelt führt bei Konrad nicht nur zur außergewöhnlichen Sensibilisierung des Gehörs, sie endet schließlich in einem grauenvollen Verbrechen.

Auf den ersten Blick wirkt das dreistöckige Mehrfamilienhaus, in dem Gregor Schneider lebt und das Nukleus und Grundlage seines Werkes darstellt, vollkommen unscheinbar und herkömmlich. Seit seinem 16. Lebensjahr baut Schneider die Räume des Hauses in der Unterheydener Straße im niederrheinischen Rheydt um, in-

Gregor Schneider – *Yilmaz Dziewior* – Translated by Toby Alleyne-Gee

In his book *Das Kalkwerk* ("The Lime Works"), Thomas Bernhard describes how the protagonist, Konrad, becomes increasingly isolated after moving into a lime works that has been rebuilt and equipped with several subterranean floors over a period of decades. Konrad's acoustic isolation from the outside world not only makes his hearing extraordinarily sensitive but also leads to a terrible crime.

At first glance, the three-storey house in which Gregor Schneider lives, and which is the nucleus and basis of his work, appears to be utterly unremarkable and ordinary. Schneider has been rebuilding the rooms in the house on Unterheydener Straße in Rheydt (Lower Rhine) since he was sixteen. For example, he

– **Totes Haus Ur, Rheydt**, 1985-99, Courtesy Galerie Konrad Fischer, Düsseldorf, Photo Gregor Schneider, © VG Bild-Kunst, Bonn 1999 – **Eingang zum Kaffeeraum Ur 10, Rheydt**, 1993, Courtesy Galerie Konrad Fischer, Düsseldorf, Photo Gregor Schneider, © VG Bild-Kunst, Bonn 1999

dem er zum Beispiel Wände vor vorhandene Wände setzt, die diesen zum verwechseln ähnlich sehen. Manchmal isoliert er die Zwischenräume dieser Wände mit schalldämmenden Materialien wie Blei oder Schaumstoff. In der Folge der prozeßhaften Umbauten und Abdichtungen ändert sich so nicht nur unmerklich die Akustik, vor allem auch die Proportionen verlieren an Realitätsbezug. Die Auswirkungen der architektonischen Eingriffe Schneiders sind körperlich spürbar, ohne daß man sie sofort erkennt; so dreht sich das Kaffeezimmer des Hauses von einem Motor langsam angetrieben unmerklich um seine eigene Achse. An manchen Stellen sind mehrere Fenster hintereinander angeordnet, wobei hinter den Glasscheiben angebrachte Lampen als Lichtquelle dienen, die selbst bei Nacht noch natürliches Tageslicht vortäuschen. Die Architektur des Hauses erfährt durch die exzessiven Eingriffe Schneiders eine mythische Aufladung, man spürt die rohe Kraftanstrengung, die er für die baulichen Veränderungen aufbringen muß. Gleichzeitig evozieren manche seiner Räume und engen Gänge eine Erotik, wie sie den nackten, verdrehten Körpern eines Bildes von Francis Bacon eigen sein könnte. Die von Schneider bewußt eingesetzten sexuellen Anspielungen (den Keller des Hauses nennt er Puff, mitunter stößt man beim Erkunden des Hauses auf eine lebensgroße weibliche Puppe) untermauern diese Assoziationen ebenso wie die Liebeslaube, ein weißer Raum mit Bett und Badewanne, den man hinter vielen Türen und endlosen, nur zu durchkriechenden Gängen erreicht. Das gesamte Haus ist durch eine latent gewaltsame, nicht rational zu erfassende Stimmung geprägt, die das Gefühl vermittelt, daß von einem Moment zum nächsten ein furchtbares Ereignis stattfinden könnte.

Für Ausstellungen baut Schneider einzelne Räume oder ganze Raumfolgen Stein für Stein aus seinem Haus heraus und plaziert sie in den Kunstkontext. Diese Praxis läßt sich in einigen Aspekten mit der von Michael Asher oder Gordon Matta-Clark vergleichen, auch wenn man den Eindruck gewinnen könnte, Schneider vernachlässige deren analytische, situationskritische Vorgehensweise zugunsten eines eher subjektiven Verfahrens, was sich jedoch bei genauerer Betrachtung als Irrtum erweist. Eine andere und deutlichere Reverenz ist der Merzbau von Kurt Schwitters. Wie dieser stellt auch das Haus von Schneider ein Gesamtkunstwerk dar, das aber im Gegensatz zum Merzbau stetig zerlegt und erneuert wird, und bei dem auch einzelne Fragmente autonome Arbeiten darstellen können. Hinzu kommen Fotos und Videos, deren Grundlage ebenfalls die Umbauten des Hauses darstellen. Einige der Videos zeigen die Sicht des Künstlers beim mühsamen Gang durch das Haus, während er schwer atmend auch Einblicke in die ansonsten nicht einsehbaren Zwischenbereiche gibt. Im Vergleich zu diesen unheilvoll und dramatisch anmutenden Aufnahmen wirken vor allem die kleinformatigen Fotos eher sachlich, ohne jedoch an Hintergründigkeit zu verlieren. In seinem Werk konstruiert Schneider ein fiktives, sehr privat anmutendes Drama, das

places walls in front of existing ones. The new walls are almost impossible to distinguish from the old. Sometimes he insulates the spaces between these walls with noise-reducing materials such as lead or foam. These structural alterations result in almost imperceptible changes in the acoustics. Above all, the proportions of the rooms lose their relationship to reality. You feel the effects of Schneider's architectural interventions physically, without immediately realising why. The coffee room, for example, turns imperceptibly on its own axis, powered by an engine. In some places, several windows are arranged behind each other; lamps behind the panes serve to simulate daylight, even at night.

Due to Schneider's excessive alterations, the architecture of the house is charged with a mystical atmosphere. You can feel the brute strength required to the make these architectural changes. At the same time, some of his rooms and narrow corridors evoke an eroticism that has a great deal in common with the naked, twisted bodies found in Francis Bacon's work. Schneider's deliberately sexual hints (he refers to the cellar as "the brothel", and one occasionally comes across a lifesize female doll) emphasise this connection. So does the love nest, a white room containing a bed and a bathtub. This room can only be reached by passing through many doors and endless corridors, which are only negotiable on hands and knees. The entire house is filled with an atmosphere of latent violence, the feeling that something dreadful could happen any moment; this feeling cannot be rationally grasped.

For exhibitions, Schneider will remove individual rooms, or entire series of rooms, from his house, brick by brick, and place them in an artistic context. To a certain extent, this practice can be compared with the work of Michael Asher or Gordon Matta-Clark, even if it could create the impression that Schneider neglects the analytical, critical procedure of these two artists in favour of a subjective approach. However, closer analysis reveals that this impression is incorrect. Another, more accurate comparison can be made to Kurt Schwitters' *Merzbau*. Like Schwitters' building, Schneider's house is a gesamtkunstwerk. Unlike Schwitters' work, however, Schneider is constantly dismantling and rebuilding his house, whose constituent parts can also stand in their own right as autonomous works of art. Schneider's œuvre also consists of photos and videos, which are also based on the alterations made to the house. Some of the videos are filmed from the artist's perspective on his arduous passage through the house; breathing heavily, he also reveals the spaces between walls that normally cannot be seen. In comparison with these ominous and dramatic images, the small-format photos seem matter-of-fact, although they remain enigmatic.

den Rezipienten (körperlich) involviert und Vorstellungen von Verbrechen, Liebe und Tod heraufbeschwört. Bei aller Romantik, die in vielen Facetten in seinem Werk eingeschrieben ist, haben seine Arbeiten aber auch eine analytische, die klassischen Parameter des White Cube relativierende Dimension. Schneider versteht es, die Ebenen der Mystifikation sukzessive aufzuheben, was dazu führt, daß man glaubt, seine Konstruktionen durchschauen zu können, doch da täuscht man sich.

Schneider constructs a fictitious, private drama that (physically) involves the viewer and evokes images of crime, love and death. However romantic some of his work might appear, Schneider's work also has an analytical dimension that relativises the classical parameters of the White Cube. Schneider manages gradually to demystify his message. This could lead one to believe one has seen through his constructions. However, anyone who does so will be mistaken.

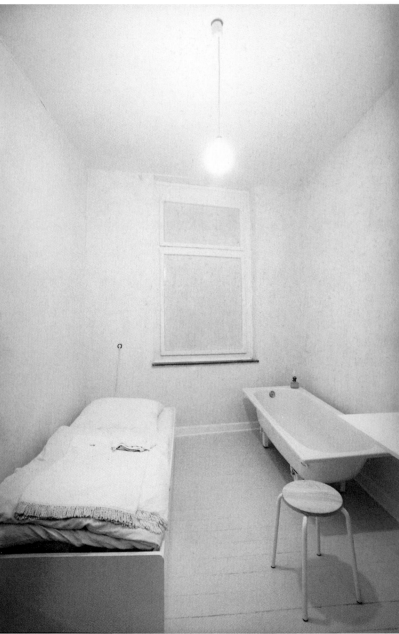

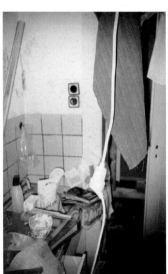

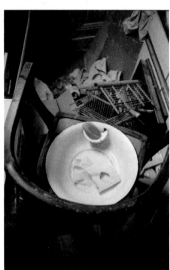

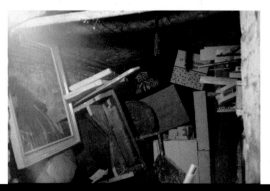

GREGOR SCHNEIDER – Rheydt, 1969 – Kunstakademien Düsseldorf, Münster und/and Hamburg – Wohnt/lives in Rheydt

Photo W. Ulrich, Frankfurt am Main

1985 – 99 Bau des Hauses u r, Rheydt **1989 – 91** Bau des total isolierten, toten Raums, Giesenkirchen **1990 – 91** Bau einer unbekannten Arbeit im verschwindenden Dorf Garzweiler **1995** Bau des total isolierten Gästezimmers, Rheydt **EINZELAUSSTELLUNG/ONE PERSON SHOWS: 2000** Douglas Hyde Gallery, Dublin – Konrad Fischer Galerie, Düsseldorf **1999** Galerie Massimo de Carlo, Milano – Gallery Chantal Crousel, Paris – Kunsthalle Bremerhaven – Kabinett der aktuellen Kunst, Bremerhaven **1998** Städtisches Museum Abteiberg, Mönchengladbach (Katalog/catalogue) – Musée d´Art Moderne de la Ville de Paris, Paris (Katalog/catalogue) – Aarhus Kunst Museum, Dänemark (Katalog/catalogue) – Galerie Wako, Tokio **1997** Konrad Fischer Galerie, Düsseldorf – Galerie Luis Campaña, Köln – Portikus, Kunsthalle Frankfurt am Main (Katalog/catalogue) – Galerie Wako, Tokio – Galerie Sadie Coles HQ, London – Galera Foksal, Warschau (Katalog/catalogue) **1996** Kunsthalle Bern (Katalog/catalogue) – Künstlerhaus Stuttgart **1995** Luis Campaña, Köln **1994** Galerie Andreas Weiss, Berlin – Museum Haus Lange, Krefeld (Katalog/catalogue) **1993** Galerie Konrad Fischer, Düsseldorf **1992** Galerie Löhrl, Mönchengladbach (Katalog/catalogue) **GRUPPENAUSSTELLUNGEN/GROUP SHOWS: 2000** Wonderland, The Saint Louis Art Museum (Katalog/catalogue) – From Kurt Schwitters until now, EXPO 2000, Sprengelmuseum Hannover – Kunstsammlung NRW, Düsseldorf, Haus der Kunst München – Kunsthalle Hamburg (Katalog/catalogue) – 1900 - 2000 -Two Turns Of The Century, Goeteborg Kunstmuseum and Nordic Institute of Contemporary Art **1999** Anarchitecture, Stichting De Appel, Amsterdam (Katalog/catalogue) – Focused, Galerie Tanit, München – Elizabeth Cherry Contemporary Art, Tucson, Arizonan – Kunststiftung Sabine Schwenk, Haigerloch – Museum Schloß Rheydt, Rheydt (Katalog/catalogue) – The Space here is everywhere, Villa Merkel, Esslingen (Katalog/catalogue) – Kunstverein Wien – 53. Carnegie International, Carnegie Museum of Art, Pittsburgh (Katalog/catalogue) – German Art, Athen (Katalog/catalogue) – Zeitenwenden, Kunstmuseum Bonn, Kunstmuseum Ludwig, Wien (Katalog/catalogue) – Horizontabschreiten, Kaiser Wilhelm Museum, Krefeld (Katalog/catalogue) – New Museum of Contemporary Art, New York – The invisible city, Centrum Beeldende Kunst, Maastricht – Private Werte, Künstlerwerkstatt, Lothringer Str. 13, München **1998** perfect usual, Kunstverein Freiburg, Germanisches Nationalmuseum Nürnberg – Kunstverein Braunschweig, Kunsthalle Kiel, Kunsthalle Gera (Katalog/catalogue) – Performing Buildings, Tate Gallery, London – The Confined Room, De Waag, Amsterdam – Center for Contemporary Art, Maastricht **1997** Niemandsland, Museum Haus Lange/Esters, Krefeld (Katalog/catalogue) – A place (to be), Galerie Paul Andriesse, Amsterdam **1996** Dorothea von Stetten Kunstpreis, Kunstmuseum Bonn (Katalog/catalogue) – Peter Mertes Stipendium, Bonner Kunstverein, Bonn (Katalog/catalogue)

Gregor Schneider

Reinigungsgesellschaft

– **Faustos**, 1999, Videostills, © REINIGUNGSGESELLSCHAFT

Reinigungsgesellschaft – *Christian Janecke*

Im Zuge neuerlicher Desillusionierung sozial engagierter Utopien findet die dienstleistungskünstlerische Zwickmühle aus praxis-relevanter "Verbraucherorientiertheit" und Zwang zur Novität einen Ausweg: Die Absenkung des dienstleistungskünstlerischen *Tuns* auf dessen *Aufführung*, oder zugespitzter noch: auf dessen Bild. Kann Dienstleistungskunst dann nur noch ästhetische Nach-hutgefechte in der Provinz austragen, oder kann sie – ebenso ent-lastet vom Weltverbesserungsanspruch wie beargwöhnt durch standhafte Verfechter desselben – zu einem neutralen *Sprach-mittel* werden?

In letztere Richtung deuten bereits frühere Arbeiten von Martin Keil/Henrik Mayer, wenn sie mit der Stadtreinigung, mit Vertretern der katholischen Kirche, später – das ist ihre Diplomarbeit – mit dem Arbeitsamt kooperieren. Und zwar so unbekümmert, als hätte es nicht 20 Jahre zuvor eine Artist Placement Group und ihren künstlerischen "Gang durch die Institutionen", oder in unse-ren Tagen Wolfgang Zinggls "WochenKlausuren" gegeben. Völlig gleichberechtigt treten gesinnungsethischer Impetus, pragmati-sche und kooperative Umsetzung neben jenes "Bild", das die Aktion selbst, überdies die kunstkontextuelle Rahmensituation gibt. Auch der Umstand, daß diese nicht durch Museum oder Galerie, sondern vor *Ort* gestiftet wird, gibt kaum mehr Anlaß zu jener noch unlängst umkämpften Frage, ob rühmliche Ausdeh-nung auf außerkünstlerisches Terrain oder ob Territorialisierung lebensweltlicher Nischen anstehe. Entsprechendes gilt für *Prä-sentationen* von Ergebnissen, etwa wenn in "Zeitjobvermittlung" Gruppen unterschiedlichen sozialen Status' – Menschen aus dem Umfeld einer Leipziger Anwaltskanzlei versus umzuschulende Arbeitslose – aus Pools von Fotos, piktogrammatischen Sym-bolen und Begriffen Kombinationen fügen und die Resultate in ausliegenden Mappen beziehungsweise in unprätentiöser Hän-gung zugänglich gemacht werden. Verpufft ist jene kunstsoziolo-gisch flankierte Strategie, die noch Clegg & Guttmanns "Offene Bibliothek" motivierte; der Betrachter allein mag noch latente Ansprüche einer "soziologischen Kunst" ernst nehmen und – gepiesackt durch das Unrepräsentative der Versuchsgruppen – aus den in Frage stehenden Foto-Symbol-Begriff-Zuordnungen signifikante Unterschiede herausfischen. Soziologisch kraus, ent-schädigen doch Bilder, mitunter die eigener Vorurteile. Der An-schauungsprozeß – zunächst Bilanz mobilisierten Halbwissens über ästhetischen Konformismus Marginalisierter, über kalkulierte Unkonventialität Bessergestellter – wird seinerseits Thema. Daß transformierte Dienstleistungskunst das "Bild" dem Aktivis-mus vorzieht, zeigen noch unmißverständlicher die "Europäischen Sibyllen": Wenn 16 Frisurmodels als Repräsentantinnen europä-

Reinigungsgesellschaft – *Christian Janecke* – Translated by Toby Alleyne-Gee

In the wake of renewed disillusionment with socially committed utopian ideals, the service-oriented art business has now found a way out of the dilemma of having to be "consumer-friendly" on the one hand and innovative on the other: that way out is the reduction of the artistic act to a performance. Put more pointed-ly, art has been reduced to an image of itself.

Can service-oriented art now only battle it out in the provinces, or – now that it has been liberated of its claim to improve the world, as stalwart supporters of this attitude suspect – can it become a neutral means of linguistic expression?

Martin Keil and Henrik Mayer's earlier works already point in this direction – their cooperation with the municipal hygiene office, representatives of the catholic church, for example, or later, for their diploma, with the labour office. The artists collaborated with these institutions as casually as if there had been no artist place-ment group with its "tour of the institutions" twenty years earlier, or Wolfgang Zinggl's *Wochenklausuren* nowadays. Ethical impe-tus, pragmatic and cooperative implementation of their ideas are represented to the same extent as the "image" produced by the artistic act itself and the artistic environment. The fact that this artistic environment is not provided by a museum or a gallery also renders the question, which until recently was the subject of con-siderable controversy, as to whether art would now be gloriously extended to non-artistic territory, or whether it would colonise specific niches. This applies to presentations of results, for exam-ple *Zeitjobvermittlung* ("Temping Agency"), in which the artists present combinations of pictures, symbolic pictograms and ter-minology relating to groups of differing social status – people from a Leipzig law practice confronted with unemployed people on a training programme – making them accessible to their audi-ence in folders, or by hanging them unpretentiously on the wall. The sociological strategy that motivated Clegg & Gutmann's *Open Library* has vanished into thin air; only the viewer may take the latent claims of a "sociological art form" seriously and, irritat-ed by the fact that the trial groups are unrepresentative, observe significant differences among the photographs, symbols and terminology in question. Sociologically muddled, images do after all compensate – at times for one's own prejudices. The process of observing a work of art – initially based on the semi-expertise of conformists who are marginalised and yet, through their calcu-lated unconventionalism, superior beings – becomes a topic of discussion.

The fact that service-oriented art prefers the "image" to activism is demonstrated even more unambiguously by the *European*

ischen Zukunftsdenkens vorgeschlagen werden, mag dies mit Blick auf den bemühten Topos antiker weissagender Frauen und den berufsoptimistischen Tonfall neudeutscher Politbroschüren als Kalauer gelten, es gewinnt aber per *Verfremdung*: Die unfreiwillige Komik älterer Zeitschriften mit angestrengt unwiderstehlich äugelnden Models tritt angesichts der Kluft zwischen vermessenem Europa-Weissagungs-Blabla und verinnerlichter physiognomischer Härte – sämtliche Bilder lichten DDR-Schönheiten ab – zur Grimasse auseinander.

"Die sieben Tugenden des Erzgebirges", ein Film zwischen Feature und Dokumentation, enthält Interviews mit Repräsentanten der Volkskunst, regionaler Politik, des vergangenen Industriezweiges Bergbau, der heimischen Küche und dergleichen. Die Klischeehaftigkeit der Auswahl ist groß, aber nicht groß genug, daß sich nicht ohne weiteres ein Landessender der ARD für die hausbacken vorgetragenen Auskünfte über Sparsamkeit, Fleiß, Bodenständigkeit, Ehrlichkeit, Gemütlichkeit usw. erwärmen könnte. Der launige Tonfall des Sprechers komplimentiert den Zuschauer durch schneebedeckte Landschaften, kuschelige Handwerkerstuben und farbig gefaßte Holzschnitzkunst. Gewiß: wenn man *in the know* und unter seinesgleichen ist, findet man Grund zum Feixen, etwa über den Museumsmann, der an sich gar nichts gegen "die Asiaten" hat: Aber wenn die schon Räuchermännchen nachmachen, dann bitte mit Schlitzaugen! Im übrigen aber antworten die Gefragten schlicht, seltener einfältig, und mit etwas eingeübt wirkender Offenheit bezüglich eines anstehenden "vereinten Europas".

Als *Appropriation Art* bezüglich vorweihnachtlicher TV-Dokumentationen würde erst spätnachmittägliche und landesweite Ausstrahlung den Hype für saturierte Kritiker garantieren (Gucken die dann auch?). In der Ausstellung andererseits wird man schauen, wie die schauen, die vorgeben, dem Volk auf's Maul zu schauen. Wird das als Patchwork zukunftsheiterer, kreuzbraver Bürger auftretende Double allabendlicher TV-Dienstleistungskunst dann in verändertem Rezeptionszusammenhang eine glückliche Phänomenologie regionaler Kultur anstiften, oder sollte es doch den hehren Anspruch verbürgen, "Verblendungszusammenhänge" aufzureißen? Das wäre dann wieder eine prä-dienstleistungskünstlerische "Dienstleistung".

Sibyls: sixteen hair models being proposed as representatives of progressive European thought may be considered a corny joke in the light of the forced *topos* of prophetesses of antiquity and the optimistic tone of modern German political brochures.
But this work gains by alienation: in view of the gulf between presumptuous European prophetic blurb and internalised physiognomic severity – all the pictures are of GDR beauties – the involuntarily comic effect of old magazines with their artificially irresistible models turns into a grimace.

Die sieben Tugenden des Erzgebirges ("The Seven Virtues of the Erz Mountains"), a film between feature and documentation, contains interviews with representatives of popular art, regional politics, the dying mining industry, local cuisine etc. The selection of trades is stereotyped, but not sufficiently so to arouse the enthusiasm of a local television station for the boringly presented information on thriftiness, diligence, local pride, honesty, cosiness etc. The cheerful tone of the speaker accompanies the viewer through snow-covered landscapes, cosy craftsmen's workshops and the art of gaudily coloured wood carvings. Of course, if one is in the know and in the company of one's own kind, there are reasons to smirk, perhaps about the museum man who basically has nothing against "the Asians": but if they copy "Räuchermännchen" (a traditional incense burner from the Erz mountains, carved from wood in the shape of a man), then they should please do so with slanting eyes! Generally, though, the interviewees answer simply, at times naively, and with a somewhat rehearsed openness towards a "united Europe". Only late-afternoon, country-wide transmission as a pre-Christmas television documentary would guarantee the enthusiasm of self-satisfied critics for this film as appropriation art. (Do they watch television at that time of day, too?) At the exhibition, on the other hand, people will watch it in the way people do so who claim to "listen to the way the ordinary man speaks". Will this double of evening TV entertainment, which presents itself as a patchwork of cheerful, future-oriented, well-behaved citizens, be received as a successful phenomenology of regional culture, or is it intended to destroy deceptive preconceptions? That would be a pre-service-oriented artistic "service" indeed.

– **Die sieben Tugenden des Erzgebirges**, 1999, Tintenstrahldrucke auf Papier/Inkjet prints on paper, © REINIGUNGSGESELLSCHAFT

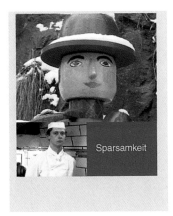 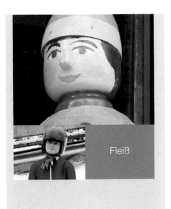

Sparsamkeit

Fleiß

Bodenständigkeit

Zuverlässigkeit

Ehrlichkeit

Bescheidenheit

Gemütlichkeit

Die sieben Tugenden des Erzgebirges

– Die europäischen Sibyllen, 1999, Digitalprint auf Leinwand/Digital print on canvas
je/each 100 x 70 cm, © REINIGUNGSGESELLSCHAFT

REINIGUNGSGESELLSCHAFT: **HENRIK MAYER** – Freiberg, 1971 – Studium Freie Kunst in Dresden, London und/and Budapest – Wohnt/lives in Dresden **MARTIN KEIL** – Schlema, 1968 – Studium Freie Kunst in Halle, Mexico-City, Dresden, Barcelona und/and Cuenca – Wohnt/lives in Dresden

EINZELAUSSTELLUNGEN/SOLO EXHIBITIONS: 1999 GLÜCK AUF, EUROPA, Galerie Ralf Zschorn, Dresden **1997** Postsoziale Gesellschaftsformen Forschung, Bestandsaufnahme – Post social society forms, Research, Stocklist, ETERNIT Hauptverwaltung, Berlin (Katalog/catalogue) – Schnellwaschgang, Ausstellung in den Projekträumen, Performance in Zusammenarbeit mit Musikverein 71 – exhibition in the project spaces, performance in cooperation with Musikverein 71, Vorstellung 1, Orangerie Schloß Pillnitz **GRUPPENAUSSTELLUNGEN/ GROUP SHOWS: 1999** Projekt/Project HEIMAT & IDENTITÄT, in Zusammenarbeit mit dem/in Cooperation with the Goethe-Institut, Dresden – DIE EUROPÄISCHEN SIBYLLEN, thematische Ausstellung und Vortrag zur europäischen Einigung/thematic exhibition and lecture about the European Union, Konsulat Luxembourg, Dresden – BESUCH AUS DRESDEN, Präsentation mit Künstlern der Galerie Zschorn im Ausstellungsraum von Konstantin Adamopoulos/Presentation with artists of the Gallery Zschorn in the exhibition space of Konstantion Adamopoulos, Frankfurt am Main (Katalog/catalogue **1998** Projekt/Project Zeitjobvermittlung, Kommunikationstraining in Dresden und Leipzig – communication training in Dresden and Leipzig, Parallelausstellung im Arbeitsamt Dresden und im Sächsischen Landtag – parallel exhibition in the Dresden job center and Saxonian state parliament, Videointerviews/video interviews **1997** Kunststudenten stellen aus, Kunst- und Ausstellungshalle der Bundesrepublik Deutschland, Bonn (Katalog/catalogue) – The Prayer (in Zusammenarbeit mit der katholischen Kirche/in cooperation with the catholic church), Frühlingssalon HfBK Dresden – Musikkassette/music tape Reinigungsgesellschaft sagt guten Tag (zum Wiederaufbau der Dresdner Frauenkirche/on the occasion of the reconstruction of the Frauenkirche in Dresden), Kunstmarkt, Dresden

Reinigungsgesellschaft

John Bock

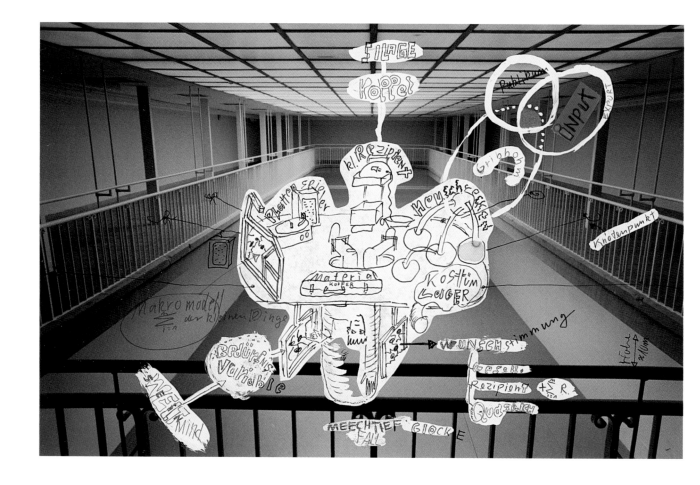

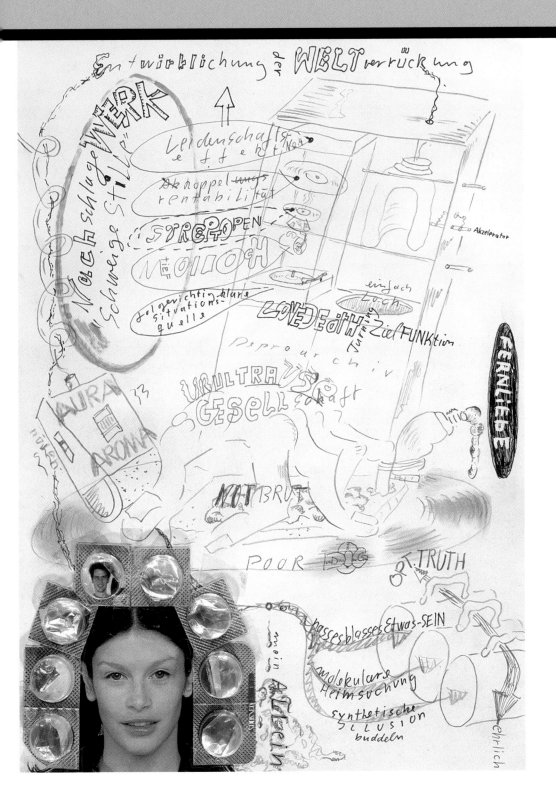

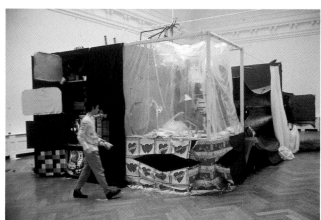

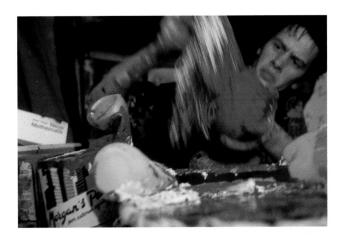

JOHN BOCK – Gribbohm, 1965 – Hochschule für bildende Künste, Hamburg – Wohnt/ lives in Berlin

John Bock

Dieser Katalog erscheint anläßlich der Ausstellung/
This catalogue is published on the occasion of the
exhibition: German Open 1999 – Gegenwartskunst in
Deutschland/Contemporary Art in Germany
Kunstmuseum Wolfsburg
13. November 1999 – 26. März 2000

Distribution in the US: D.A.P. Distributed Art Publishers Inc
155 Avenue of the Americas, 2nd floor
USA - New York N.Y. 10013 –1507
Phone 212 – 6271999, Fax 212 – 6279484

Konzeption und Realisation der Ausstellung/Concept and
realization of the exhibition: Andrea Brodbeck, Veit Görner
Assistenz/Assistance: Jose Presmanes, Kea Wienand

ISBN 3 - 7757 - 0904-5

KATALOG/CATALOGUE

Printed in Germany

Konzeption/Concept: Gerard Hadders,
Minke Themans, Andrea Brodbeck, Veit Görner
Gestaltung/Design: Minke Themans, Gerard Hadders,
BLH, Schiedam
Lektorat/Copy editing: Cornelia Plaas

Kunststiftung Volkswagen/Volkswagen Art Foundation
Kuratoriumsvorsitzender/Chairman of the Board of
Trustees: Dr. Carl Hahn
Vorstand/Board of Directors: Jürgen Schow,
Gijs van Tuyl

© 2000 Kunstmuseum Wolfsburg und die Autoren/
and authors

Kunstmuseum Wolfsburg
Porschestraße 53
D – 38440 Wolfsburg
Telefon: 05361 – 26690, Telefax: 05361 – 266920
E-mail: info@kunstmuseum-wolfsburg.de
Internet: www:kunstmuseum-wolfsburg.de

Gesamtherstellung/Printed by: Dr. Cantz'sche Druckerei,
Ostfildern bei Stuttgart

Vertrieb/Distribution: Hatje Cantz Verlag,
Senefelderstraße 12, D – 73760 Ostfildern-Ruit
Telefon 0711 – 44050, Telefax 0711 – 4405220
Internet: www.hatjecantz.de